JN089611

靴、バッグ、帽子、
ベルト、手袋、メガネの
デザインを学ぶ

ファッション小物の
デザインと描き方

マヌエーラ・ブラムバッティ／ファビオ・メンコーニ 著
清水玲奈 訳

FASHION ILLUSTRATION & DESIGN

FASHION ILLUSTRATION & DESIGN

靴、バッグ、帽子、
ベルト、手袋、メガネの
デザインを学ぶ

ファッション小物の
デザインと描き方

マヌエーラ・ブラムバッティ／ファビオ・メンコーニ 著
清水玲奈 訳

目 次

はじめに

　多くの読者に役立つ情報を届けるための実践的なマニュアル本を作ることは、刺激的な体験であり、大いにやりがいがあります。私はこれまで、不定期ではあっても、大好きな分野で本を出す機会に恵まれてきました。ですから「ファッションアクセサリーの描き方の本を作らないか」と編集者から提案されたときは、迷わずに引き受け、大きな熱意と喜びを持って取り組みました。協力してもらったのが、プロ意識と優れた能力を備え、ファッション界での長年の経験を持つファビオ・メンコーニです。私たちは靴やバックといったファッション小物の代表的な歴史をまとめ、さらにはその歴史をより深く理解するための情報やヒントをこの一冊に盛り込みました。

　出発点は、コンセプトを決めることでした。構造の基本解説から彩色の技術までを紹介し、さらにはファッション小物を身につけている様子をイメージできるように、創造性や実験精神を発揮したデッサン画を使って、内容をできる限り充実させました。創造力を鍛えることは、少なくとも描く技術を鍛えるのと同じくらい重要です。ファッション小物の魅力的な世界に初めの一歩を踏み入れるという読者も含め、自分でやってみたい、楽しみたいという皆さんのニーズにこの本が応えられることを願っています。

<div align="right">——マヌエーラ・ブラムバッティ</div>

　私は1990年代、イタリアのファッションブランド、ジェニーで働いていました。当時は同僚のステファノ・シトロンとともに、メゾン・ヴェルサーチ（訳注：1973年からジェニーのデザイナーを務めていたジャンニ・ヴェルサーチのアトリエ）から毎シーズン送られてくる新しいデザイン画を心待ちにしたものでした。それをもとに調整を加え、ジェニーの商品を完成させるのが私たちの仕事でした。

　メゾン・ヴェルサーチのデザイン画のほとんどが、マヌエーラ・ブラムバッティとブルーノ・ジャネージが手掛けた作品でした。ジャンニ・ヴェルサーチのアイデアをもとに、2人はいつも息をのむほど美しい夢のようなデザイン画を描きました。私は何年もの間、机の上にオリジナルのスケッチを置いて仕事をし、細部に至るまで研究し、とても役立つ実践的な技術を学び、それまで私が習ったのとは全く異なる新しい描き方を身につけました。

　少年時代の私は、プロのファッションイラストレーターの秘訣を凝縮していて、さらにテクニックやコツが完璧に学べるような本を探し求めたものでした。ドローイングと着色、作品の形とバランスといった基本が一冊で網羅されているような本です。でも実際に出ていたのは、必要なことの20〜30％しか書かれていないような本ばかり。そんな経験を踏まえて、私たちの本は読めばすぐに目に見えて腕が上がるように作りました。ファッションイラストレーターが身につけておくべきテクニックと、具体的な手順を丁寧に解説しています。デッサンの基本から出発し、色の使い方に加えて、ニュアンスや色合いの応用までをまとめました。この一冊をマスターすれば、いつでもプロのような効果を出せるようになるでしょう。

　さまざまな形の表現だけではなく、各種のレザー、スワロフスキーのクリスタル、陰影、モノクロ、プリント生地やエンボス加工のレザー、千鳥格子、毛皮のディテールや小さなメタルなどさまざまな要素が使いこなせるように、自分らしい創造性を発揮するために必要な鉛筆やペンの選び方と、ステップごとの手順を解説しています。

　この本は、イラストレーション・図版とノウハウをいずれも豊富に掲載し、アートと実践的な解説が相乗効果を生み出すことを目指しました。マニュアルとして使うことを目的とした本ですが、ただパラパラとめくって美しい図版を楽しむこともできます。衣装デザイン史における重要人物や、定番のファッションアイテムの名前の由来になった有名人についてのエピソードも多数掲載しました。

　これまで私を指導し励ましてくれたマヌーことマヌエーラに感謝します。マヌーのおかげで私は自分の腕を磨き、新しいことを次々と教わりました。そして、このような美しい本を共著として出す機会を与えてくれたことにも感謝します。この本は、意欲を持つ読者の皆さんに捧げられています。ファッションアクセサリーのデッサン、デザインとイラストの描き方を学ぶために必要な実践的な知識を惜しみなく詰め込んだ一冊です。

　この本は、実践的なマニュアルを求めている方だけではなく、感動に満ちたマジックのような世界を表現する「アート」として、イラストレーションを眺めたいという方にもおすすめです。私が少年時代、大好きなデザイン画を眺めるたびにおぼえたのと同じ感動を、皆さんにも感じていただけることを祈っています。

<div align="right">——ファビオ・メンコーニ</div>

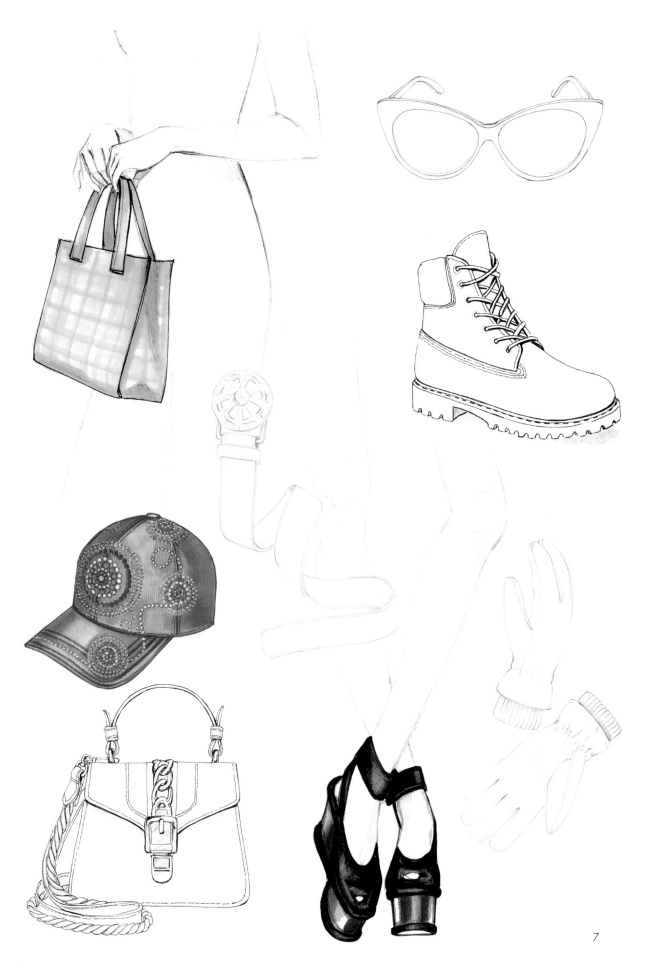

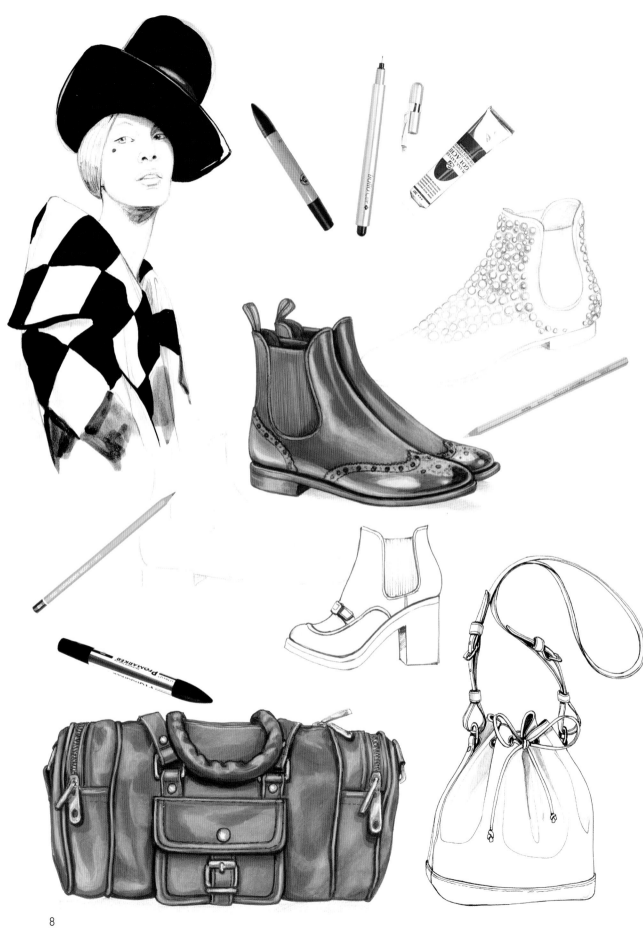

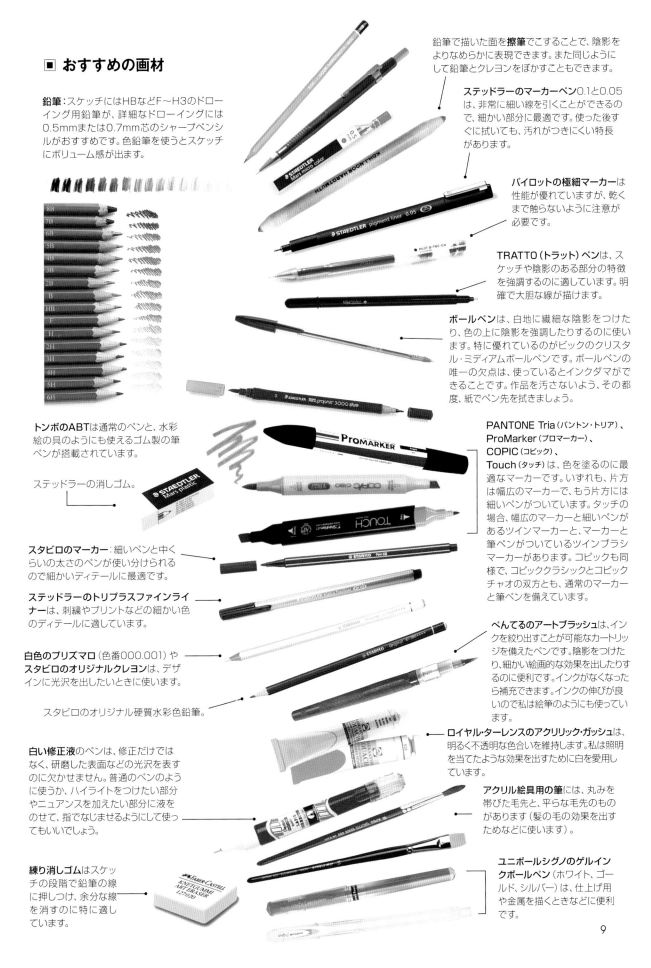

■ おすすめの画材

鉛筆：スケッチにはHBなどF〜H3のドローイング用鉛筆が、詳細なドローイングには0.5mmまたは0.7mm芯のシャープペンシルがおすすめです。色鉛筆を使うとスケッチにボリューム感が出ます。

鉛筆で描いた面を**擦筆**でこすることで、陰影をよりなめらかに表現できます。また同じようにして鉛筆とクレヨンをぼかすこともできます。

ステッドラーのマーカーペン0.1と0.05は、非常に細い線を引くことができるので、細かい部分に最適です。使った後すぐに拭いても、汚れがつきにくい特長があります。

パイロットの極細マーカーは性能が優れていますが、乾くまで触らないように注意が必要です。

TRATTO（トラット）ペンは、スケッチや陰影のある部分の特徴を強調するのに適しています。明確で大胆な線が描けます。

ボールペンは、白地に繊細な陰影をつけたり、色の上に陰影を強調したりするのに使います。特に優れているのがビックのクリスタル・ミディアムボールペンです。ボールペンの唯一の欠点は、使っているとインクダマができることです。作品を汚さないよう、その都度、紙でペン先を拭きましょう。

トンボのABTは通常のペンと、水彩絵の具のようにも使えるゴム製の筆ペンが搭載されています。

ステッドラーの消しゴム。

PANTONE Tria（パントン・トリア）、ProMarker（プロマーカー）、COPIC（コピック）、Touch（タッチ）は、色を塗るのに最適なマーカーです。いずれも、片方は幅広のマーカーで、もう片方には細いペンがついています。タッチの場合、幅広のマーカーと細いペンがあるツインマーカーと、マーカーと筆ペンがついているツインブラシマーカーがあります。コピックも同様で、コピッククラシックとコピックチャオの双方とも、通常のマーカーと筆ペンを備えています。

スタビロのマーカー：細いペンと中くらいの太さのペンが使い分けられるので細かいディテールに最適です。

ステッドラーのトリプラスファインライナーは、刺繍やプリントなどの細かい色のディテールに適しています。

白色の**プリズマロ**（色番000.001）や**スタビロのオリジナルクレヨン**は、デザインに光沢を出したいときに使います。

スタビロのオリジナル硬質水彩色鉛筆。

ぺんてるのアートブラッシュは、インクを絞り出すことが可能なカートリッジを備えたペンです。陰影をつけたり、細かい絵画的な効果を出したりするのに便利です。インクがなくなったら補充できます。インクの伸びが良いので私は絵筆のようにも使っています。

ロイヤル・ターレンスのアクリリック・ガッシュは、明るく不透明な色合いを維持します。私は照明を当てたような効果を出すために白を愛用しています。

白い修正液のペンは、修正だけではなく、研磨した表面などの光沢を表すのに欠かせません。普通のペンのように使うか、ハイライトをつけたい部分やニュアンスを加えたい部分に液をのせて、指でなじませるようにして使ってもいいでしょう。

アクリル絵具用の筆には、丸みを帯びた毛先と、平らな毛先のものがあります（髪の毛の効果を出すためなどに使います）。

練り消しゴムはスケッチの段階で鉛筆の線に押しつけ、余分な線を消すのに特に適しています。

ユニボールシグノのゲルインクボールペン（ホワイト、ゴールド、シルバー）は、仕上げ用や金属を描くときなどに便利です。

靴

　靴のデザインは、バリエーション豊かです。目もくらむようなハイヒール、刺繍で飾られたバレリーナパンプス、セクシーなブーツ、マスキュリンな印象を与えるモカシン…。ファッション史に革命をもたらした靴や、今でも多くの女性たちの憧れの的となっている靴もあります。

　靴作りの名人たちは、一般女性からプリンセスまで、幅広い女性たちの足元を飾るために、まさに夢のような靴を作り続けてきました。靴を題材にしたおとぎばなしも忘れられません。シンデレラが美しいガラスの靴を履いていたのは、靴に女性の運命を変える力があるからです。21世紀のシンデレラは、仕事をしたり旅行をしたりする女性で、自分らしいスタイルやディテールを大切にしながらも快適さにも妥協しません。

　魅惑的ですらりとした体型を演出するハイヒールは根強い人気があります。現代女性は、大胆なヒールも、サテンのリボンで飾られたピンクのバレリーナパンプスも履きこなすのです。

　靴とバッグはファッションアクセサリーの双璧ともいえる存在で、相乗効果によってスタイルを完成させます。デザイナーにとっても、身につける人にとっても、靴とバッグには想像力を無限に羽ばたかせてくれる魅力があります。

　クリエーターやファッションに敏感な人たちの間でも、靴のスタイルに関連づけられた人物や逸話は必ずしも知られていません。実際にはディテールの違いによって全く違う種類に分類されるべき靴が混同されているケースもあります。

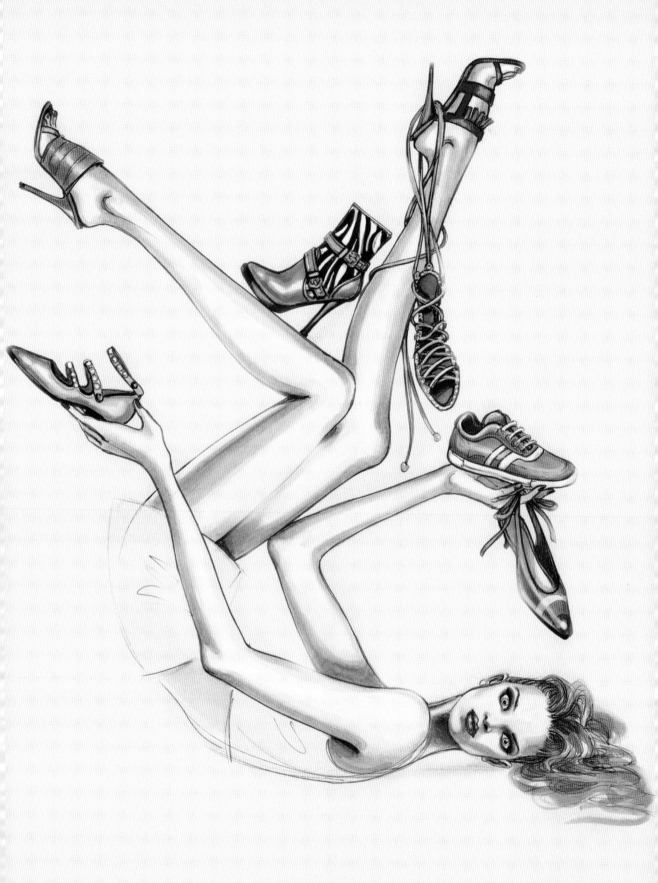

▣ 足の形

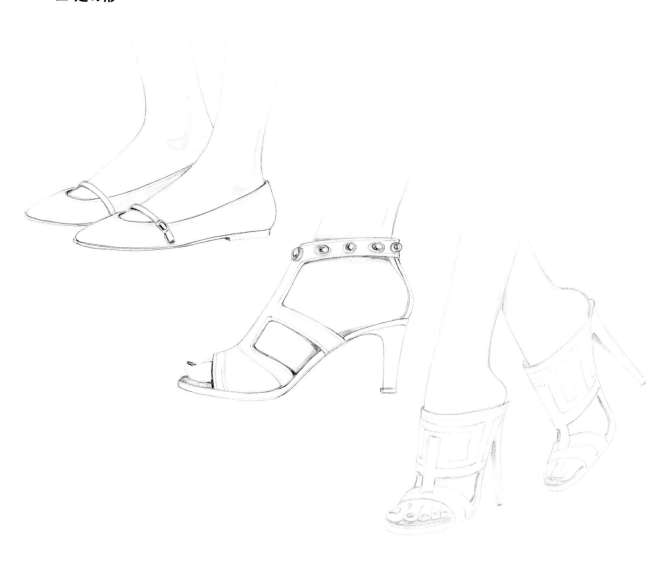

靴の描き方をマスターするには、解剖学の基本的知識が必要です。サンダル、ドルセーパンプス、ビーチサンダルやミュールなどのオープンシューズを描く際には、足の形態に関する知識が非常に役立ちます。

足のポジションによって、体全体の動きが決まります。ハイヒールでもフラットシューズでも、体はさまざまな姿勢をとります。靴はファッションアクセサリーの中でも特殊で、スタイリッシュにデザインを表現するために、さまざまな角度からの詳細なアプローチが必要となります。トゥのシルエット、ヒールの刺繍のディテール、靴の側面を飾る複雑に編み込まれたストラップなどを見せるため、靴の全体像を示すように上から見た図や、3/4の角度から見た透視図を描きます。

足の描き方を知っていると、靴の基本的なデザインを作るときにも、必ず役に立ちます。たとえば、ニーハイブーツやアンクルブーツ、スニーカーなどのように、足がすっかり覆われるデザインの場合でも同様です。私の意見では、特にかかと側の形に気を配ることが重要です。かかと側をどれくらい特徴的な形にするかをよく考えましょう。アッパーの形は、どれだけ丸みを帯びさせるかがポイントです。レザーを準備して裁断するときにその点に留意すると、履きやすい靴ができあがります。

基本的なデザインを作成する際には、柔らかい鉛筆を使ってスケッチによって理想的な形を探ることをおすすめします。失敗してもすぐに修正できるので、イメージ通りの仕上がりになります。また、アウトラインが完成したら、ペンでなぞって保存しておきましょう。このようなイメージのアーカイブを作っておけば、このスケッチをもとに靴をデザインすることができるので、作業がはかどります。靴の種類によって基本的な形や角度が異なりますから、デザインを特徴づける最も重要なディテールを強調するとよいでしょう。

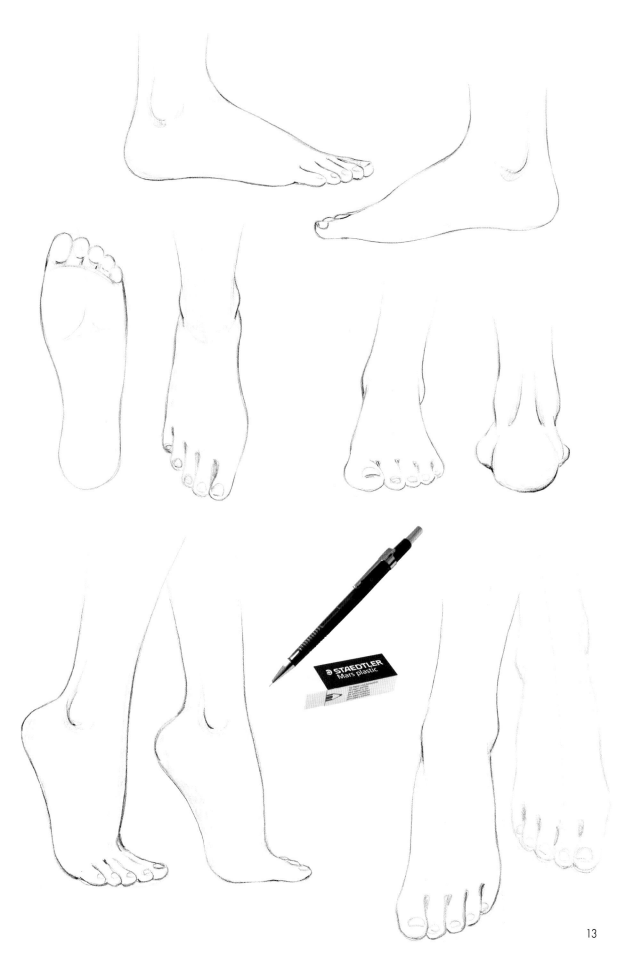

■ フラットヒール

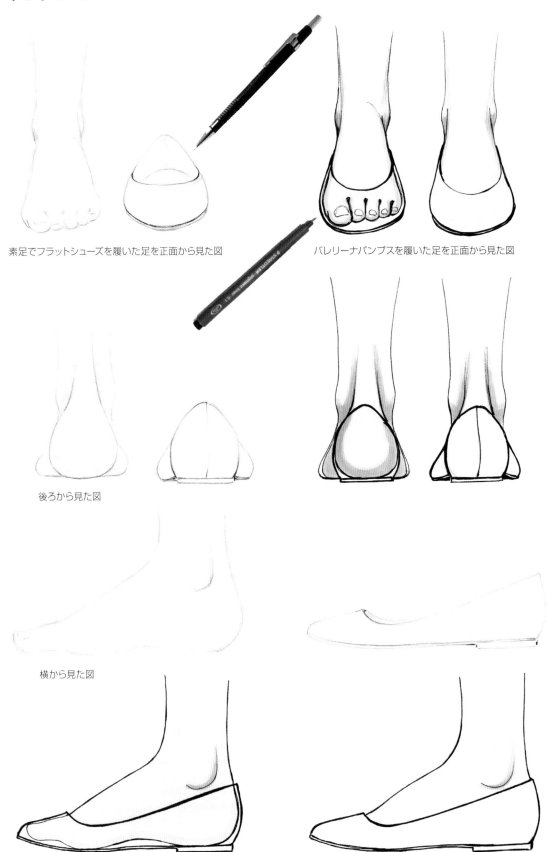

素足でフラットシューズを履いた足を正面から見た図

バレリーナパンプスを履いた足を正面から見た図

後ろから見た図

横から見た図

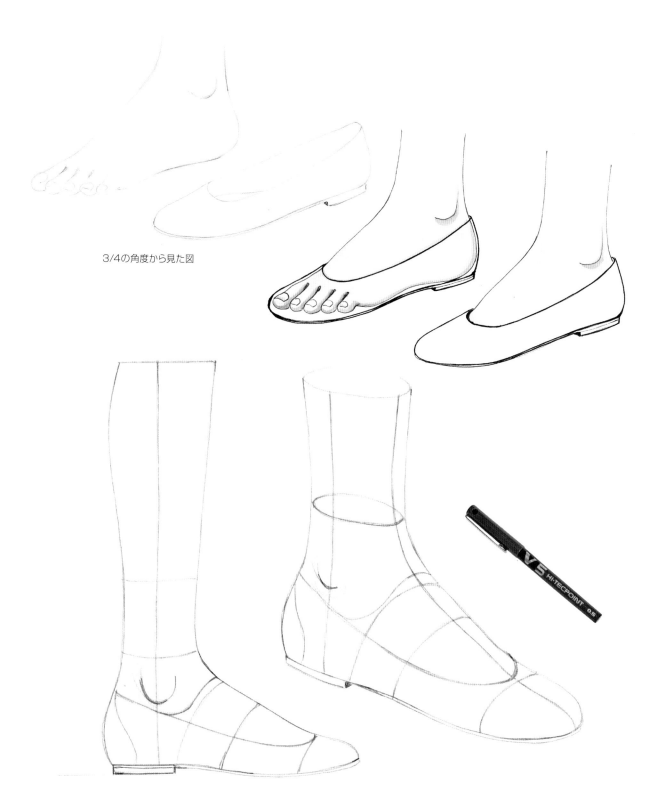

3/4の角度から見た図

フラットヒールの靴をデザインするときは、横から見た図と3/4の角度から見た図が役に立ちます。基本的なテンプレートとなるスケッチで、靴の半分のライン（ストラップの高さやデコルテの丸みなど）をすでにマークしておき、これをバレリーナパンプスからブーツまで、それぞれのデザインに合わせてアレンジしていきます。

テンプレートとしてTRATTO（トラット）ペンなどのマーカーで輪郭をはっきりと描いた絵を用意しておくと、白い紙を重ねて鉛筆で形をなぞるだけで使えるようになります。そうすれば、デザインをさまざまなバリエーションに自由に応用できます。

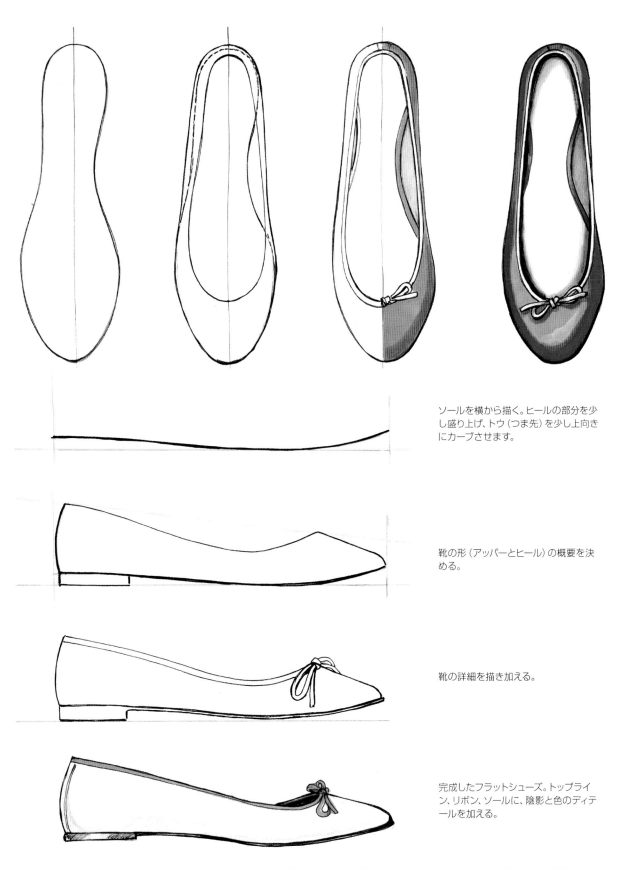

ソールを横から描く。ヒールの部分を少し盛り上げ、トウ（つま先）を少し上向きにカーブさせます。

靴の形（アッパーとヒール）の概要を決める。

靴の詳細を描き加える。

完成したフラットシューズ。トップライン、リボン、ソールに、陰影と色のディテールを加える。

ここでは、フラットシューズ（この場合はバレリーナパンプス）の例をさまざまな角度から見てみましょう。まず、靴底を描いて

から、輪郭をなぞり、テンプレートを取り除くと、完成図ができあがります。後は色を塗るだけです。

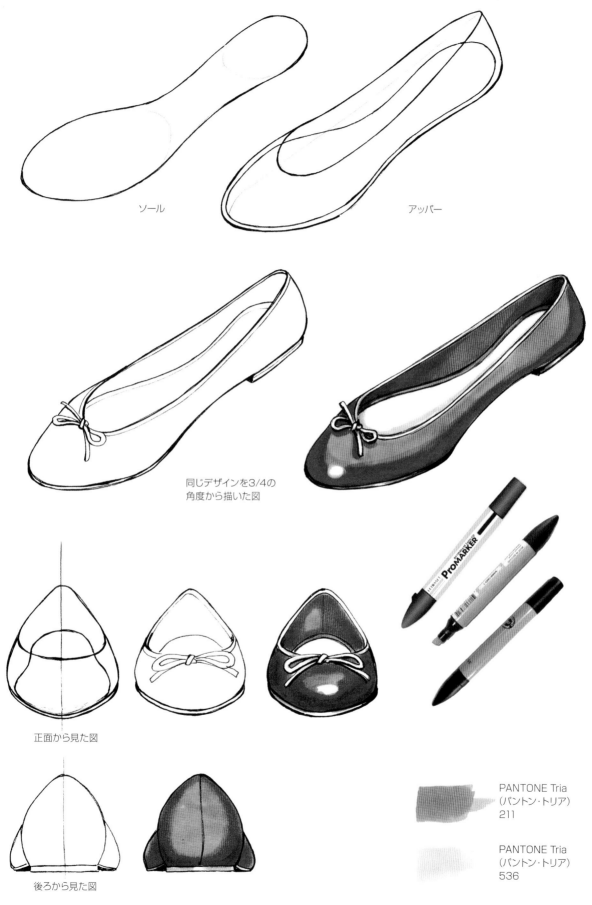

ソール

アッパー

同じデザインを3/4の
角度から描いた図

正面から見た図

後ろから見た図

PANTONE Tria
(パントン・トリア)
211

PANTONE Tria
(パントン・トリア)
536

17

■ ミッドヒール

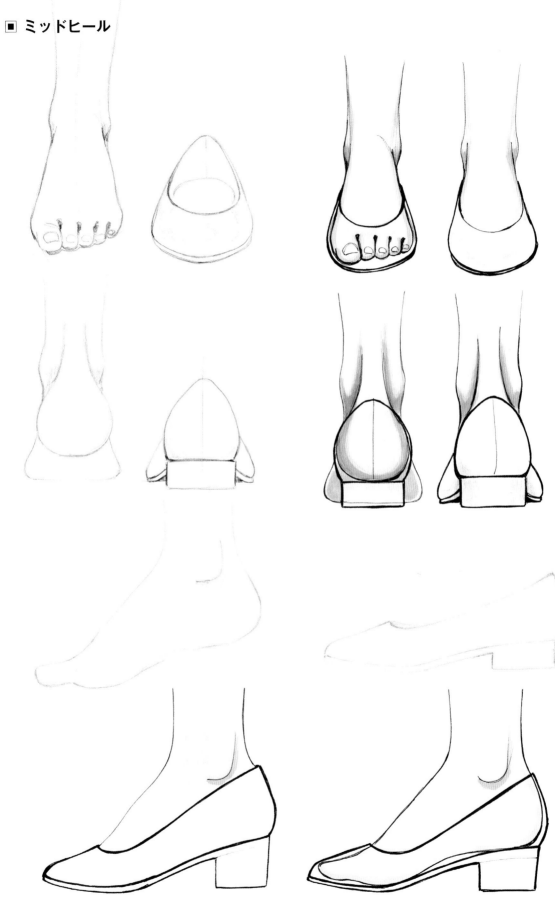

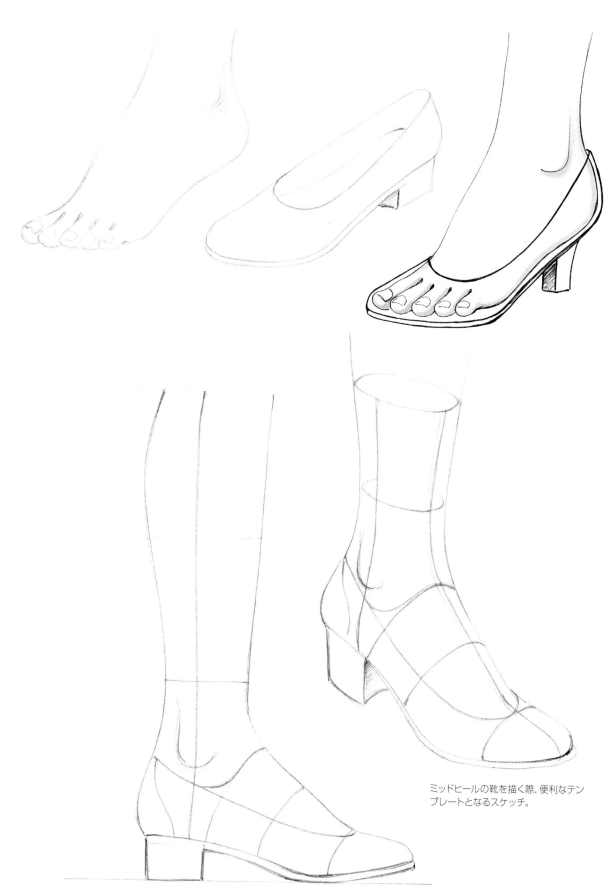

ミッドヒールの靴を描く際、便利なテンプレートとなるスケッチ。

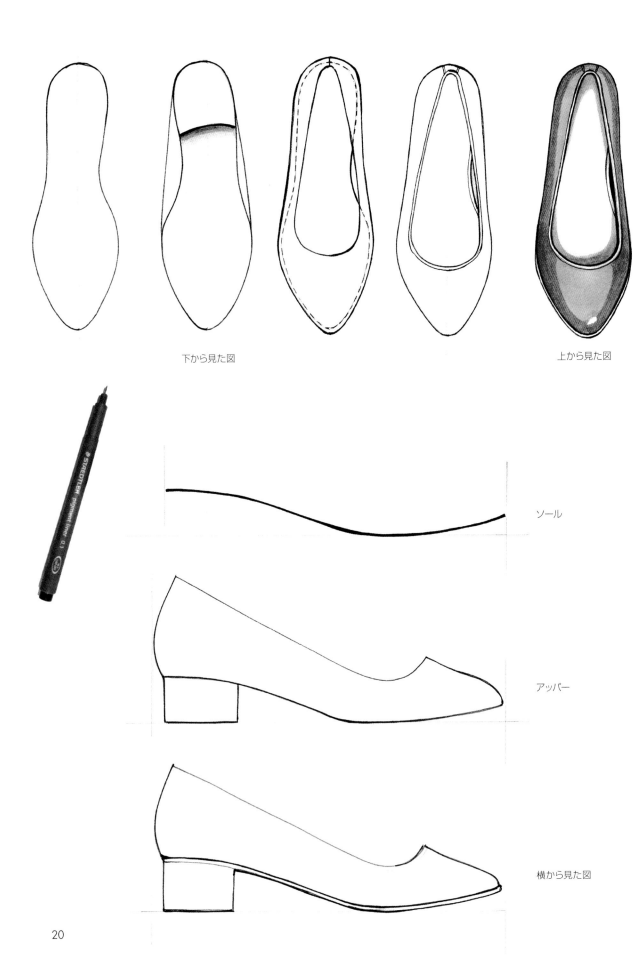

下から見た図　　　　　　　　　　　　　　　　　　　　上から見た図

ソール

アッパー

横から見た図

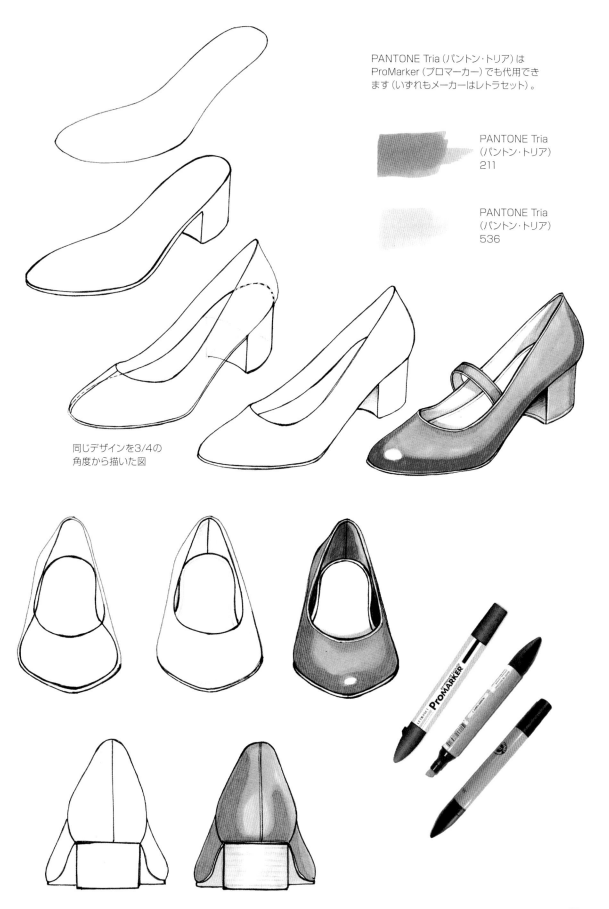

PANTONE Tria（パントン・トリア）は
ProMarker（プロマーカー）でも代用でき
ます（いずれもメーカーはレトラセット）。

PANTONE Tria
（パントン・トリア）
211

PANTONE Tria
（パントン・トリア）
536

同じデザインを3/4の
角度から描いた図

■ ハイヒール

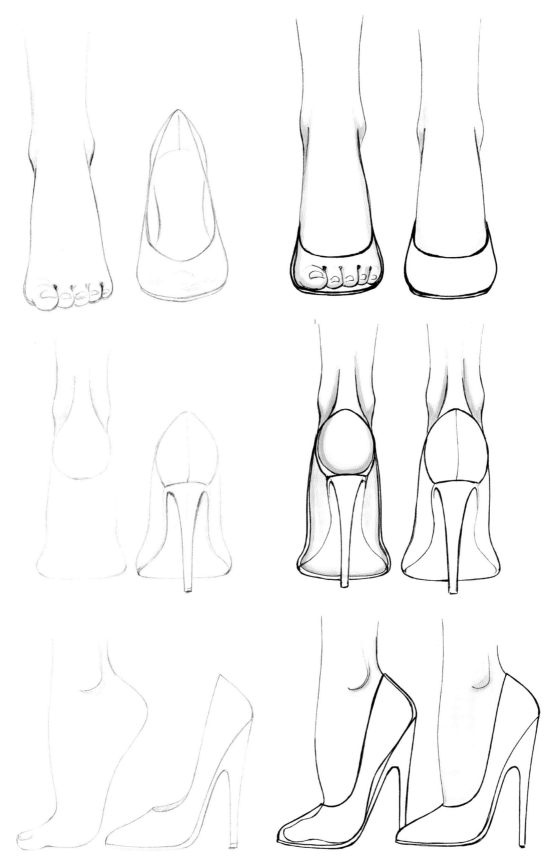

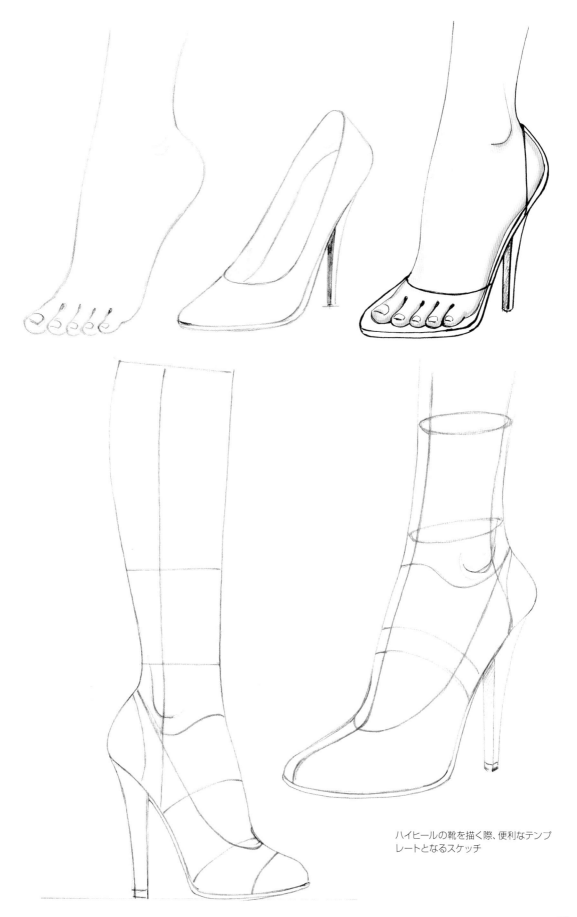

ハイヒールの靴を描く際、便利なテンプ
レートとなるスケッチ

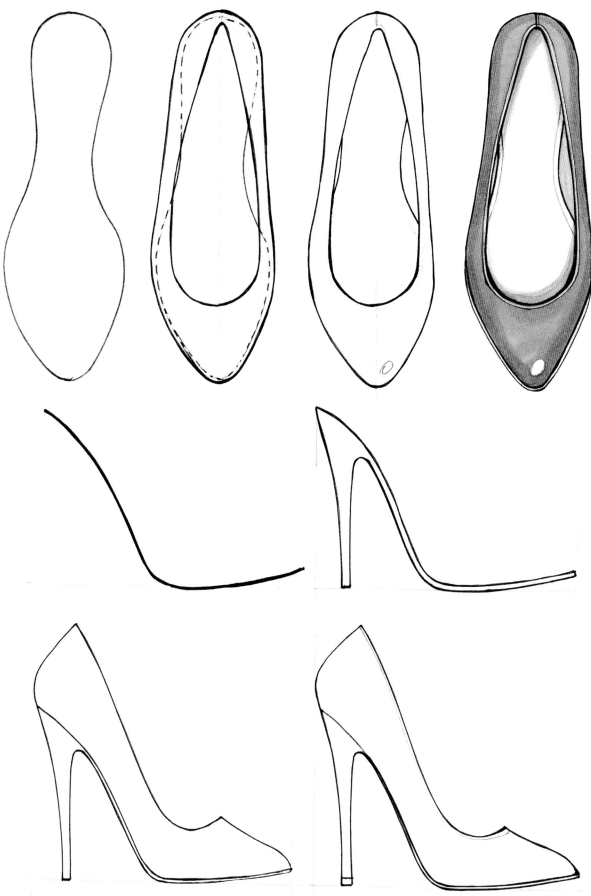

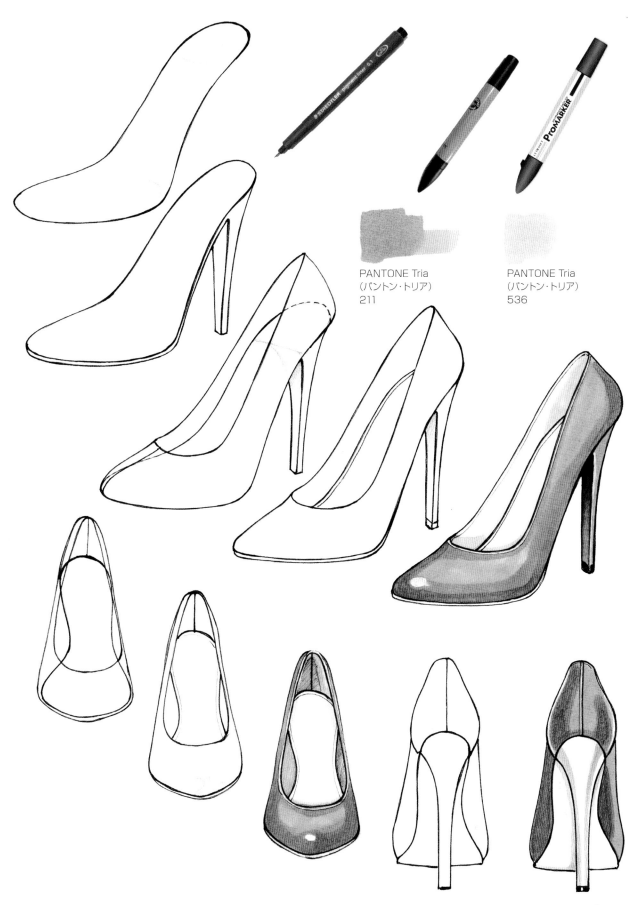

PANTONE Tria
（パントン・トリア）
211

PANTONE Tria
（パントン・トリア）
536

25

■ バレリーナパンプス

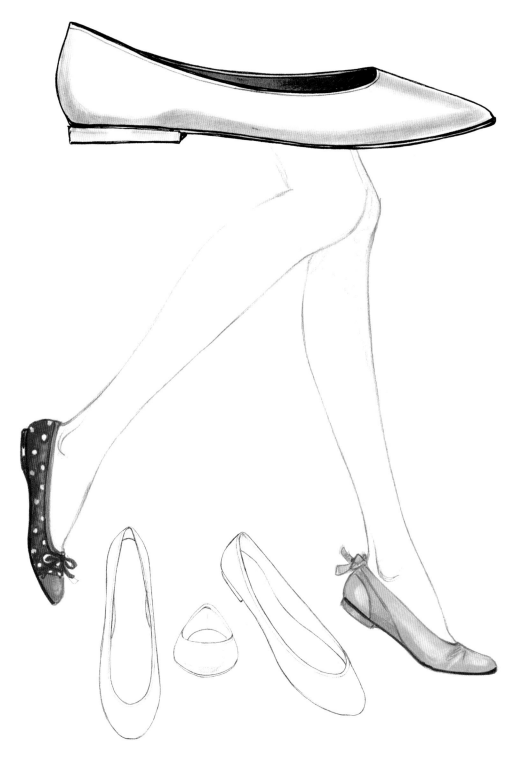

　クラシックバレエのダンサーが履くバレエシューズをもとにしたパンプスで、フラットかごく低いヒールと薄いソールが特徴です。1930年代初頭にロシア系の靴職人が発表し、後に改良されてさらに履きやすい形になりました。

　1950年代には、ブリジット・バルドーが映画『素直な悪女』で、オードリー・ヘップバーンが『ローマの休日』で着用したことによりカルト的人気を博しました。

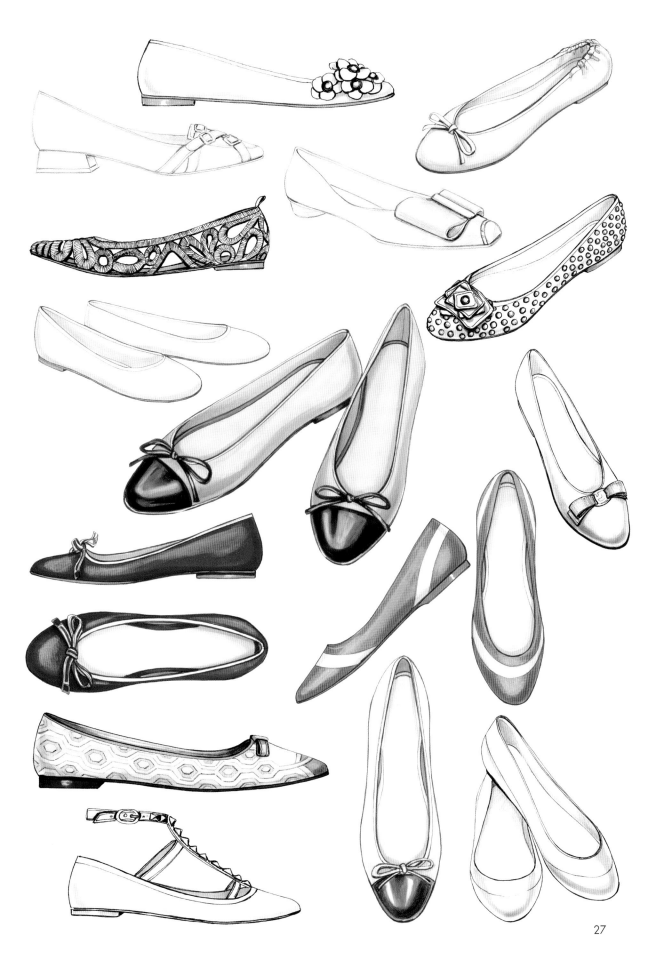

■ ビートルズ

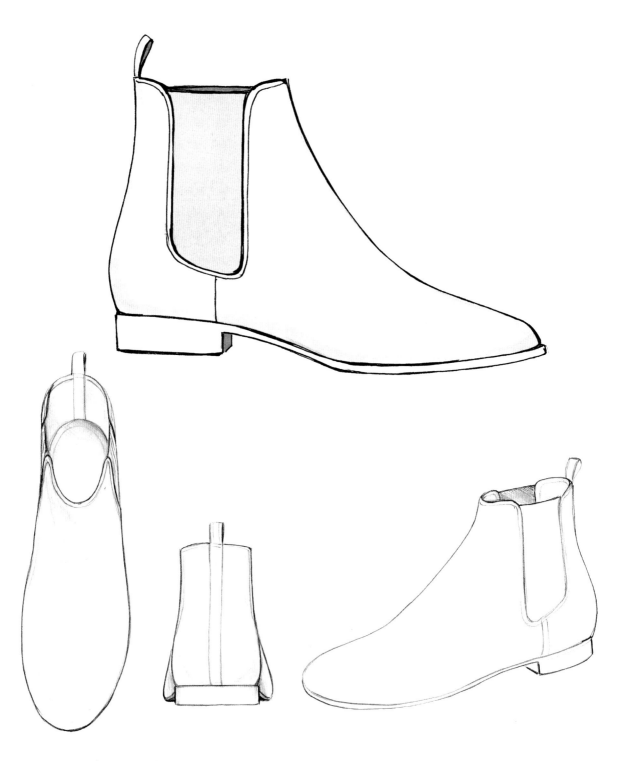

チェルシーブーツとしても知られるビートルズは、もちろん英国のミュージシャンのビートルズが愛用したことがその名の由来です。多くの人に愛されているクラシックなデザインで、世界を圧巻したビートルズ時代を彷彿とさせます。

もともと男性靴としてデザインされましたが、ビートルズやビート・ジェネレーションの影響を受けてさまざまなバージョンに進化し、サイドの伸縮バンドの部分に工夫を凝らしたデザインなど、複数のバリエーションに発展しました。

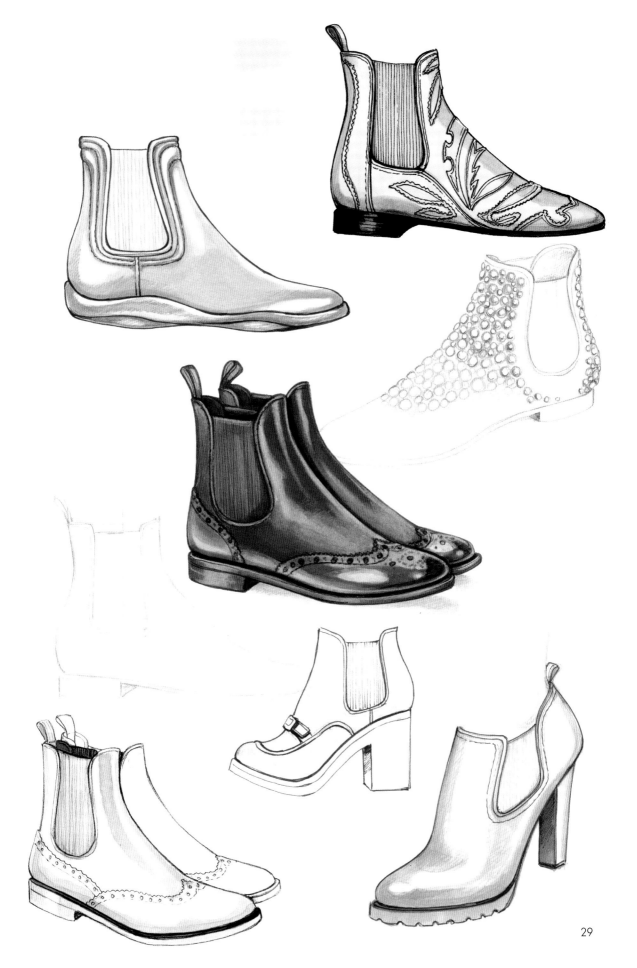

◾ バイカーブーツ

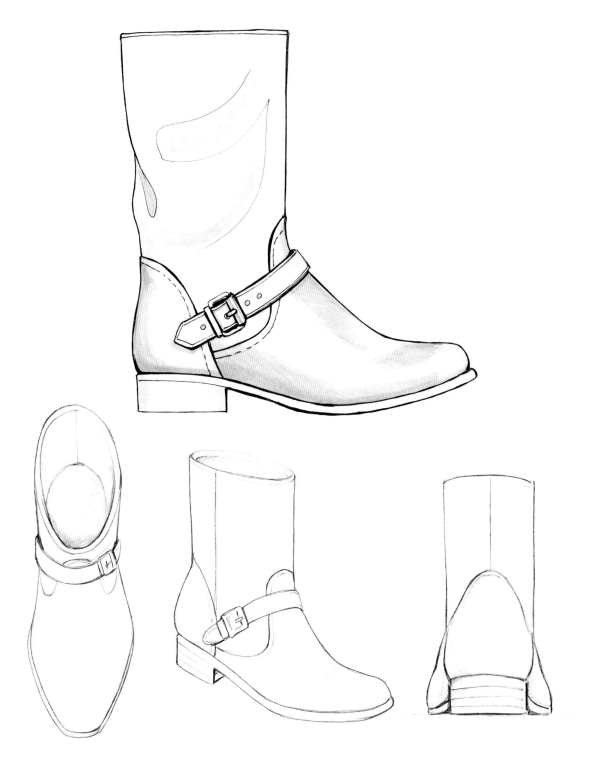

　バイカーブーツは、ブーツの長さとしてはミディアムハイブーツ、またはアンクルブーツで、当初はバイカーが愛用していました。映画『理由なき反抗』のジェームズ・ディーンや『乱暴者』のマーロン・ブランドのようなスクリーン・アイコン（注目を集める映画スター）が履いたことで、強い印象を残しました。そのおかげで人気が広まり、スタッズ（飾り鋲）付きの革ジャンを着たバイカーや不良少年たちのイメージと相まって、今日でも完全な形で変わらずに受け継がれているスタイルです。

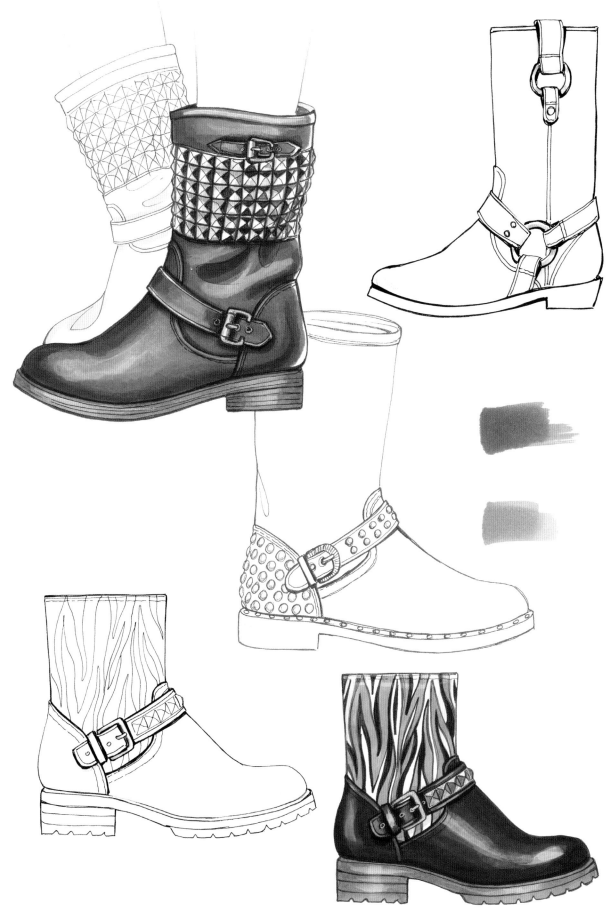

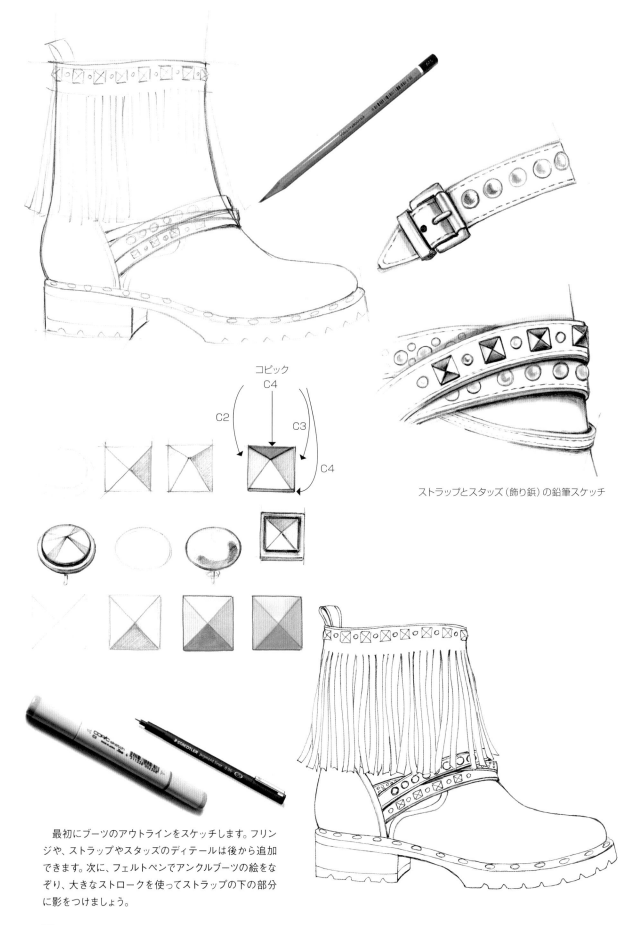

コピック
C4

C2

C3

C4

ストラップとスタッズ（飾り鋲）の鉛筆スケッチ

最初にブーツのアウトラインをスケッチします。フリンジや、ストラップやスタッズのディテールは後から追加できます。次に、フェルトペンでアンクルブーツの絵をなぞり、大きなストロークを使ってストラップの下の部分に影をつけましょう。

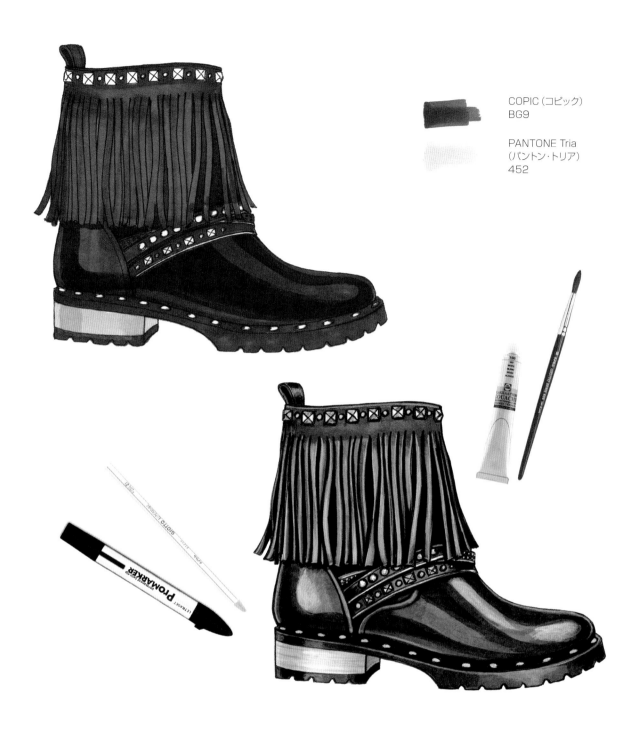

COPIC (コピック)
BG9

PANTONE Tria
(パントン・トリア)
452

　フリンジを含むブーツ全体のベースカラーとしてCOPIC (コ
ピック) BG9を使用します。これは黒に近い非常に暗いブルー系
のダークグレーです。グレーを使う利点は、黒のマーカーを使っ
て影を追加するとコントラストをうまく表現できることです。

　ダークグレーを使って、ブーツの陰影のある部分、特にかかとの
外側のカーブ、つま先、甲、内部の空洞などを描きます。次に、
黒のマーカーでフリンジの下と、フリンジとフリンジの間にある
影を濃くします。白い色鉛筆で、つま先、甲の中心線、かかとの
内側、手前のフリンジにハイライトのコントラストをつけます。
木製のヒールには、サンドトーンなどベージュ系のパントンを使

用します。ここでは、やや明るめのPANTONE　Tria (パントン・
トリア) 452を使しています。

　ライトグレーとダークグレーのフェルトペンは、陰影のある表
面とピラミッドスタッズを強調するために使用できます。小さく
て丸いスタッズには、シルバーやホワイトのマーカーやゲルペン
を使って、シンプルに点を打つだけで輝きを加えることができま
す。フリンジとブーツ本体に光沢を加えるために、ホワイトテン
ペラのタッチを使いました。ストラップの縁には、白のゲルペン
を使用しました。

■ シャネルのバイカラー

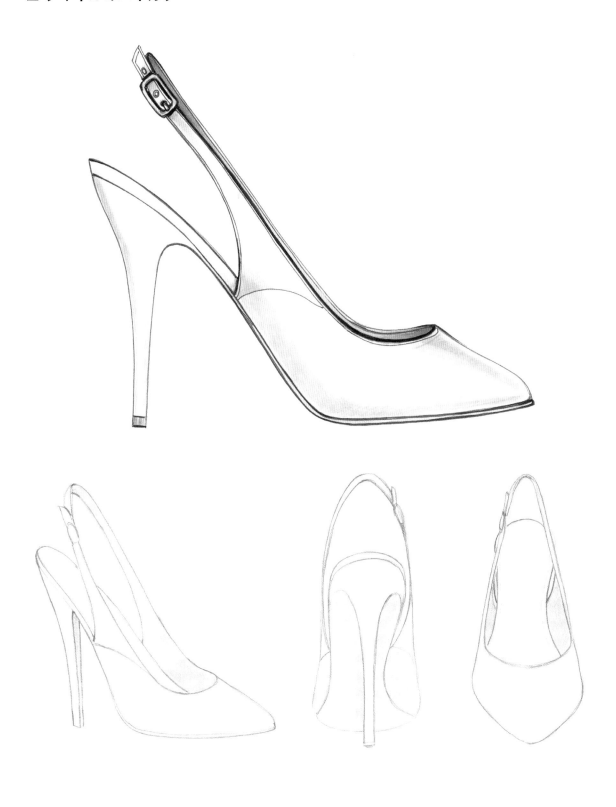

1957年にココ・シャネルがデザインした永遠の魅力を放つバックストラップのシューズ。かかとを露出させ、薄い革や布の細いストラップだけで支えるデザインは世界初でした。

当初はツートンカラーでしたが、シャネルはその後、同じ形でさまざまな色や素材を使い、足をあまり見せたくない女性にもうれしいシューズを作りました。

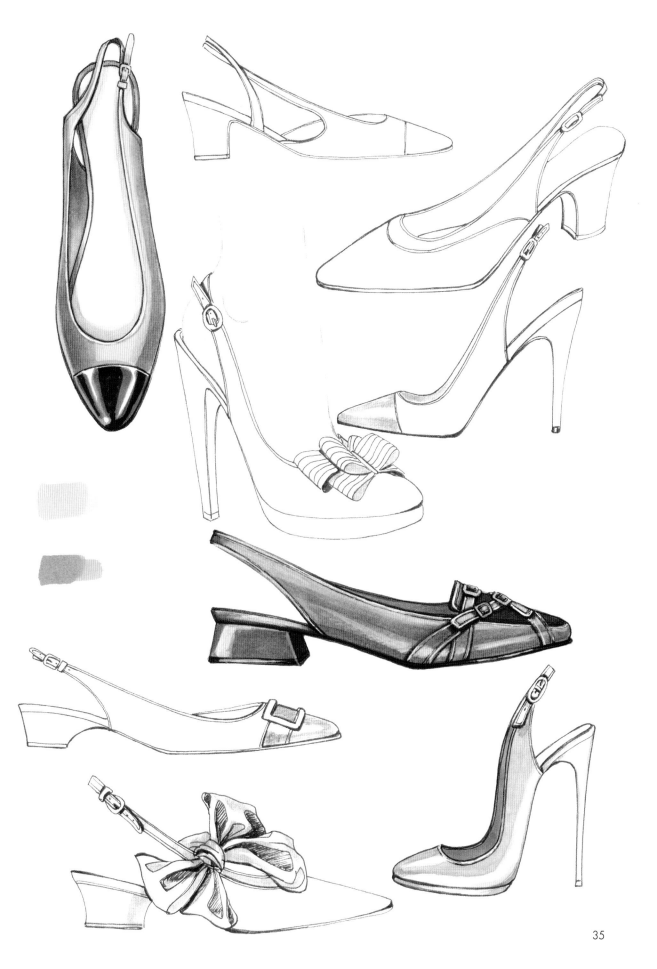

靴の鉛筆のスケッチ

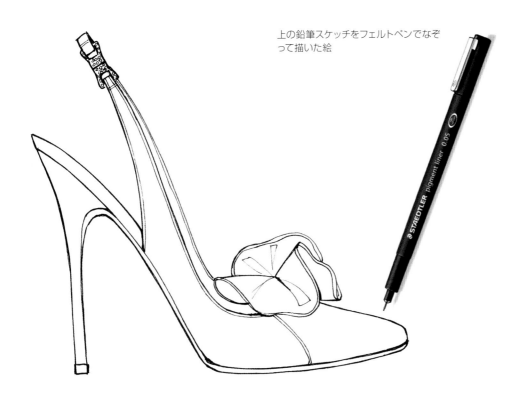

上の鉛筆スケッチをフェルトペンでなぞ
って描いた絵

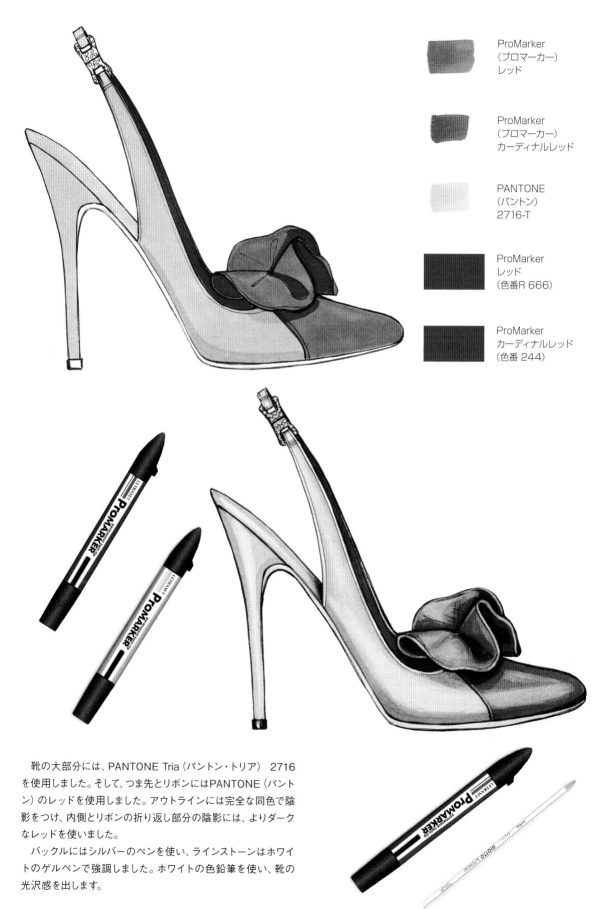

ProMarker
（プロマーカー）
レッド

ProMarker
（プロマーカー）
カーディナルレッド

PANTONE
（パントン）
2716-T

ProMarker
レッド
（色番R 666）

ProMarker
カーディナルレッド
（色番 244）

　靴の大部分には、PANTONE Tria（パントン・トリア） 2716
を使用しました。そして、つま先とリボンにはPANTONE（パント
ン）のレッドを使用しました。アウトラインには完全な同色で陰
影をつけ、内側とリボンの折り返し部分の陰影には、よりダーク
なレッドを使いました。

　バックルにはシルバーのペンを使い、ラインストーンはホワイ
トのゲルペンで強調しました。ホワイトの色鉛筆を使い、靴の
光沢感を出します。

■ デコルテ

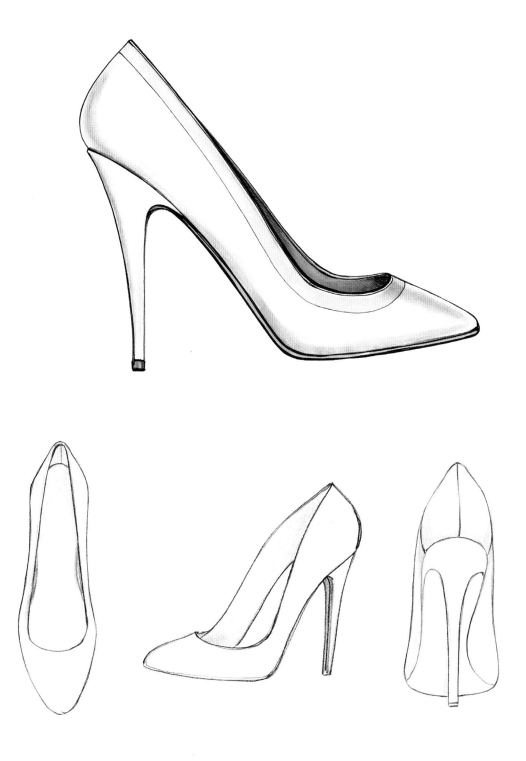

　間違いなく最も広く知られていて、最もクラシックなハイヒール。女性の靴の中では究極の定番とされ、つま先を覆ったクローズド・トゥと、つま先が開いたオープン・トゥがあり、さらにはつま先からかかとまで厚底になったバージョンもあります。素材や色によって季節や機会を問わないため、すべての女性のワードローブに欠かせない永遠の定番です。

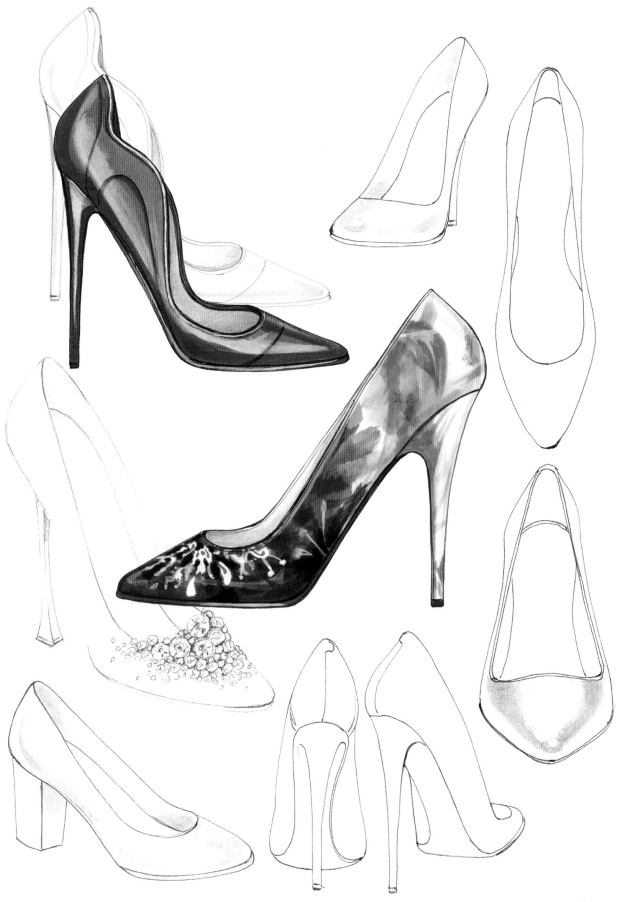

■ ドルセー

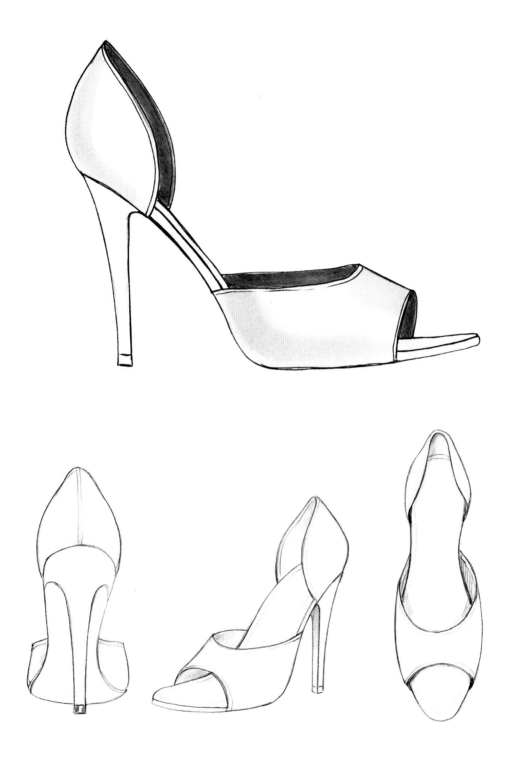

　足の側面を見せるデザインで、かかとが覆われているものと覆われていないものがあり、また細い革のストラップで固定されている場合もあります。ダンスシューズとして、あるいはイブニングドレスと合わせて使われるピープ・トゥ（つま先を少しだけ見せる

デザイン）のサンダルで、足元を優雅に包んでくれます。
　ハイヒール、ミディアムヒール、ローヒール、さらには完全なフラットヒールなど、さまざまなヒールのドルセーがあります。

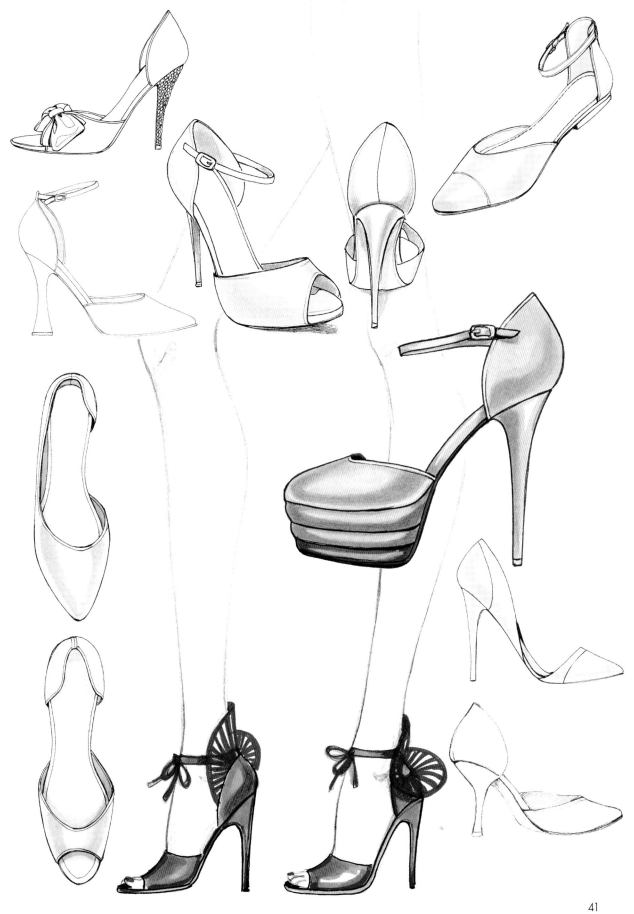

41

◼ エスパドリーユ

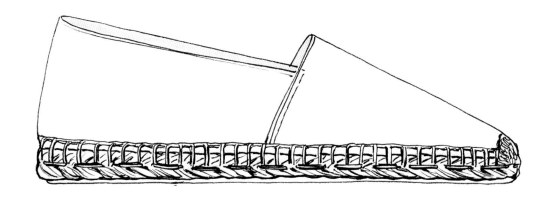

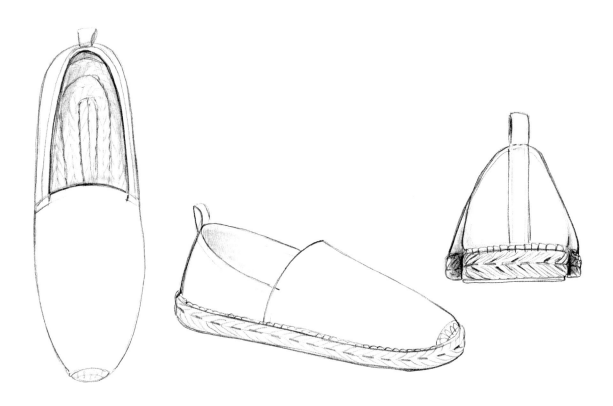

　スペイン生まれで、夏のビーチにぴったりの靴として長年親しまれているエスパドリーユには、長い歴史があります。編み込んだロープのソールと布製のアッパー部分で作られた靴は、紀元前2000年頃から存在していたらしいのです。

　直接の語源はフランス語ですが、さらに遡るとカタルーニャ語で「エスパルトグラス製の靴」（エスパルトグラスはかつてロープの材料として使われていた植物素材）を意味する「エスパルデニヤ」に由来します。

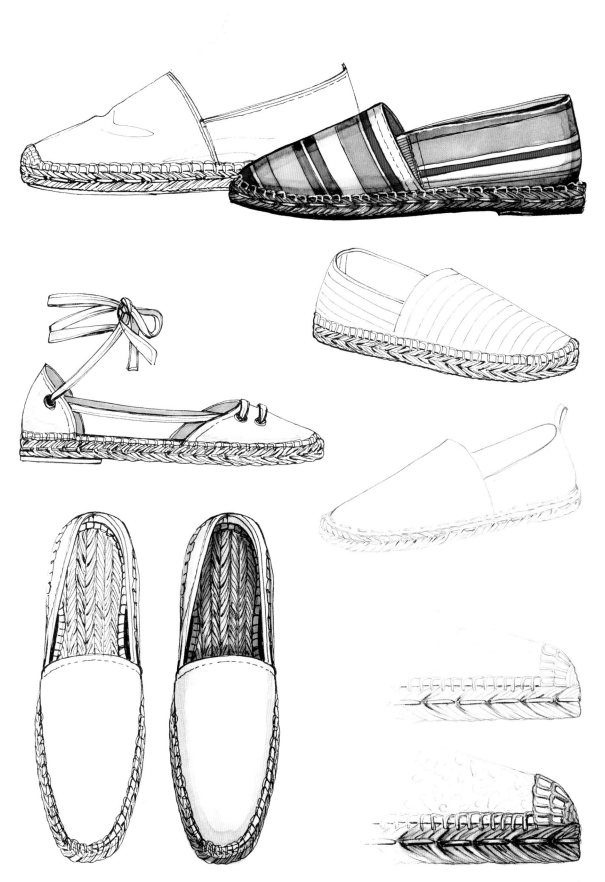

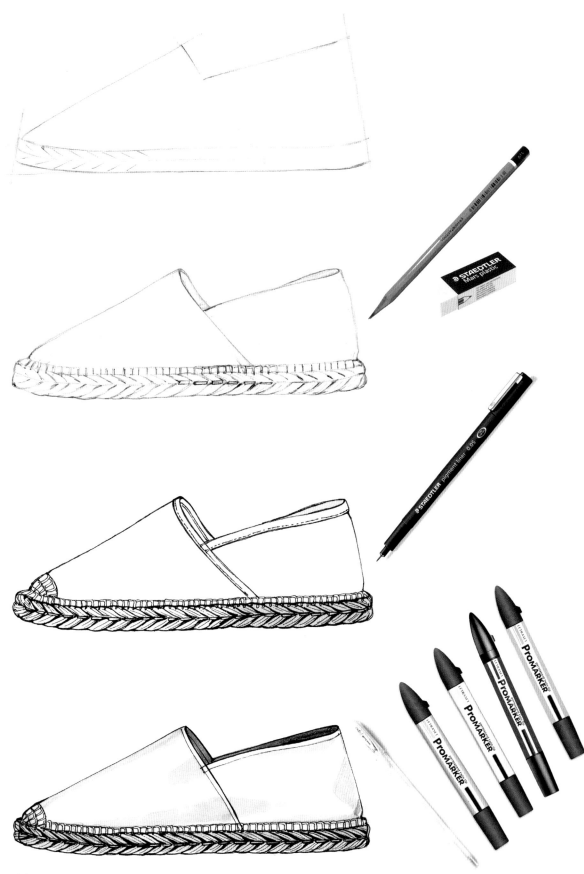

エスパドリーユのテンプレートに、フェルトチップペンで着色。

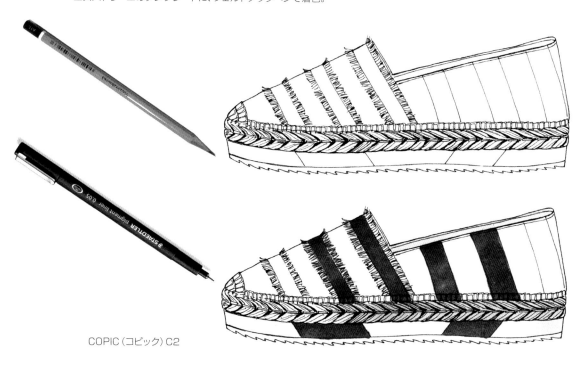

COPIC（コピック）C2

Touch（タッチ）ブルーベリー

PANTONE（パントン）
452-T

ステッドラーの
トリプラスファインライナー
ブルー

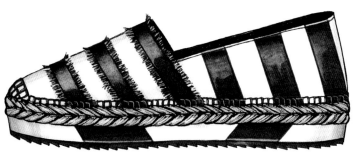

プロマーカー（ProMarker）
サンドストーン

スタビロ・オリジナル87-405

COPIC（コピック）T5

　カラー部分にはTouch（タッチ）ブルーベリーを、ロープには
PANTONE Tria（パントン・トリア）452（サンドストーン）を使
用しました。完成した靴は、白い部分はライトグレー、色のつい
た部分はブルーで陰影をつけました。ロープとフリンジの最後
の仕上げにはブルーのファインライナーとホワイトのゲルペンを
使いました。ロープが編み込まれたインナーソールには、スタビ
ロの中細ペン（色番68/88）で陰影をつけました。

■ フリップフロップ

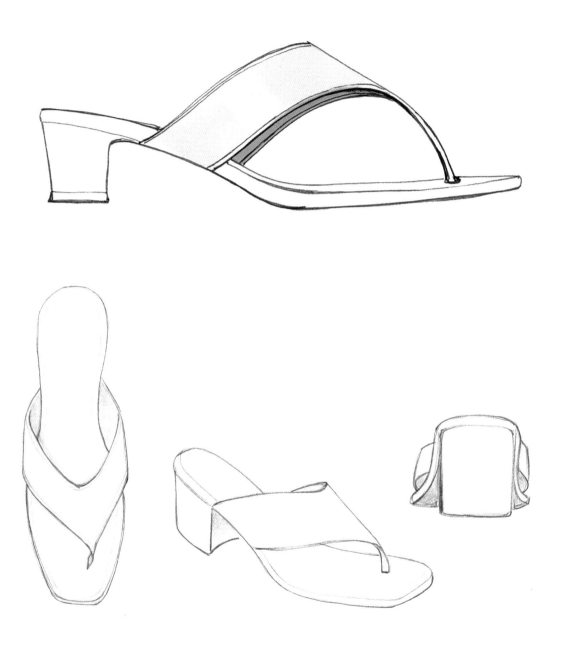

　夏のフットウェアとして人気があるフリップフロップは、世界中のビーチで日光浴をする人たちの足元に見られます。ヒールがあるデザインのものもあります。特徴的なのは、足の両サイドから親指と人差し指の間まで続いて足にフィットするY字型のストラップです。

　フリップフロップは、エメリーレザーやラバー、ロープや編み込みレザーなど、さまざまな素材で作られます。究極におしゃれなフリップフロップといえば、イタリア・カプリ島で作られるレザーとラインストーンを使ったサンダロ・カプレーゼでしょう。

　プールサイドからナイトクラブまでさまざまなシーンで、ベーシックなものからグラマラスなものまで幅広いバリエーションのフリップフロップが愛用されています。

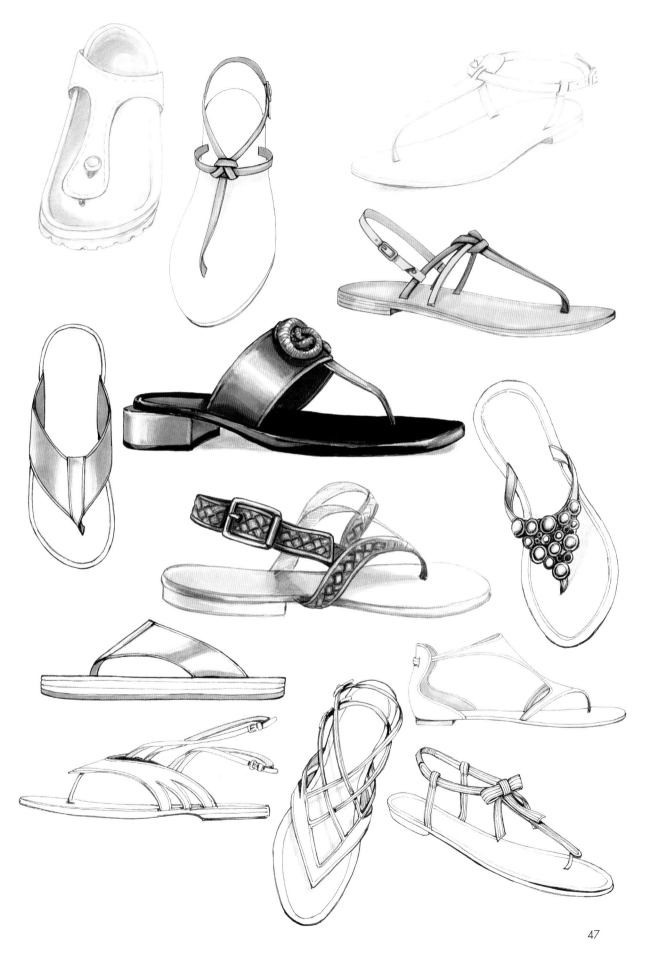

■ キトンヒール

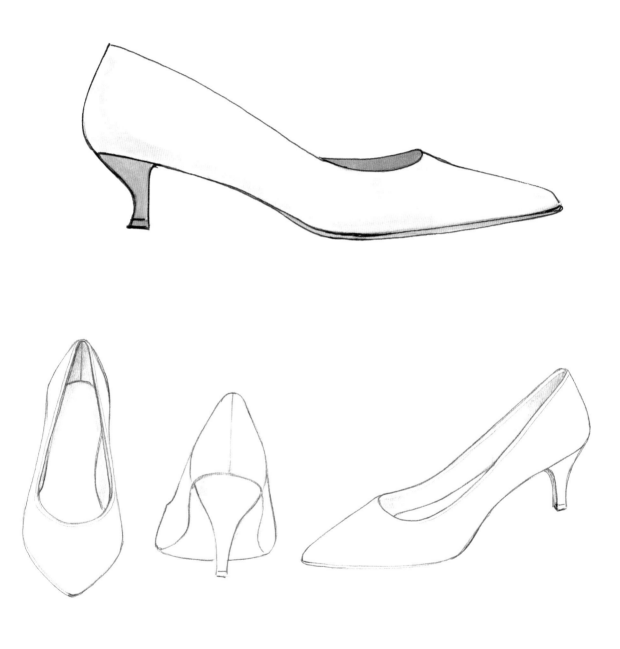

　ハイヒールのデコルテとバレリーナパンプスの中間のような洗練された靴です。きちんとした印象なのに歩きやすく、ビジネスにもぴったり。3.5cm以下のキトンヒールなら、管理職の女性や会社秘書が正統派のスーツと合わせるのに理想的です。立ち

時間が長い人も、繊細で控えめなヒールのおかげで良い姿勢が維持できるので洗練された印象を演出します。かかとを露出させたシャネルのバイカラーのようなキトンヒールは、50年代に良家の子女たちがこぞって履いていました。

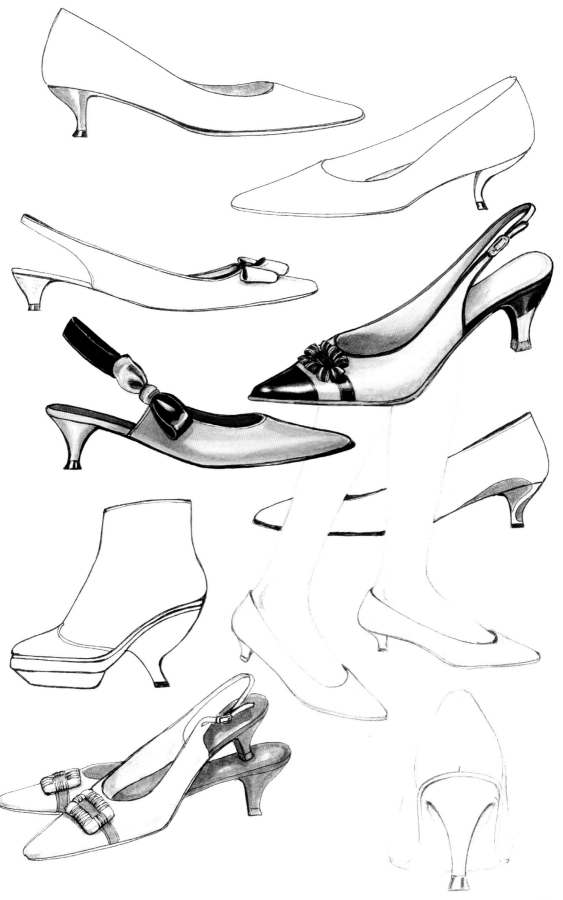

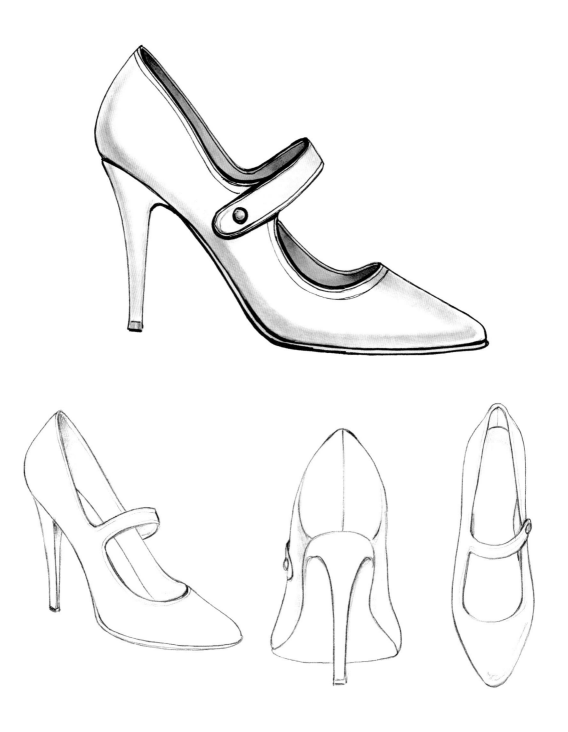

　ストラップシューズは欧米では「メアリー・ジェーン」という愛称で知られています。由来となったのはコミックでした。1902年、アメリカのコミックの草分けであるリチャード・フェルトン・アウトコールトが、いたずら好きな金髪のキャラクター、バスター・ブラウンを生み出し、その妹がメアリー・ジェーンで、この靴を履いていたのです。

　メアリー・ジェーンはその後ヒールタイプや厚底タイプが追加されるようになり、さまざまな形に発展を遂げて、今日もファッション誌のページにたびたび登場しています。

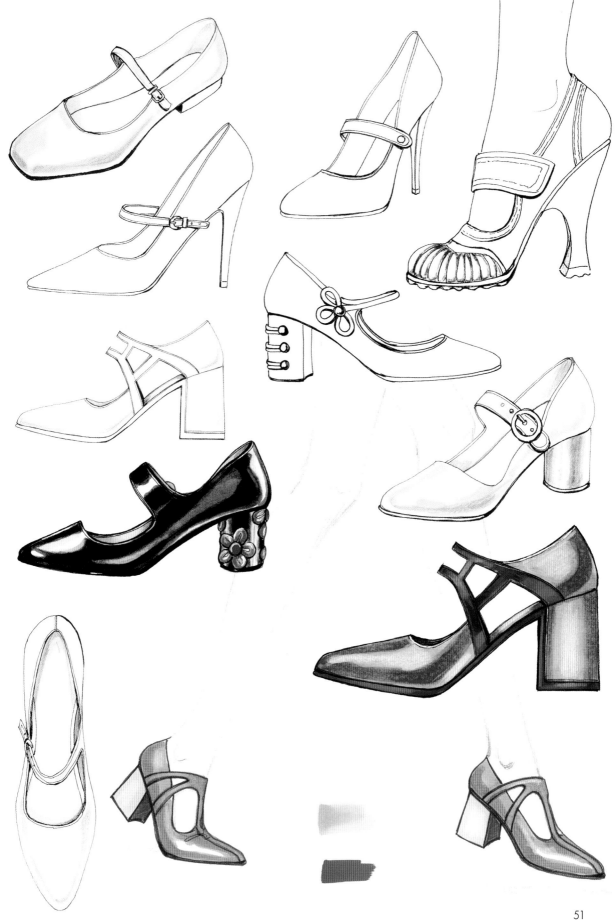

◼ モカシン

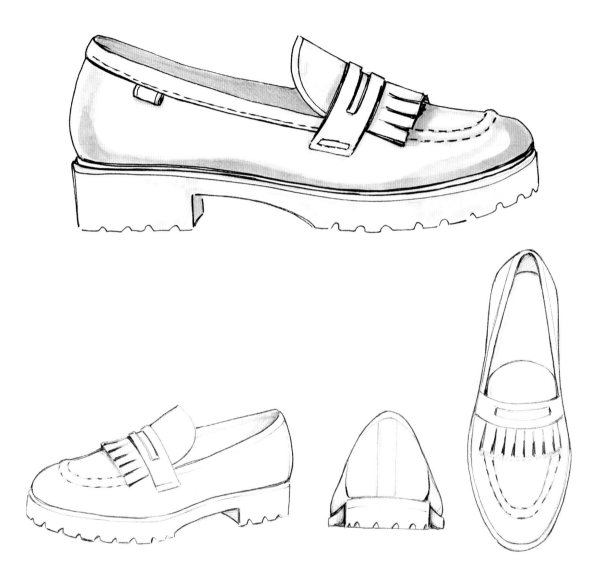

　男性靴から「借用」したカジュアルなフラットシューズです。通常靴紐はなく、タッセルやフリンジ、あるいはグッチの製品に見られるようなスナッフルビット（ハミ。馬の口にかませる馬具の一種）の形をした金属のパーツなどが装飾として使われます。

　非常に履き心地がよく、一日中どんな場面にもぴったり。クラシックなスポーツウェアや大学生のような若々しい装いはもちろん、どんなファッションにも似合い、仕事にも遊びにもオールマ

イティーに活躍する靴です。

　数十年前から、イタリアの靴ブランド、トッズが非常に柔らかい履き心地のモカシンを発表しています。ソールからつま先までゴム製のパッドが連続しているデザインが特徴で、これによりモカシンには新たな命が吹き込まれました。トッズのモカシンは、富裕層がスポーツカーの運転やセーリングの際などに愛用する靴として定着しています。

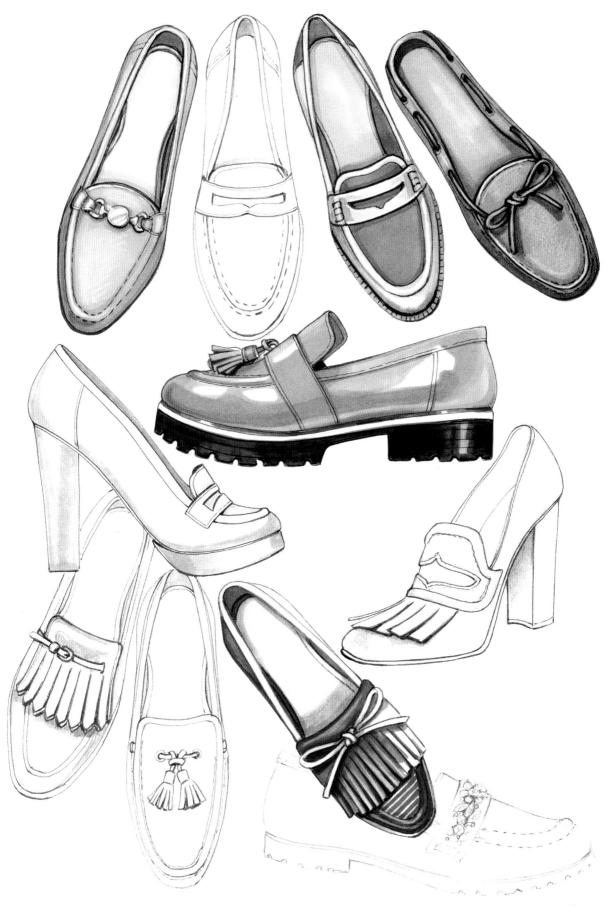

53

■ オックスフォード

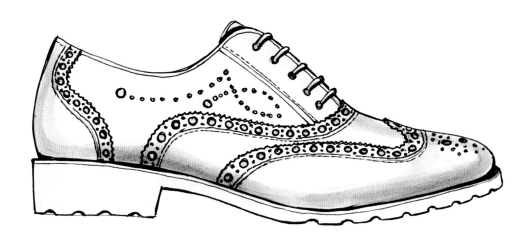

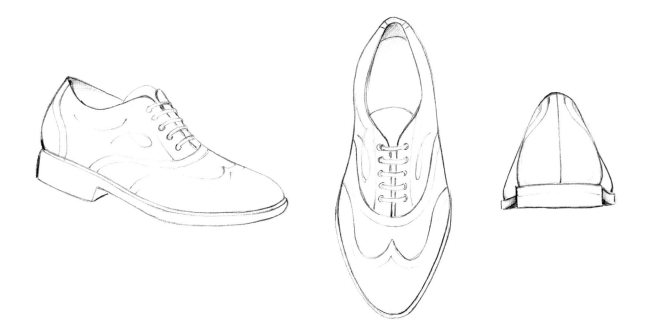

オックスフォードは、フランス革命に参加した若い女性たちが履いていた靴にちなんで、イタリアでは「フランチェジーナ」と呼ばれることもあります。鳩目に靴紐を通すデザインが特徴で、シンプルでありながら洗練された印象を与えることから、男性靴として注目を集めました。スカートやテーパードパンツにもよく合い、完璧なカレッジファッションを演出します。最も有名なブランドは英国のチャーチで、伝統的なオックスフォードを作り続けています。

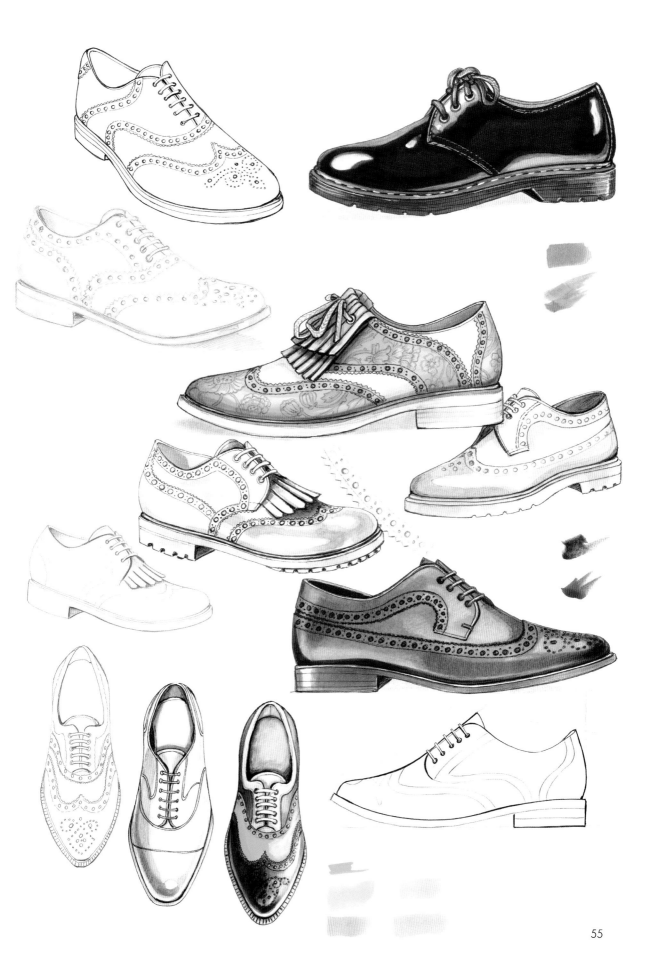

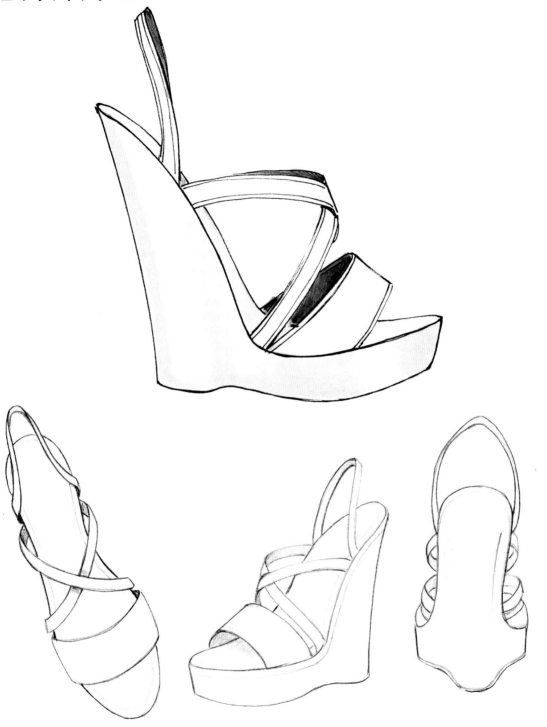

プラットフォームはウェッジソールとも呼ばれます。特に身長が標準、または小柄の女性に人気があります。ソール全体にコルクや木材の層を貼り付けてヒールの代わりにしているのが特徴で、これまでさまざまな洗練されたデザインと革新的な素材のプラットフォームが作られ、多くの人たちに愛されています。

1940年代初め、フィレンツェの靴ブランドの創始者であるサルヴァトーレ・フェラガモのおかげで注目を集めるようになった

のが、人気の始まりだったといえるでしょう。フェラガモのプラットフォームは、アメリカ映画を通じて世界を席巻していきます。

さらに60年代には新たな展開としてプラットフォームのサンダルが登場しました。90年代には英国の「スパイス・ガールズ」の歌手たちが履いていたプラットフォームのスニーカーが脚光を浴びました。

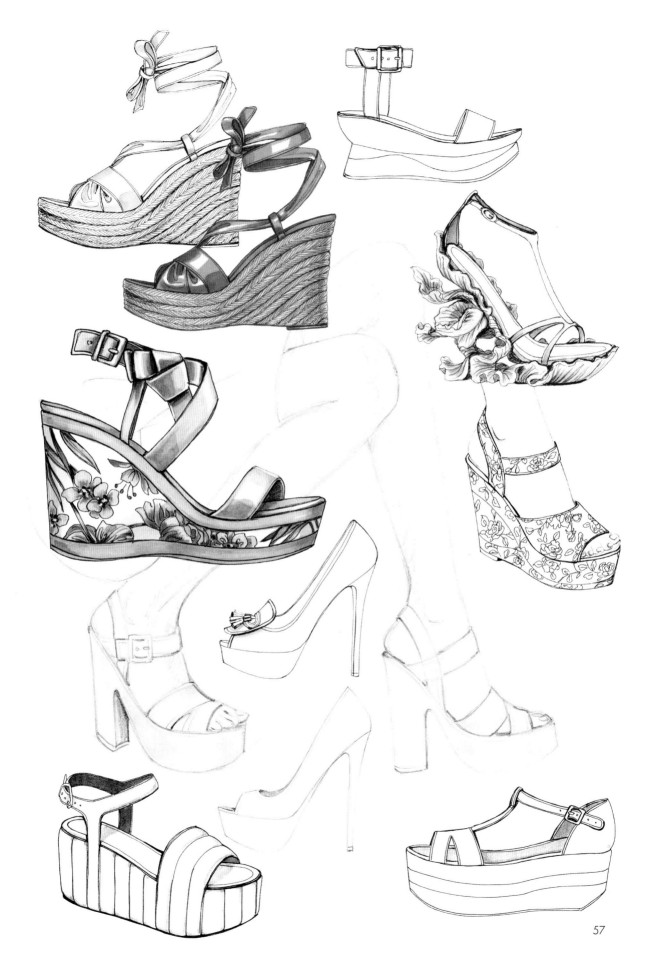

■ ミュール

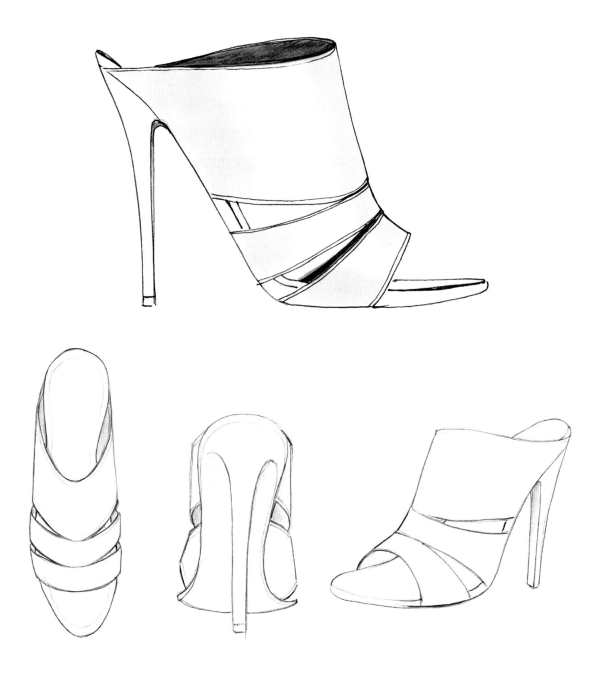

　クロッグやサボと同じようにかかとを完全に露出させたスリップオンの靴です。ヒールの高さに決まりはなく、オープン・トゥのものもつま先が閉じているものもあります。

　とてもおしゃれな雰囲気のミュールの起源は不明ですが、18世紀のフランスの宮廷で用いられていた記録があります。19世紀には農民が履くようになり、1960年代〜1970年代にはヒッピーたちに愛され、新たなスタイルが生まれました。

　革の種類や装飾的なディテールによりエレガントにもスポーティにもなるミュールは、今も愛されています。

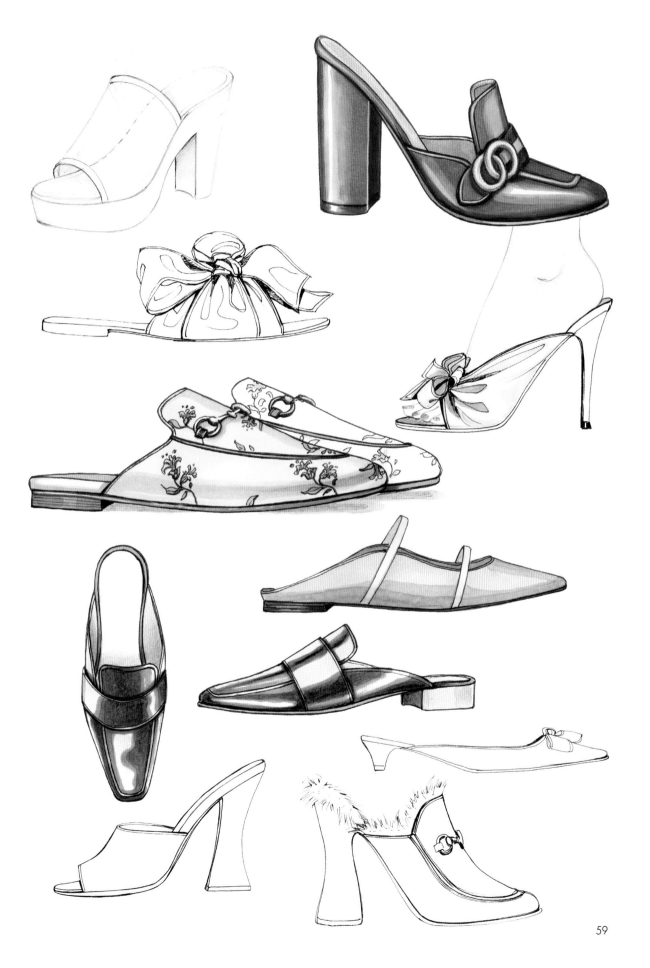

■ サンダル

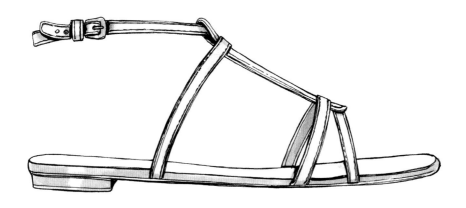

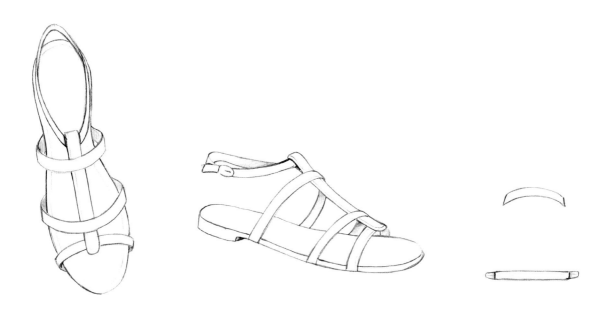

　夏に欠かせないサンダルは通常、レザー（またはレザーのような仕上げのラバー）のソールと、布製などのアッパーで作られていて、面ファスナーが使われることもあります。足の甲を部分的に覆って素足の一部を露出させるサンダルは、ヒールの形や高さによってスポーティにもエレガントにもなります。

　半貴石や刺繍、金属のパーツ、レザーのフリンジなどの装飾があるサンダルなら、海辺だけでなく街中でもおしゃれな印象です。さらに、ピンヒールのサンダルで、マルチカラーやミラー効果のスワロフスキーのクリスタルビーズをあしらったシルクサテン素材のサンダルなら、正装でレッドカーペットを歩くのにもぴったりの雰囲気です。

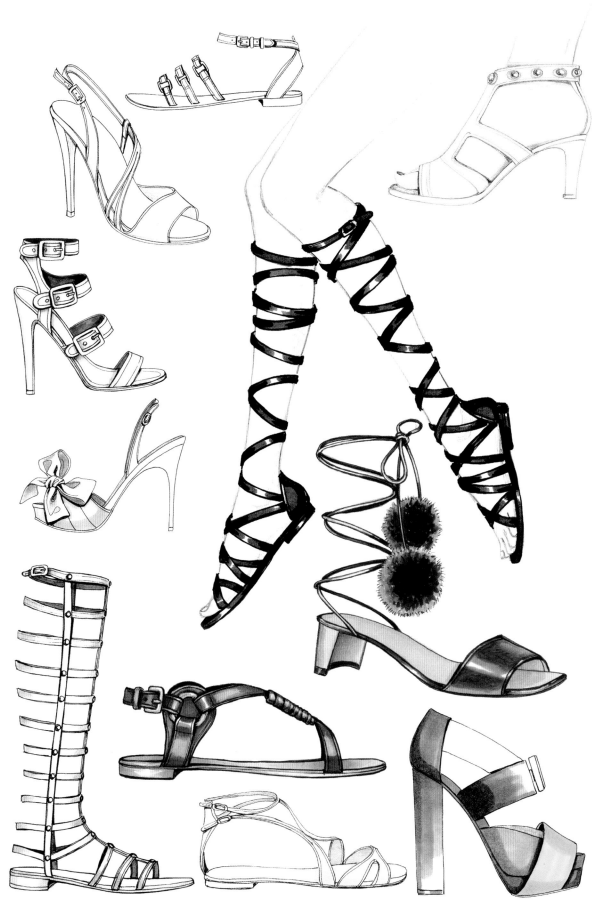

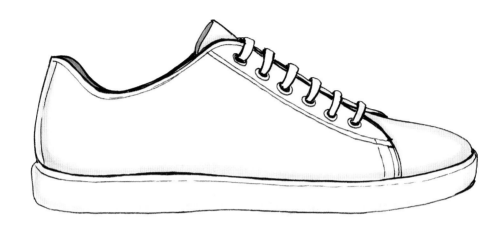

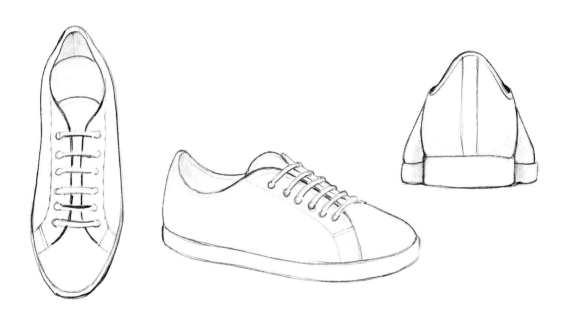

　ラバーソールが特徴的なヒールのないスポーツシューズです。かつては純粋なスポーツシューズでしたが、1990年代から2000年代にかけて、日常に履けるカジュアルな靴として市民権を得ました。

　スポーツシューズには自由な発想が求められ、新しい魅力的な形が次々と生み出されています。今日、流行の最先端の靴とい

えばスニーカーかもしれません。さまざまなデザインがありますが、一番重要な特徴は快適さです。ストリート用だけではなく、ドレスアップしたいときに履きたい洗練されたスニーカーもあり、過去にとらわれないクリエイティブな想像力を生かしたスニーカーが誕生しています。

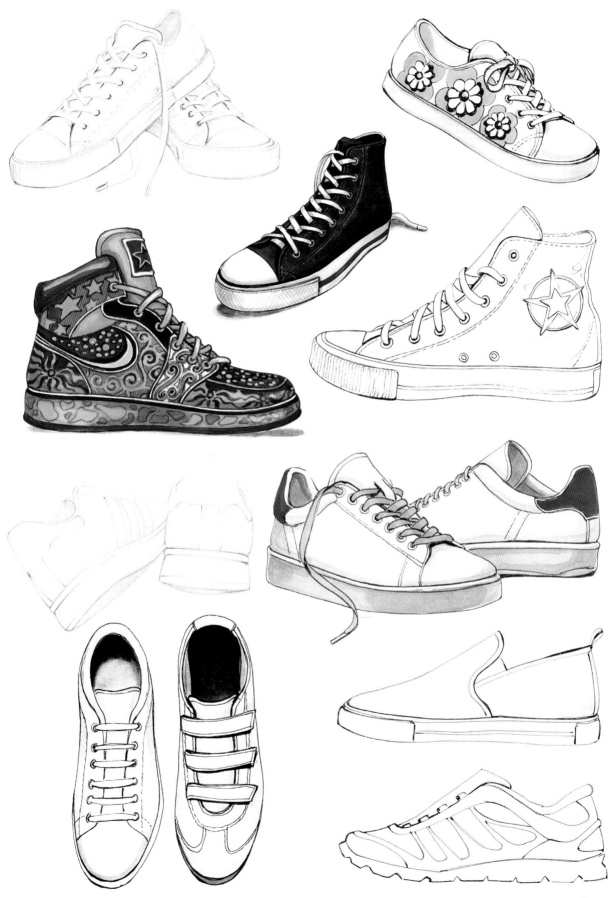

63

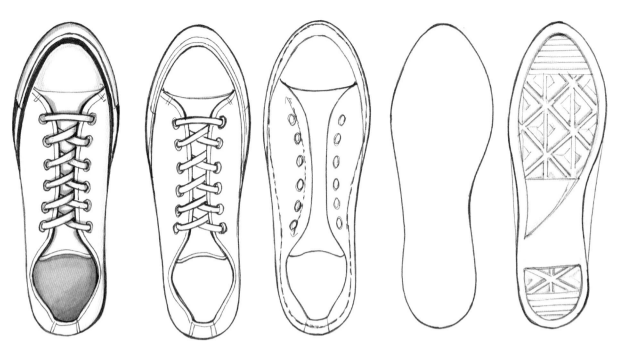

上から見た図。ソールの輪郭から靴の完成まで。　　　　　　　　　　　　　　　ソールを下から見たところ。

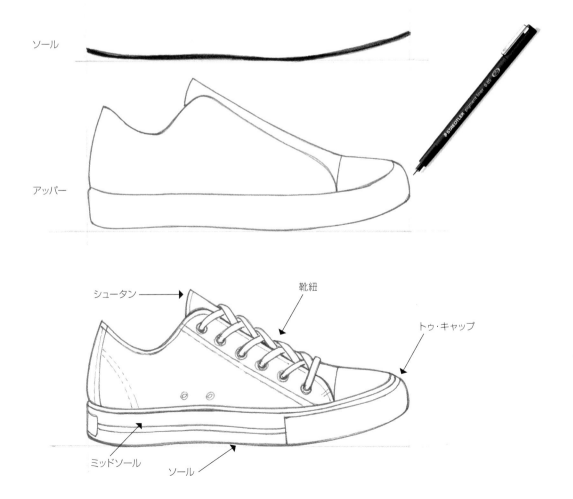

ソール

アッパー

シュータン

靴紐

トゥ・キャップ

ミッドソール

ソール

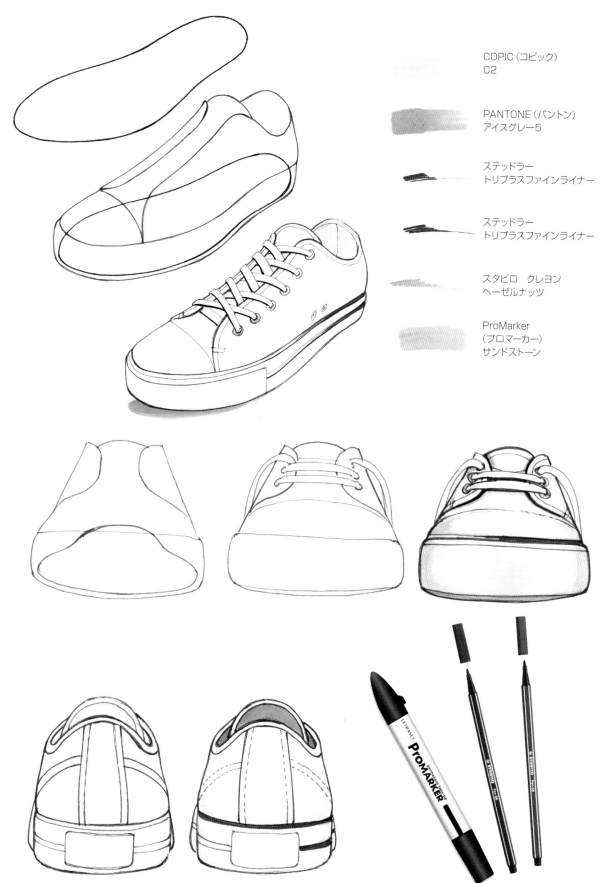

COPIC (コピック)
C2

PANTONE (パントン)
アイスグレー5

ステッドラー
トリプラスファインライナー

ステッドラー
トリプラスファインライナー

スタビロ　クレヨン
ヘーゼルナッツ

ProMarker
（プロマーカー）
サンドストーン

■ ブーツ

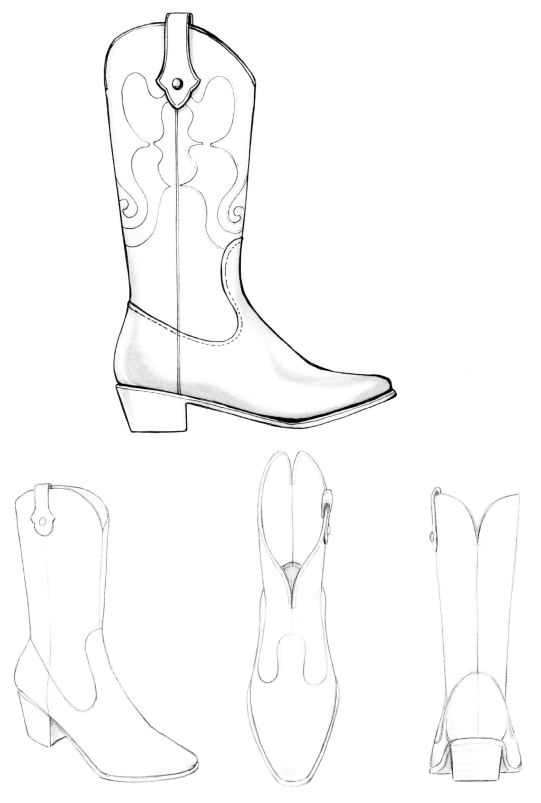

　ブーツは足首や膝下、膝上など多様な長さのものがあり、ヒールの高低もさまざま。雨の日にぴったりのゴム長靴から、高貴なクリスタルで飾られた繊細な刺繍入りのサテンのブーツまで、無数のスタイルがあります。昔のハリウッド映画に登場するカウボーイたちの影響で、若者たちの間ではジーンズにカウボーイブーツを合わせたラフな装いが人気を博しました。

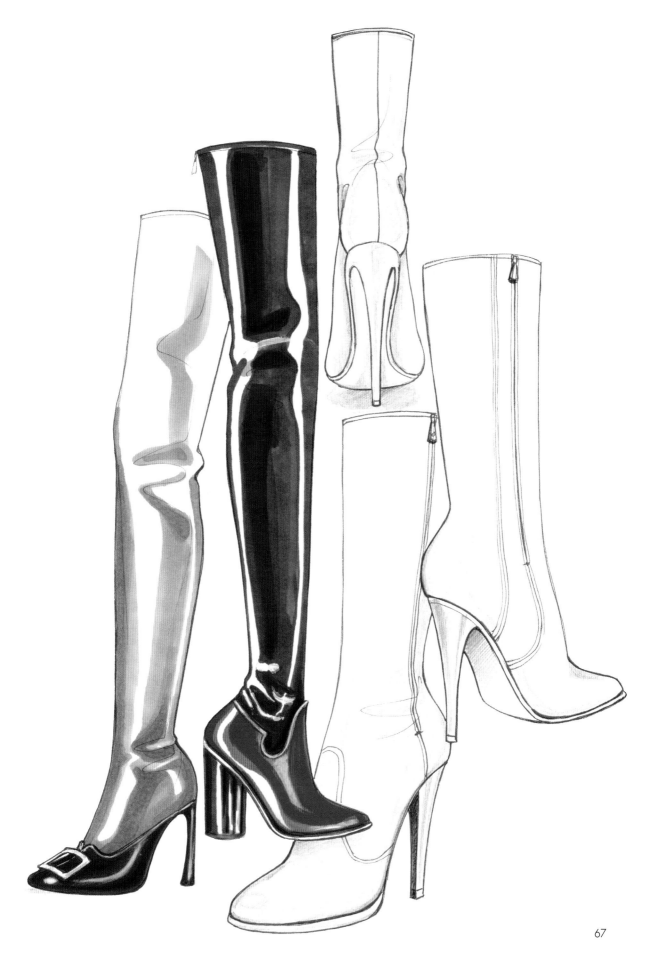

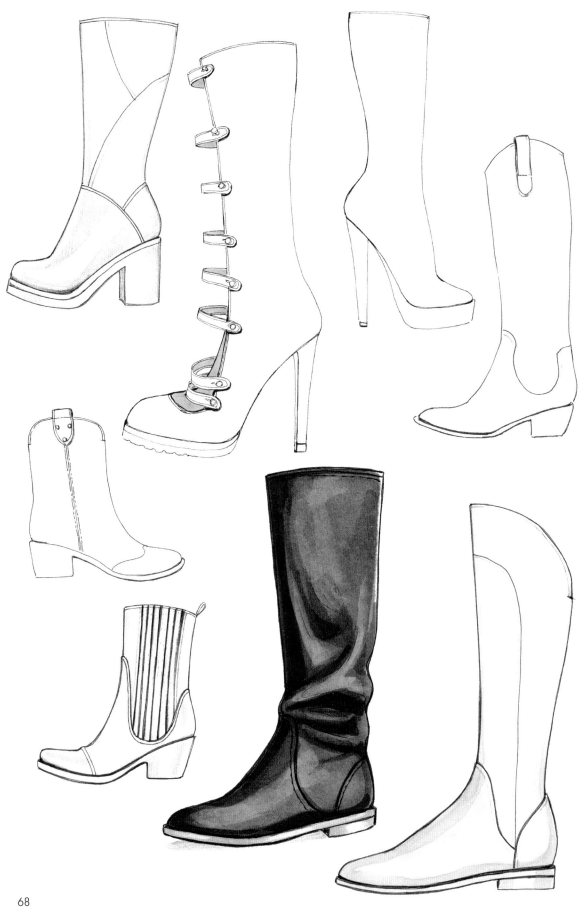

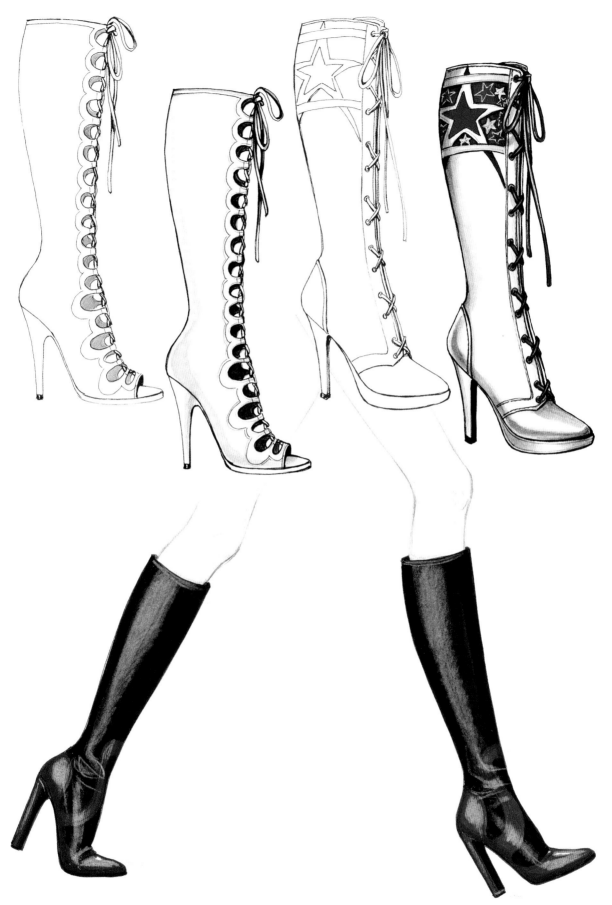

■ アンクルブーツ

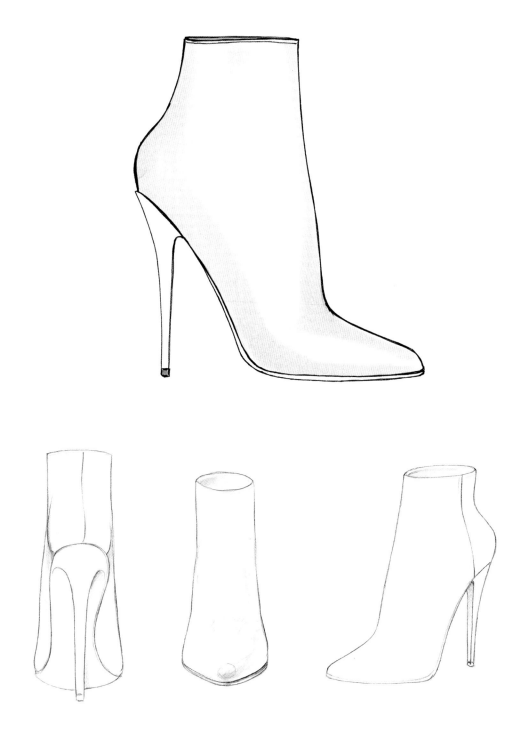

　足首のところでスパッと切り落としたような短いブーツで、クラシックな印象があります。特にジーンズやレギンスと合わせやすいので愛用されています。また、パリのキャバレー「ムーラン・ルージュ」のカンカン・ダンサーたちがタフタ生地のフレアスカートの衣装を蹴って踊るときに、足元に縦にボタンが並ぶア

ンクルブーツが見える様子は広く知られていて、挑戦的な雰囲気のあるセクシーな靴でもあります。

　スタッズ（飾り鋲）付きのものならバイカー風の着こなしにぴったりですし、低めのプラットフォーム（56ページ参照）やさまざまなヒールのアンクルブーツがあります。

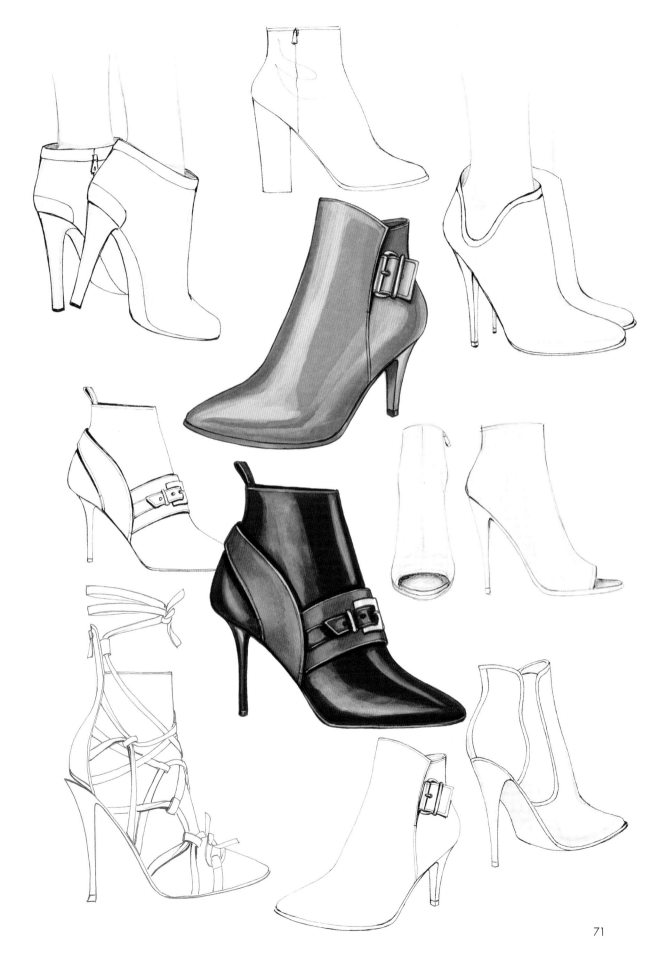

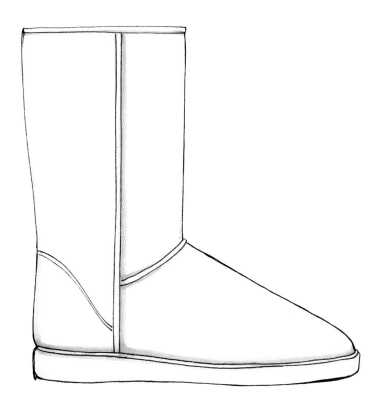

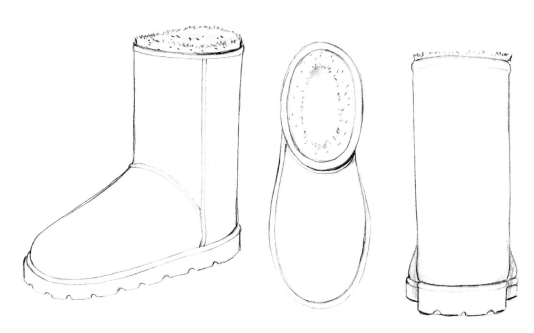

　冬のフットウェアとして人気のUGGブーツは、フラットなゴム製ソールと、ふくらはぎの途中までの長さの柔らかいスエードのアッパーでできていて、内側が羊の毛皮でとても温かいのが特徴です。

　オーストラリアのサーファーが、寒い海から上がったときに足元を保温するのに考案したブーツが起源で、やがてUGGブランドが生まれ、これがブーツの名前にもなり、カリフォルニアの若者やハリウッドのセレブの間で人気になりました。ジーンズや冬用のレギンスと合わせるのが定番の着こなしです。

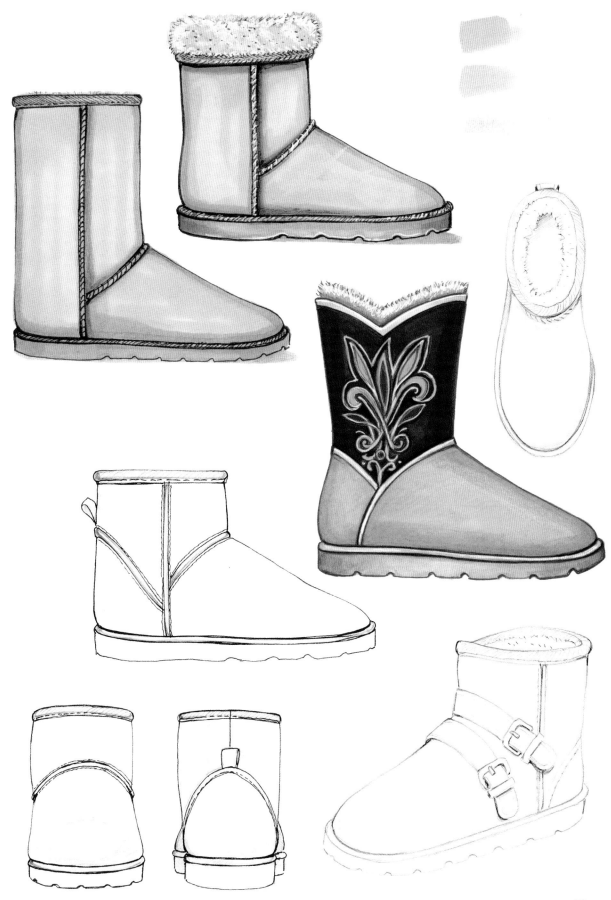

■ 靴のバリエーション

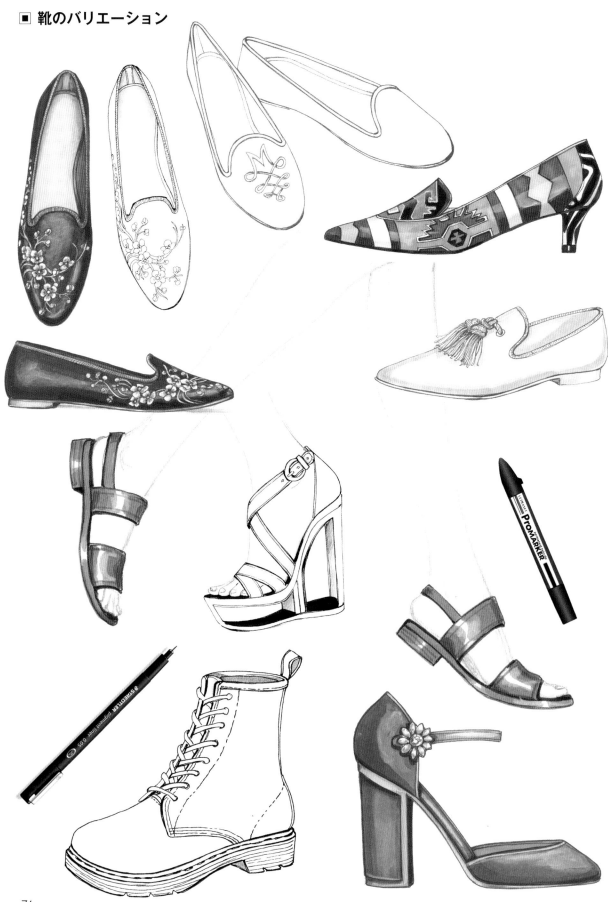

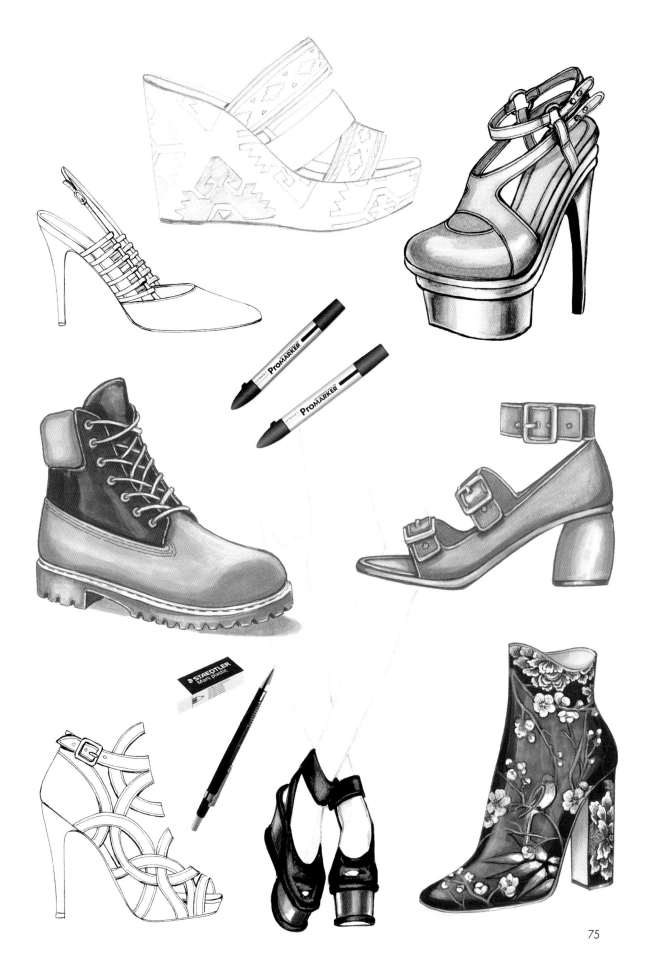

バッグ

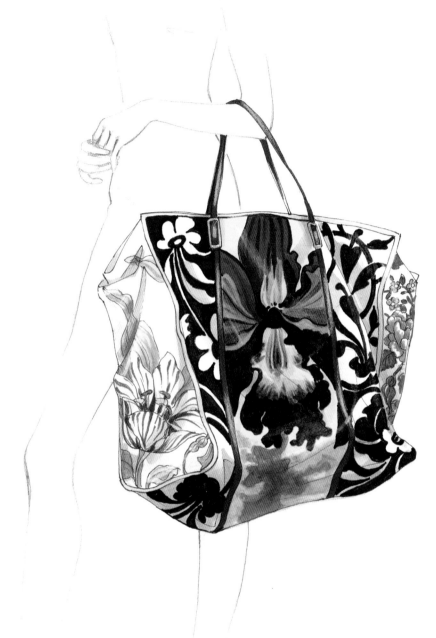

バッグは常に、女性のスタイルを演出するうえで最も重要な小物であり、どんな女性にとっても必須のアイテムです。日常的に使うものを持ち歩くための実用品として誕生しましたが、洗練された様子や品格を示すためにもなくてはならない小物となり、多くの人が手に入れたいと願う名作も生まれるようになりました。用途やTPOに合わせてさまざまなデザインのバッグが登場し、過去数十年間のファッション界において、バッグは服と一緒に発表されるアート作品のような存在にまで発展しました。

バッグをはじめとする小物は、ドレスよりも重要な存在になりえます。20世紀後半から、プレタポルテ(既製品)の登場やデザイナーの専門的な指導により、企業はさまざまな形、スタイル、サイズのバッグを作れるようになりました。夢のような新素材や機能が現実のものとなり、多くの女性の羨望の的となるバッグが次々と登場しています。有名な女性の手元を飾ったことから、時代を超えた魅力を放つ不朽のファッションアイテムとなっているバッグもあります。

今日、バッグが女性のワードローブの基本要素であることは、誰もが認める事実でしょう。カジュアルにもフォーマルにも欠かせない実用的なアイテムであり、コーディネートの差し色となり、スタイル全体の格を上げてくれる効果もあります。この章では、バッグの素材や形、名称、それに刺繍や色といったディテールに秘められたストーリーを紹介し、奥深いバッグの世界に皆さんをお誘いします。

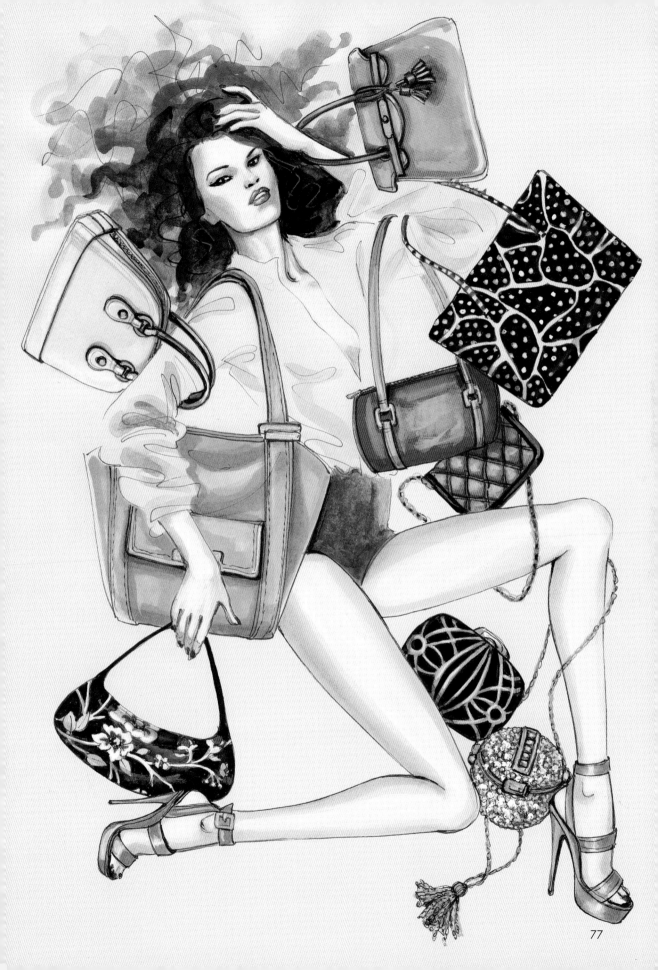

■ バッグをデザインする　形、バランス、パース

バッグをはじめとするファッション小物を選ぶ際に重視するべき要素としては、まず素材と機能が挙げられますが、バッグの場合には特に、バランスにも大いに気を配る必要があります。

消費者の立場からいえば、バッグを購入するにあたってサイズは十分に検討するべきです。大きすぎるバッグは避けなくてはなりません。小柄な女性がオーバーサイズのショッピングバッグなどを持つと、さらに背が低く見えてしまいます。逆に、背の高い女性や体格の良い女性はミニサイズのバッグを避けるべきです。特に体格の良い人も、体型にふさわしいサイズのバッグを選ぶとよいでしょう。超大型の小物を身につけると、体の重量感が増して見えることにも気をつけましょう。

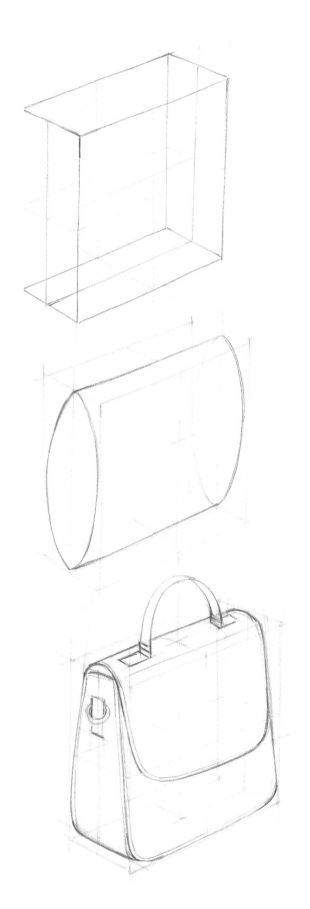
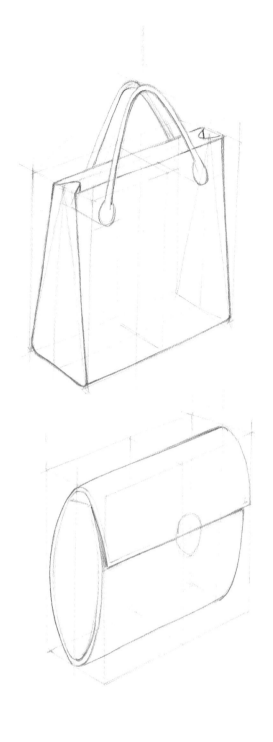

　このページでは、デザイン画やイラストを描く際、またはデザインのインスピレーションを得るために役立つ図形の例を、さまざまな角度から紹介しています。
　基本的な鉛筆のデッサンを出発点にして線を描き足していき、その上をペンでなぞることで、バッグの形を完成させることができます。

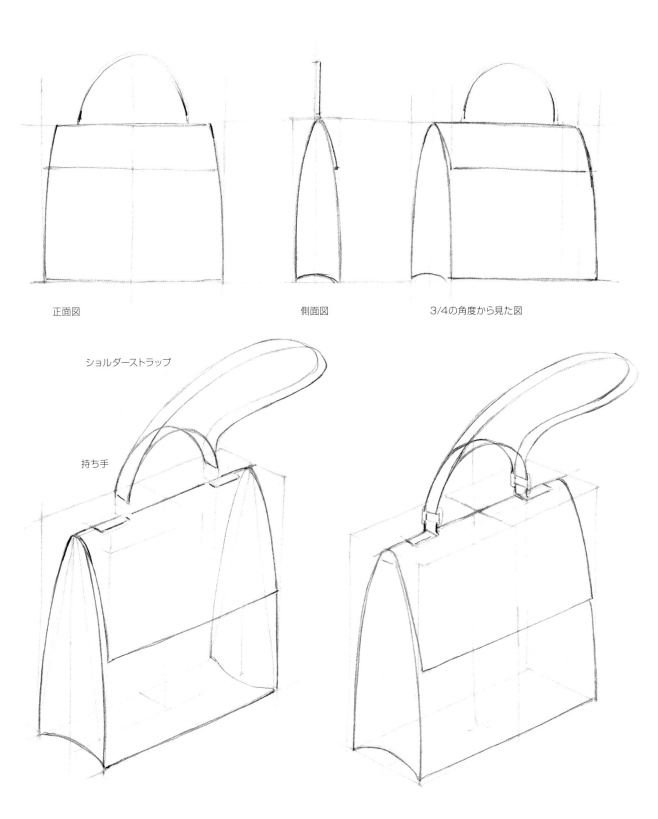

正面図　　　　　　　　　　側面図　　　　　　　　3/4の角度から見た図

ショルダーストラップ

持ち手

　商品開発の担当者やデザイナーにとって、プロポーションを考慮することは、良いデザインを生み出すために非常に重要な要素です。ほんの少しの違いが、魅力的なデザインの製品になるかどうかを左右し、さらには消費者が見て購入に至るかどうかの分かれ目になります。

　バッグをデザインする際には、パース（透視図法）をおぼえておくと便利です。手に取ってみたくなり、そして自分のものにしたくなるようなバッグを作りたいと願うデザイナーにとって、パースの基本を習得するだけでも大いに役立ちます。

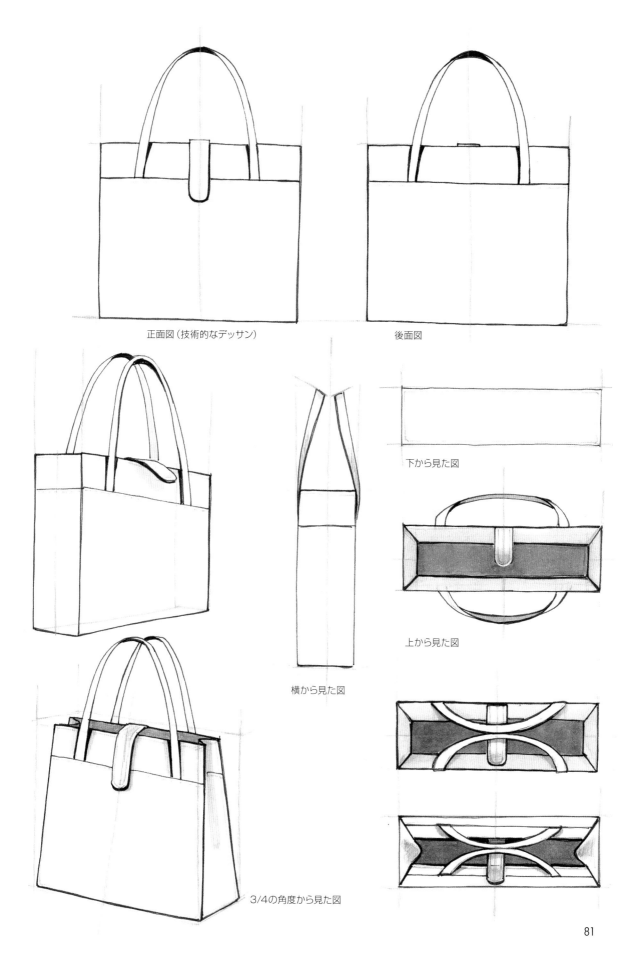

正面図（技術的なデッサン）

後面図

下から見た図

横から見た図

上から見た図

3/4の角度から見た図

81

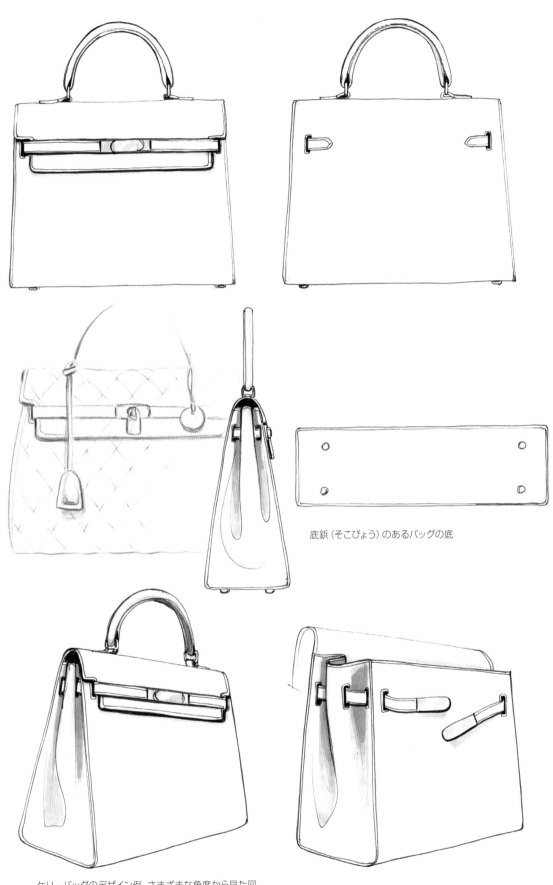

底鋲（そこびょう）のあるバッグの底

ケリーバッグのデザイン例、さまざまな角度から見た図

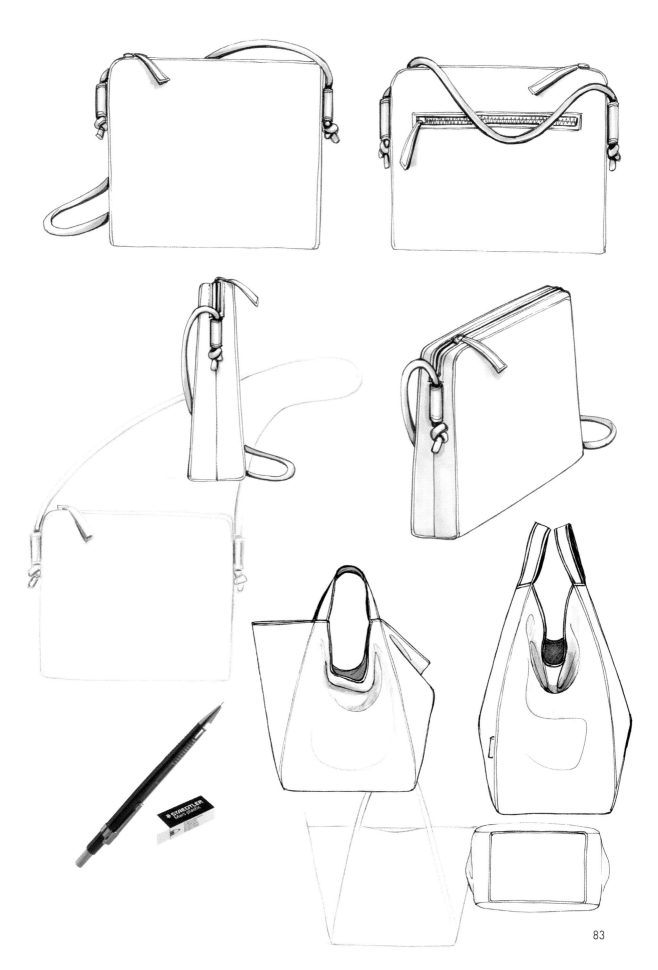

■ バゲット（BAGUETT）

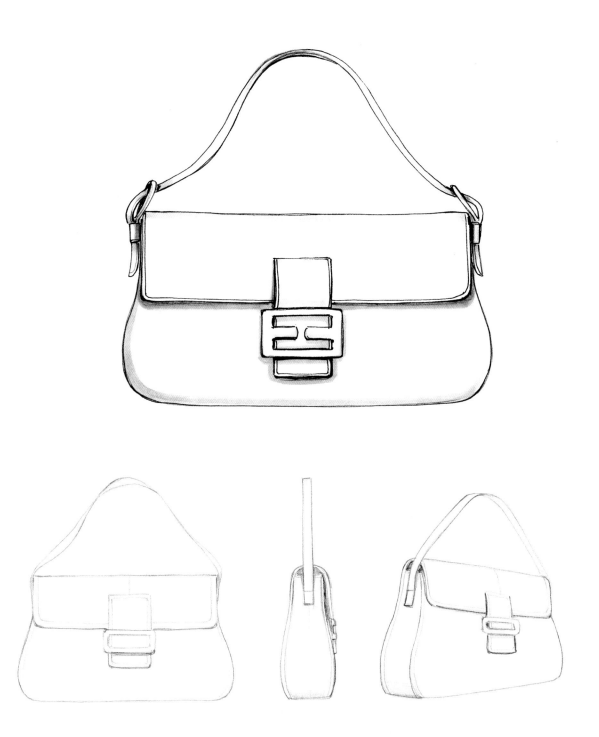

　フランスパンに由来する名前を持つ「バゲット」は、パリジャンがパン屋でバゲットを買ったときのように小脇に抱えて持つことの多いバッグです。もちろんフランスのみならず海外でも愛されており、サテンやレザーで作られたバゲットは純粋なエレガンスの代名詞とも呼ぶべきバッグです。

　1990年代、フェンディがさまざまに変化をつけてバゲットを多数発表すると人気は絶頂に達し、有名人にも愛用されました。『セックス・アンド・ザ・シティ』ではサラ・ジェシカ・パーカーがフェンディの刺繍入りバゲットを持っていて強盗に狙われるというシーンがあり、フェンディはさらに幅広い人たちに注目されるようになりました。

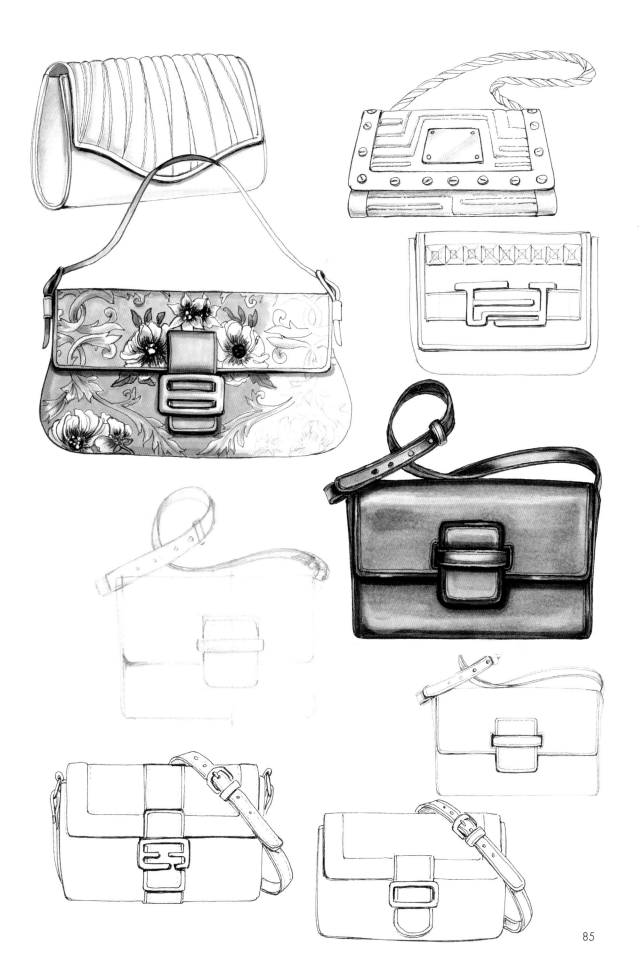

85

■ ボストンバッグ

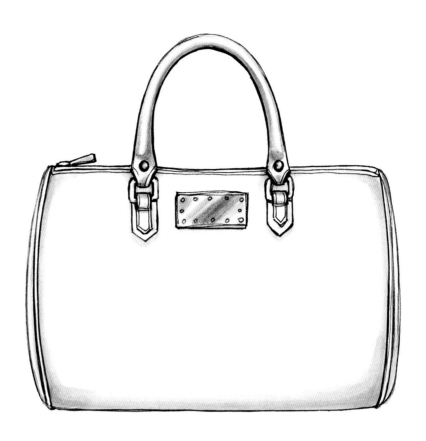

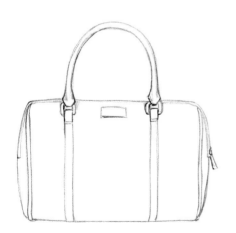

　昔のトランクのような形が特徴のボストンバッグは、1930年代に容量の大きい実用的な旅行鞄のニーズから生まれました。

　当時、ルイ・ヴィトンが、モノグラムがプリントされたキャンバスを使って最初のボストンバッグを発表しました。ルイ・ヴィトンの小型ボストンバッグ「スピーディ」のシリーズは、1960年代ファッションを代表する存在であるオードリー・ヘップバーンによって誕生しました。ヘップバーンがルイ・ヴィトンに、従来よりも小さいサイズのバッグを作ってほしいとリクエストして誕生したのが、「スピーディ25」だったのです。

　数字はバッグの横幅をセンチメートルで表しています。現在では、4種類のサイズのスピーディが販売されています。

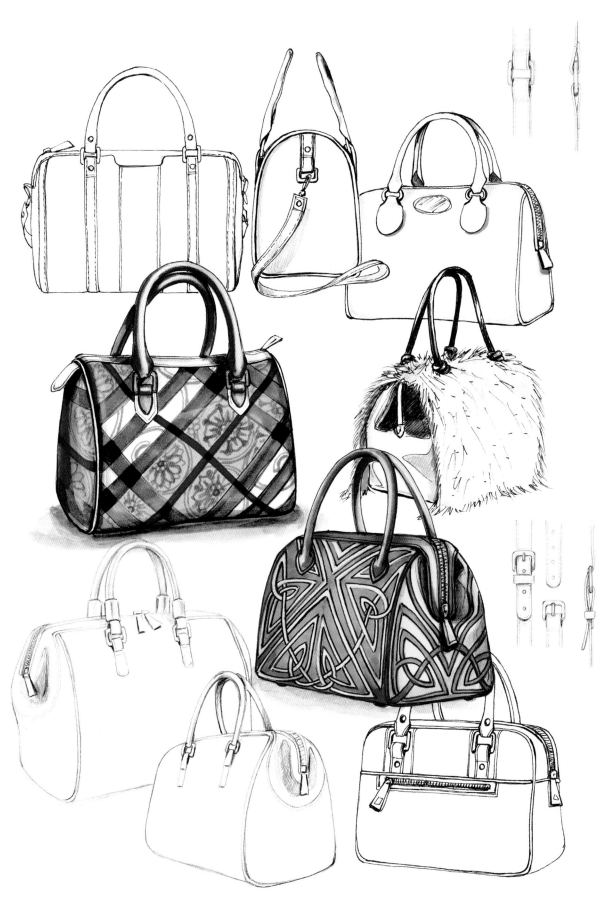

■ バーキン

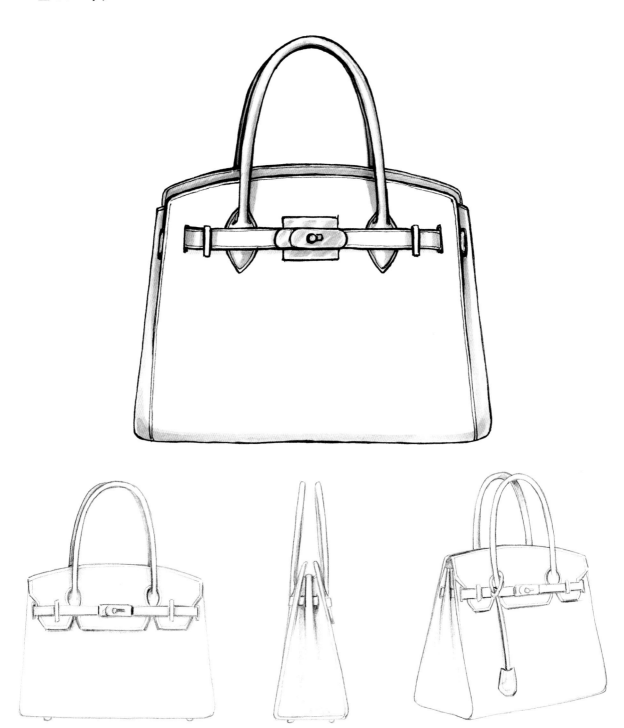

　世界で最も広く認知されているロングセラーです。「バーキン」は、予期しない偶然の出会いから生まれた逸話があります。

　1981年、当時フランスで人気のあったミュージシャン、セルジュ・ゲンスブールのパートナーだった、英国の歌手・女優のジェーン・バーキンが飛行機に乗っているときに、バッグを荷物入れに入れようとしたところ、すべてが床に落ちてしまいました。その様子を隣席で見ていた紳士が、エルメスの故ジャン・ルイ・デュマ社長（当時）だったのです。ジェーン・バーキンは、デュマ社長と目が合うと「旅行用バッグはきれいじゃないし、きれいなバッグは大きさが足りない」と言ったとか。こうして意気投合した2人のコラボレーションにより、短期間のうちにエルメスのバーキンが誕生しました。

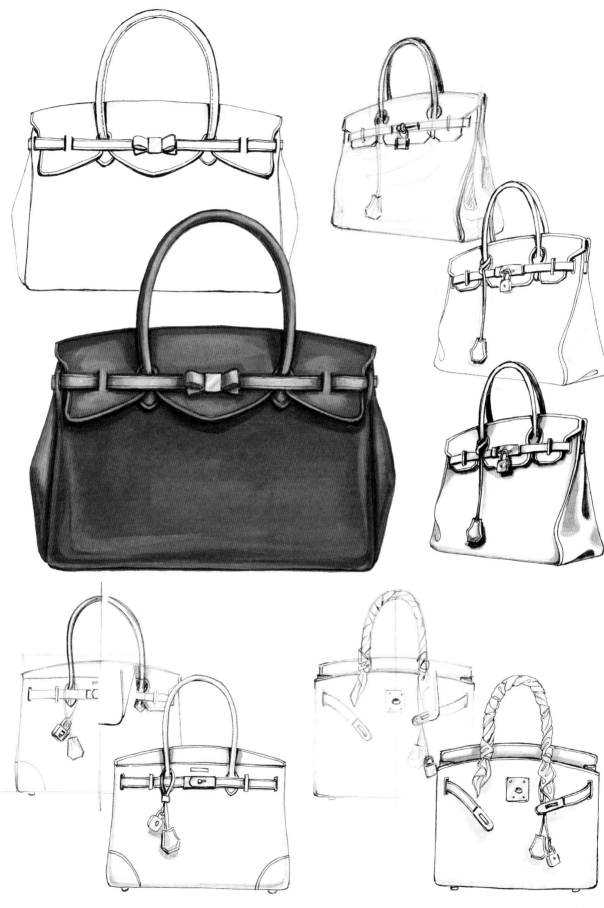

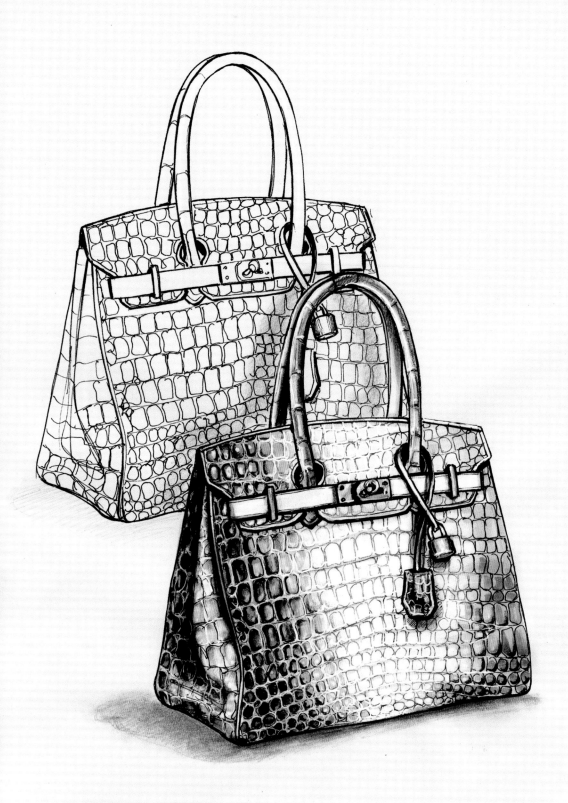

▣ ブリーフケース

特にビジネスパーソンに人気があります。郵便配達の肩掛け鞄が由来のサッチェル（イギリスの伝統的な学生鞄）のようなフラットな形状で、上部にファスナーがついているため、書類やノートパソコンを持ち運ぶのに最適なバッグです。

硬い素材で作られていることが多く、内部には仕切りがあり、中身を整理して入れられるのも魅力です。短めの持ち手は持ちやすく、ショルダーストラップ用のリングなど金属のパーツがアクセントになっているものもあります。

92

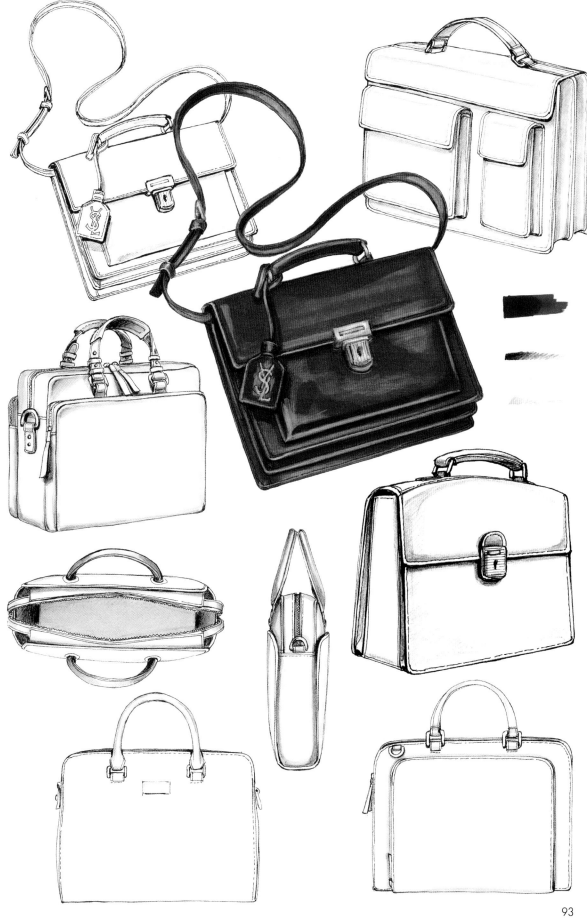

◼ エンベロープ

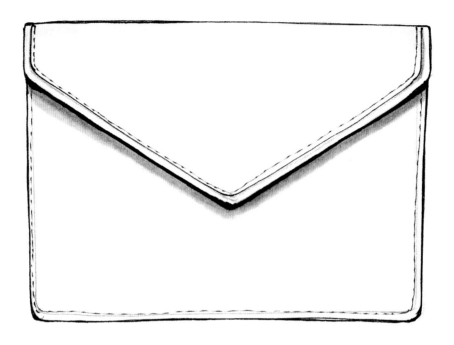

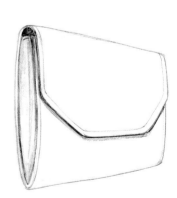

　ベーシックでありながらおしゃれな雰囲気のクラッチバッグ（96ページ参照）で、郵便に使う封筒のような形をしていることから「エンベロープ（封筒）」の名があります。
　薄くてすっきりしたデザインはパンツスーツにもぴったりです。持ち手がないため手で握るか、小脇に抱えて持ちます。

　形を保持するために素材としては硬いレザーが使われることが多く、その場合はハードな雰囲気になります。ビジネスパーソンが持つととりわけフェミニンな感じが演出できます。柔らかい素材を使ったカジュアルなエンベロープもあります。

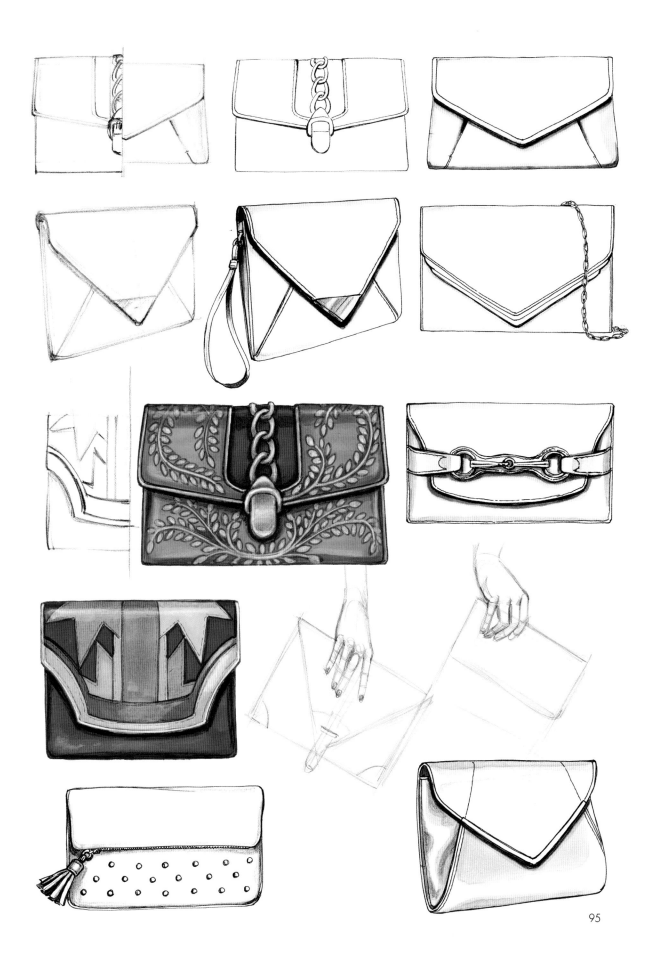

■ クラッチ

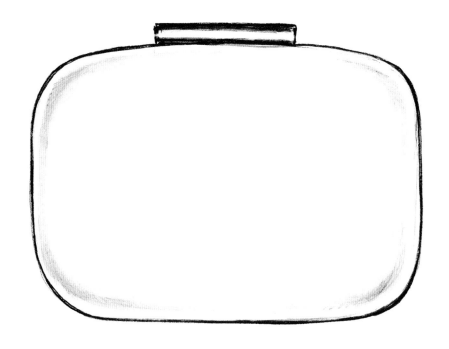

　手の中で「握りしめる」（クラッチ）ようにして持つことが名前の由来です。クラッチは高級な小型のバッグで、フォーマルでエレガントな場面には欠かせません。世界中のレッドカーペットで見られ、国際的な称賛を浴びる女性の手元を彩るバッグです。

　トレーンのあるロング丈のイブニングドレスや、スカートを膨らませたクリノリンドレスにぴったり。高貴な地位を誇るクラッチは、ファッション史の偉大なデザイナーたちにも愛され、ゴールドやダイヤモンドなどの高級素材と個性的なデザインで類まれな美しさを見せるクラッチが、世に送り出されてきました。

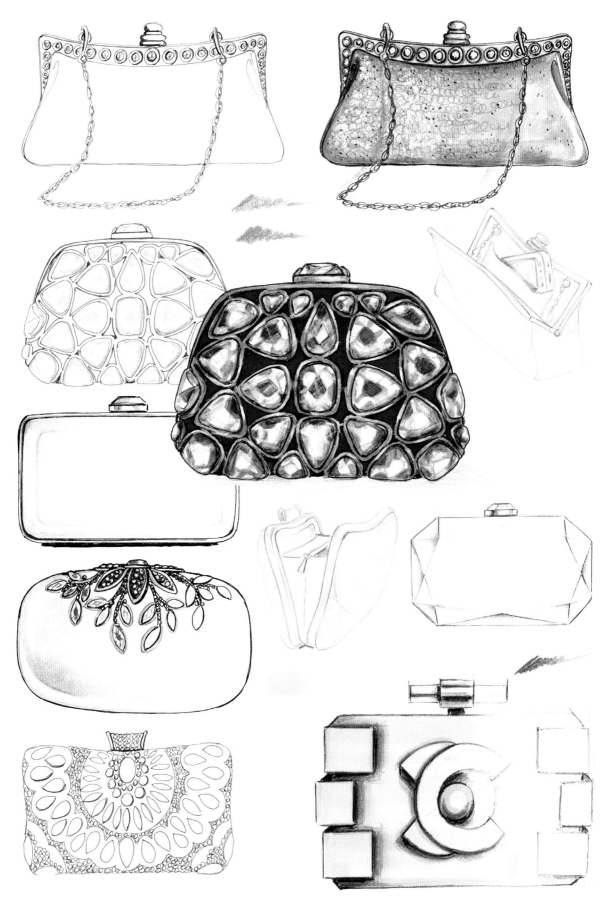

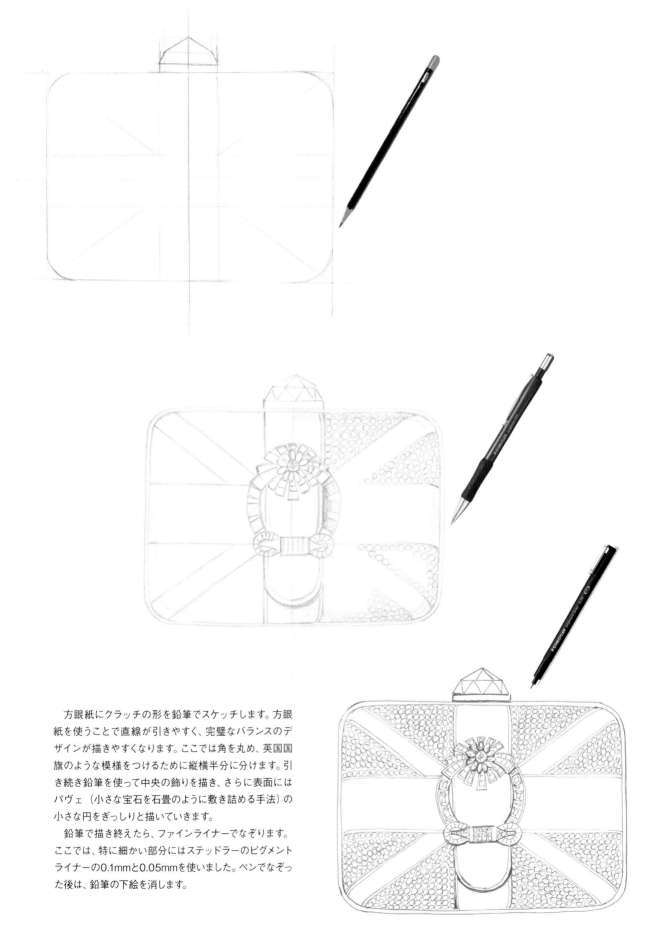

　方眼紙にクラッチの形を鉛筆でスケッチします。方眼
紙を使うことで直線が引きやすく、完璧なバランスのデ
ザインが描きやすくなります。ここでは角を丸め、英国国
旗のような模様をつけるために縦横半分に分けます。引
き続き鉛筆を使って中央の飾りを描き、さらに表面には
パヴェ（小さな宝石を石畳のように敷き詰める手法）の
小さな円をぎっしりと描いていきます。

　鉛筆で描き終えたら、ファインライナーでなぞります。
ここでは、特に細かい部分にはステッドラーのピグメント
ライナーの0.1mmと0.05mmを使いました。ペンでなぞっ
た後は、鉛筆の下絵を消します。

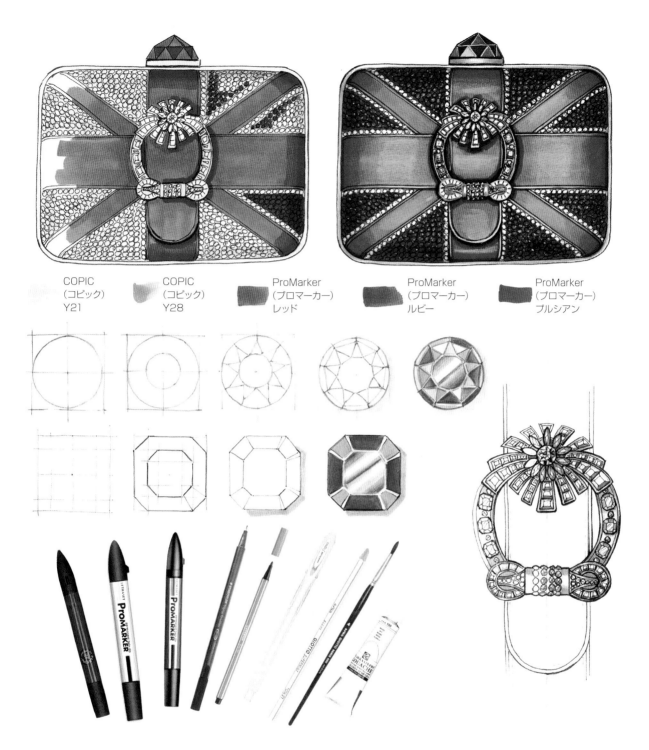

COPIC
（コピック）
Y21

COPIC
（コピック）
Y28

ProMarker
（プロマーカー）
レッド

ProMarker
（プロマーカー）
ルビー

ProMarker
（プロマーカー）
プルシアン

　PANTONE（パントン）のペンで色を塗っていきます。最初の絵では宝石の背景色は黄色です。

　宝石の間隔が離れている場合には個別に塗りますが、ここでは密集しているので宝石の色（ブルー）で埋めてしまいましょう。さらに、ダークブルーのフェルトペンや黒のTRATTO（トラット）ペンで小さな宝石の間を細かく塗って奥行きを出します。またはそれぞれの宝石の下部に暗い半円状のあいまいな輪郭を入れるだけでもいいでしょう。その後、白いゲルペンで点をのせて輝きを加えます。

　バッグ全体を立体的にするには、PANTONE（パントン）の暗色を使って外周に影を作り、その上から白の色鉛筆か薄めた白のアクリル絵具を中央に向かって軽くぼかし明るさを出します。

　上部の留め具の宝石は、まずProMarker（プロマーカー）のレッドで背景にポピーのような赤を塗ってから、白の色鉛筆でハイライト部分を着色します。白のゲルペンで、それぞれの宝石の輝いている部分と輪郭を描きます。

　ゴールドの縁取りは、側面に濃い黄色を塗ってなじませた後、白の色鉛筆で中央にハイライトを加えます。

　宝石のディテールには、スタビロの中細のマーカーと、ステッドラーのトリプラスファインライナーを使用しました。

◼ フレーム

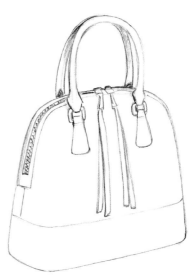

　ヴィンテージバッグの愛好家にとって、最も魅力的な個性を持つのがフレームのハンドバッグかもしれません。小銭入れのような形と金属製のクラスプ（留め具）が特徴的です。

　形は四角く、常に（少なくとも上部は）硬い構造になっています。1990年代以降、ドルチェ＆ガッバーナがこのスタイルを確立しました。アンナ・マニャーニやソフィア・ローレンら往年の映画女優が演じた戦後イタリアのたくましい女性のファッションを思い起こさせるバッグです。素材としては光沢のある黒のエナメルやクロコダイル・レザーが代表的です。

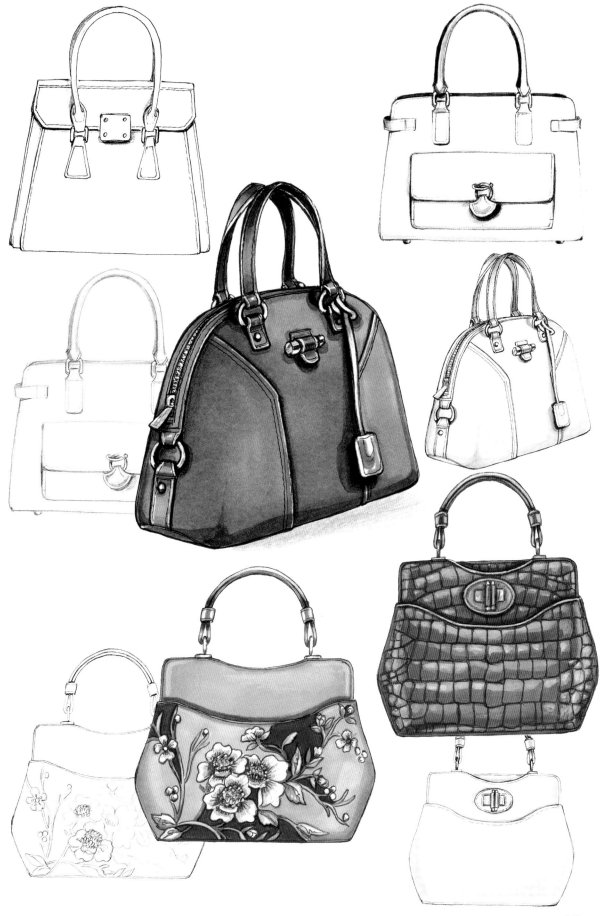

◼ ホーボー

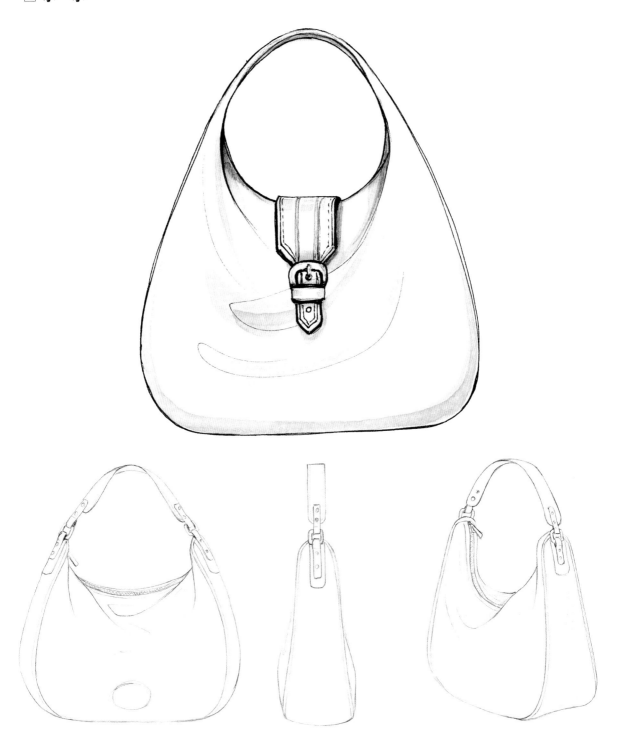

　柔らかい素材を使用した半円形のおしゃれなバッグです。ファスナーとフック、または中央のバックルで閉めることができます。

　ファッション史で一時代を築いた最も有名なホーボーといえばグッチの「ジャッキー」。もとケネディ大統領夫人で、大統領暗殺ののちにギリシャの大富豪オナシスと結婚したジャクリーン・リー・ブーヴィエ・ケネディ・オナシスのために作られたことが名前の由来です。

　今日に至るまで、世界中のブランドがジャッキーを思わせる魅力的なホーボーを発表し、人気を呼んでいます。

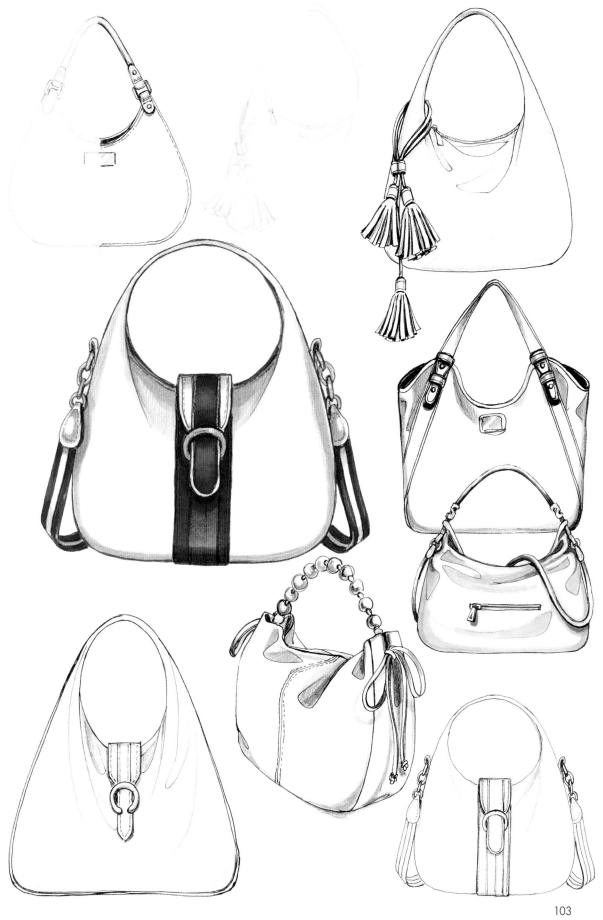

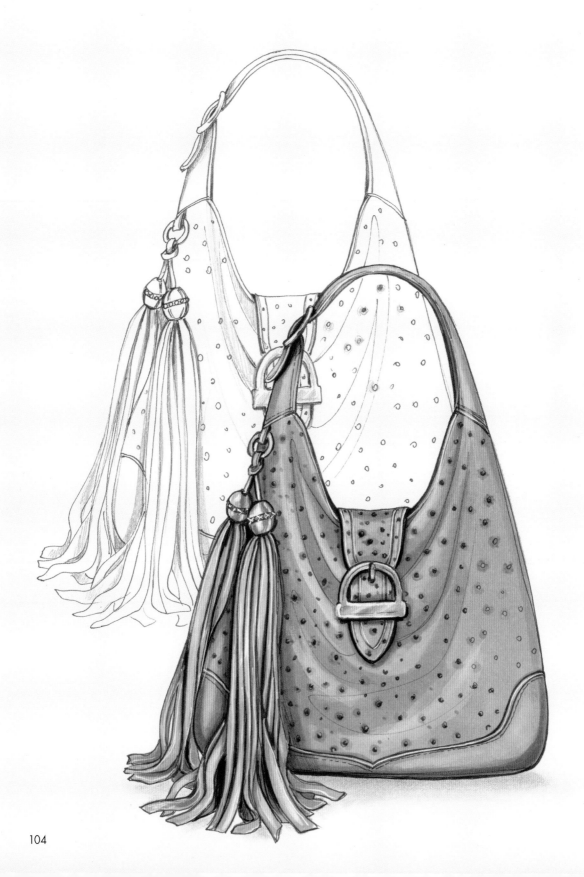

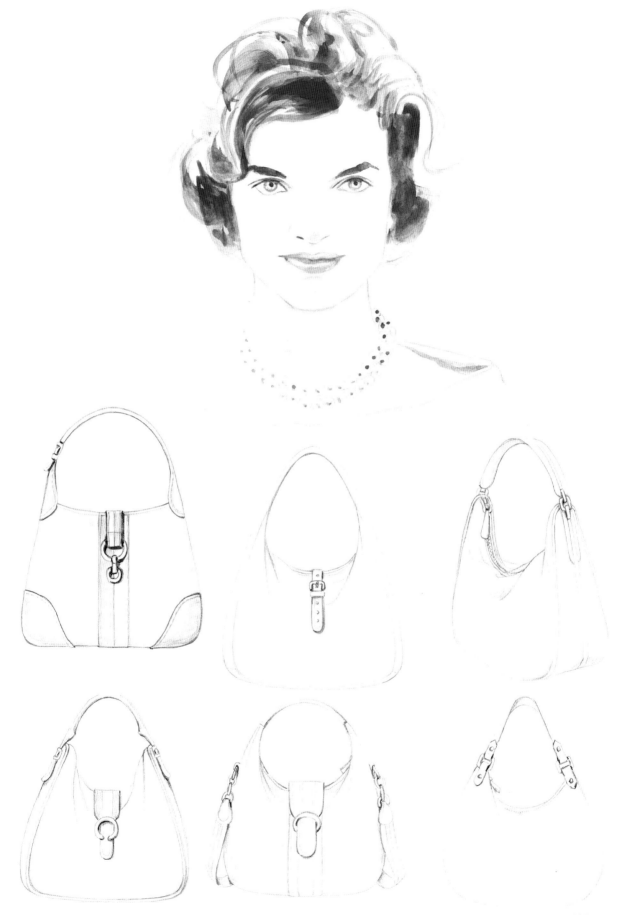

◨ ケリー

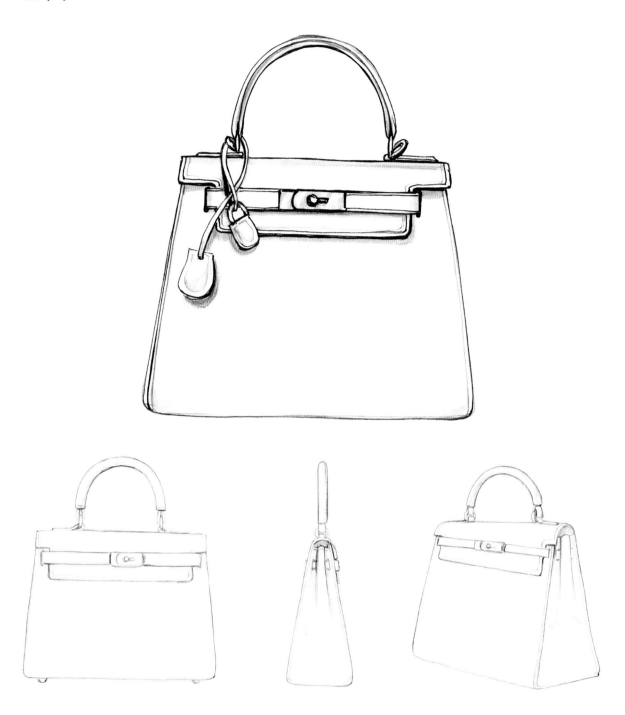

　ケリーバッグはフランスのブランド、エルメスを象徴する存在であり、エルメスの最も有名なバッグであることは間違いありません。その名は類まれな美しさで知られたモナコのグレース・ケリー公妃に由来しています。

　狩猟用のサドルバッグとして考案されたデザインをもとに、エルメス兄弟は女性がレジャーに使えるバッグを作りました。このバッグはすぐに人気になりましたが、今日知られているケリーという名前がつけられたのは、それから20年後のことでした。きっかけは1956年、アメリカ人の元女優でプリンセスになったばかりのグレース・ケリーが、妊娠を隠そうとこのバッグをお腹の前で持ったことです。その写真が世界中に広がり、エレガントなバッグが思いがけない形で脚光を浴びました。

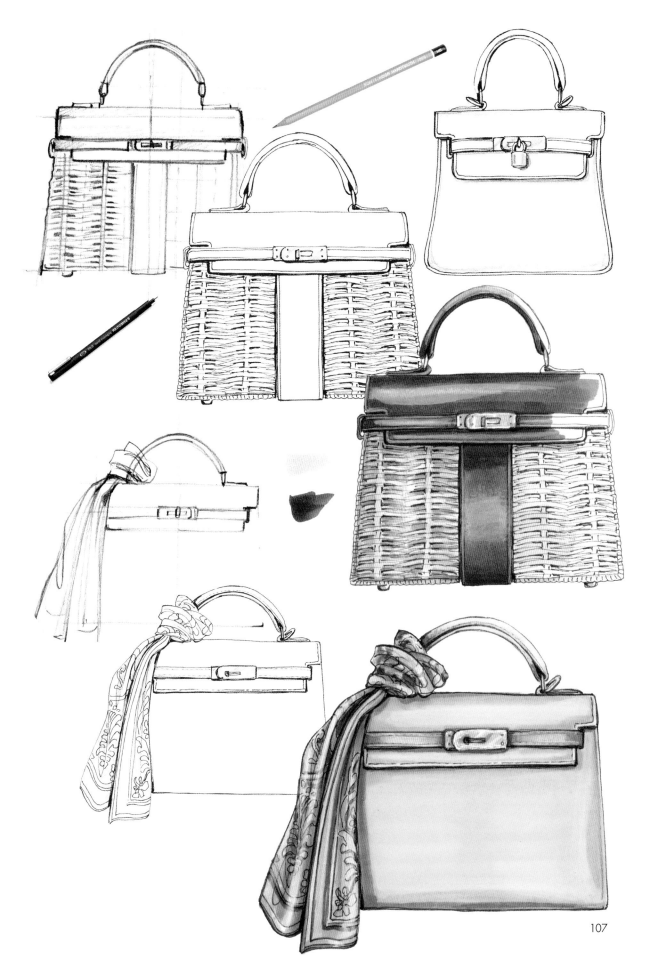

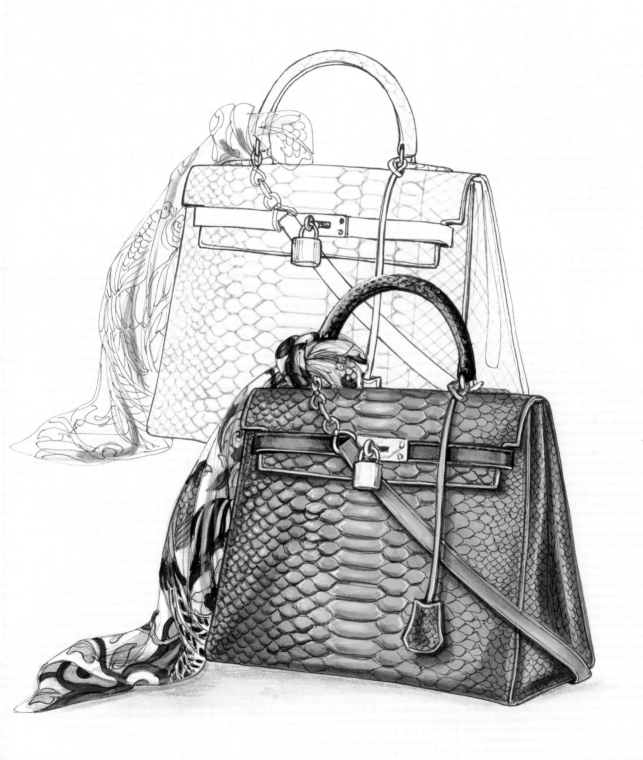

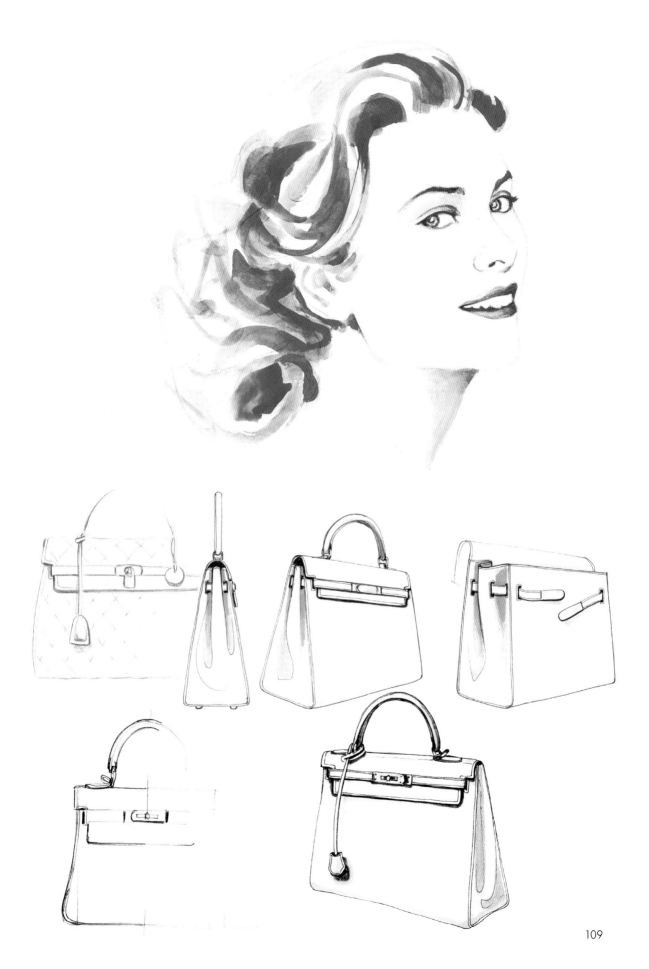

■ レディ ディオール

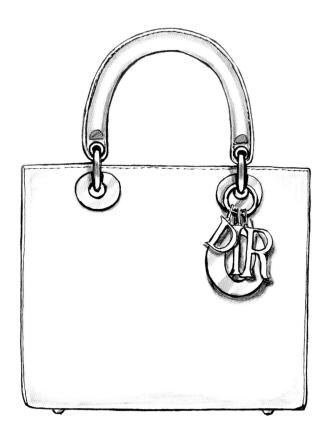

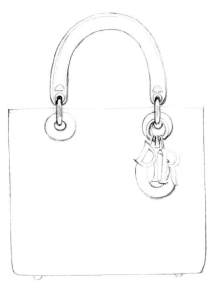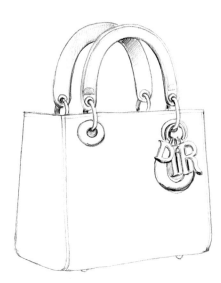

広く知られている「レディ ディオール」は、1995年、パリを公式訪問した英国のダイアナ妃に、フランス大統領夫人（当時）のベルナデット・シラクが贈ったバッグです。

キルティングのステッチは、後に多くのディオール製品で使われるようになった藤編み家具のようなカナージュのパターンを取り入れています。四角形のデザインに、大文字で「DIOR」と書かれた金属のチャームがアクセントです。レディ ディオールは、ダイアナ妃が持ったことで大流行しました。

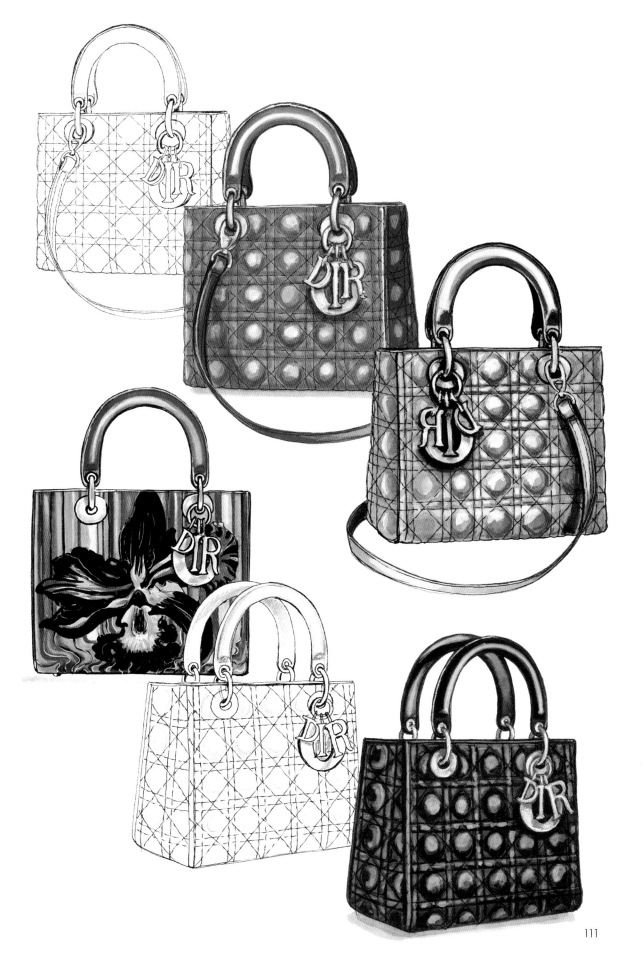

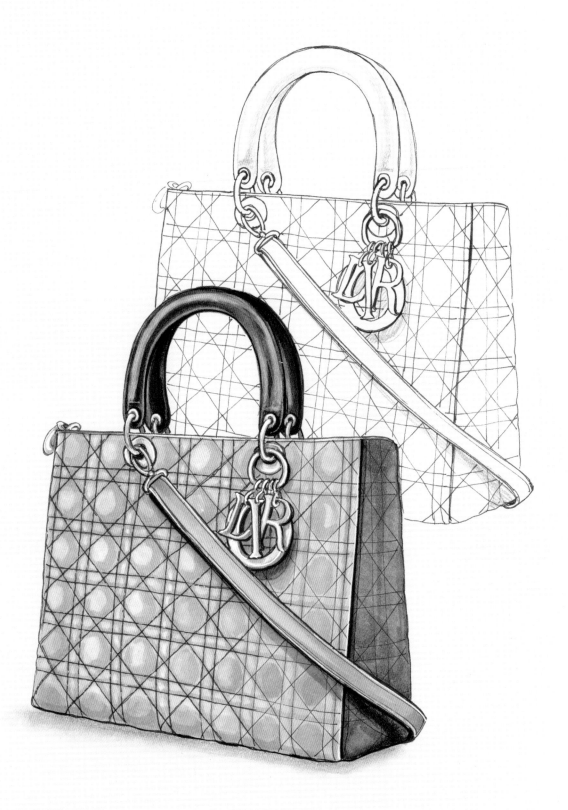

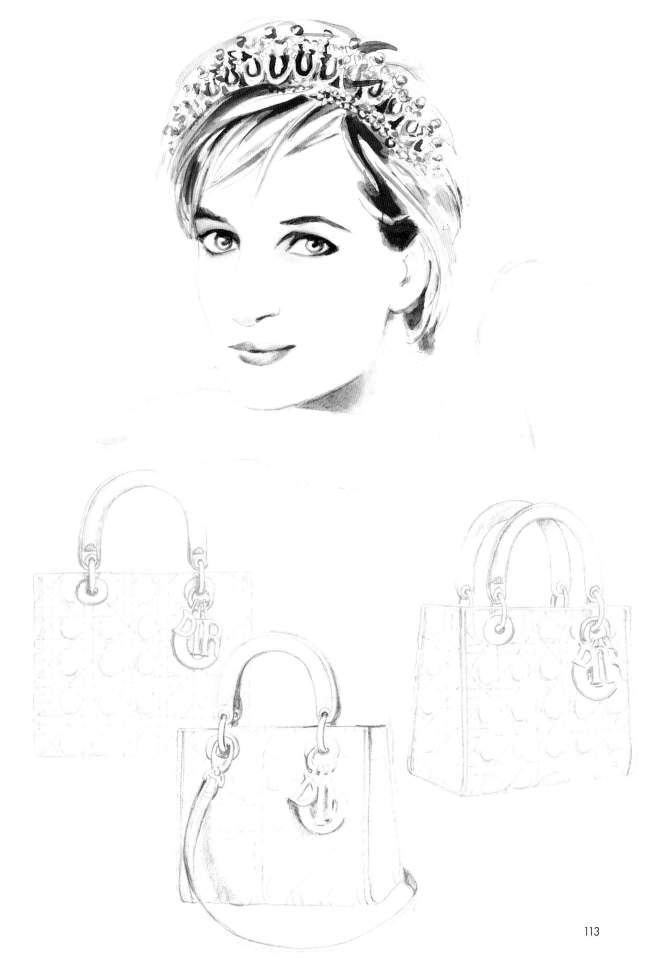

■ ミナウディエール

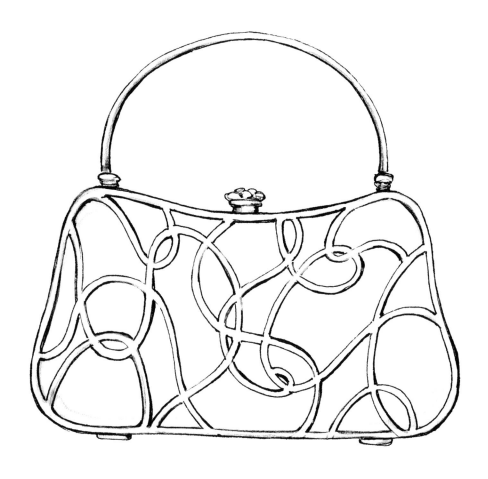

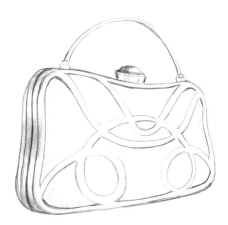

　実用性を超えて、きらびやかなデザインで魅了するバッグです。コンパクトなので、特別なパーティーにぴったり。
　化粧品や鍵などの貴重品が少し入る宝箱のようなバッグで、シルクサテンやラメなどの高級素材を使い、多くの場合はスワロフスキー・クリスタルがあしらわれています。クラッチバッグとは異なり、しっかりと安全に握れるように、ハード、またはソフトな素材の持ち手がついている場合もあります。

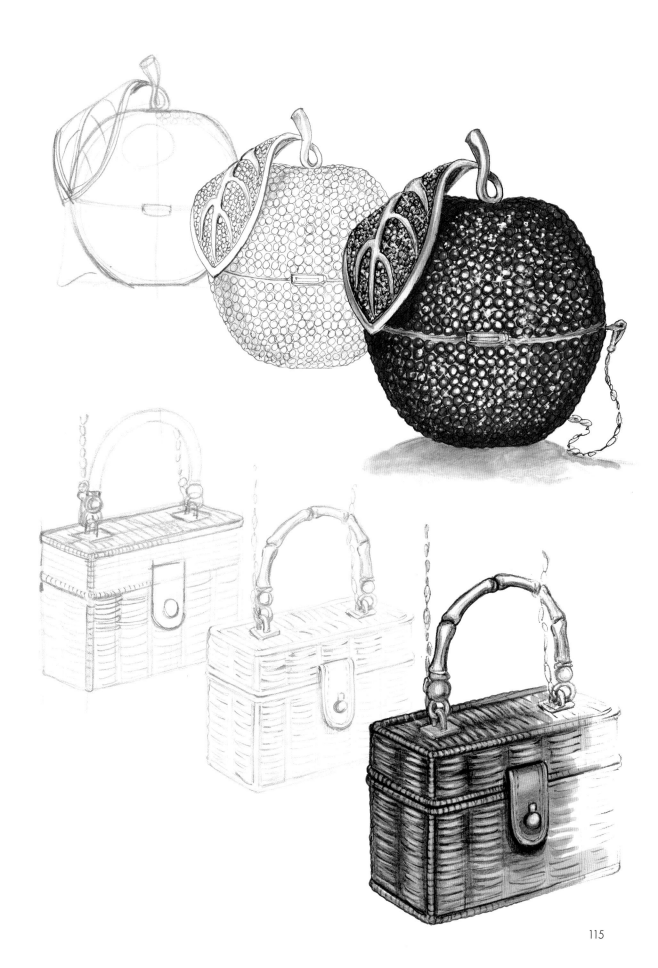

115

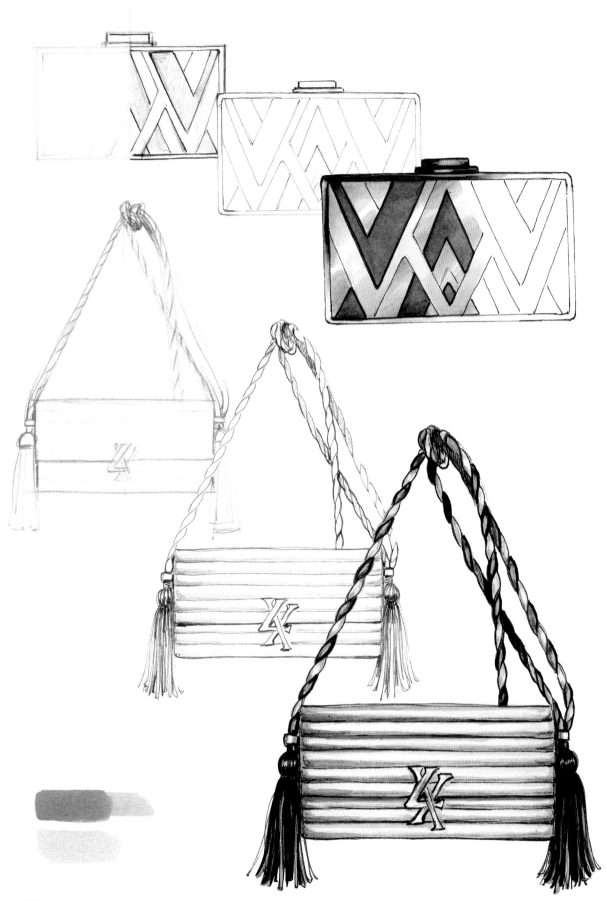

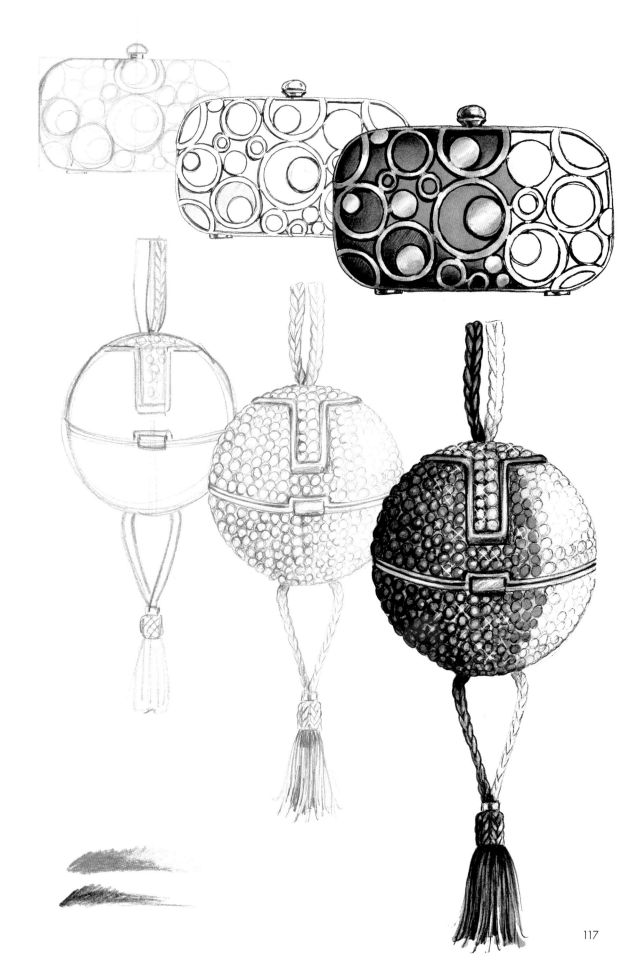

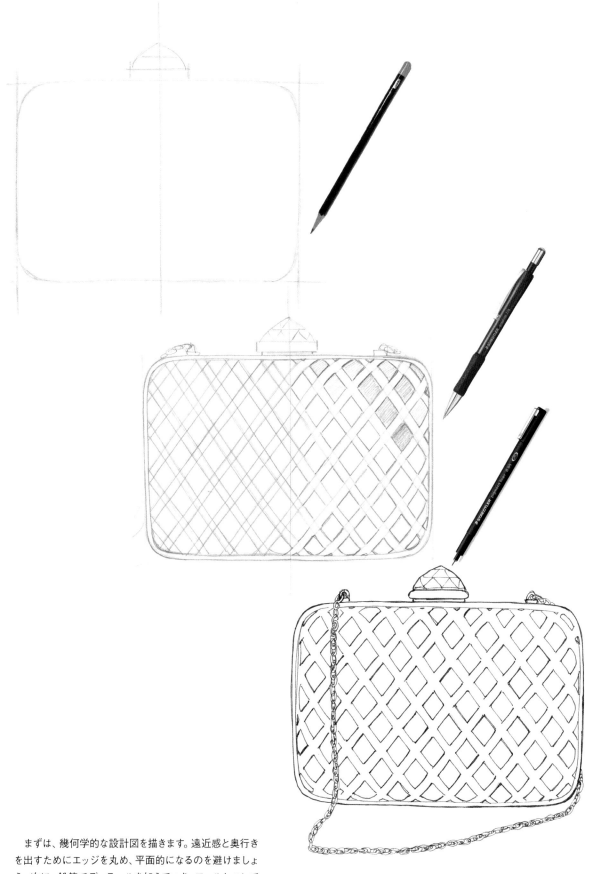

　まずは、幾何学的な設計図を描きます。遠近感と奥行き
を出すためにエッジを丸め、平面的になるのを避けましょ
う。次に、鉛筆でディテールを加えていき、フェルトペンで
鉛筆の下絵をなぞります。

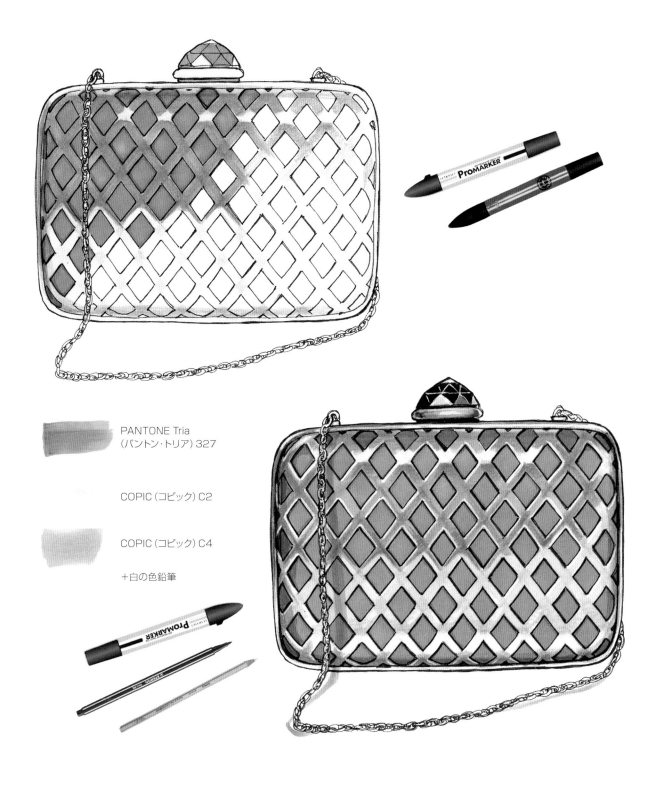

PANTONE Tria
（パントン・トリア）327

COPIC（コピック）C2

COPIC（コピック）C4

＋白の色鉛筆

　まず、緑とグレーの部分に陰影をつけずに色を塗ります。ここでは、メタリック感を出すためにグレーを使っているので、ハイライト部分は白のままにしておきます。

　続いて、仕上げの作業に入ります。外側の輪郭に、先ほどと同じ色か、より暗い色で陰影をつけます。乾くまで数分待ってから、別の色を塗って濃淡をつけます。乾かす理由は、インクが染み込んで重ね塗りの効果が低くなるのを防ぐためです。

　金属のパーツの下にできる影を出すためには、スタビロのファインライナーなどの極細ペンを使い、ダークグリーンの線を加えます。金属そのものに陰影をつけるには、ダークグレーや黒の色鉛筆がよいでしょう。また、白の色鉛筆で輝きを加えることもできます。

■ **メッセンジャーバッグ**

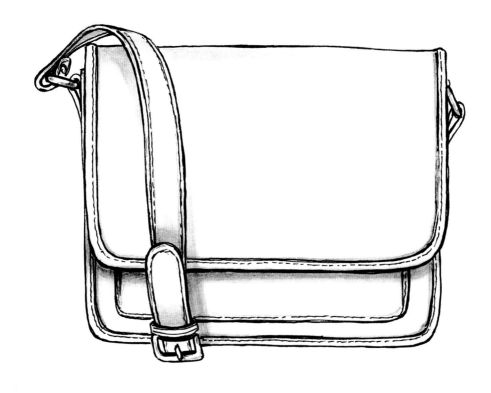

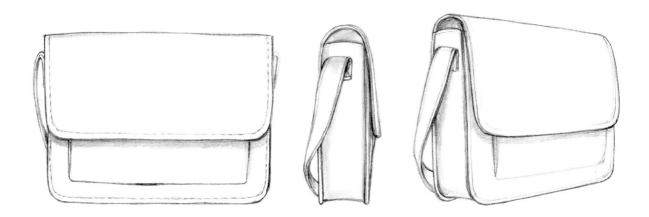

　郵便局で使われていたことからメッセンジャー（配達人）のバッグと呼ばれているマスキュリン（男性的）なバッグです。今では一般にも愛用されていて、両手が自由に使えるように長めの肩ひもがついていることが特徴。バイクや自転車に乗る人にも愛用されています。

　平たい形で、内側には物を分けて入れるのに便利な大き目のポケットがあり、全体を覆う革のフラップに留め具がついたデザインが一般的です。機能性を考慮し、素材としては硬いレザーが使われます。

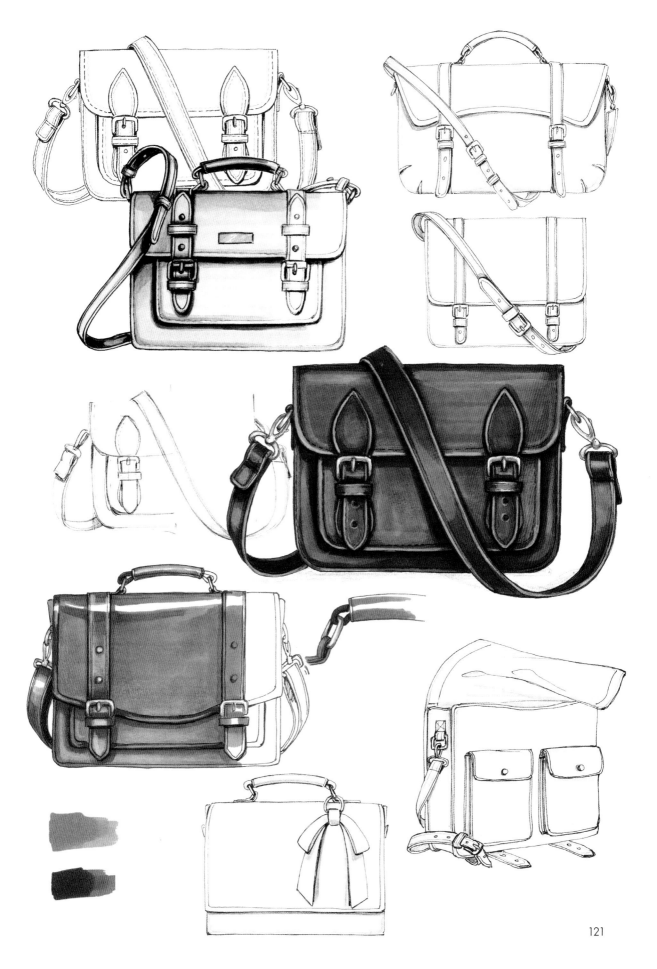

■ サドルバッグ

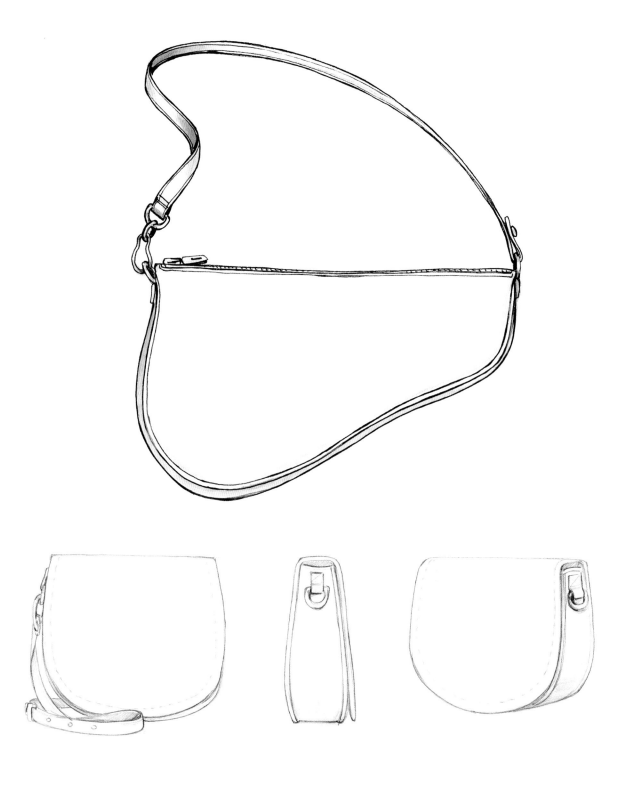

　近年人気の高い個性的なバッグ。馬の鞍（サドル）のような形を
していることからこう呼ばれます。ジョン・ガリアーノがディオール
で発表したサドルバッグは、すぐにディオールのベストセラー商品
となりました。

　人気を受けて、革新的な素材や色でも作られるようになり、大胆
なファッションを好む女性たちに人気を博しました。鞍の鐙（あ
ぶみ）のような大文字のDの形をした金属製のループがアクセン
トで、これをレザーストラップで留めることができます。

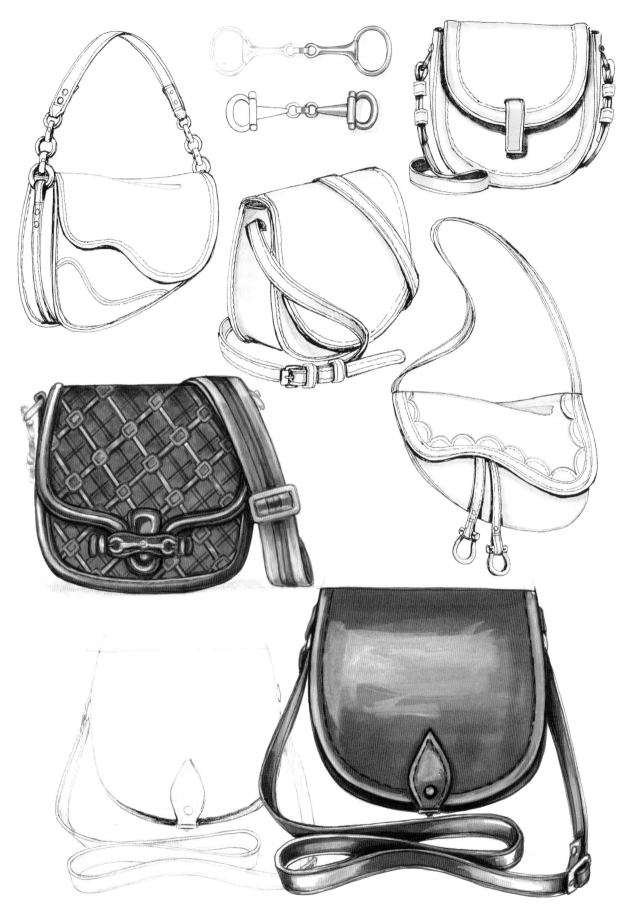

■ バケット（BUCKET）

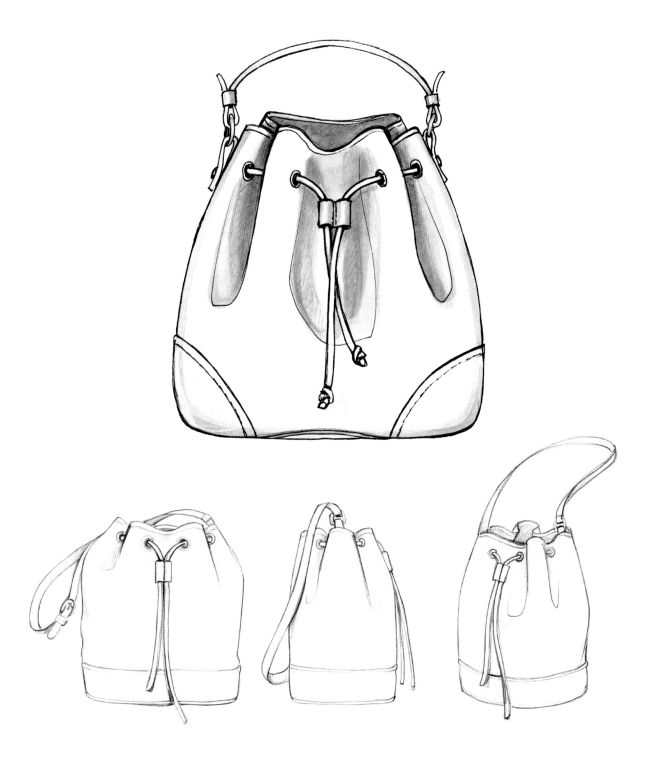

　バケット（バケツの意味）は、1930年代、フランスのシャンパー
ニュ地方のワイン生産者が、ルイ・ヴィトンに4〜5本のボトルが
入るバッグの製作を依頼したのが起源です。当初「ノエ」と呼ばれ
たバッグは、当時の上流社会でピクニックに欠かせない小物とし

て流行しました。
　その後、さまざまな高級ブランドがバケットを発表してきました
（特徴的な円筒形の形状は保持されています）。たとえば、エルメ
スはイノシシの皮を使い、夏用のバケットバッグを作っています。

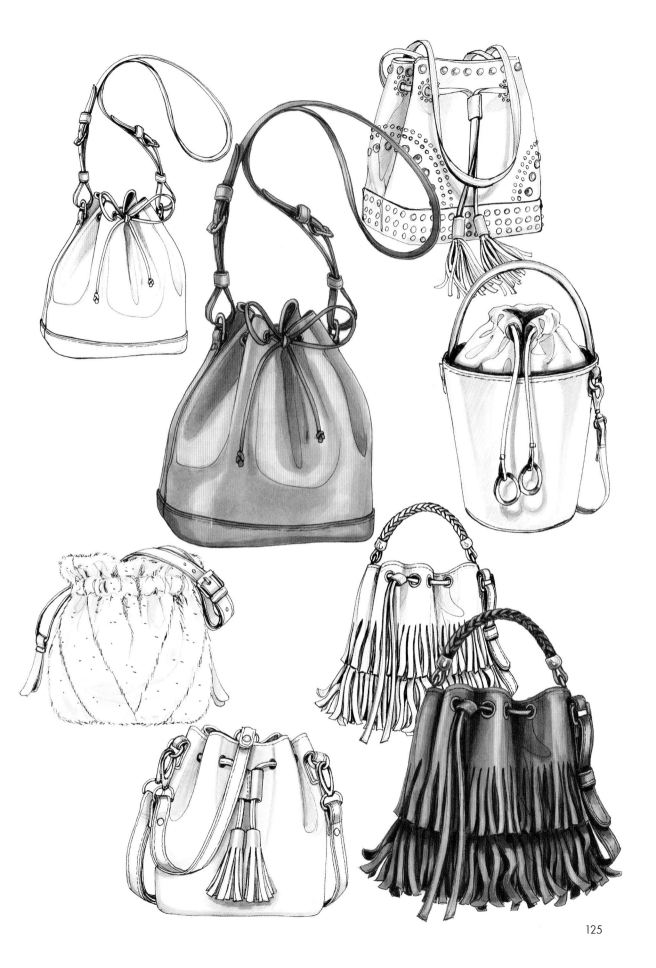

125

■ ショッパー

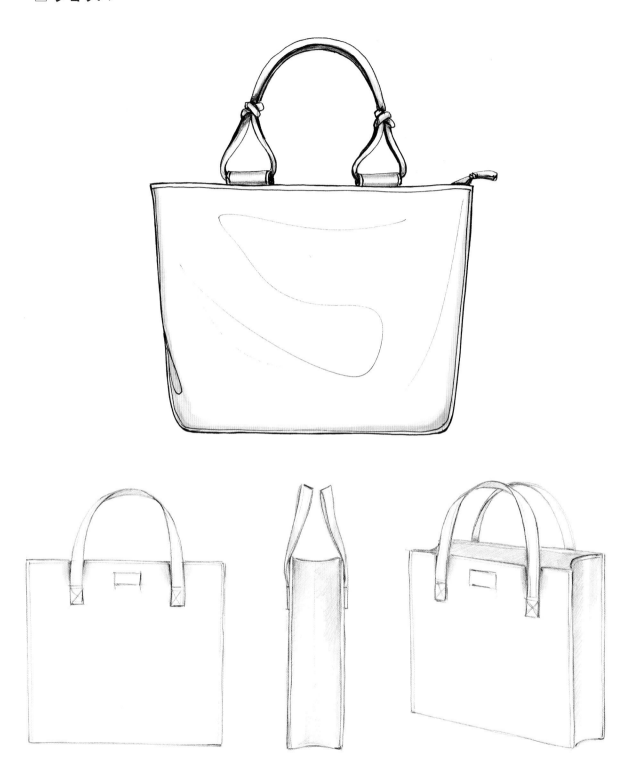

昔ながらのブティックのショッピングバッグが名前の由来です。ラフなキャンバス地で作られることが多く、海辺をはじめ、カジュアルな場面にぴったりです。実用的で持ちやすいことから、高級なものも含めてさまざまな素材で作られるようになりました。

有名なラグジュアリーブランドも、モノグラムやファブリック、上質なプリントレザーなどを用いて、都会の装いにもふさわしいおしゃれなショッパーを発表しています。

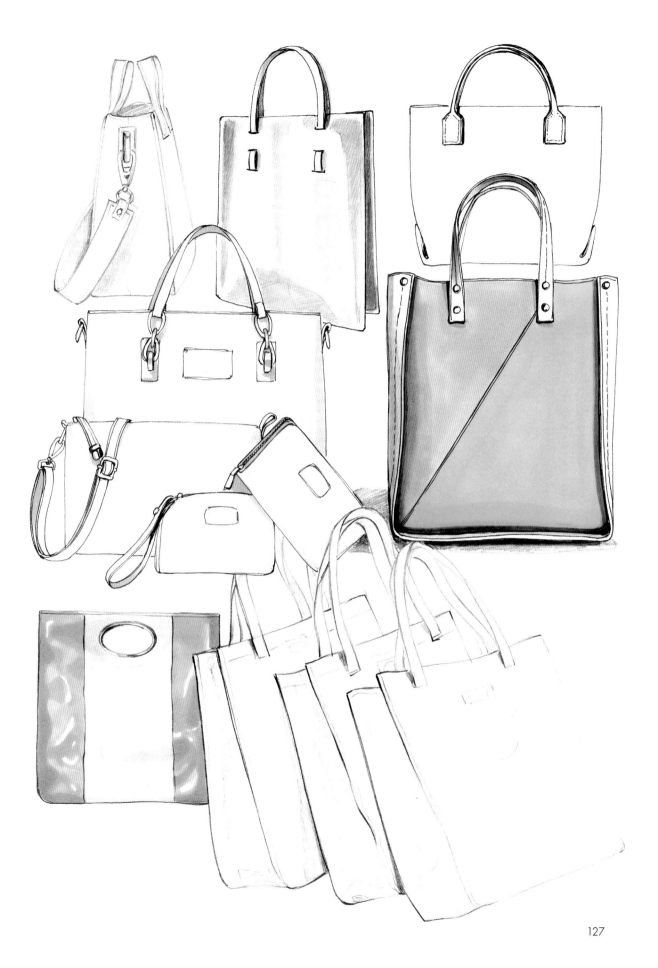

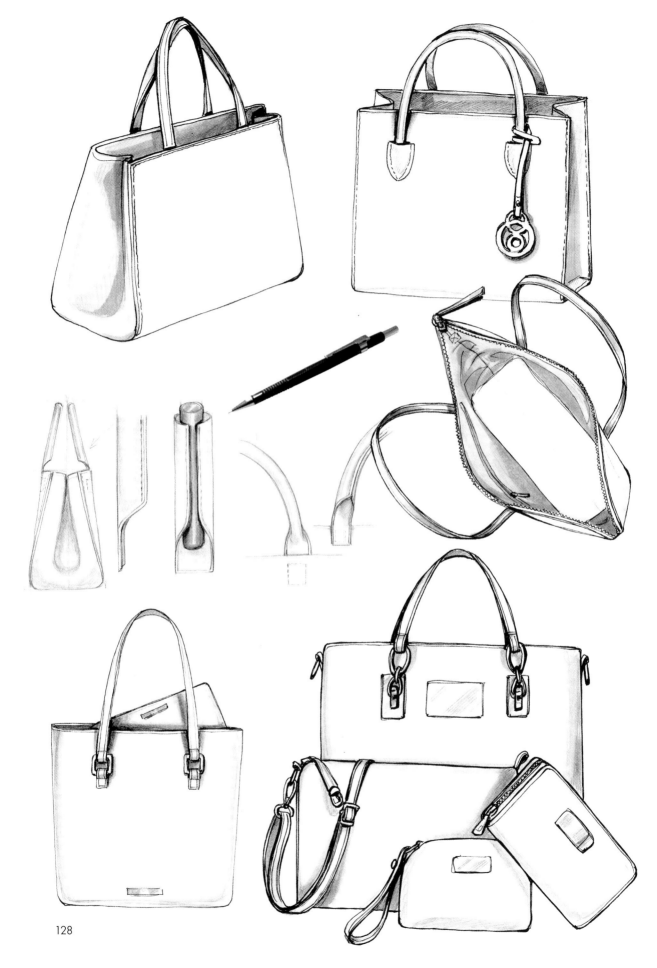

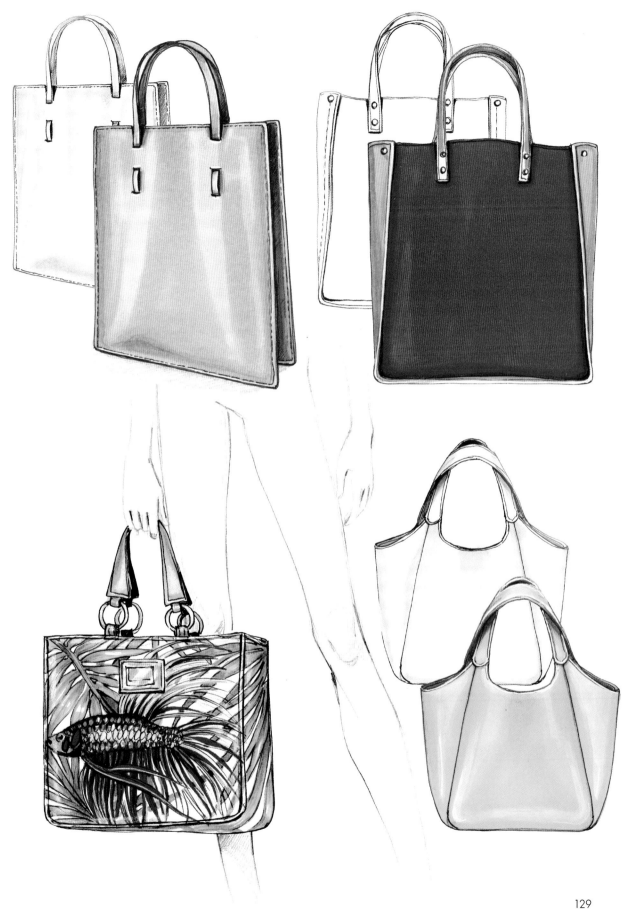

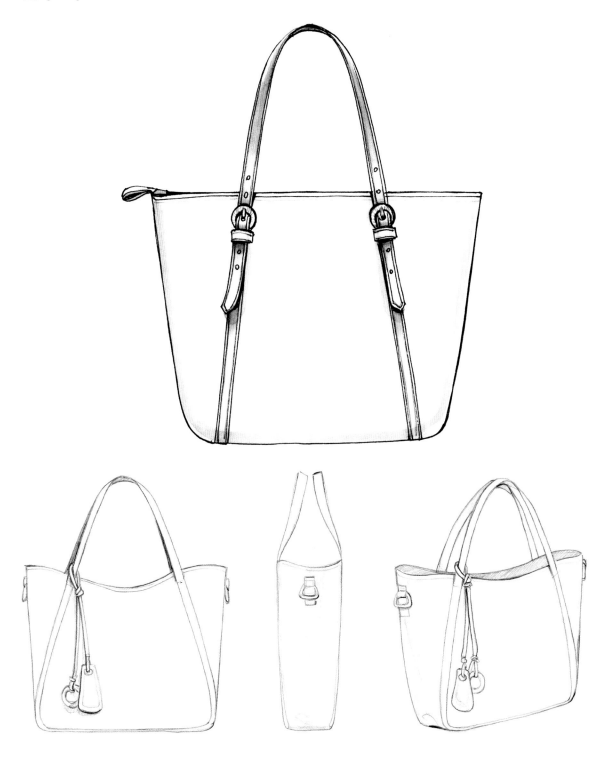

　ショッパーとよく似ているトートは、持ち手が2本ついた大型の
バッグです。台形や長方形で、開口部が広いため、荷物がたくさん
入ります。ノートパソコンやタブレットを収納できるので、ビジネ
スにも適しています。また、食料品の買い物や、子ども連れで両手
をあけておきたいときにも理想的です。

　素材としては布、革、ナイロン、キャンバスなどで作られ、2本の
長い持ち手がついているので肩にかけて持ち運べます。1940年
代初頭にはキャンバス地のトートバッグが作られ、当時の女性や
新聞配達少年たちに愛用されました。

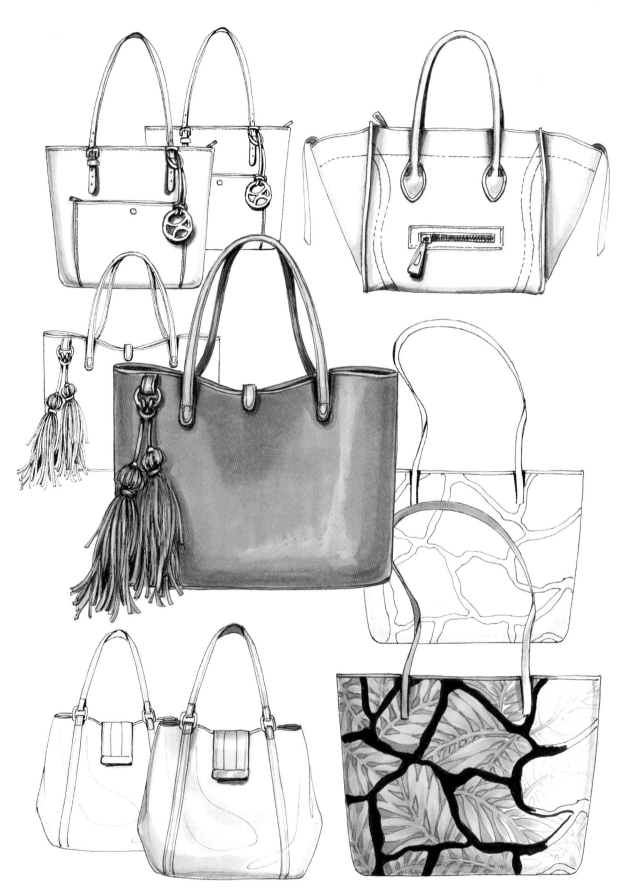

■ キルティング

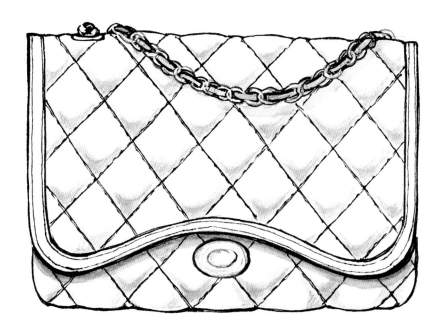

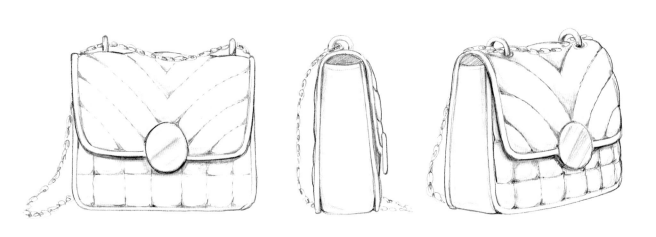

　キルティングバッグと聞いてすぐに思い浮かぶのが、シャネルの「2.55」です。発表された日付である1955年2月に由来してこの名があります。現在も販売されていて、時代を超えて愛され続ける定番です。かつて女性はクラッチバッグを手に持つ習慣がありま

したが、小さくて使いにくいのが難点でした。2.55のデザインは革命的で、現代女性にふさわしいスタイルと機能を両立させています。バッグにはチェーンがついていて、肩から提げて両手をあけられるようになっています。

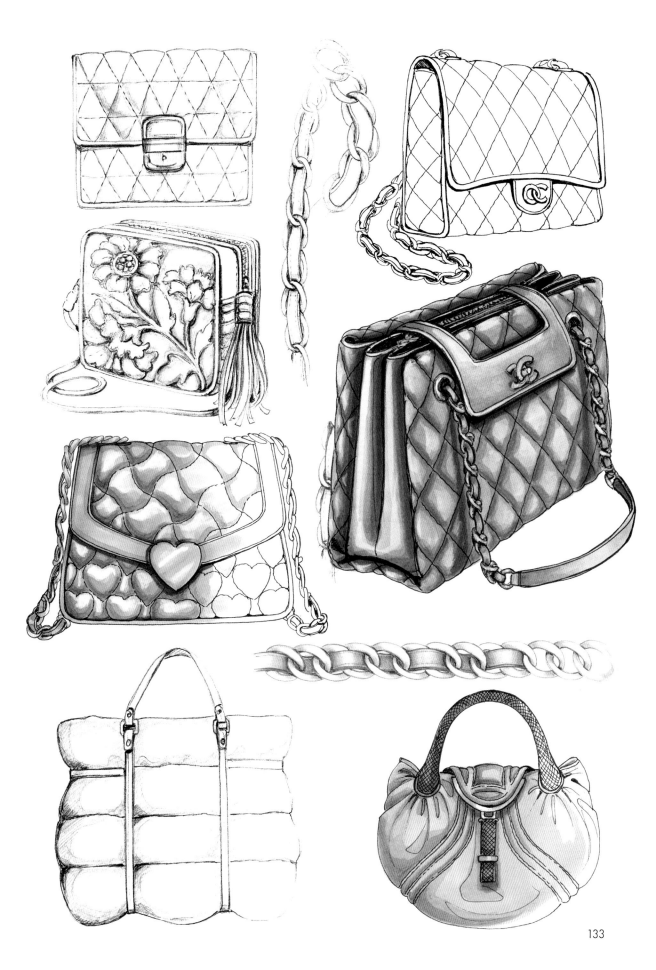

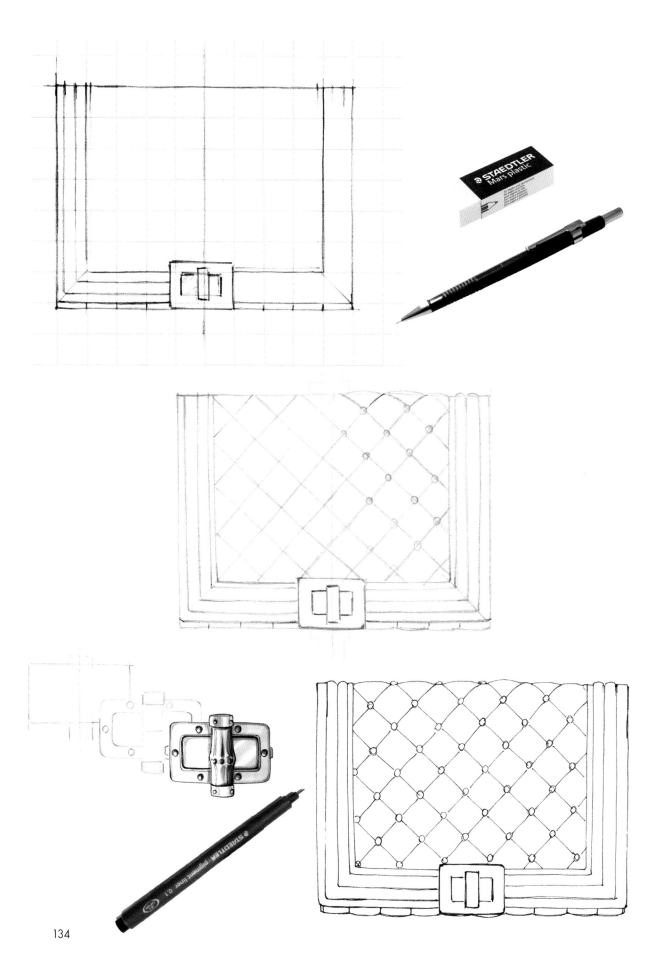

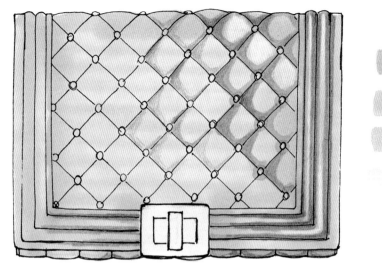

PANTONE Tria（パントン・トリア）
500

ProMarker（プロマーカー）
ローズピンク

COPIC（コピック）Y26

COPIC（コピック）Y21

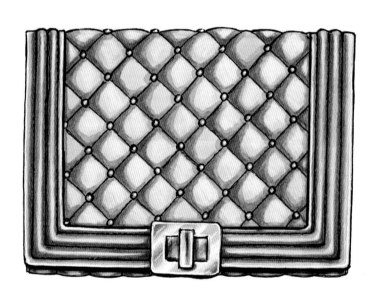

　大きな正方形の紙に、鉛筆でバッグの半分の位置を示す縦線を描き、これによって中央のクラスプ（留め具）の位置を決めます。バッグの端の位置が決まったら、鉛筆でひし形の模様を描いていきます。鉛筆で描いたデザインをフェルトペンで描き足していきます。

　ローズピンクのProMarker（プロマーカー）で全体に色をつけます。上の図の左側は、まだ陰影をつけていないので平面的な印象を受

けます。右側では、ひし形のキルティングに沿って陰影をつけているので、立体的な効果が得られます。

　さらに立体感を出すには、縫い目に沿って少しだけ暗い色（ここではPANTONE 500-T）を使います。ひし形の部分は、隣のひし形から落ちる影を濃く描き、それ以外は明るく描きます。

　輪郭部分は、細長いパッドの中央を明るくし、縫い目に向かって濃くなるように濃淡をつけます。

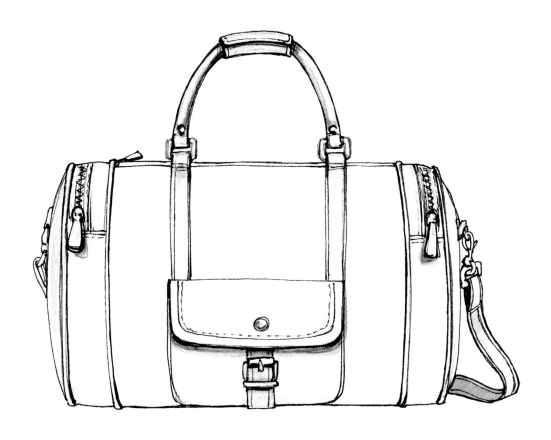

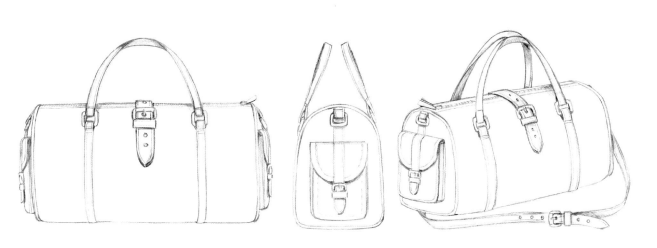

その名のとおり、週末の外出や1泊だけの旅行など、ちょっとしたレジャーにぴったりのバッグ。スポーツバッグのような素材とデザインが特徴で、バッグの両面を持ち手によって合わせたような形です。男性向け、女性向け、ユニセックスのものがあります。

細長い円筒形のバッグは中に物を入れるのも取り出すのも簡単。ファスナーが広く開くので、中の物や洋服が見つけやすいという利点があります。

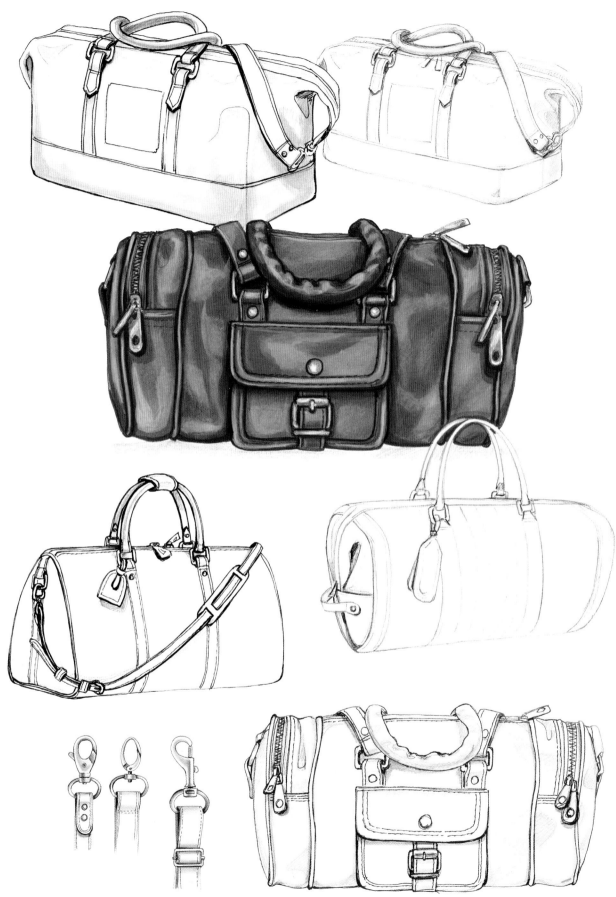

◼ バックパック

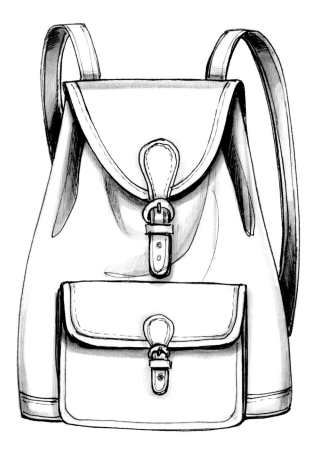

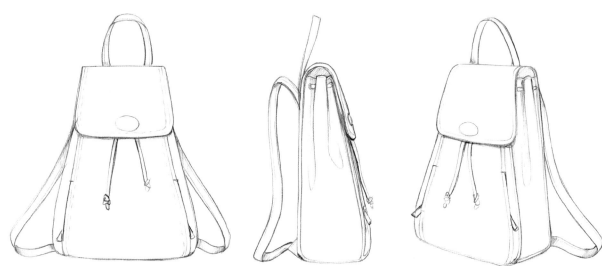

　アメリカのボーイスカウトなどで使われるリュックサックから生まれたのが、若々しく開放的な印象のバックパックです。実用性が高いことから若い世代に愛用者が多く、通学やレジャーに使われています。

　若者の間での人気を受けて、高級ファッションブランドは、洗練されたデザインと都会での日常生活での実用性を兼ね備えたエレガントなデザインを生み出しました。登山用のリュックとは全くかけ離れた高級感のある黒のキャンバスで作られたプラダのバックパックは、まれに見る人気を博しました。

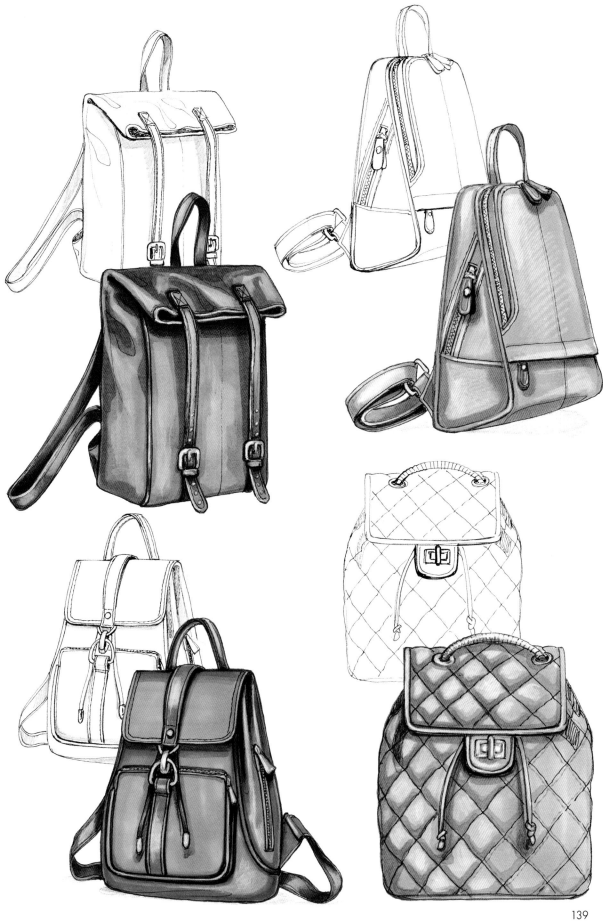

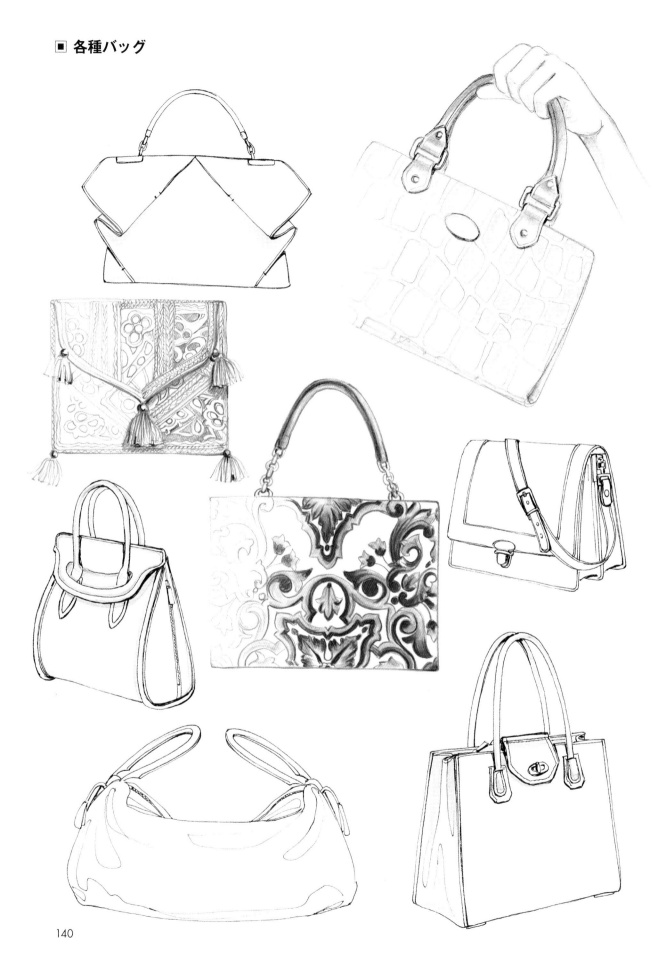

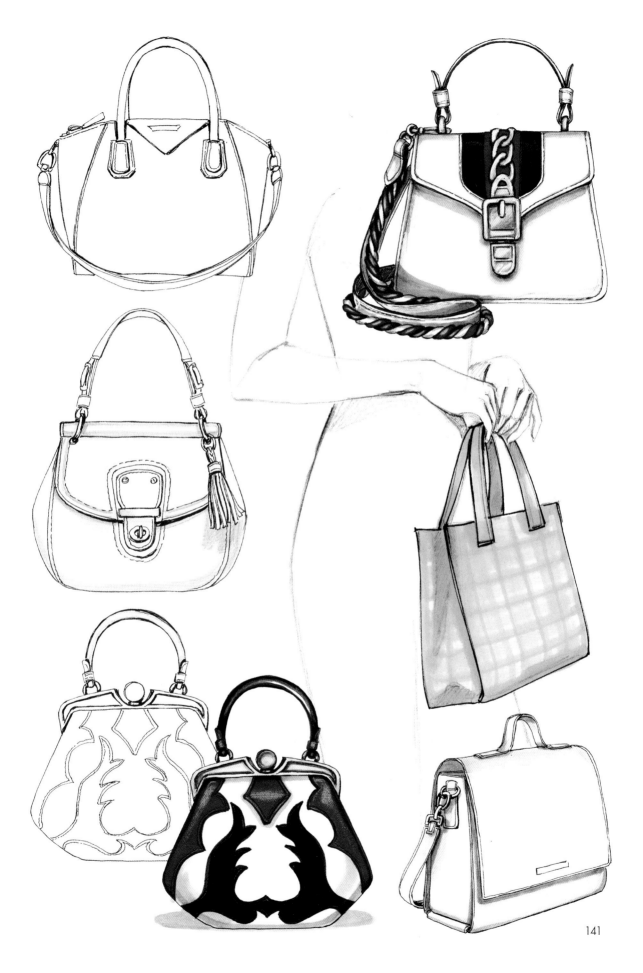

ベルト

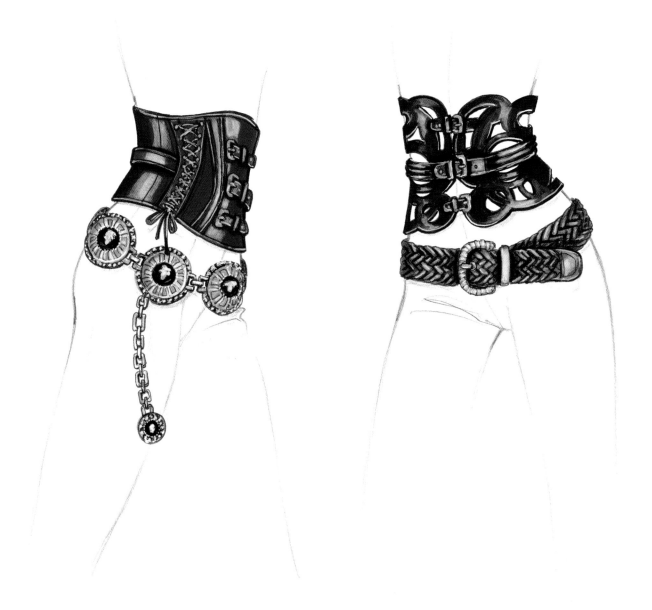

　男性の小物として生まれたベルトが、女性のファッションの世界に入ってきたのはルネッサンス期でした。女性たちがボディス（紐で締め付けるように着るベスト）やコルセットの代わりにゆったりとしたチュニックを身に着け、ウエストをベルトで締めるようになったことが背景にあります。

　現代のベルトは、バッグや靴と同じように、上質なレザーをはじめとする贅沢な素材や新素材、個性的なデザインによって魅力的なバリエーションが展開しています。ベルトが服以上に全身のコーディネートの決め手となることもあります。たとえばラインストーンやパールが施されたベルトは、シンプルでベーシックな黒のシースドレス（細身の直線的なドレス）を引き立てますし、繊細なレースのように切り抜いた模様のあるレザーベルトをジャージ素材のパ

ンツに合わせれば、スタイリッシュな着こなしが楽しめます。

　ベルトはバッグや靴とセットでデザインされることもありますが、違う組み合わせで身に着けることももちろん可能です。ベルトはズボンが下がるのを防ぐという基本的な機能を超えて、デザイン性を重視して選ばれるようになっています。ファッションの要請に応じて、また流行によって、ベルトはさまざまな形や幅で作られていますが、一番の装飾的な要素があるのはバックルで、とりわけバラエティに富んでいます。

　細いレザーを手作業で三つ編みにしたベルトから、シルクのプリントにファーをあしらったベルト、厚手のレザーにスタッズ（飾り鋲）をあしらったベルト、さらにはスワロフスキーのラインストーンを散りばめたジュエリーベルトまで、デザインは無限に広がります。

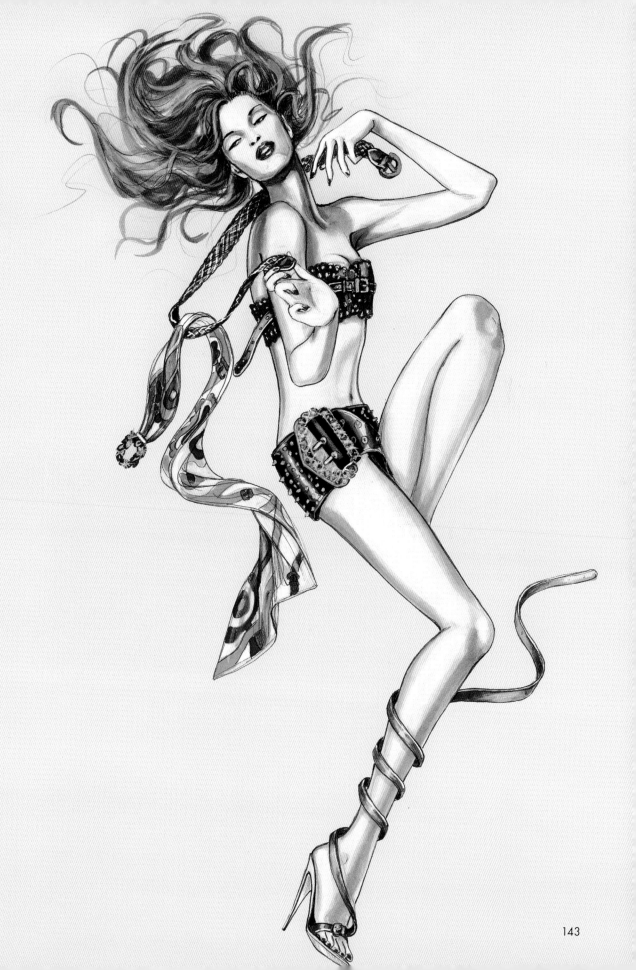

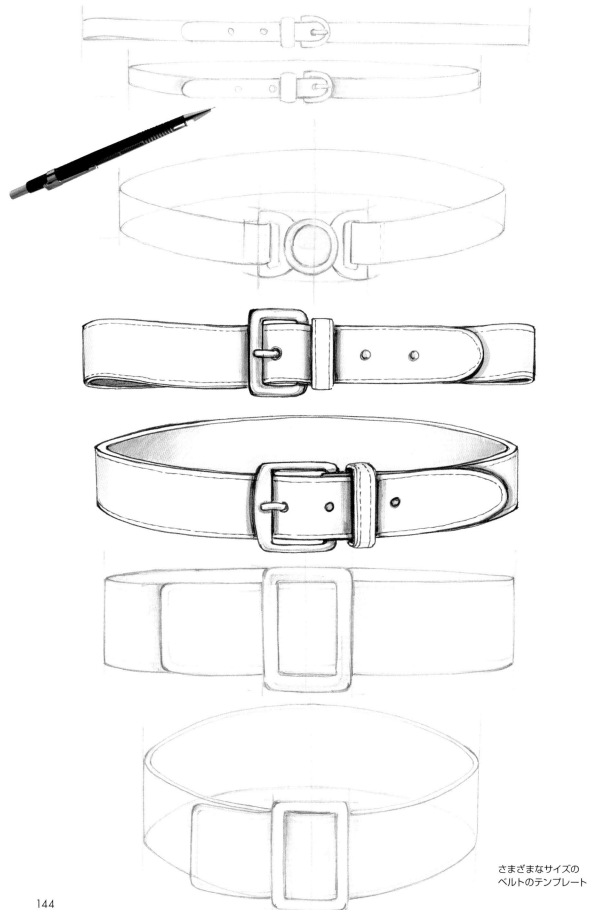

さまざまなサイズの
ベルトのテンプレート

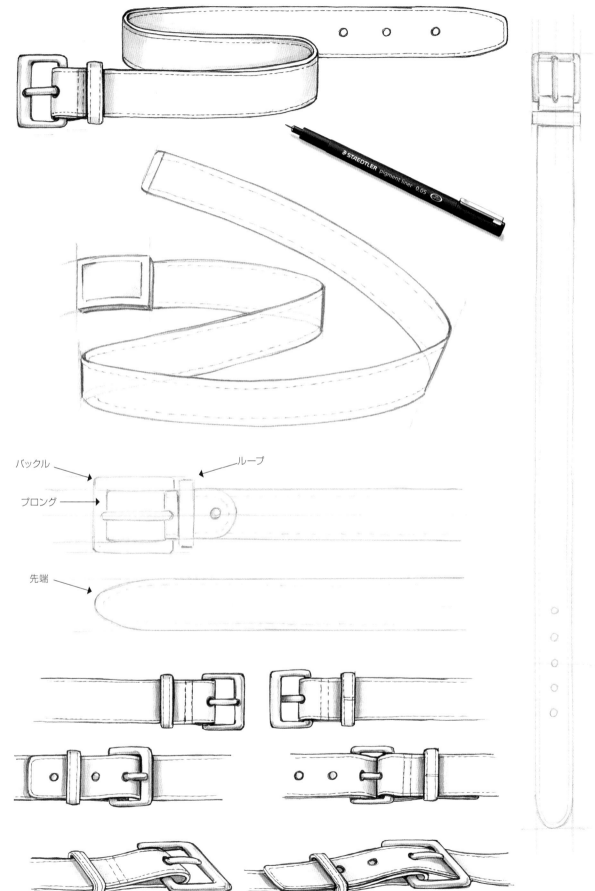

バックル

ループ

プロング

先端

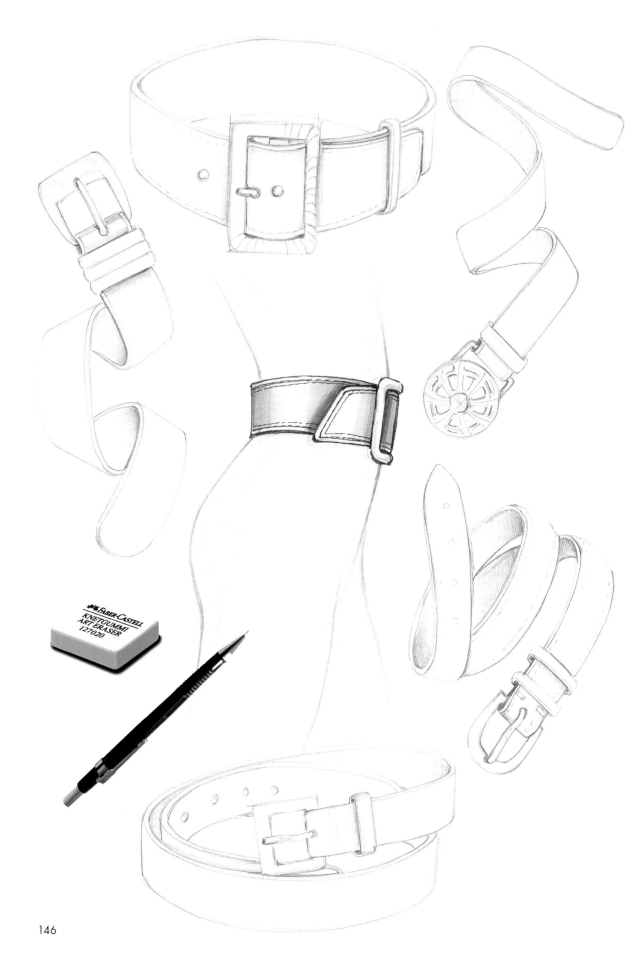

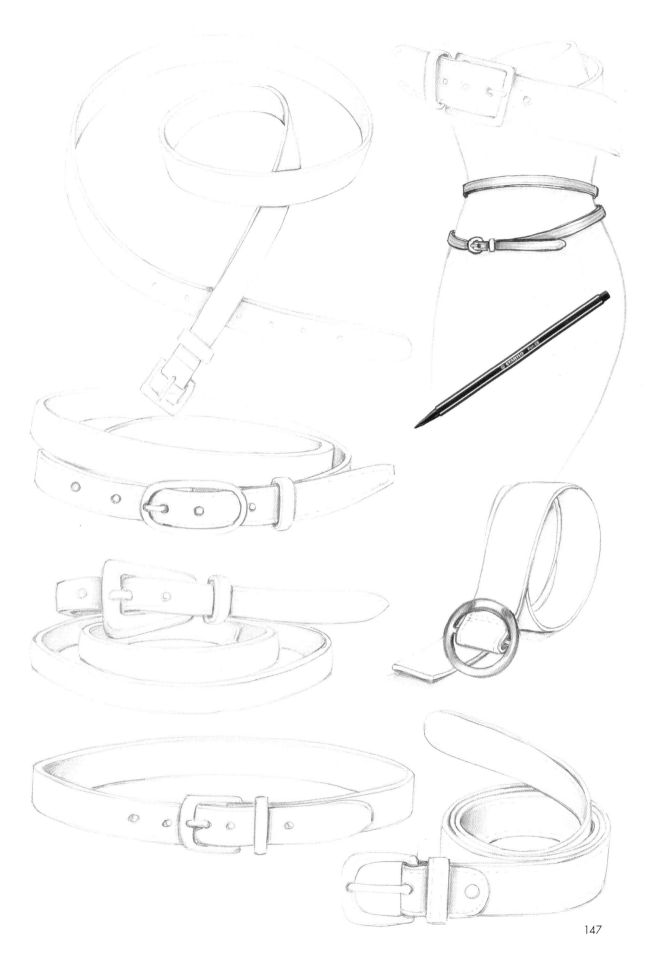

■ スタッズ付きベルト

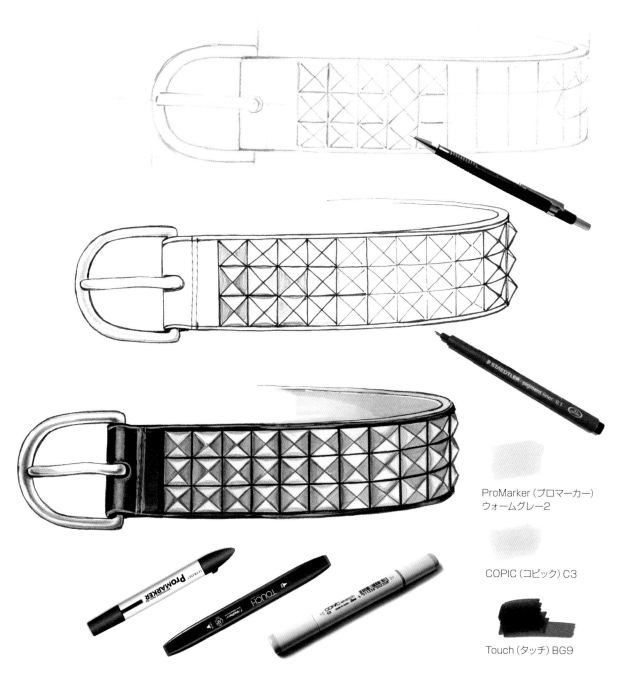

ProMarker (プロマーカー)
ウォームグレー2

COPIC (コピック) C3

Touch (タッチ) BG9

　大胆なスタッズ（飾り鋲）付きの革のベルトには、辛口でセクシーな雰囲気があります。シルバーカラーの尖ったスタッズが全体を埋め尽くすデザインは、1980年代の英国パンクファッションを彷彿とさせます。

　当初はもっぱらパンクやロックのミュージシャンが愛用していましたが、やがて都会の若いバイカーたちに広まり、今では一般の人にも日常的なアイテムとなりました。今日のデザイナーたちは、金属色だけではなく多色づかいの素材を合わせて使うなど、想像力に富んだスタイルのスタッズ付きベルトを発表してい

ます。ピンストライプのジャケットの下に合わせれば、ビジネスの場面でもドレスコードを守りつつ個性的なアクセントを加えることができます。

　上の図は、規則正しく並ぶピラミッド型のスタッズを鉛筆で描いたスケッチです。フェルトペンでディテールを加え、鉛筆で陰影をつけ、横向きの三角形の部分を暗くすることによって、上下の三角形に明るさを出します。その後、PANTONE（パントン）を使ってベルトの革を濃いグレー、バックルを薄いグレーで塗ります。

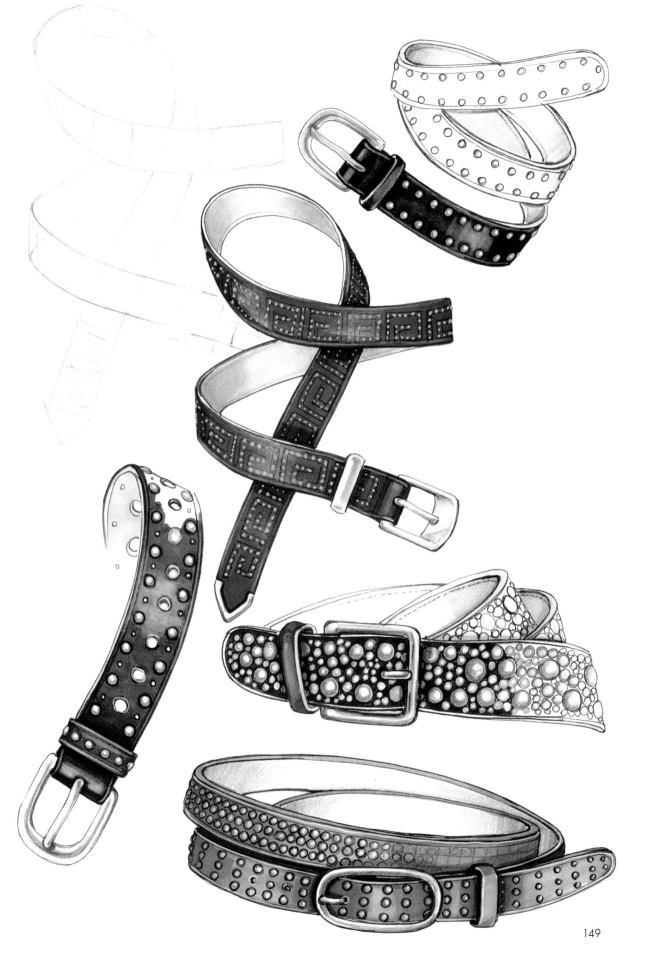

149

■ ビスチェ

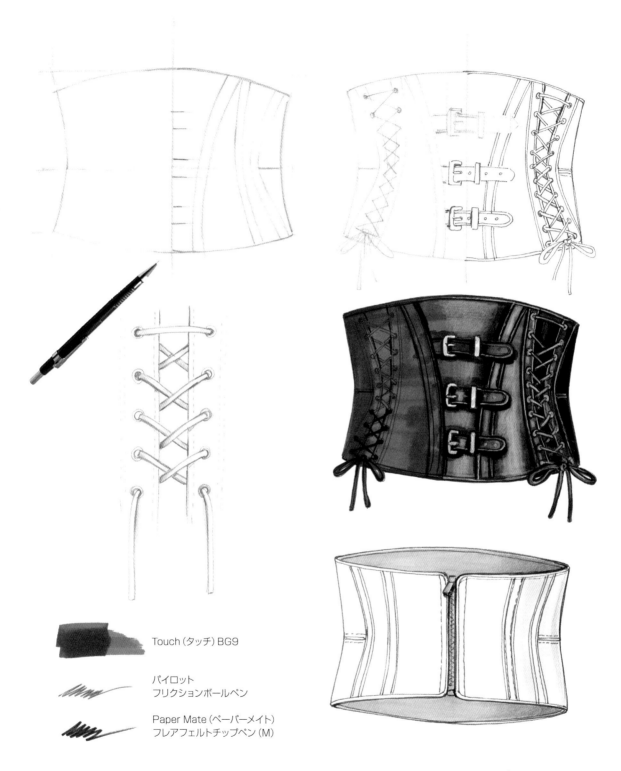

Touch（タッチ）BG9

パイロット
フリクションボールペン

Paper Mate（ペーパーメイト）
フレアフェルトチップペン（M）

　幅の広いハイウエストのベルトの一種に分類できるビスチェ
は、シンプルなイブニングドレスやジャケットなど服に合わせる
と、セクシーで大胆な効果を出せます。過去の女性が愛用してい
たコルセットが、現代女性にふさわしい新しいファッション小物

として生まれ変わりました。服が体からずれないようにウエスト
を締めるというベルトの基本的な機能は失われ、流行を生かし
たデザインと革新的な素材で、純粋に装飾的なアイテムとなっ
ています。

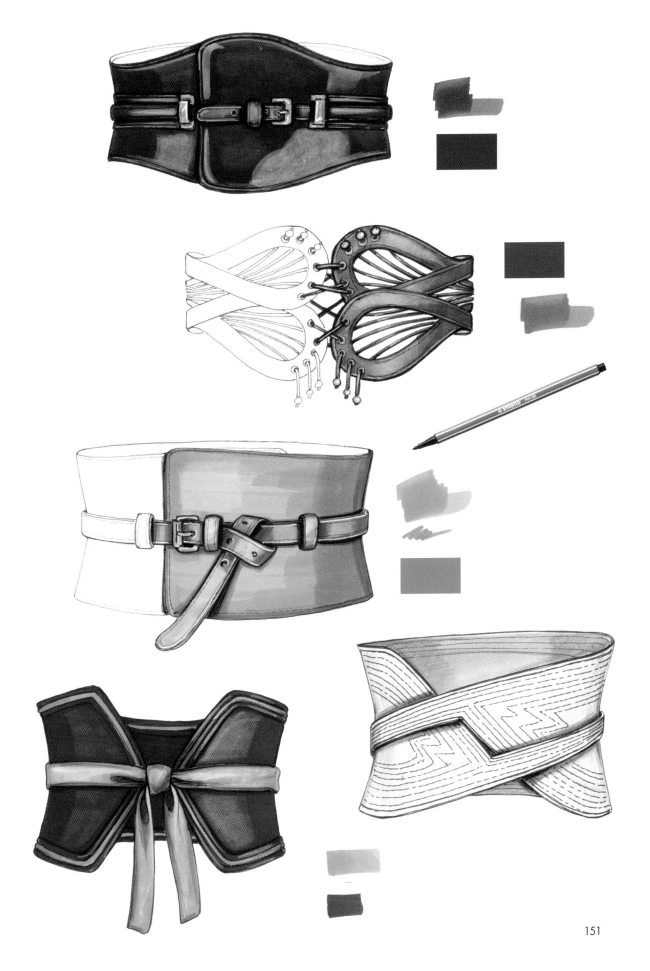

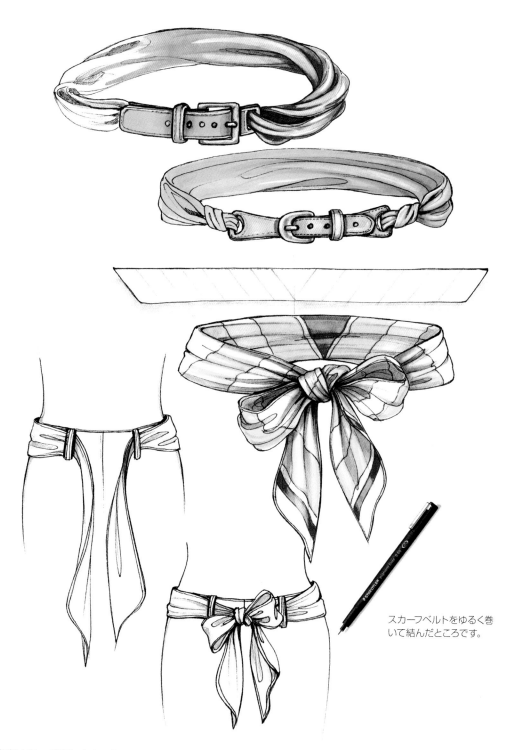

スカーフベルトをゆるく巻
いて結んだところです。

新鮮な装いが楽しめるスカーフベルトは遊び心のある小物
で、デザインも素材も通常のベルトとは異なります。シルクツイ
ルやビスコースの布で作られ、若々しさの中にもシックな個性
が演出できます。

季節に合わせた装いが楽しめるよう、さまざまなデザインが
あります。レザーを編み込んだバックルのスカーフベルトは夏に
ぴったりですし、ファーをあしらったデザインは温かみがあり冬
のファッションにぴったり。帯状のプリントでできたシンプルな
スカーフベルトは、爽やかな印象で、ジーンズとも抜群の相性で
す。スカーフベルトは、いつまでも色あせることのないファッショ
ン小物です。

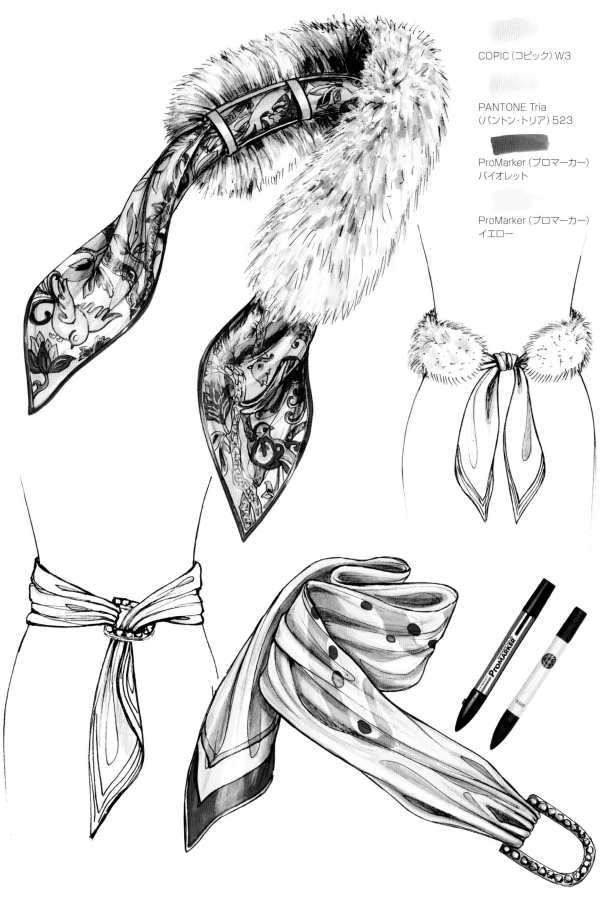

COPIC（コピック）W3

PANTONE Tria
（パントン・トリア）523

ProMarker（プロマーカー）
バイオレット

ProMarker（プロマーカー）
イエロー

153

■ ジュエリー付きベルト

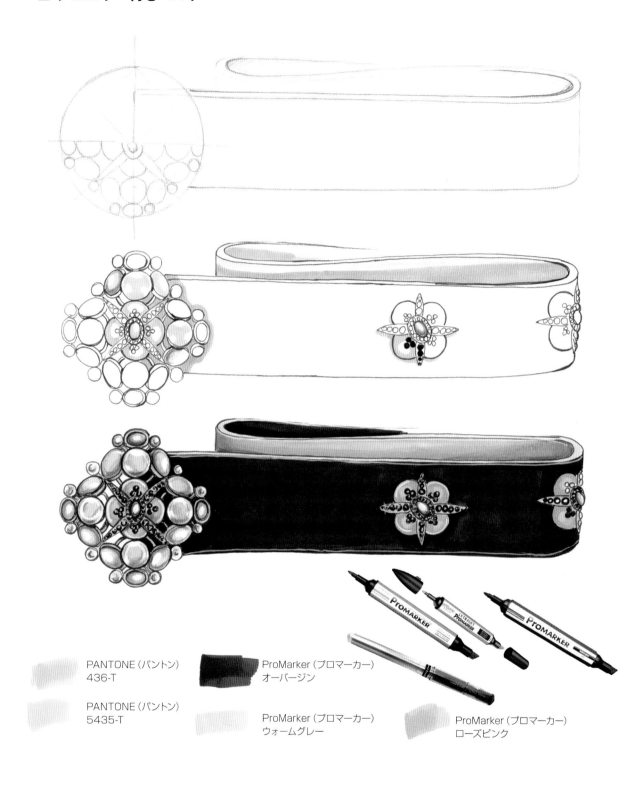

PANTONE（パントン）
436-T

PANTONE（パントン）
5435-T

ProMarker（プロマーカー）
オーバージン

ProMarker（プロマーカー）
ウォームグレー

ProMarker（プロマーカー）
ローズピンク

クリスタルや半貴石など、豪華に輝くジュエリーを散りばめた
ベルトです。ジュエリーはさまざまな色の花柄や幾何学模様など
のパターンになるようにあしらわれます。ミニスカートやレギン
スに合わせれば、クラブやパーティーなど夜のお出かけにふさわ
しい華やかで個性的なコーディネートになります。

ジュエリー付きのベルトは近年、インドなど東洋の民族衣装
からもインスピレーションを得て、デザインの幅も広がりまし
た。安定した人気を誇っています。

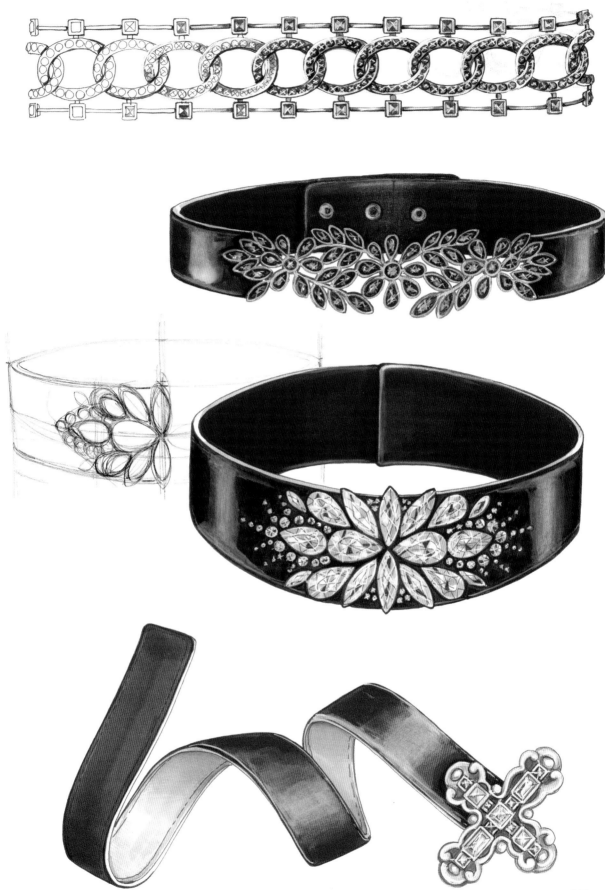

155

■ メッシュベルト

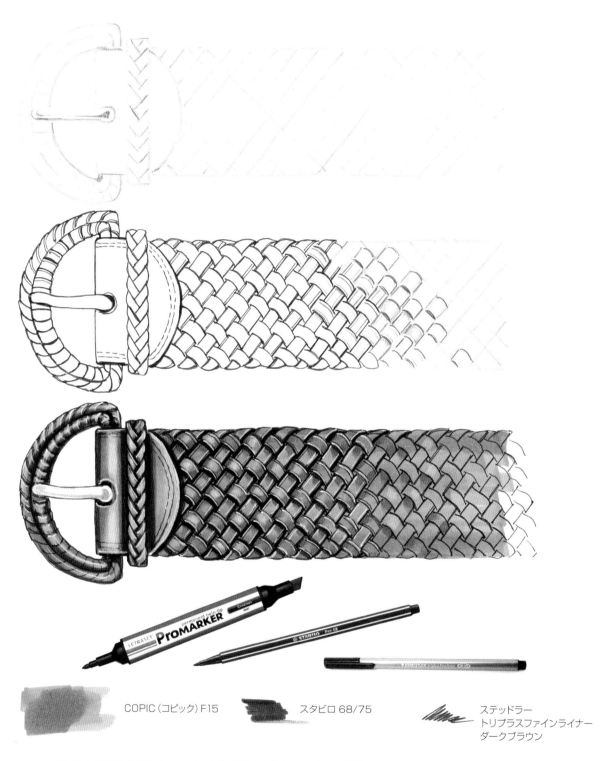

COPIC（コピック）F15　　　スタビロ 68/75　　　ステッドラー
　　　　　　　　　　　　　　　　　　　　　　　　　トリプラスファインライナー
　　　　　　　　　　　　　　　　　　　　　　　　　ダークブラウン

　メンズベルトの定番であるメッシュベルトは、夏らしく爽やか
な雰囲気です。ビスコース（合成繊維でレーヨンの一種）やコッ
トンで作られたドレスのウエストを締めるのにぴったりで、女性
にも愛用されています。

　革だけではなくグログラン（密に織った生地）などの素材も使

われ、鎖状につないだり、リボンのように編んだりして数多くの
デザインのメッシュベルトが作られています。

　熟練した技術を持つ職人が手作業で素材を加工し、古くから
伝わる伝統的なデザインを踏まえつつ、現代にふさわしいメッシュ
ベルトを生み出します。

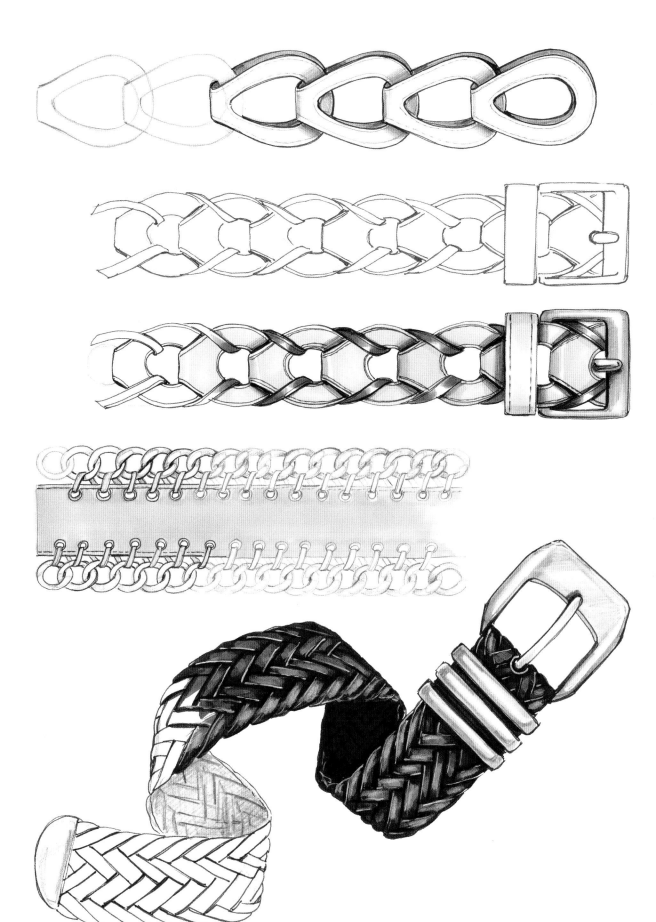

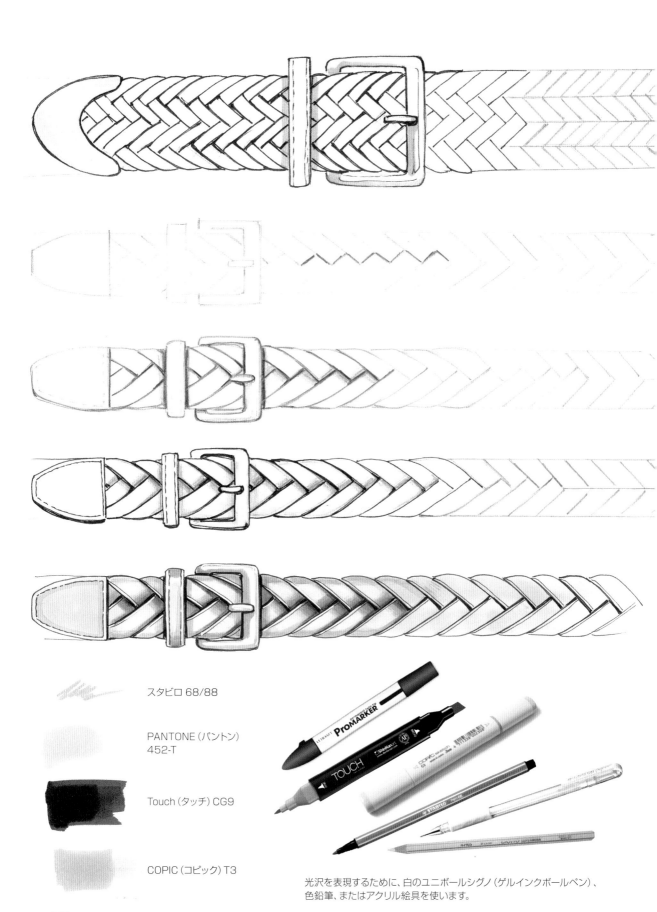

スタビロ 68/88

PANTONE (パントン)
452-T

Touch (タッチ) CG9

COPIC (コピック) T3

光沢を表現するために、白のユニボールシグノ (ゲルインクボールペン)、
色鉛筆、またはアクリル絵具を使います。

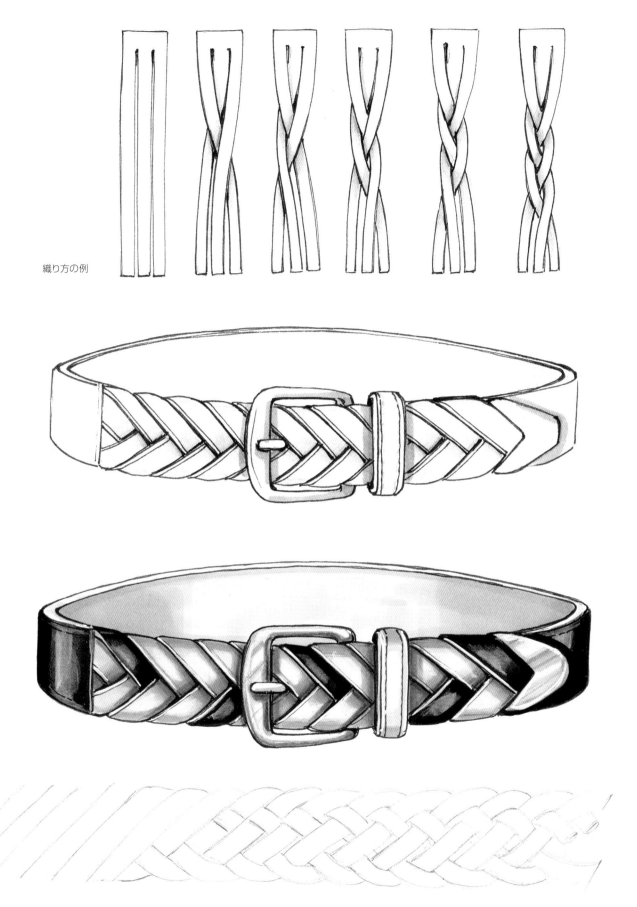

織り方の例

159

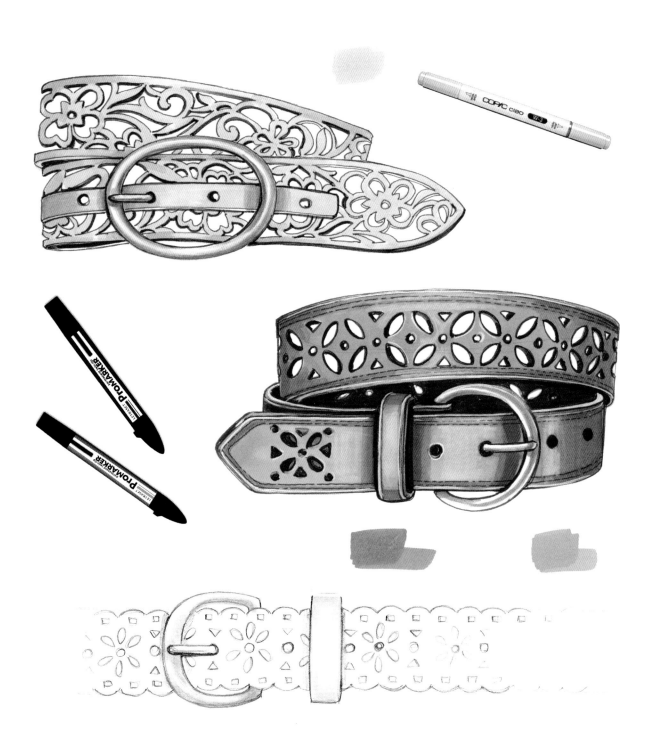

さまざまな模様にレザーを切り抜いて作るカットアウトベルトは、夏の装いにとりわけ似合う小物で、個性的なデザインがたくさん見つかります。伝統的な民族衣装のベルトが原型ですが、現代的な幾何学パターンでも作られています。革を切り抜く工程は、金属製のアウル（革細工用のキリ）や小型の型抜き道具、ハンマーなどを使って手作業で行うか、大量生産の場合はもっとシンプルな工業用金具で行います。丈夫な硬い革が、フランス風レースや19世紀のかぎ針編みのように軽やかでロマンチックな小物に変身します。この手法はベルトだけでなく、セットでデザインされるバッグや靴にも広く使われます。

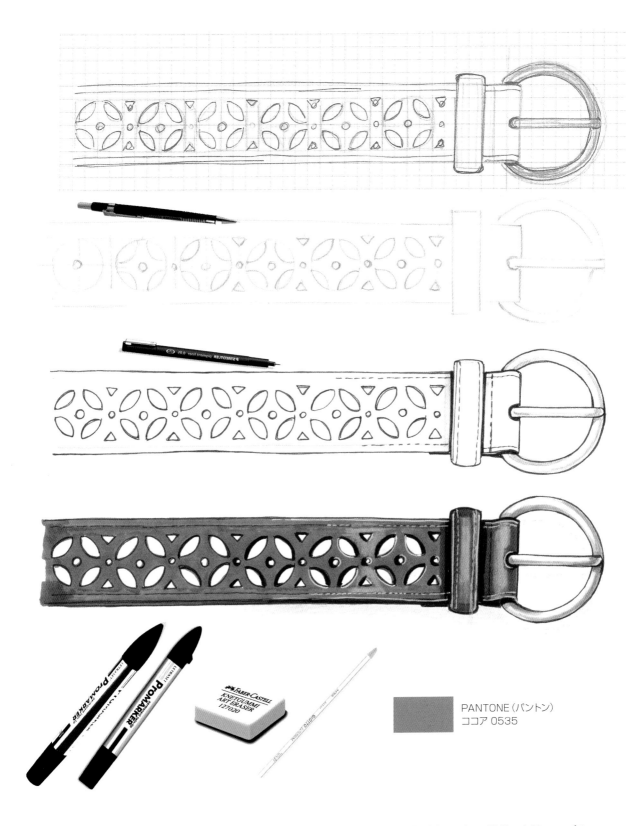

PANTONE（パントン）
ココア 0535

方眼紙を用意します。直線が描きやすいうえに、正確な比率で透かし模様が描けるという利点があります。

まず、鉛筆を使ってベルトの輪郭やディテールを下描きしてから、黒のマーカーで描きます。さらにココアなどブラウン系のPANTONE（パントン）で色を塗ります。次に、ダークブラウンのスタビロを使って、革の側面と透かし模様の内側、ループの下に陰影を出します。白の色鉛筆で革の丸みと透かし模様の縁を強調します。バックルは、ライトグレーで金属の外周と内周に陰影を出し、色鉛筆やアクリル絵具で光沢を加えます。

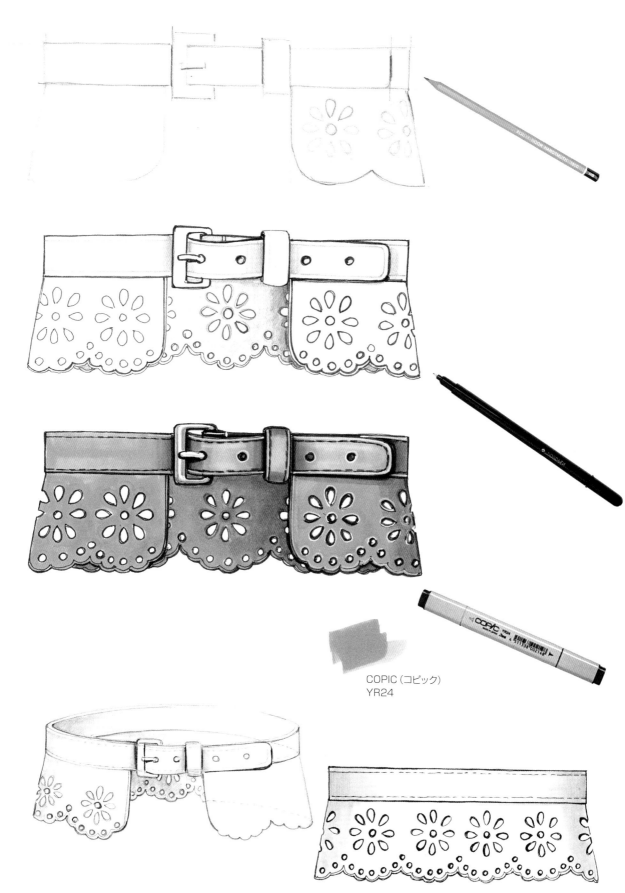

COPIC (コピック)
YR24

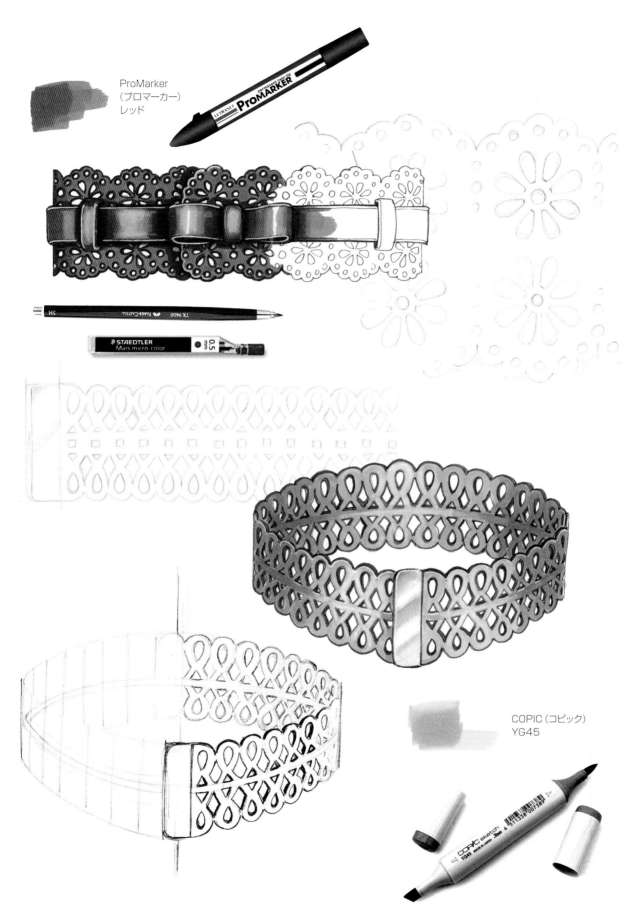

ProMarker
（プロマーカー）
レッド

COPIC（コピック）
YG45

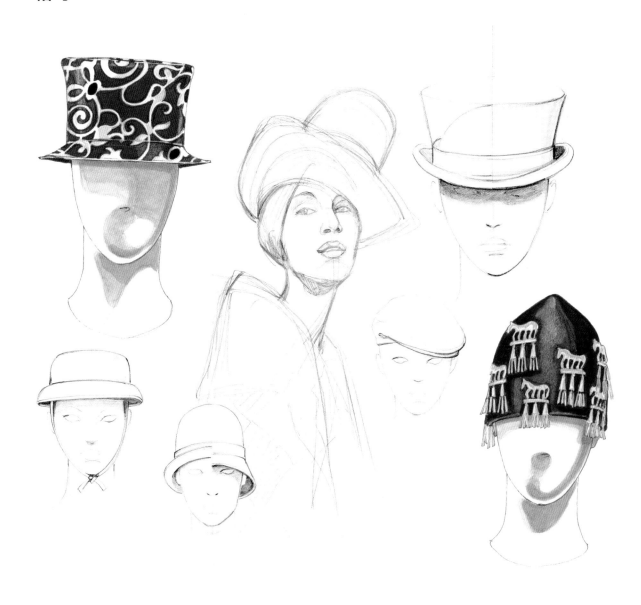

4章

帽子

ファッションには数々のトレンドがありますが、中でも奇想天外なアイデアが生かされる小物といえば帽子です。

英国の王族をはじめ中・上流階級の女性たちは、フォーマルなイベントで個性的なアートのような帽子を披露しあいます。帽子は伝統的に、冬の防寒小物という機能を遥かに超えた優雅なステータスシンボルであり、ファッションの楽しさを存分に味わわせてくれるアクセサリーなのです。

かつて、帽子は女性のおしゃれに欠かせない小物でした。髪を保護して清潔に保ち、あるいは見られないように隠す目的で考案されたことから、女性らしい魅力の象徴でもあります。

伝統的な帽子職人は、細かく織られたラフィア（椰子の葉）や、オンドリやハゲコウ（コウノトリ科の鳥）の羽根など昔ながらの素材を使いつつ、斬新で未来的なデザインの作品を作ります。華やかで遊び心のある帽子は常に私たちを魅了し、エレガントな場面には欠かせないアイテムです。毎年初夏に英国王室が主催する競馬大会「ロイヤルアスコット」で女性たちのファッションの決め手となる帽子は特に有名で、世界中の注目を集めます。

これに対して、ストリートやスポーツにふさわしい帽子は、華やかさよりも手頃な価格と実用性が求められます。カラフルなベースボールキャップや、寒い冬の日の外出にふさわしいファーで縁取ったウールの帽子、レザーのキャップ、ストローハット（麦わら帽子）、プリントされたコットンの布帽子など、バリエーションは無限です。デザイナーや帽子作家が生み出す夢と創造性に満ちたデザインが、チームワークによって形になっていきます。

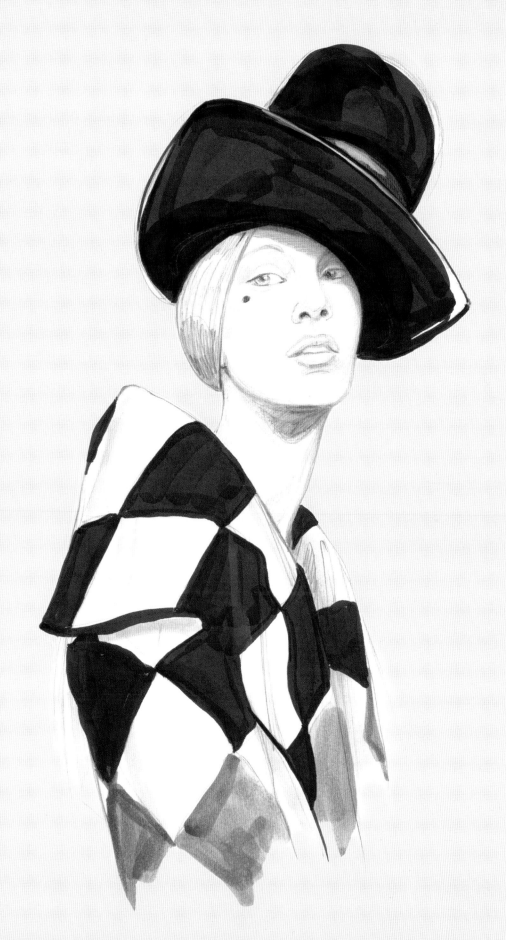

マネキンヘッドの輪郭。正面、背面、横顔、3/4の角度から見た図のテンプレートとして使えます。

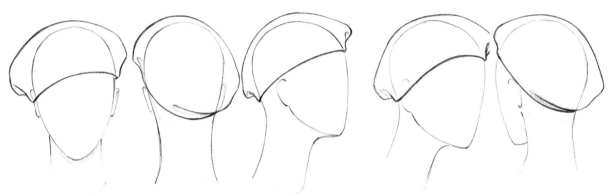

マネキンヘッドにかぶらせたベレー帽の輪郭を、
上図と同じ角度から見た図です。

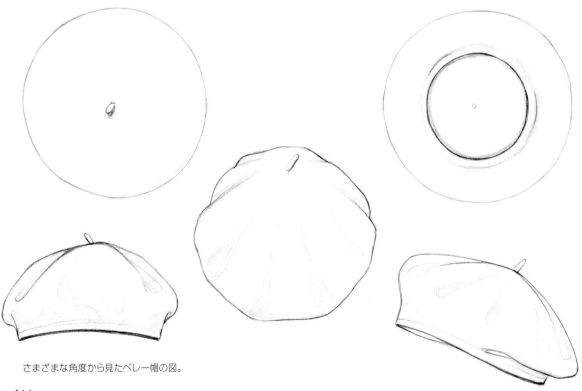

さまざまな角度から見たベレー帽の図。

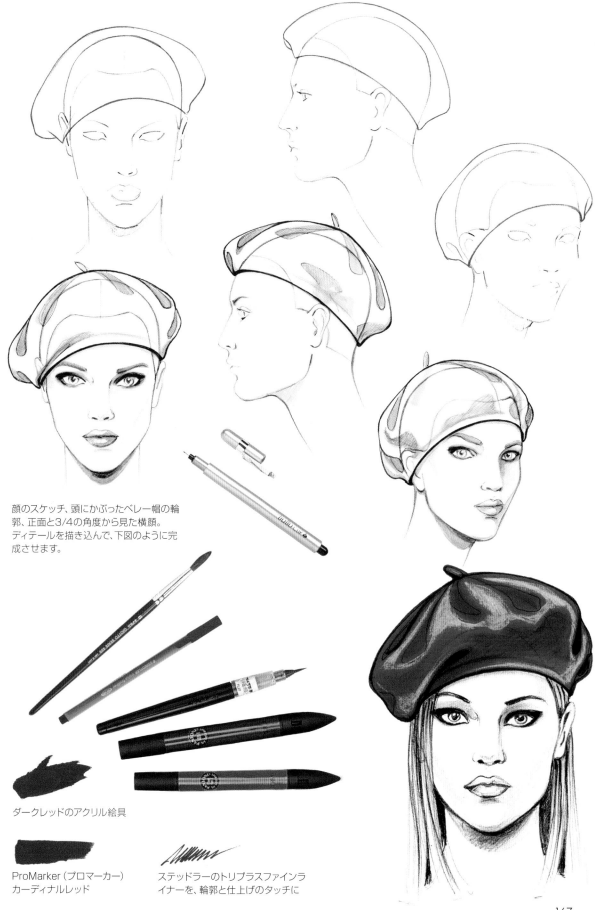

顔のスケッチ、頭にかぶったベレー帽の輪
郭、正面と3/4の角度から見た横顔。
ディテールを描き込んで、下図のように完
成させます。

ダークレッドのアクリル絵具

ProMarker（プロマーカー）
カーディナルレッド

ステッドラーのトリプラスファインラ
イナーを、輪郭と仕上げのタッチに

■ カジュアルな帽子

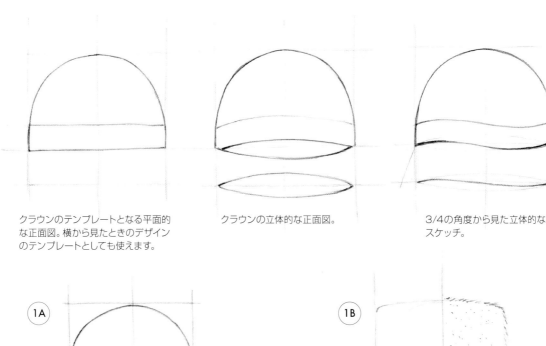

クラウンのテンプレートとなる平面的な正面図。横から見たときのデザインのテンプレートとしても使えます。

クラウンの立体的な正面図。

3/4の角度から見た立体的なスケッチ。

1A

基本となる平面図を書くには、長方形を半分にして、その内側にクラウンの丸みを描きます。

1B

クラウンを目安に帽子の形を作っていきます。左はテンプレートとなる輪郭。右は同じ形にファーの質感を加えたものです。

2A

1Aと同じデザインを、今度は立体的に描いています。正面から見て横方向にやや上向きにカーブした線を描き、背面では下向きにカーブした線を繰り返します。ファーが少し盛り上がっているように見えて、絵に奥行きと丸みが出ます。

2B

1Bと同じデザインを立体的に表現した図。

　帽子のデザインには、機能性に加えて、デザイナーのセンスと洗練された素材が求められます。正装用のエレガントな帽子は、流行も反映しつつデザイナーが考えたアイデアを、伝統的な職人が手作業で形にしていきます。

　ふだん使いの帽子にも、防寒や、夏の日差しを防ぐなどの機能性だけでなく、シンプルな着こなしをおしゃれに見せたり、スポーツウェアを個性的に見せたりする効果があります。

　軽量のナイロンのプリントの帽子や、名門ブランドのモノグラムをあしらった帽子は非常に人気があります。また、スタッズ（飾り鋲）、刺繍、半貴石などを飾ったレザーやコットンのベースボールキャップは、若者のファッションに欠かせません。どんな形にも加工しやすいストロー（藁）やフェルトなどを素材に使った帽子は快適で、流行に左右されない魅力があります。

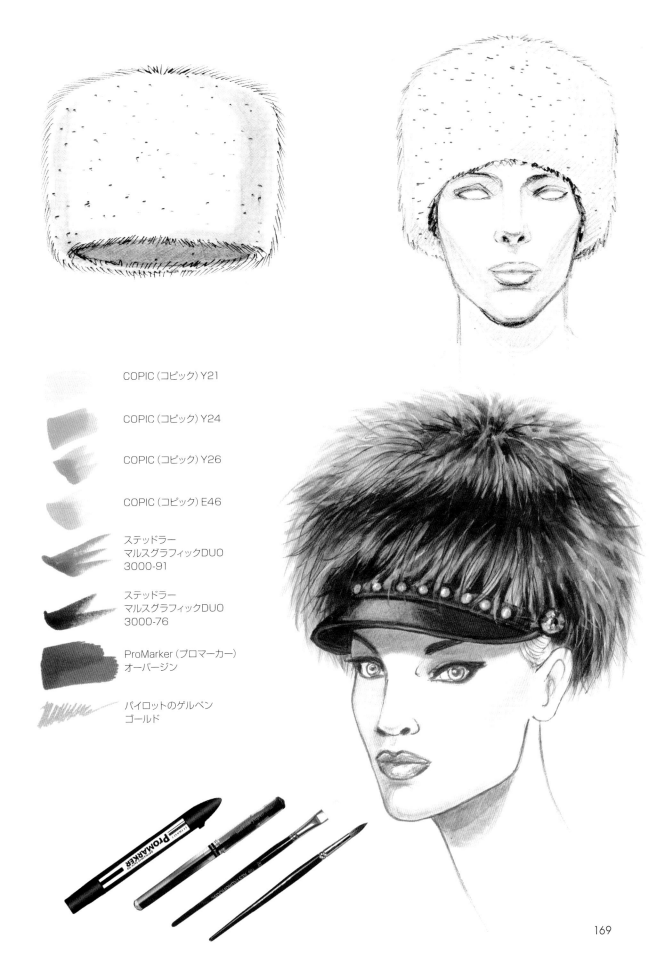

COPIC（コピック）Y21

COPIC（コピック）Y24

COPIC（コピック）Y26

COPIC（コピック）E46

ステッドラー
マルスグラフィックDUO
3000-91

ステッドラー
マルスグラフィックDUO
3000-76

ProMarker（プロマーカー）
オーバージン

パイロットのゲルペン
ゴールド

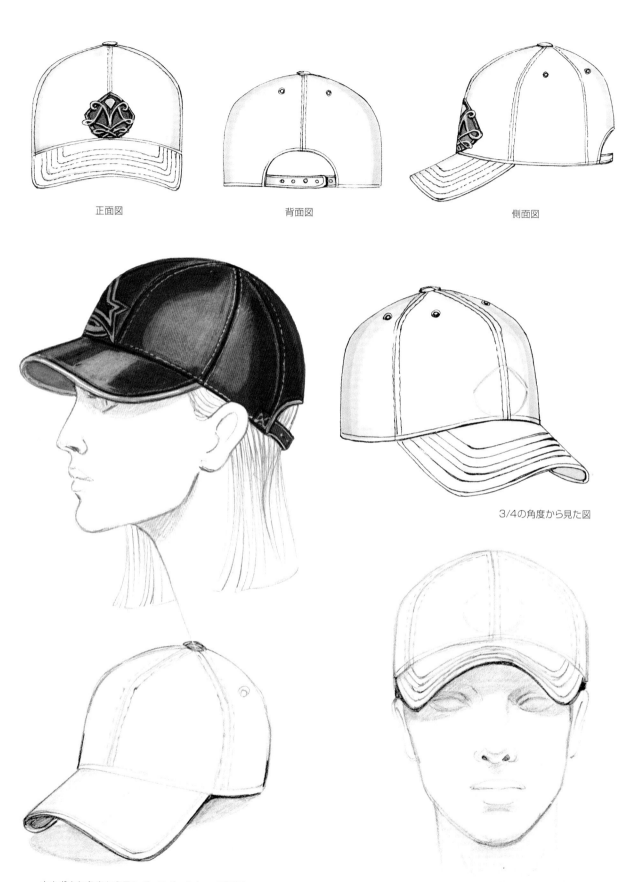

正面図 　　　　　　　　背面図 　　　　　　　　側面図

3/4の角度から見た図

さまざまな角度から見たベースボールキャップの図。

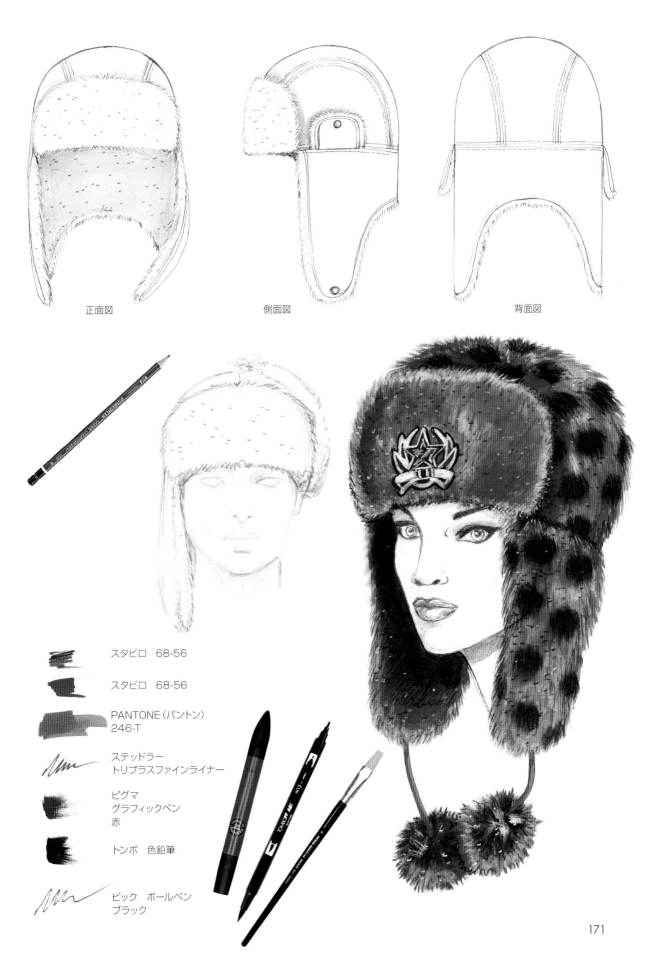

正面図　　　　　　　　　側面図　　　　　　　　　背面図

スタビロ　68-56

スタビロ　68-56

PANTONE (パントン)
246-T

ステッドラー
トリプラスファインライナー

ピグマ
グラフィックペン
赤

トンボ　色鉛筆

ビック　ボールペン
ブラック

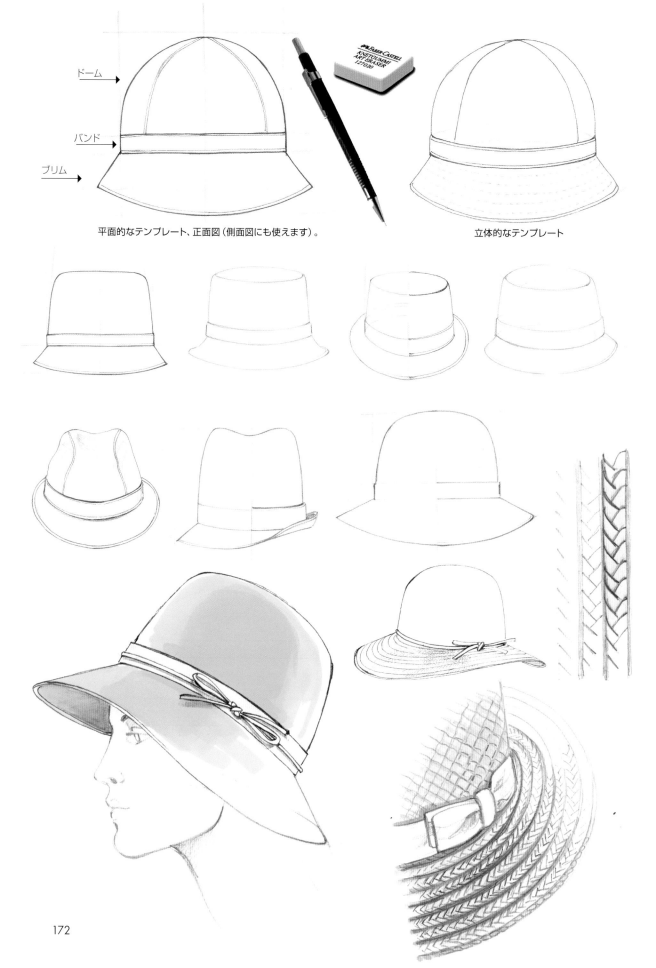

ドーム

バンド

ブリム

平面的なテンプレート、正面図（側面図にも使えます）。

立体的なテンプレート

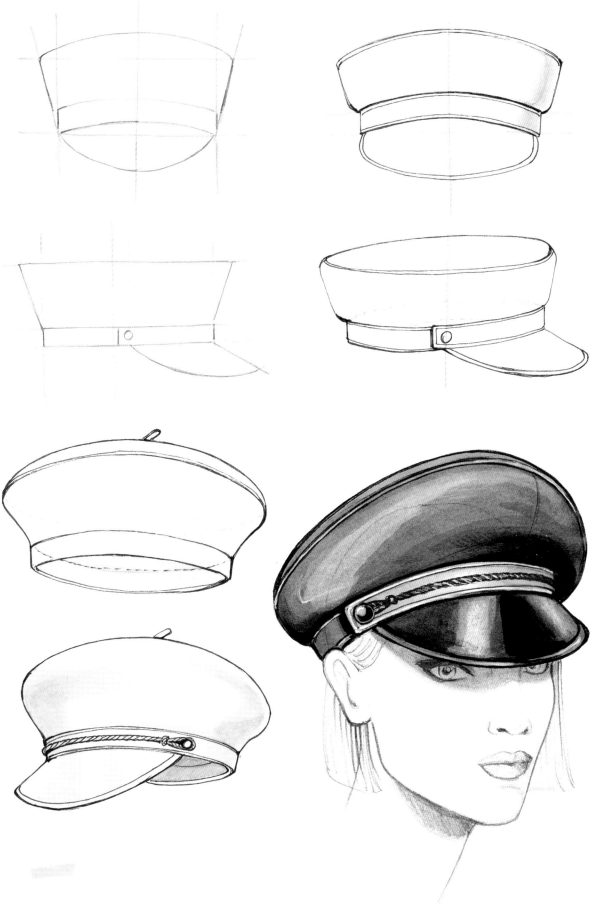

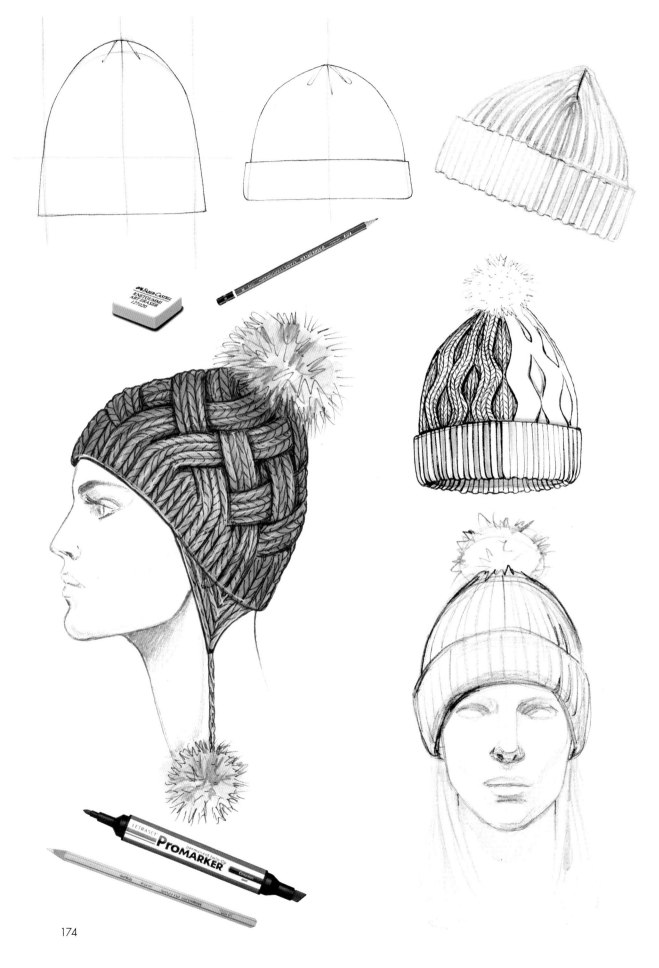

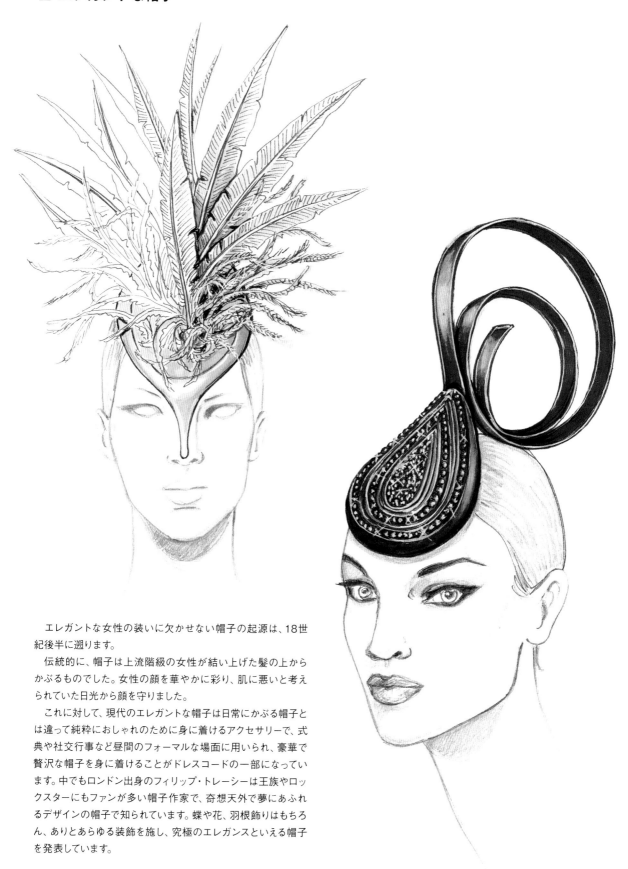

■ エレガントな帽子

　エレガントな女性の装いに欠かせない帽子の起源は、18世紀後半に遡ります。

　伝統的に、帽子は上流階級の女性が結い上げた髪の上からかぶるものでした。女性の顔を華やかに彩り、肌に悪いと考えられていた日光から顔を守りました。

　これに対して、現代のエレガントな帽子は日常にかぶる帽子とは違って純粋におしゃれのために身に着けるアクセサリーで、式典や社交行事など昼間のフォーマルな場面に用いられ、豪華で贅沢な帽子を身に着けることがドレスコードの一部になっています。中でもロンドン出身のフィリップ・トレーシーは王族やロックスターにもファンが多い帽子作家で、奇想天外で夢にあふれるデザインの帽子で知られています。蝶や花、羽根飾りはもちろん、ありとあらゆる装飾を施し、究極のエレガンスといえる帽子を発表しています。

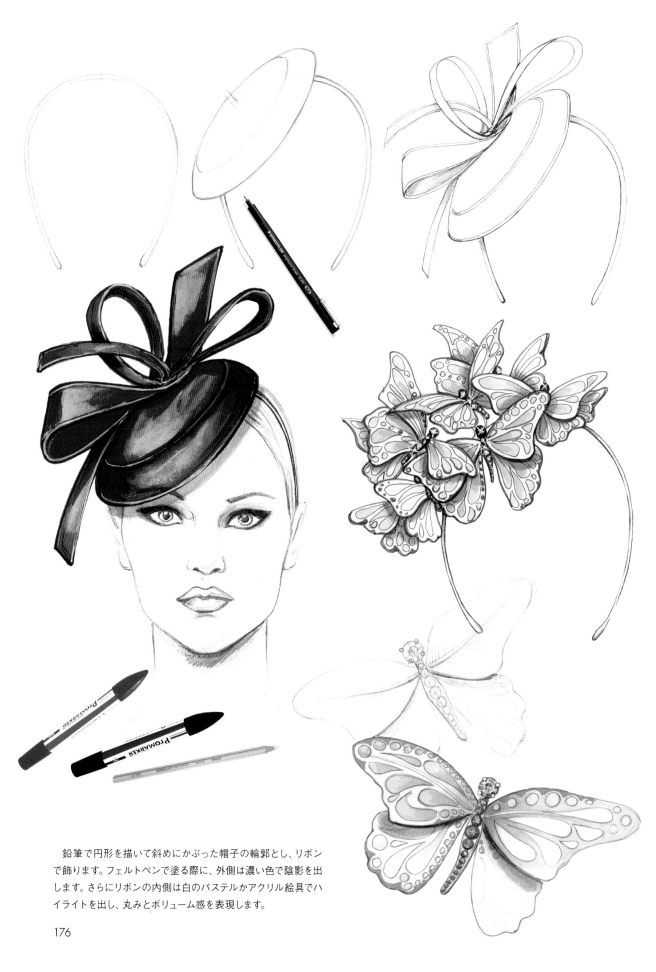

　鉛筆で円形を描いて斜めにかぶった帽子の輪郭とし、リボン
で飾ります。フェルトペンで塗る際に、外側は濃い色で陰影を出
します。さらにリボンの内側は白のパステルかアクリル絵具でハ
イライトを出し、丸みとボリューム感を表現します。

176

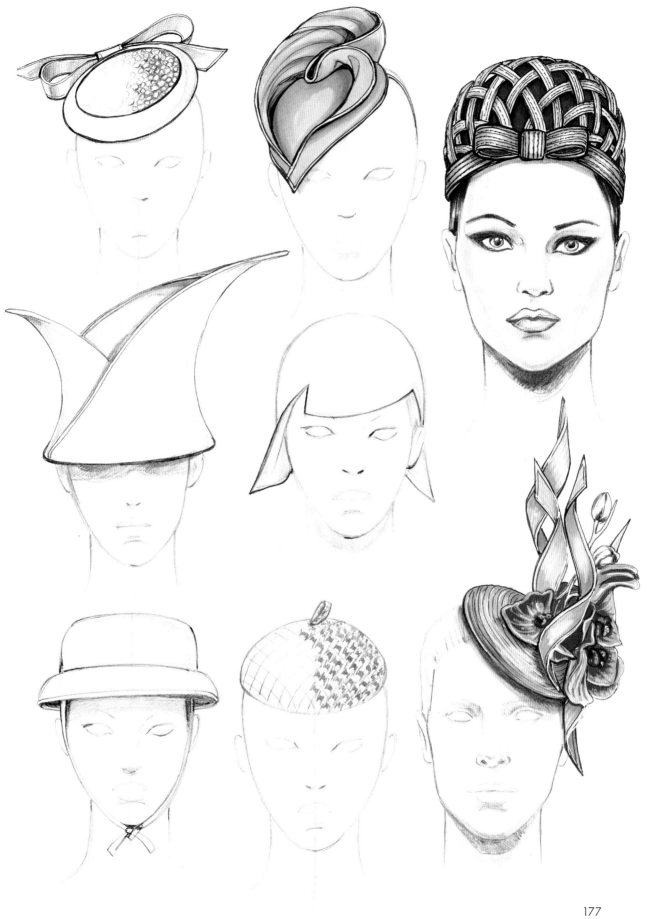

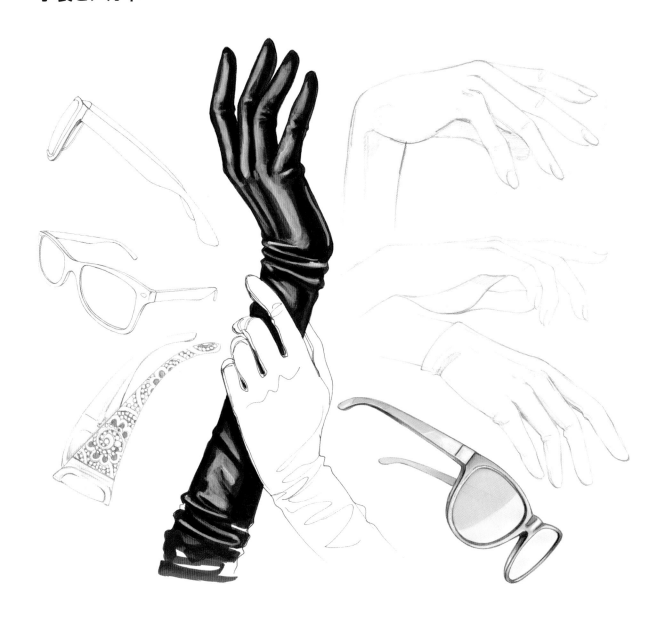

　手袋やメガネの起源は、古代に遡ります。古代ギリシャでは、ヴィーナスの傷ついた手を守るために美の女神たちが最初の手袋を作ったと考えられています。歴史的には、エジプトのファラオの時代にすでに手袋が作られ、さらに中世ヨーロッパにおいて、君主の権威や封建制度上の特権のシンボルとなりました。9世紀から、手袋は女性にも用いられるようになりました。

　一方、メガネの最も古い考古学的証拠は、グリーンランドで雪の照り返しから身を守るためにイヌイットの人々が使っていたもので、木の棒や骨を結び合わせ、その間にスリットを設けたものでした。1287年になるとようやく、2枚のレンズを留め具で留めたメガネが発明されました。その後、メガネは数世紀にわたる進化を遂げて、20世紀初頭には革新的な軽量素材の使用により、大幅に軽くなりました。

　手袋は、やはり20世紀に入ると、毛皮のマフ（筒状で両手を入れて温める防寒具）に代わって用いられるようになり、刺繍を施したチュール（メッシュ生地）やシルクの手袋は、女性らしさを象徴するアクセサリーとなりました。貧困のために衣服や小物が不足しがちだった戦後の時代には、実用的なウール製の手袋が登場しました。

　今日のファッションでは、手袋やメガネはファッションの主役級といえる重要な小物です。職人技とデザインの粋が生み出す傑作が、ファッション誌の表紙を飾ることもあります。

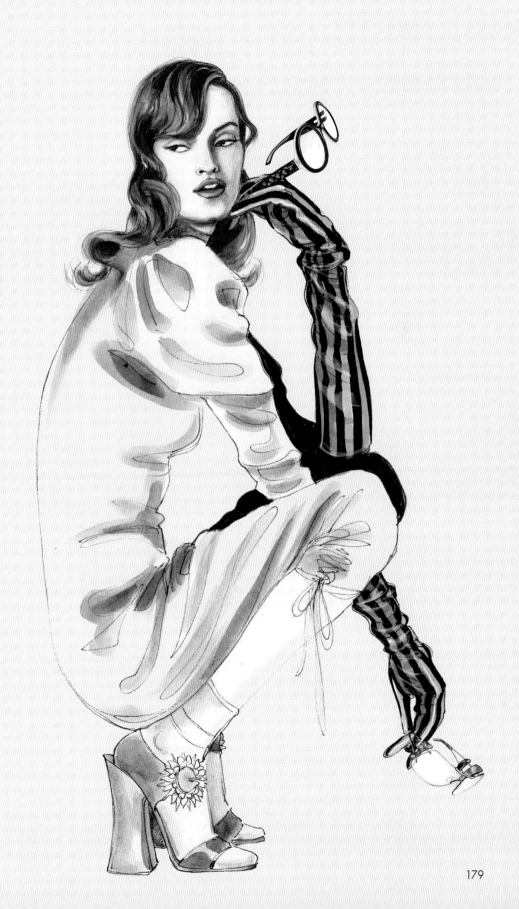

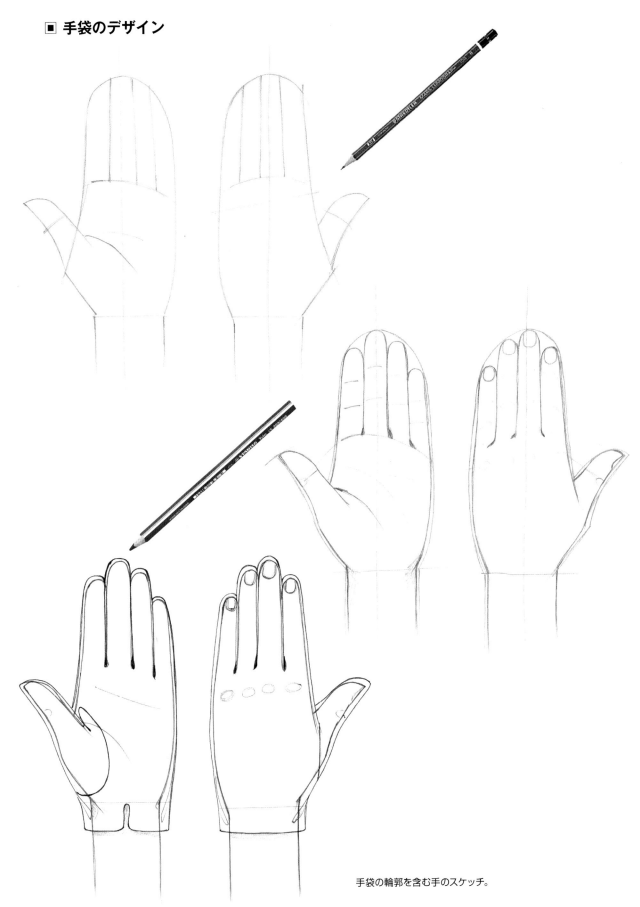

◼ 手袋のデザイン

手袋の輪郭を含む手のスケッチ。

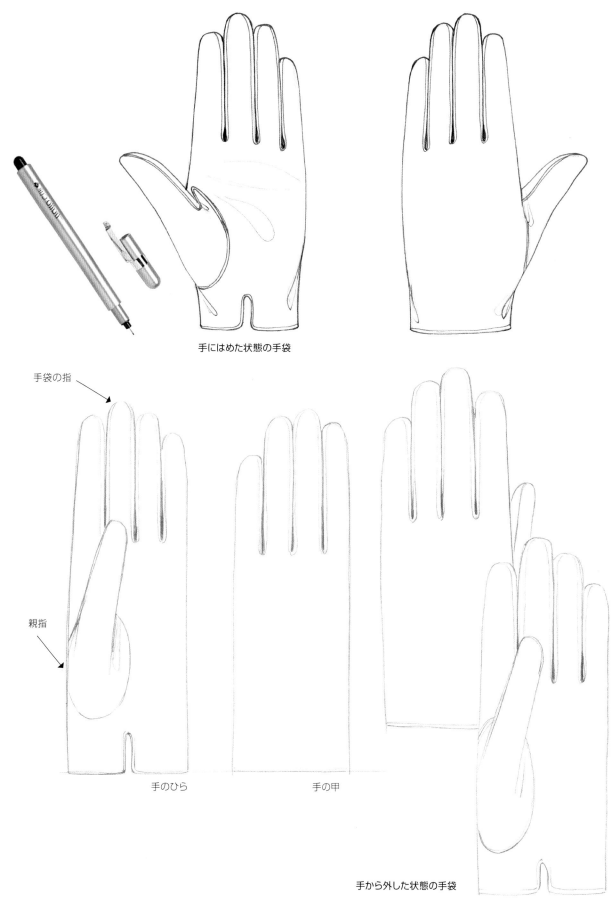

手にはめた状態の手袋

手袋の指

親指

手のひら　　　　　手の甲

手から外した状態の手袋

◼ スポーツ手袋

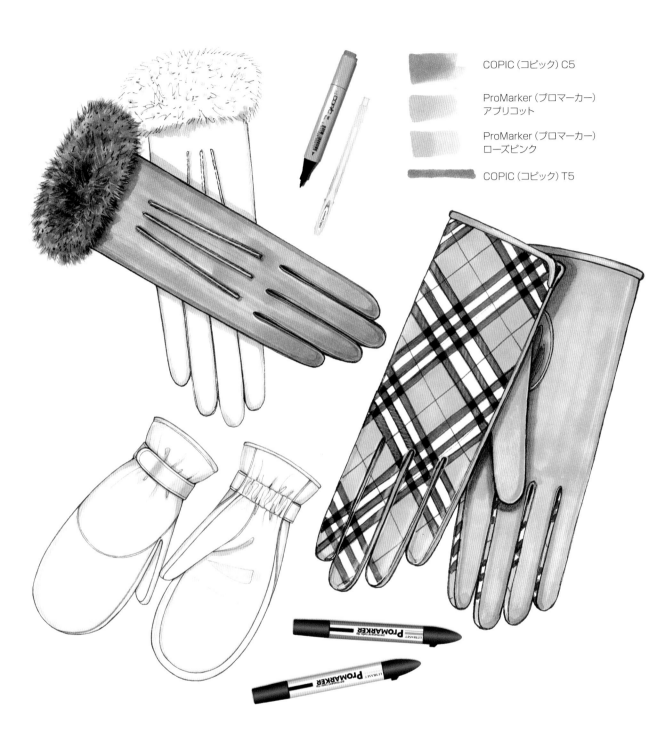

COPIC（コピック）C5

ProMarker（プロマーカー）
アプリコット

ProMarker（プロマーカー）
ローズピンク

COPIC（コピック）T5

　ウィンタースポーツや馬術の過酷な環境から選手の手を守るために生まれたスポーツグローブは、快適さと実用性、そして耐久性を兼ね備え、さまざまな活動に使用されています。

　さらに、最初の自動車の出現により、ドライバーがハンドルをしっかり握れるように指なしのレザーグローブが作られました。スケートをする人やバイクに乗る人は、機能性に優れた丈夫な手袋を着用してけがを防止します。

　街中でコートやキルトジャケットに合わせて着用する毛足のある素材の手袋は、肌触りの良さと温かさが特長です。流行の変遷や新素材の開発により、1970年代後半にアメリカでポリエステルを原料に誕生したソフトフリースの手袋も発売され、人気を得ました。

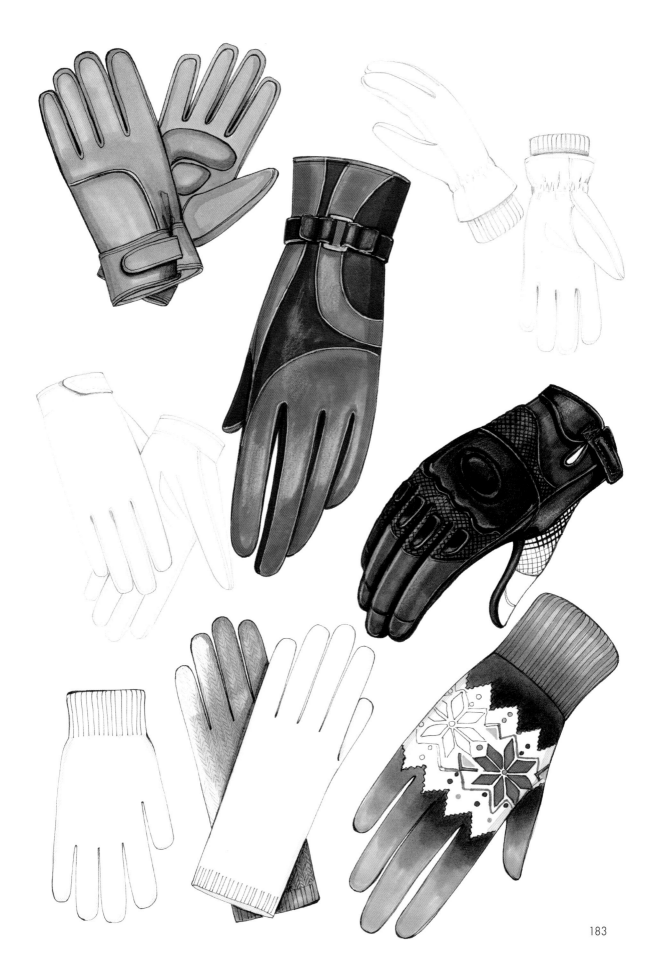

◼ エレガントな手袋

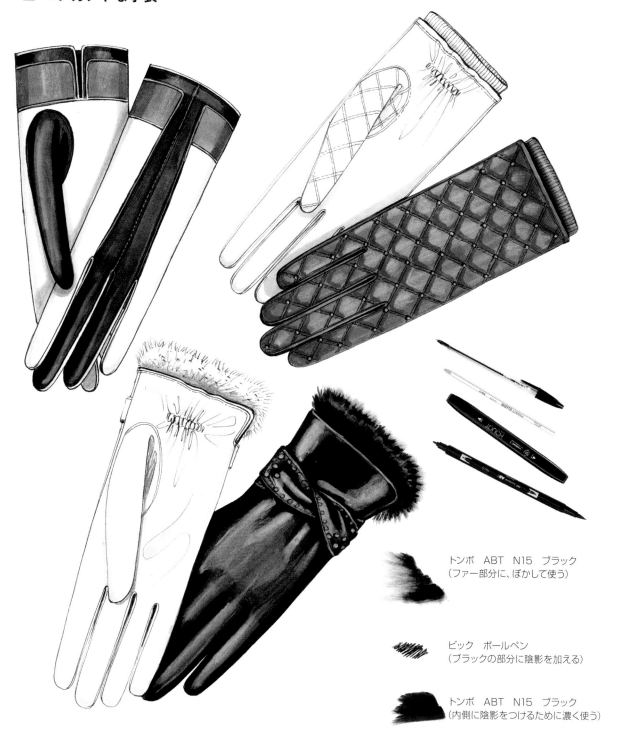

トンボ　ABT　N15　ブラック
（ファー部分に、ぼかして使う）

ビック　ボールペン
（ブラックの部分に陰影を加える）

トンボ　ABT　N15　ブラック
（内側に陰影をつけるために濃く使う）

　エレガントなおしゃれ用の手袋は、優雅さと社会的地位を象徴する小物として用いられます。

　今日では、職人による熟練した技術と新しいテクノロジーの双方を生かして、豪華な高級素材の手袋が作られています。たとえば洗練されたレースをあしらったナイロン製の模様入りネットの手袋や、柔らかな山羊革に透かし模様を表現して手の肌をか

いま見せる手袋などがあります。

　現代の忙しいライフスタイルは20世紀初頭のブルジョワジーとは異なり、こうした手袋が当時のように日常的に使われるわけではありませんが、光沢のあるタンニンなめし革をはじめとする最高級の素材を使い、ブランドのモノグラムの刺繍やクリスタルで飾った手袋が、夜の社交の場面で用いられます。

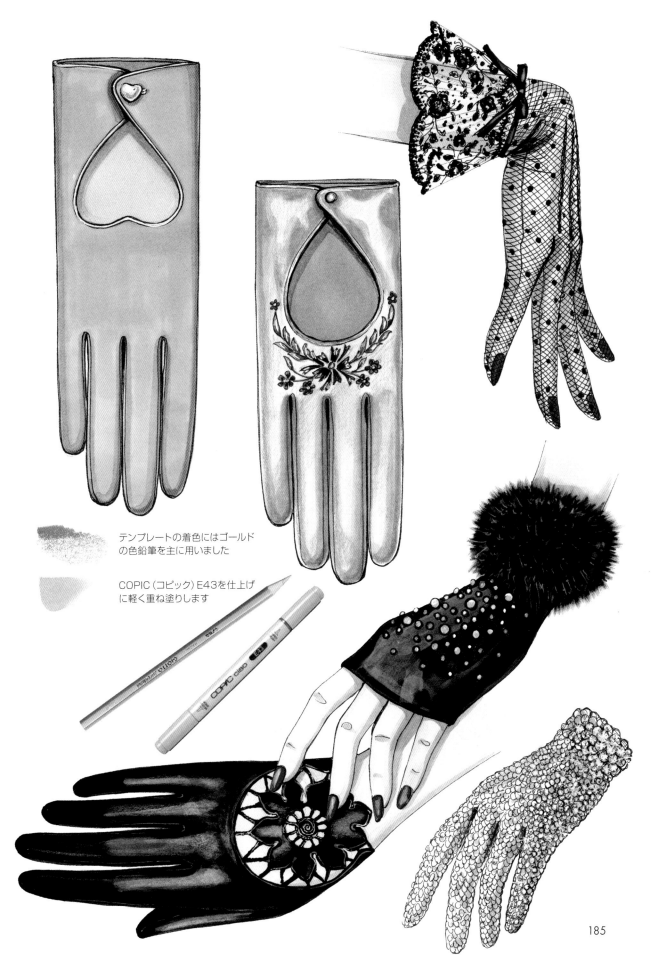

テンプレートの着色にはゴールド
の色鉛筆を主に用いました

COPIC（コピック）E43を仕上げ
に軽く重ね塗りします

185

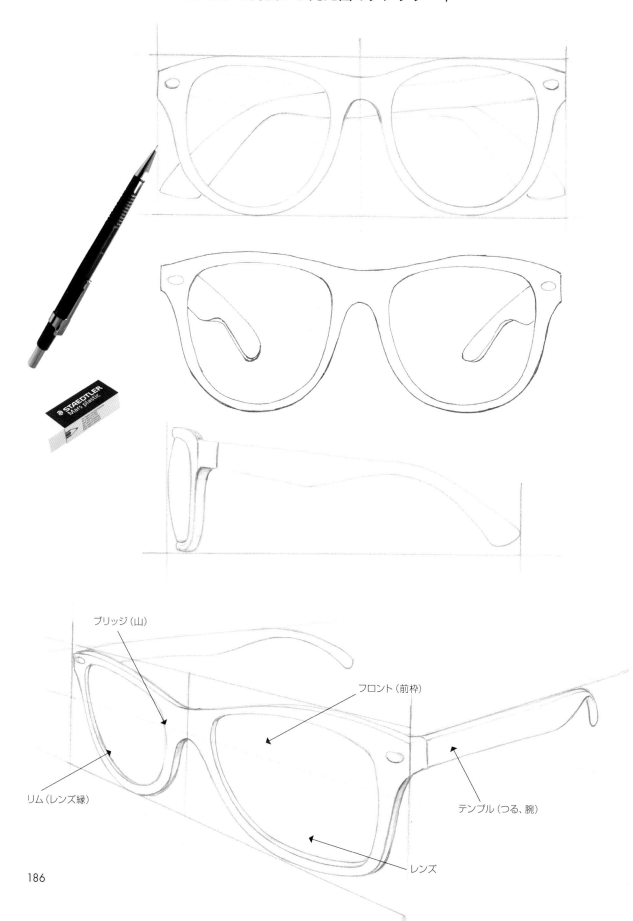

ブリッジ（山）

フロント（前枠）

リム（レンズ縁）

テンプル（つる、腕）

レンズ

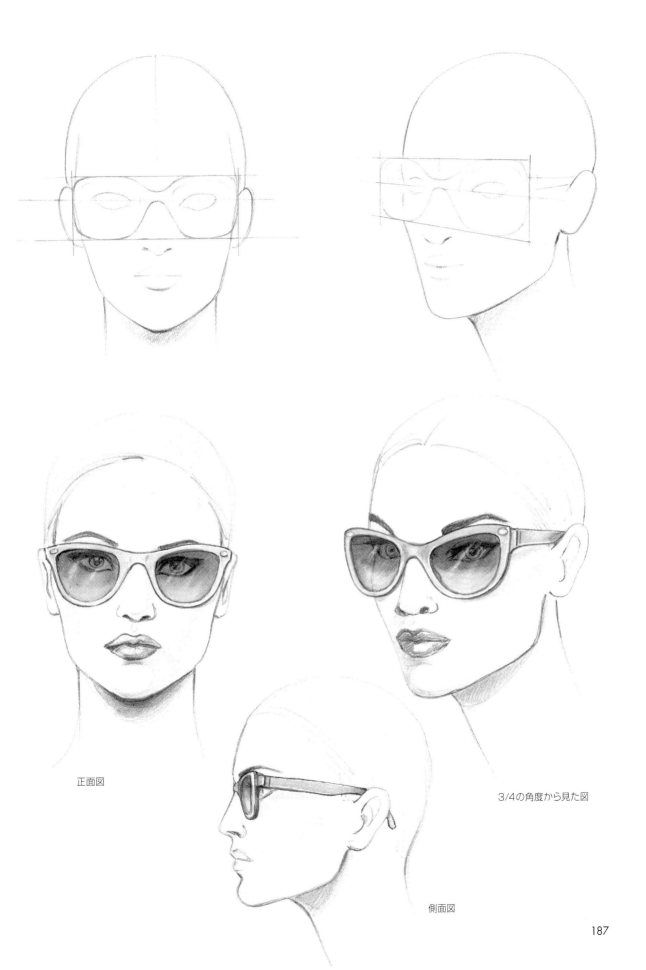

正面図

3/4の角度から見た図

側面図

■ メガネ

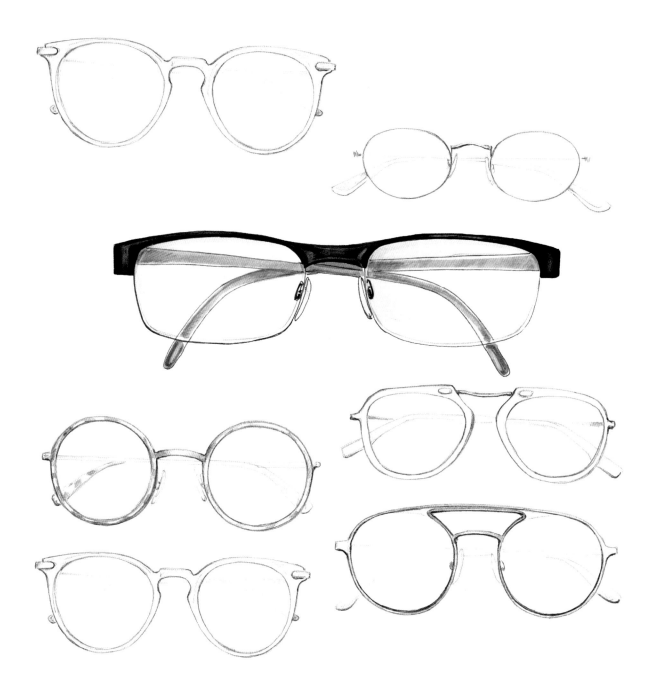

　視力矯正のためのメガネが登場したのは、太陽光から目を保護するためのメガネの発明よりも後のことでした。原始時代にすでに使用されていたレンズは、もっぱら火を起こすために使われていたのです。

　冶金技術の進化と産業革命により、フレームはより快適で軽くなり、しかも幅広い人たちが入手できる価格になりました。また、モダンなデザインで作られるようになり、顔立ちを個性的に演出する小物として愛用されるようになりました。

　映画『百万長者と結婚する方法』（1953年）で、金髪のモデルで極度の近眼という役柄を演じたマリリン・モンローがメガネをかけた姿は、ハリウッド映画史に刻まれています。また、近年では、映画『ハリー・ポッター』シリーズ（2001年～2011年）で、丸メガネが主人公の魔法使いの少年のトレードマークになっています。

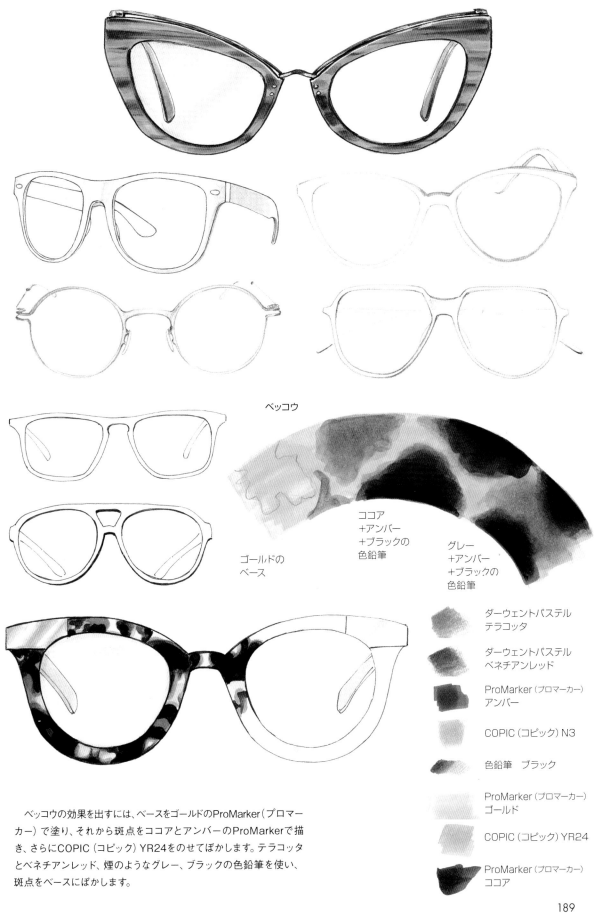

ベッコウ

ゴールドの
ベース

ココア
+アンバー
+ブラックの
色鉛筆

グレー
+アンバー
+ブラックの
色鉛筆

ダーウェントパステル
テラコッタ

ダーウェントパステル
ベネチアンレッド

ProMarker（プロマーカー）
アンバー

COPIC（コピック）N3

色鉛筆　ブラック

ProMarker（プロマーカー）
ゴールド

COPIC（コピック）YR24

ProMarker（プロマーカー）
ココア

　ベッコウの効果を出すには、ベースをゴールドのProMarker（プロマー
カー）で塗り、それから斑点をココアとアンバーのProMarkerで描
き、さらにCOPIC（コピック）YR24をのせてぼかします。テラコッタ
とベネチアンレッド、煙のようなグレー、ブラックの色鉛筆を使い、
斑点をベースにぼかします。

■ サングラス

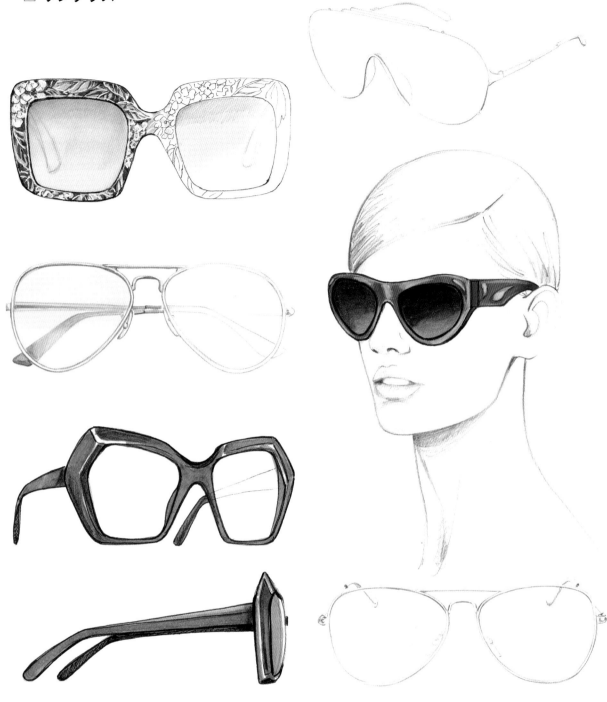

　サングラスはおしゃれなだけではなく、誘惑やミステリアスな雰囲気を演出する小道具にもなります。スターたちがプライバシーを守り、パパラッチから身を隠すためにサングラスをかけるようになったことから人気が出ました。

　私たちにとって、サングラスは日差しから目を守るための小物であると同時に、日常の装いにちょっとした神秘的で魅力的な味わいと個性を与えてくれます。誰でも簡単に、映画の中でスターたちが不朽のものにしたサングラスの魅力を取り入れることができます。

　たとえば映画『トップガン』でトム・クルーズがかけていたレイバンのアビエイターサングラスや、映画『ティファニーで朝食を』のオードリー・ヘップバーンのミステリアスで茶目っ気のある大きな黒縁のサングラスは不朽のファッションアイテムです。

　サングラスの魅力を引き出すため、ブランドやデザイナーは毎シーズン工夫を凝らしたデザインと新素材による作品を発表しています。サングラスは日常的に気軽に使用でき、私たちの目を守るだけでなく、より美しく見せてくれるすばらしいアクセサリーです。

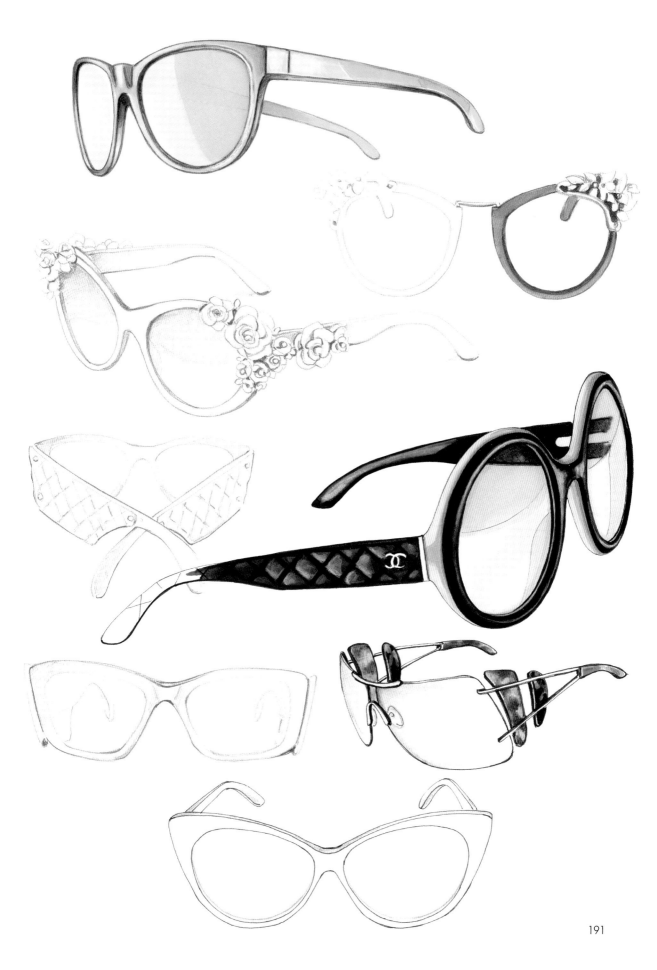

191

素材と質感

革、ファー、刺繍、プリント、ニット、ファブリックなど

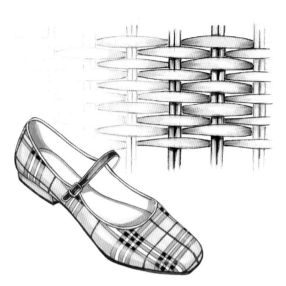

優れたデザインを生み出すうえで欠かせないのが、素材と質感への配慮です。世界各地の伝統文化に色や素材の組み合わせを探究し、そのディテールに目を配ることで、デザイナーは貴重なインスピレーションを得られます。

たとえばマラケシュの市場で売られているのは、安価なウールや布をもとに職人が実現したカラフルで温かみのある魅力的なアートのような製品です。インド各地では、エネルギッシュで豊かな色と輝きを見せる個性的な服や小物が、熟練した職人による刺繍で手際のよく生み出されています。

商業的に成功するデザインを生み出す鍵となる素材も、民族の伝統の中に見つかります。シャグリーン（サメ革やそれを模した革などの素材）、ワニ革、シルクのプリントやグログランの布地、スワロフスキーのクリスタルの刺繍など、伝統的な高級素材をモダンなテクノロジー素材と組み合わせる試みが、近年では珍しくなくなりました。そのほかにも靴、バッグ、ベルトに使われる高級素材としてオーストリッチ（ダチョウ革）などがあります。

こうした素材をもとに作られた斬新なデザインのバッグや靴、ベルトが、たとえば軽やかな白の麻のサマードレスの着こなしに、暑い夏の日にふさわしい爽やかなタッチを加えます。天然皮革のベルトにラインストーンや貝殻をあしらい、あるいはリザード（トカゲ革）やスネークスキン（ヘビ革）にヘリンボーンステッチや半貴石の装飾や幾何学的なモチーフを組み合わせて個性的なデザインが生まれます。

また、ホースハイド（馬革）にアニマルプリントを施すことで、トラやヒョウ、ゼブラ、キリンなどの野生動物の革のように見せた素材もあります。トップグレインレザーやナッパレザーは、いずれも革新的ななめし加工を行い、光沢のある仕上げが施されています。ナイロン素材にレザーや精巧に織られたストロー（麦わら）のモチーフを組み合わせたショッピングバッグは、スポーティでどこかヒッピーな雰囲気が変わらぬ人気で、さまざまな形とスタイルの帽子とコーディネートできます。丸や尖った形のスタッズ（飾り鋲）はパンクファッションを思わせますし、シルバーのパーツをあしらった黒の革やコットンプリントのバッグはクールな印象になります。さらに、木や鋳鉄、竹などの身近な素材を持ち手に使い、籐編みやジュート、あるいはウールやコットンのニットと組み合わせたバッグは、折衷的な味わいがあるレトロモダンな小物です。

近年の消費者の動向に合わせて注目されているのが、環境に配慮した素材です。たとえば、動物愛護に配慮した素材として、革新的なフェイクファーやビーガンレザー（人工皮革）が登場し、最高級の革や毛皮に匹敵する質感を実現しています。本物の毛皮と同じ高級感はなくても、優れたデザインとトレンド感を表現できます。

また、持続可能なファッションを目指してリサイクル素材の研究開発も進んでいます。技術革新によって、魅力と倫理を両立させた未来のファッションが実現しつつあるのです。

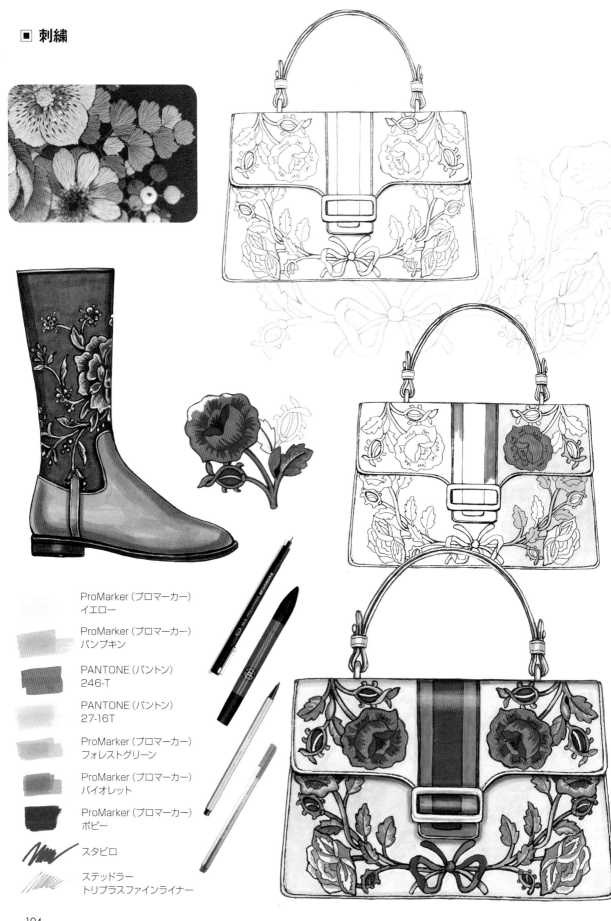

■ 刺繍

ProMarker（プロマーカー）
イエロー

ProMarker（プロマーカー）
パンプキン

PANTONE（パントン）
246-T

PANTONE（パントン）
27-16T

ProMarker（プロマーカー）
フォレストグリーン

ProMarker（プロマーカー）
バイオレット

ProMarker（プロマーカー）
ポピー

スタビロ

ステッドラー
トリプラスファインライナー

■ ストーンとスパンコール

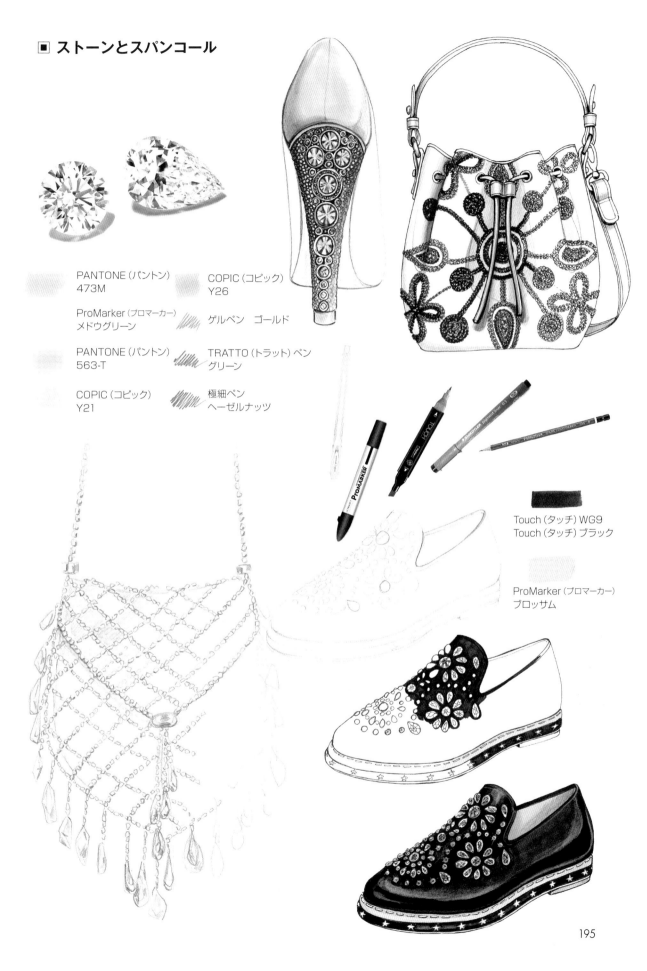

PANTONE（パントン）
473M

ProMarker（プロマーカー）
メドウグリーン

PANTONE（パントン）
563-T

COPIC（コピック）
Y21

COPIC（コピック）
Y26

ゲルペン　ゴールド

TRATTO（トラット）ペン
グリーン

極細ペン
ヘーゼルナッツ

Touch（タッチ）WG9
Touch（タッチ）ブラック

ProMarker（プロマーカー）
ブロッサム

■ ホースハイド（馬革）

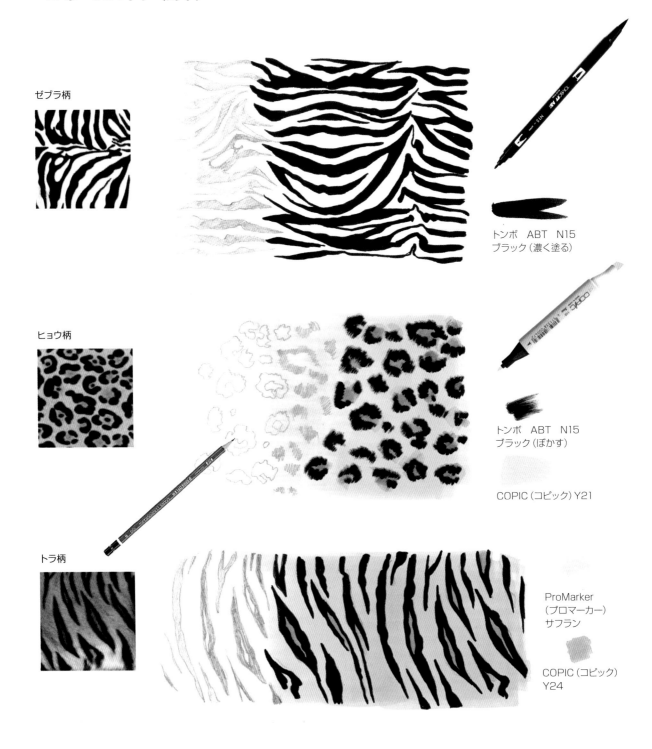

ゼブラ柄

ヒョウ柄

トラ柄

トンボ　ABT　N15
ブラック（濃く塗る）

トンボ　ABT　N15
ブラック（ぼかす）

COPIC（コピック）Y21

ProMarker
（プロマーカー）
サフラン

COPIC（コピック）
Y24

ゼブラ柄：鉛筆でデザインを描いた後、マーカーで黒く塗り、極細ペンで縁をしっかり描きます。

ヒョウ柄：ベースを明るい黄色に塗ってから、鉛筆で黒いヒョウの斑点を描き、中央に暗めの黄色のタッチを加えます。斑点をにじませたような効果を出すには、トンボのABTなどの黒いフェルトペンを使います。

トラ柄：ベースを薄い黄色のPANTONE（パントン）のサフランで塗り、PANTONE（パントン）の温かみのある黄色（ゴールド）と重ねてニュアンスのある色を作り、部分的にグラデーションを出して濃くします。鉛筆で模様を描き、黒で塗ります。その後、真ん中をライトブラウンで塗ります（ボタンホールのような形）。

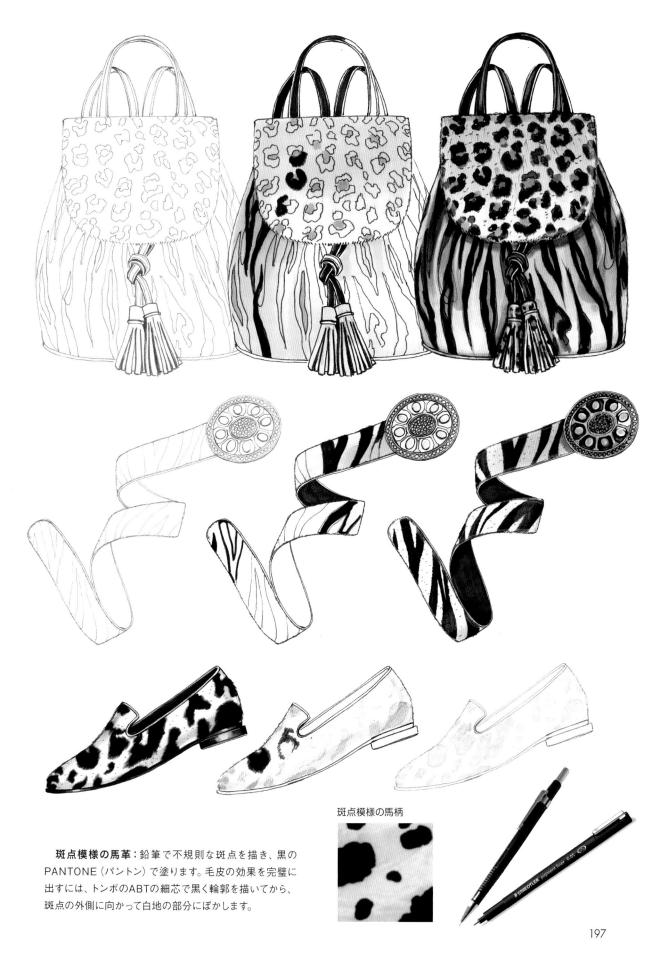

斑点模様の馬革：鉛筆で不規則な斑点を描き、黒の
PANTONE（パントン）で塗ります。毛皮の効果を完璧に
出すには、トンボのABTの細芯で黒く輪郭を描いてから、
斑点の外側に向かって白地の部分にぼかします。

斑点模様の馬柄

■ クロコダイル

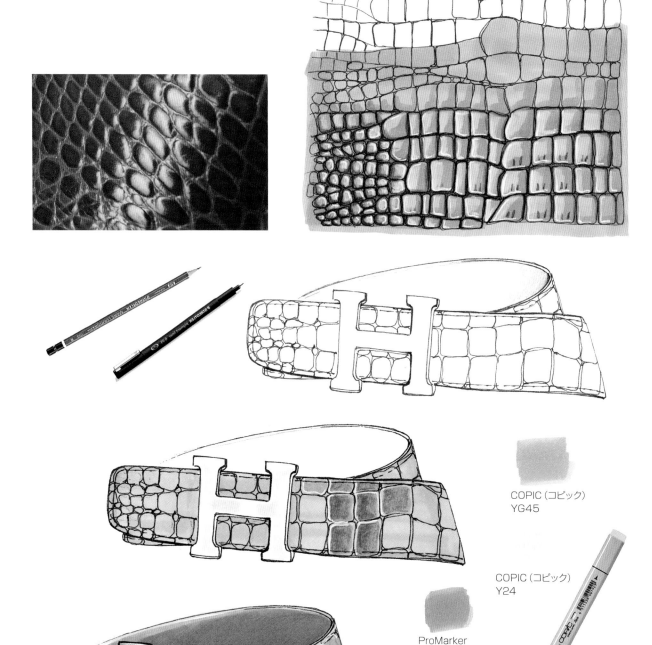

COPIC（コピック）
YG45

COPIC（コピック）
Y24

ProMarker
（プロマーカー）
WG5

スタビロ　硬質色鉛筆オリ
ジナル87-685をバックル
の陰影に使います。

　クロコダイルを表現するには、まず鉛筆を使って、少しずつ大きさが増していくマス目の模様を描きます。マス目の輪郭は極細ペンを使い、角が少し丸くなるように描きます。濃い色の極細ペンで四角形の下に陰影を出し、左上の角に白い色鉛筆でハイライトをつけます。

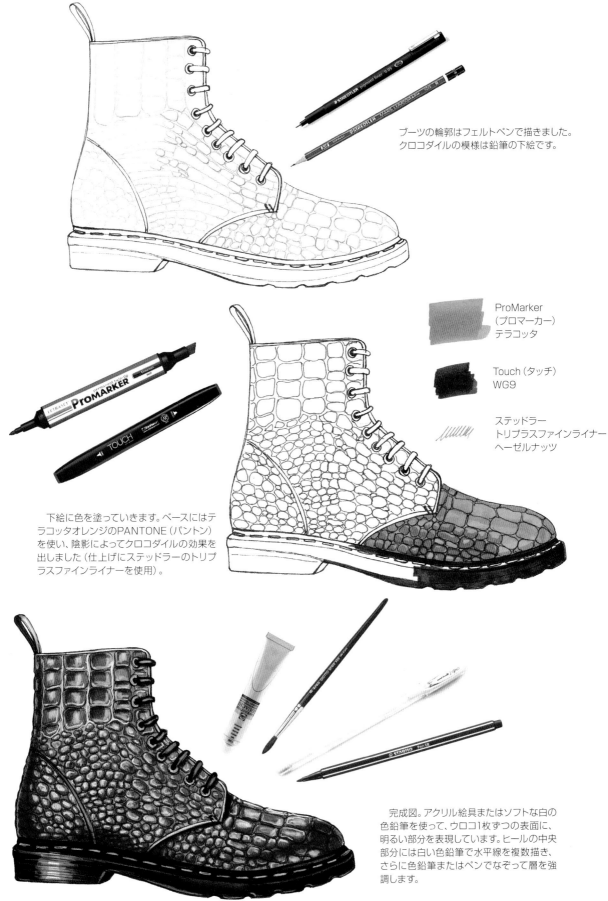

ブーツの輪郭はフェルトペンで描きました。
クロコダイルの模様は鉛筆の下絵です。

ProMarker
（プロマーカー）
テラコッタ

Touch（タッチ）
WG9

ステッドラー
トリプラスファインライナー
ヘーゼルナッツ

下絵に色を塗っていきます。ベースにはテ
ラコッタオレンジのPANTONE（パントン）
を使い、陰影によってクロコダイルの効果を
出しました（仕上げにステッドラーのトリプ
ラスファインライナーを使用）。

完成図。アクリル絵具またはソフトな白の
色鉛筆を使って、ウロコ1枚ずつの表面に、
明るい部分を表現しています。ヒールの中央
部分には白い色鉛筆で水平線を複数描き、
さらに色鉛筆またはペンでなぞって層を強
調します。

■ シャグリーン（鮫革）

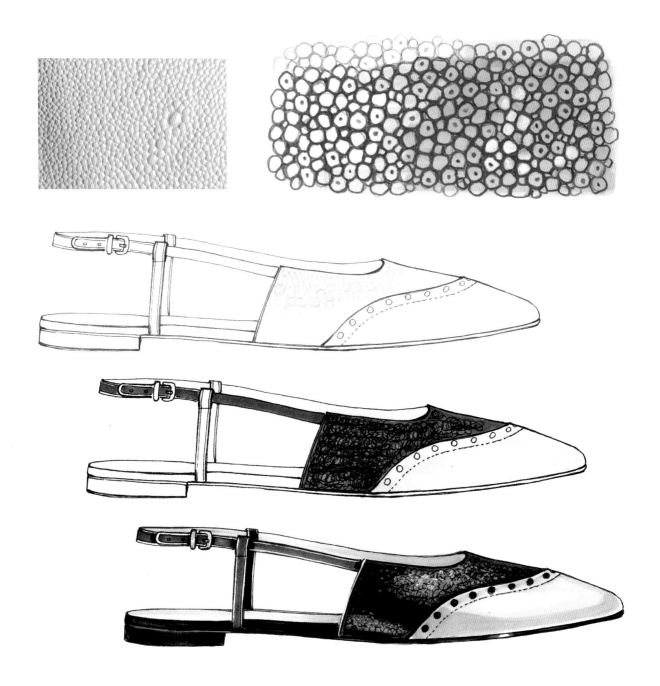

　まずベースの色（ここでは黒）を塗ります。そして、ボールペンで小さなゆがんだ円形をはっきり描いてから、白の色鉛筆を軽く押しつけるようにしてハイライトを入れます。光が強く当たっている部分は白色を強く出します。

　次に、ショルダーストラップとフラップ（フタ）がついた、シャグリーンのバッグを例に、デザイン画を描く過程を説明しましょう。白と黒でデザイン画の下絵を描いたら、フェルトペンでレザーの色を、ボールペンでシャグリーンの粒子（質感）を描きま

す。最後にブラックのPANTONE（パントン）で、フラップの上端と縫い目の膨らみに沿って陰影をつけて完成です。

　フラップの光沢（上端の陰影のすぐ下にあたる部分）は横長にホワイトの色鉛筆をぼかして明るさを表現します。横長の光沢の中央部分では、白の色鉛筆を強いタッチで使い、白のゲルペンで点をはっきりと描き、サイドに向かって徐々に散らばるようにします。乾かないうちに指で触れてインクを広げると、光の反射のような効果が得られます。

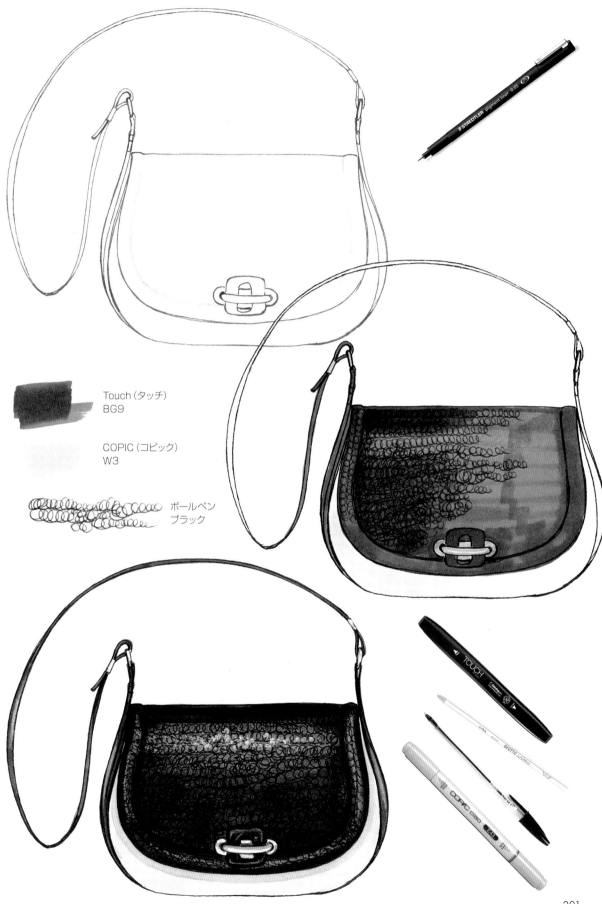

Touch（タッチ）
BG9

COPIC（コピック）
W3

ボールペン
ブラック

■ スネークスキン（ヘビ革）

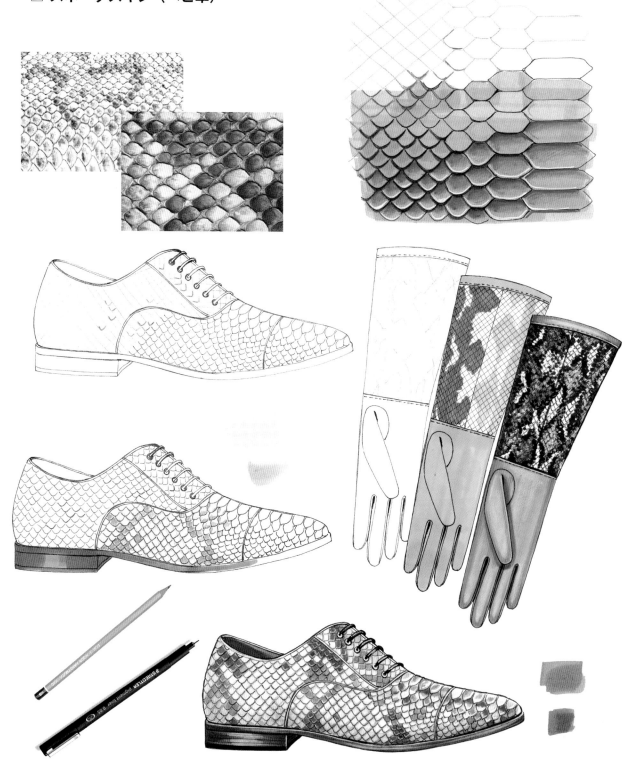

　ヘビ革は、45度に傾けた正方形のマス目を、階段状に連ねた
ひし形のように描いていきます。さらに、部分的に見られる濃い
色の斑点を全体に散らすように描き足します（ほぼ偏りなく全体
に分布させます）。斑点の面積が小さければマス目1個だけを塗
ります。

　もっとディテールを表現したい場合は、それぞれの正方形、す
なわちウロコの下部にある丸みを出すように描くのがおすすめで
す。クロコダイルと同様、ウロコの大きさや形は一定ではなく、
部位によって段階的に大きくなり、横長の形になっています（右
上のサンプル参照）。

■ オーストリッチ（ダチョウ革）

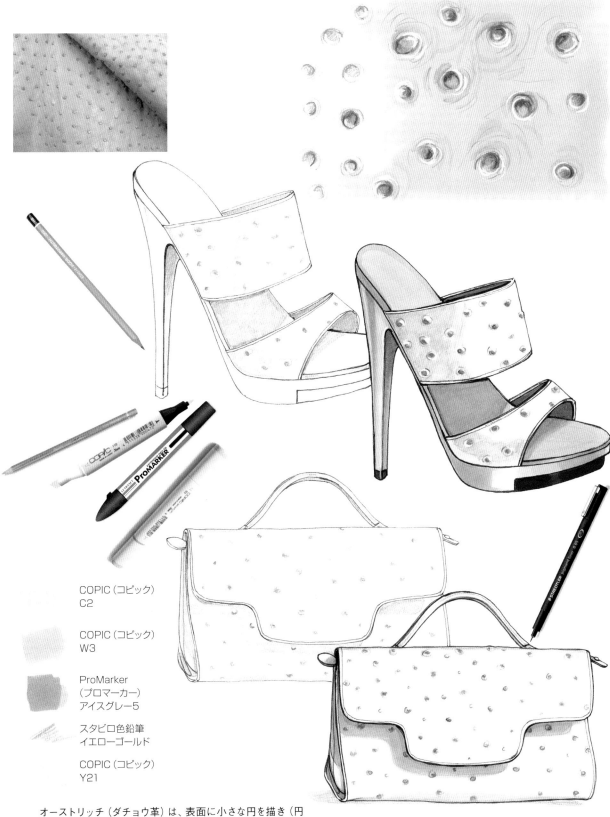

COPIC（コピック）
C2

COPIC（コピック）
W3

ProMarker
（プロマーカー）
アイスグレー5

スタビロ色鉛筆
イエローゴールド

COPIC（コピック）
Y21

　オーストリッチ（ダチョウ革）は、表面に小さな円を描き（円
によって輪郭は開いているものもあります）、下側に陰影をつ
け、上部を白くしてハイライトを加えます。

◼ エンボスレザー

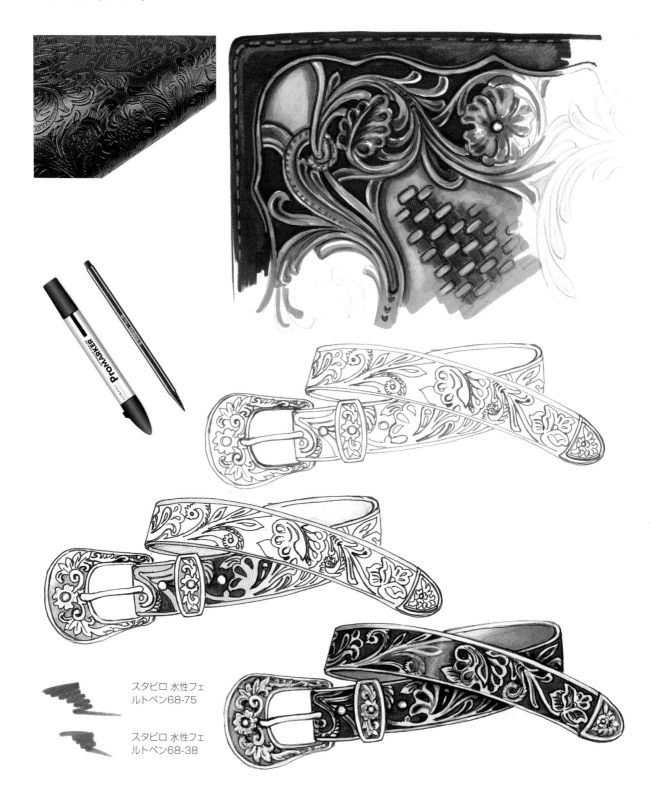

スタビロ 水性フェ
ルトペン68-75

スタビロ 水性フェ
ルトペン68-38

革細工の装飾は、柔らかい白の色鉛筆で丸みを帯びた部分に光沢を描きます。または薄めたアクリル絵具を使うと、不透明になりすぎずにハイライトを出すことができます。

右のバッグでは、濃淡のある部分、外側の縁、持ち手とバッグの底には、濃いブラウンのスタビロのペンを使います。白のゲルペンを使って縫い目を強調してもよいでしょう。

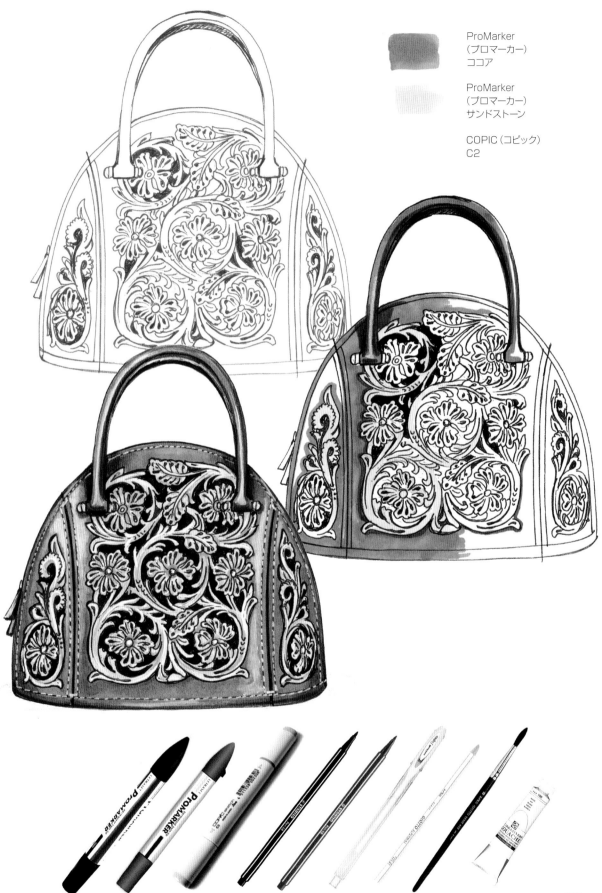

ProMarker
（プロマーカー）
ココア

ProMarker
（プロマーカー）
サンドストーン

COPIC（コピック）
C2

◼ パテントレザー

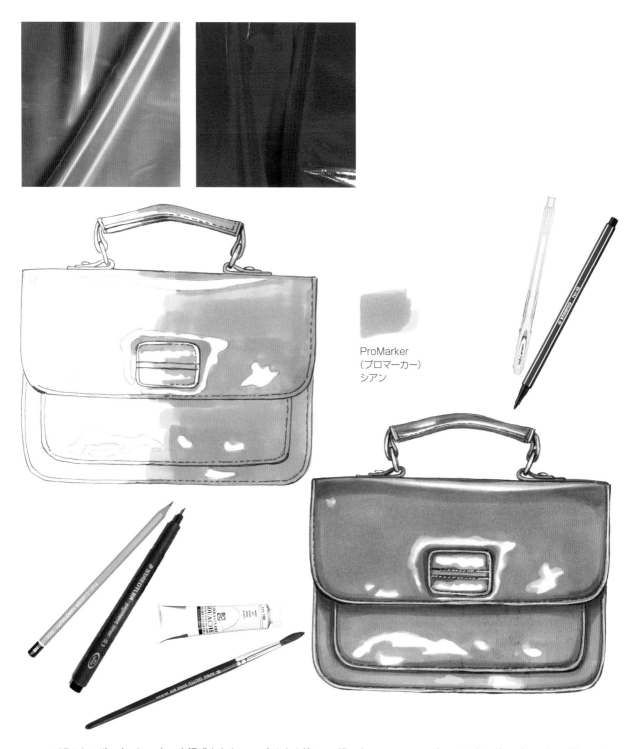

ProMarker
（プロマーカー）
シアン

パテントレザー（エナメル）の光沢感を出すには、主な色を塗る際に、不規則に白い部分を残します。ここでは、留め金の丸みを帯びた部分や出っ張っている部分など、通常は白の色鉛筆で強調する部分を塗り残しています。白のアクリル絵具を使って、白い部分の端をベースの色に優しくなじませてもよいでしょう。

濃い色のPANTONE（パントン）を使えば、明暗の対比が強調できます。また、さらに暗い影になっている部分（フラップやポケットの下など）には、スタビロのゲルペンなどの中細ペンの暗い色を使って、輪郭や縫い目を描くこともできます。

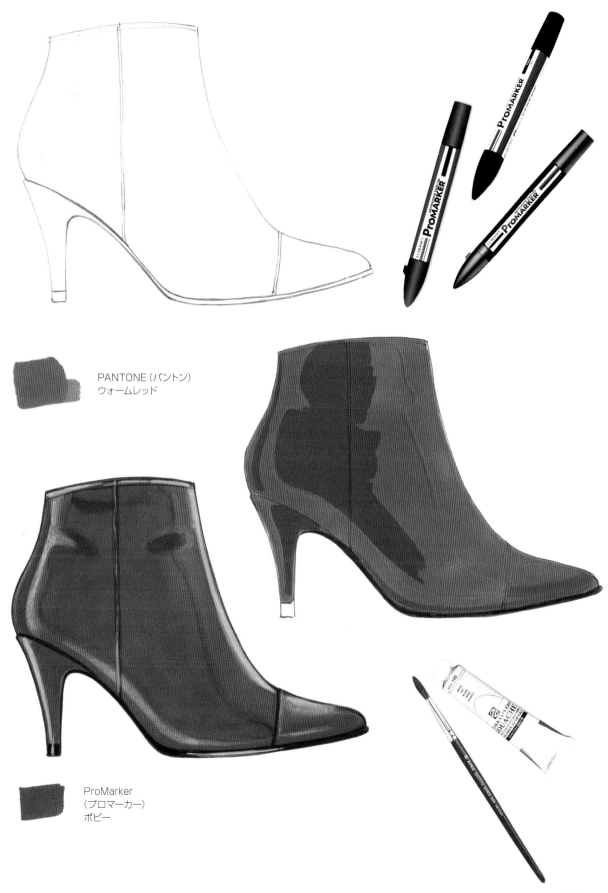

PANTONE (パントン)
ウォームレッド

ProMarker
(プロマーカー)
ポピー

■ ファー

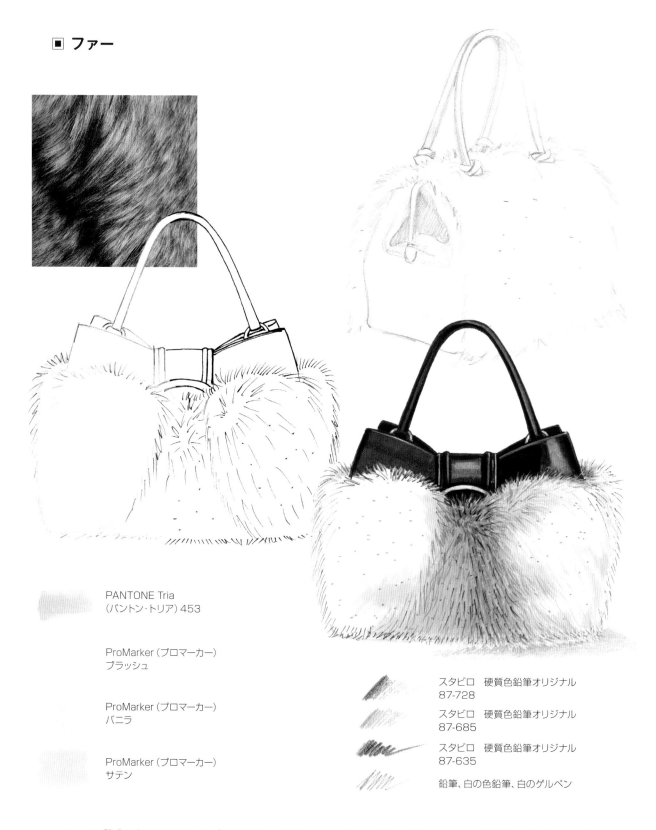

PANTONE Tria
(パントン・トリア) 453

ProMarker (プロマーカー)
ブラッシュ

ProMarker (プロマーカー)
バニラ

ProMarker (プロマーカー)
サテン

スタビロ　硬質色鉛筆オリジナル
87-728

スタビロ　硬質色鉛筆オリジナル
87-685

スタビロ　硬質色鉛筆オリジナル
87-635

鉛筆、白の色鉛筆、白のゲルペン

　ファーの質感を表現するには、まず周囲に向かって柔らかいストロークで1本ずつ短い線を描きます。そして、ファーの部分に極細ペンでそばかすのような点を加えていきます。ここでは、PANTONE Tria (パントン・トリア) 453で中央から外側に向かって描き、さらにProMarker (プロマーカー) のブラッシュ、バニラ、サテンで毛並みの方向に線を描くように塗り、全体になじませます。仕上げに同じ色合いの色鉛筆と白のゲルペンを使って暗い部分との対比を強調すると、ファーを立体的に見せることができます。

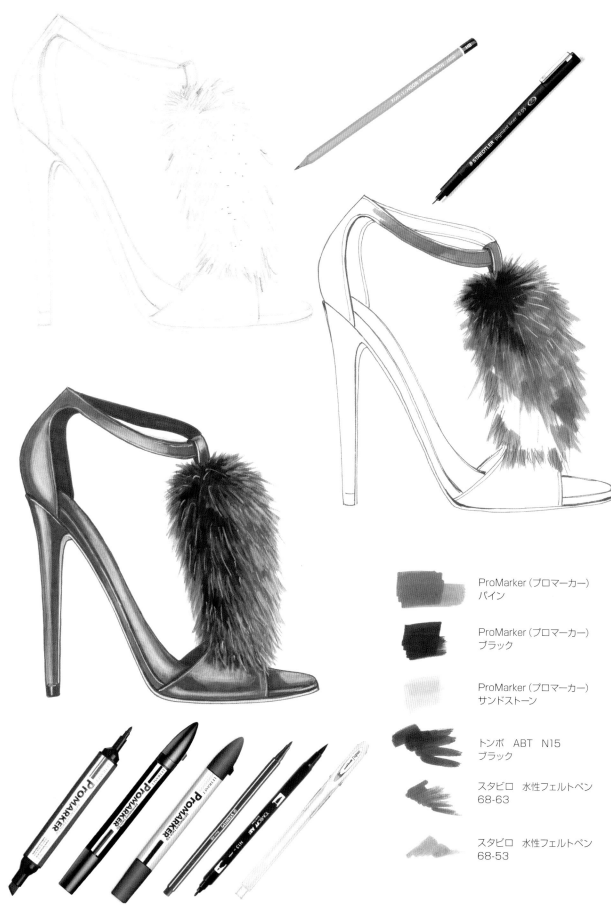

ProMarker（プロマーカー）
パイン

ProMarker（プロマーカー）
ブラック

ProMarker（プロマーカー）
サンドストーン

トンボ　ABT　N15
ブラック

スタビロ　水性フェルトペン
68-63

スタビロ　水性フェルトペン
68-53

■ ニット

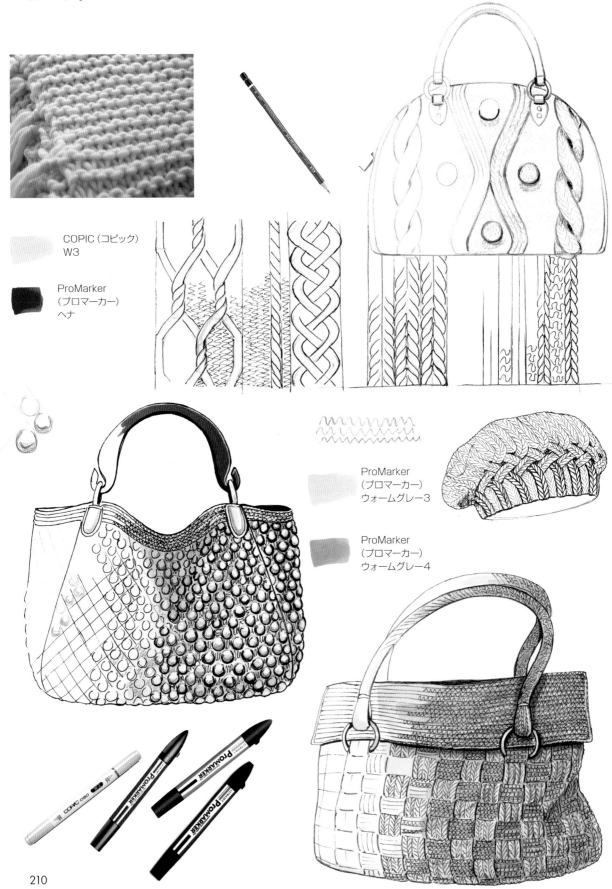

COPIC（コピック）
W3

ProMarker
（プロマーカー）
ヘナ

ProMarker
（プロマーカー）
ウォームグレー3

ProMarker
（プロマーカー）
ウォームグレー4

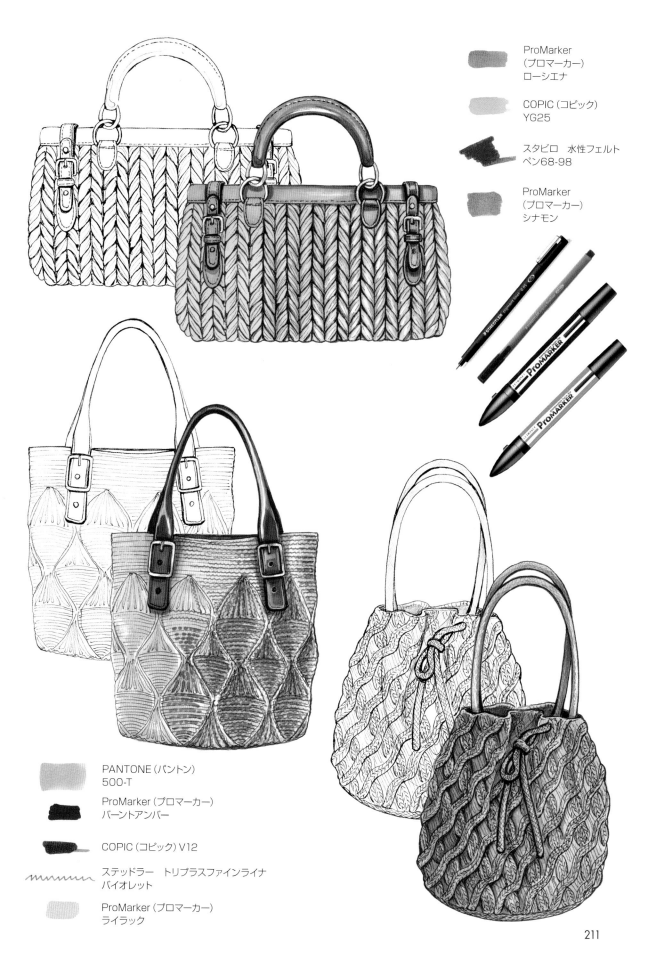

ProMarker
(プロマーカー)
ローシエナ

COPIC (コピック)
YG25

スタビロ　水性フェルト
ペン68-98

ProMarker
(プロマーカー)
シナモン

PANTONE (パントン)
500-T

ProMarker (プロマーカー)
バーントアンバー

COPIC (コピック) V12

ステッドラー　トリプラスファインライナ
バイオレット

ProMarker (プロマーカー)
ライラック

211

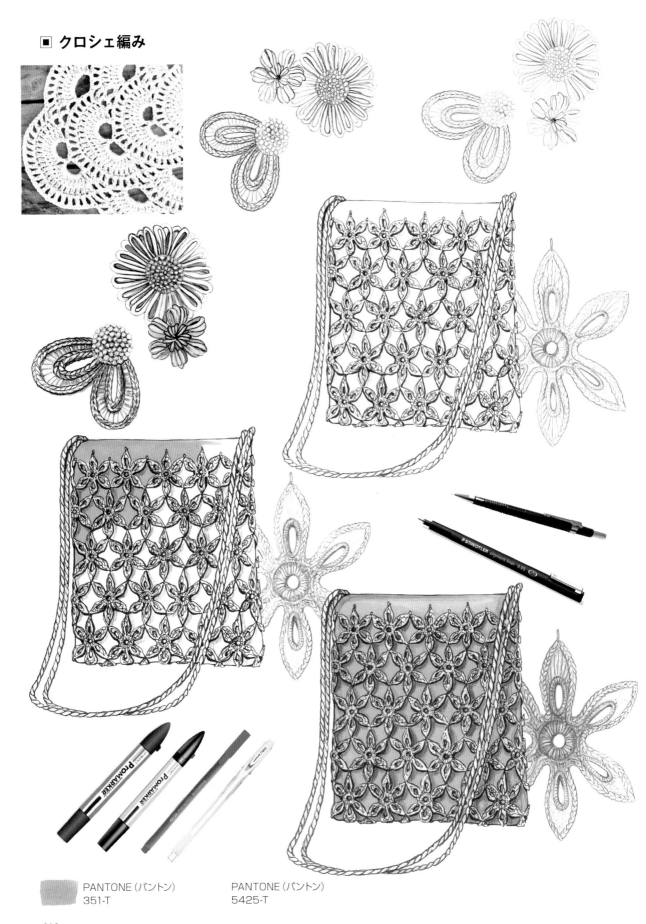

■ クロシェ編み

PANTONE (パントン)
351-T

PANTONE (パントン)
5425-T

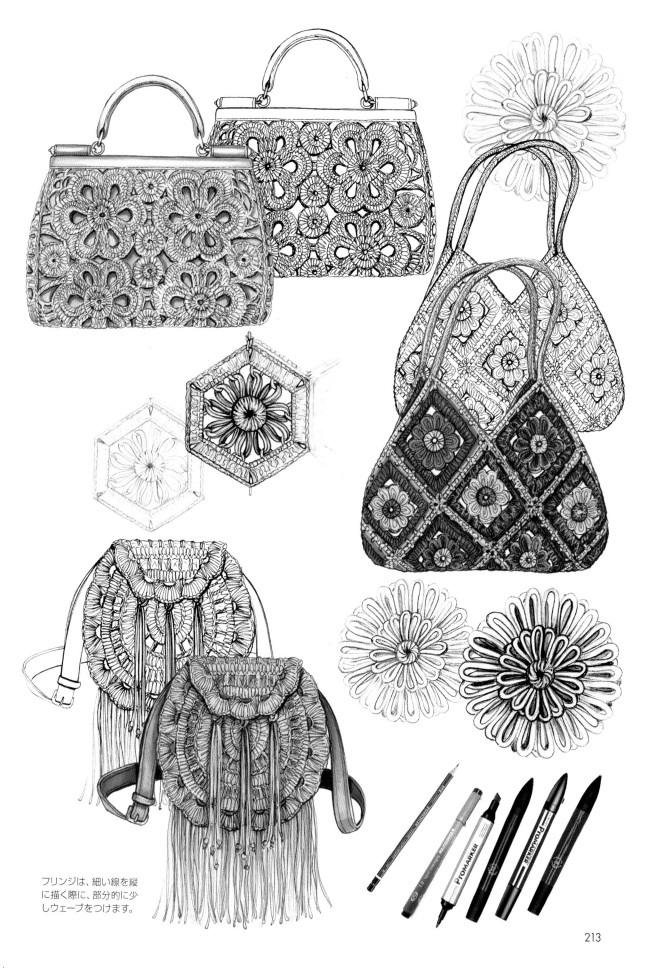

フリンジは、細い線を縦
に描く際に、部分的に少
しウェーブをつけます。

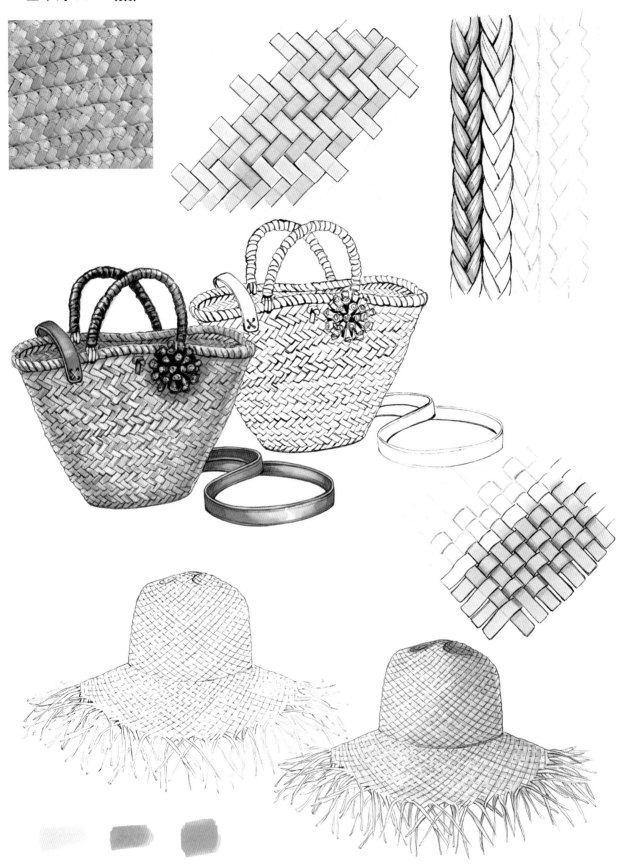

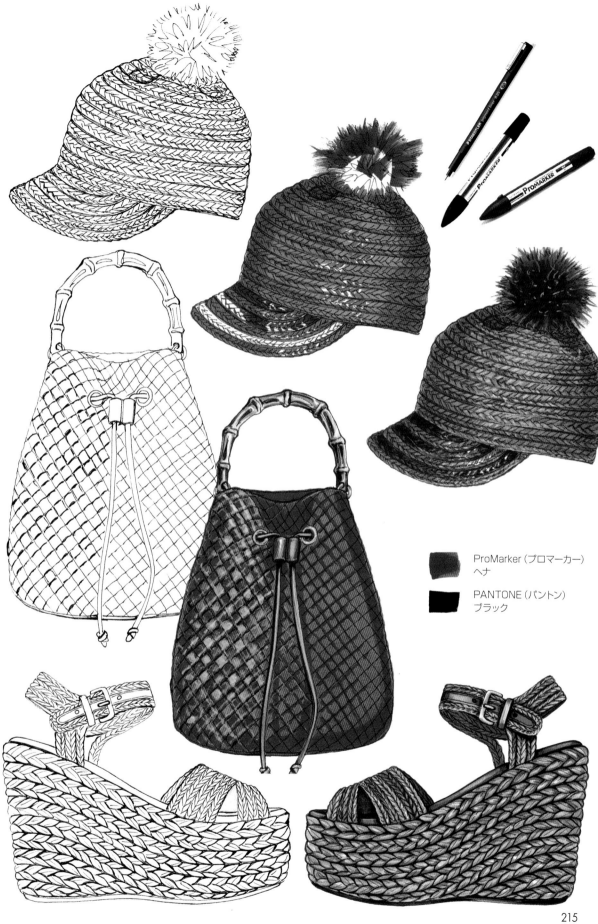

ProMarker (プロマーカー)
ヘナ

PANTONE (パントン)
ブラック

■ ラタン（籐）ウィッカー編み

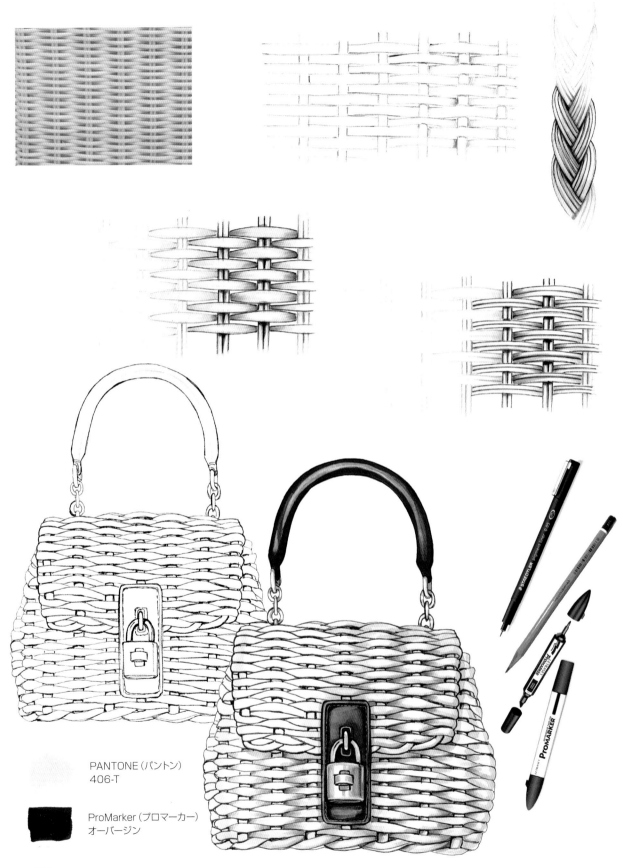

PANTONE（パントン）
406-T

ProMarker（プロマーカー）
オーバージン

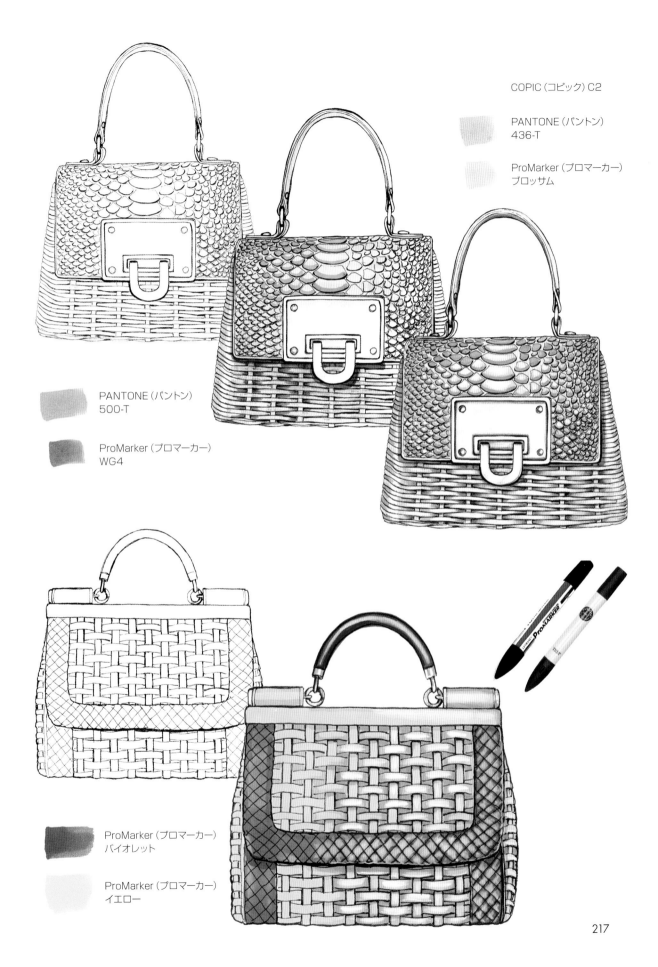

COPIC (コピック) C2

PANTONE (パントン)
436-T

ProMarker (プロマーカー)
ブロッサム

PANTONE (パントン)
500-T

ProMarker (プロマーカー)
WG4

ProMarker (プロマーカー)
バイオレット

ProMarker (プロマーカー)
イエロー

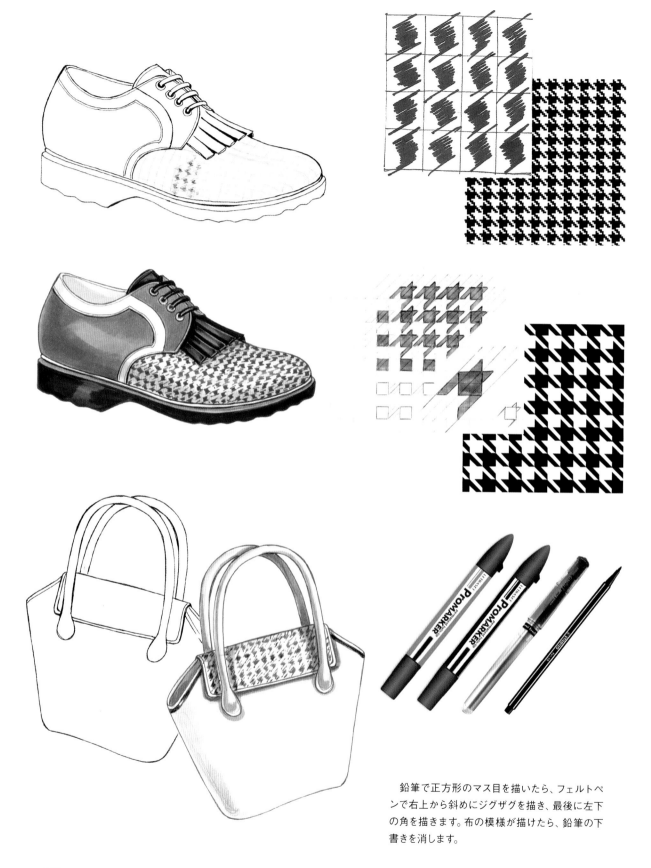

■ ハウンドトゥース（千鳥格子）

鉛筆で正方形のマス目を描いたら、フェルトペンで右上から斜めにジグザグを描き、最後に左下の角を描きます。布の模様が描けたら、鉛筆の下書きを消します。

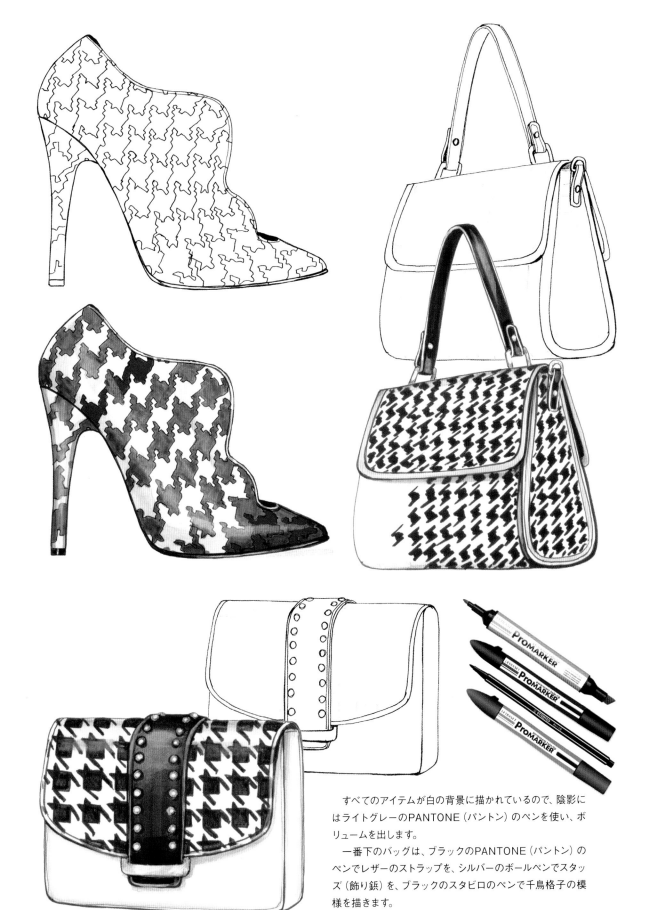

すべてのアイテムが白の背景に描かれているので、陰影には
ライトグレーのPANTONE（パントン）のペンを使い、ボ
リュームを出します。
　一番下のバッグは、ブラックのPANTONE（パントン）の
ペンでレザーのストラップを、シルバーのボールペンでスタッ
ズ（飾り鋲）を、ブラックのスタビロのペンで千鳥格子の模
様を描きます。

■ プリンス・オブ・ウェールズ・チェック

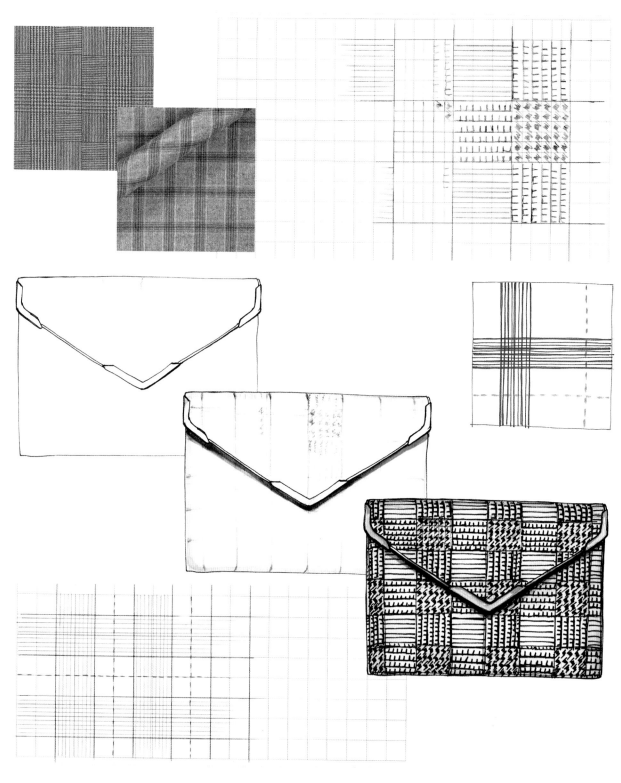

　鉛筆で4〜5本の縦線を等間隔に並べて描きます。その後、こ
れらの線と並行するようにさらに線を書き足します。水平方向に
も同じように線を引いて、規則正しい格子模様を作ります。広

い正方形の中心を通るように、カラーの極細ペンで垂直と水平
方向に点線を描きます。

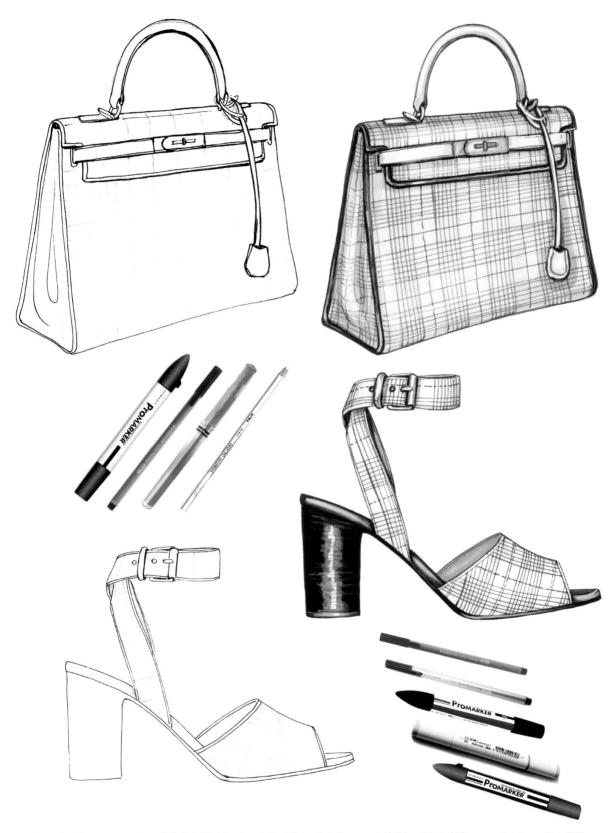

　上のバッグは、ベースの色に薄紫色を選びました。実線は濃いライラック色のトリプラスファインライナーで、点線はブルーのペンで描き、バッグのフチには同じくブルーのスタビロのマーカーで色付けしました。金属製のクラスプ（留め金）にはゴールドのゲルペンを使用し、それから濃いヘーゼルナッツ色で陰影をつけ、白の色鉛筆でハンドルの丸み、バッグ上部の曲線、側面にできる柔らかいひだにハイライトをつけました。

■ タータンチェック

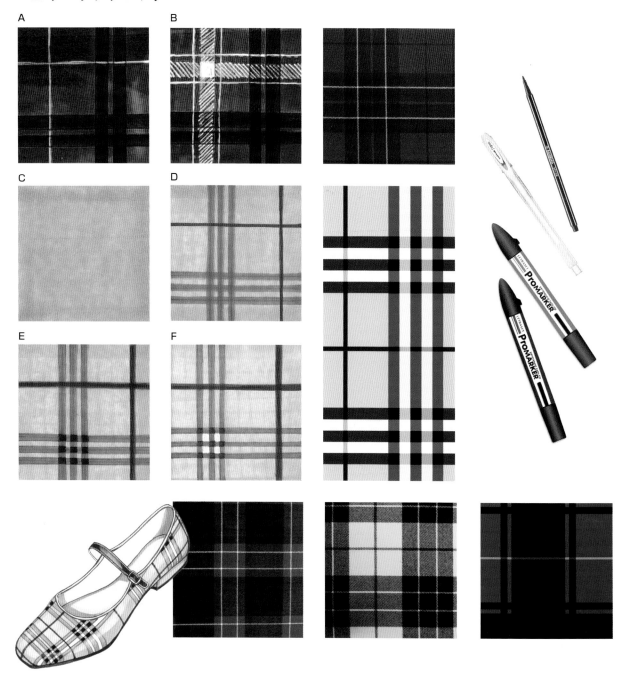

A A B

C D

E F

A）赤に黒いラインのタータンチェック（最上段左）は、ベースにPANTONE（パントン）のレッドを選びます。2本組の線の輪郭を鉛筆で縦方向と横方向に描いてから、ダークグレーか黒のPANTONE（パントン）で塗ります。さらに、白のペンで細線を引きます。

B）その隣り（最上段中央）では、白で黒の太線と同じ太さの線を描き加えています。この際、縦線と横線が赤い正方形の中心で交差するようにし、白線の中は白ペンで斜め線を描くようにして埋めていきます。交差する部分の四角形は白のベタ塗りにします。

C）ベージュのタータンチェック（2段目左）は、ベースにサンドストーンのProMarker（プロマーカー）またはキャメルのPANTONE（パントン）を使います。

D）さらに、クールグレー4のPANTONE（パントン）で縦横に3本組の線を描いて交差させ、赤の細いマーカーでも線を縦横に描きます（2段目中央）。

E）はっきりした黒線が印象的なチェックの場合、黒線が交差した部分には黒のスタビロペンを使います（3段目左）。

F）線に囲まれた白い四角形の部分は白ペンで色をつけると、模様がくっきり出ます（3段目中央）。

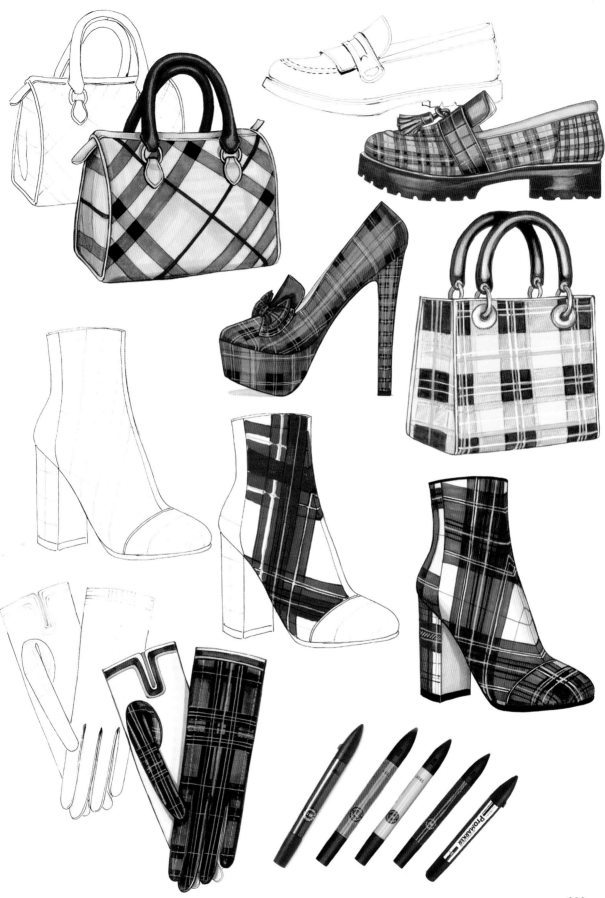

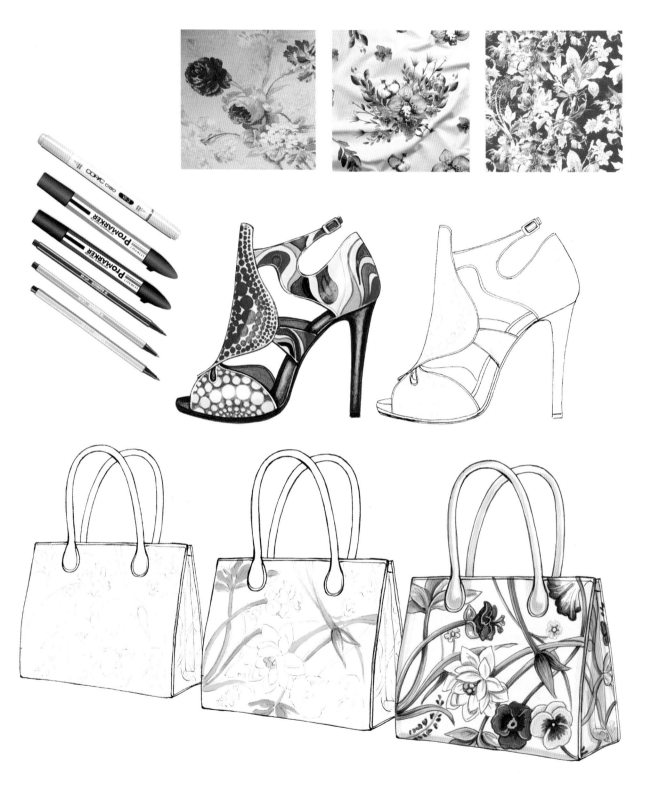

　鉛筆でデザインの下絵を描いてから、極細ペンを使って実線を描きます。それからペンで陰影をつけたり、ベースの色をつけたりして、模様を細かく描きます。最後の仕上げには極細ペンを使います。

　色を塗り終えたら、白い色鉛筆で輪郭に沿って光沢を加え、丸みを強調します。

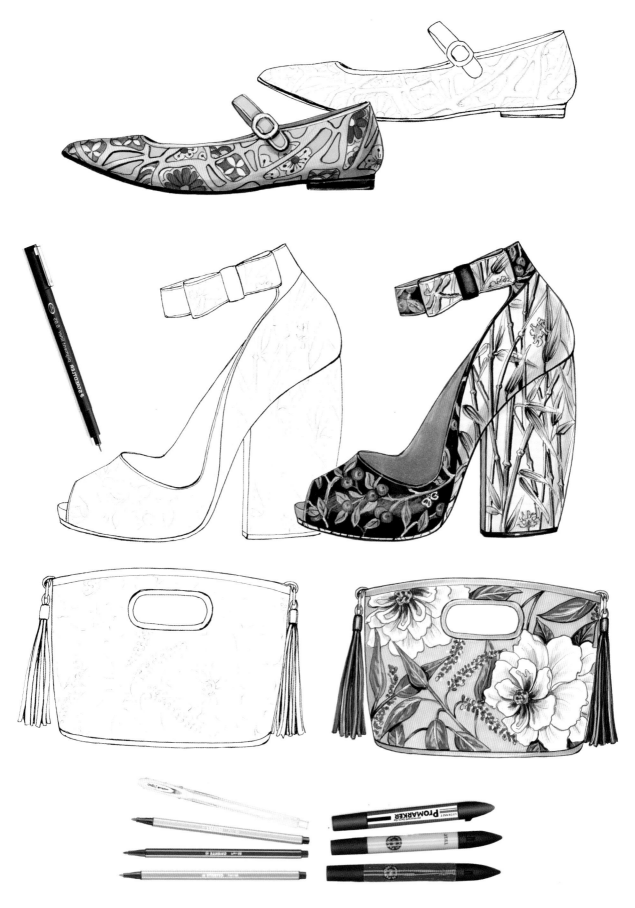

作品の形とデザイン

着想を得るために

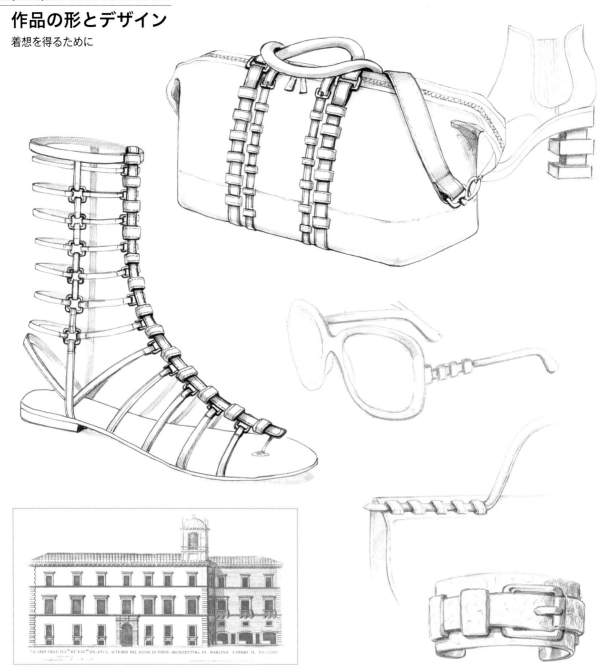

　風にひるがえるスカート、息をのむような自然の風景、歴史的建造物の正面デザイン、写真集、あるいは1枚の絵はがきなど。クリエイティブな人は、常に自分の周りにあるものからインスピレーションを得ています。

　ファッションにおいて売れる商品を作るために、創造性は不可欠な要素です。創造性とは技術ではなく、発想を得て発展させるための能力であり、その過程では失敗するリスクも受け入れなければなりません。

　創造性は、アートの原動力でもあり、ルールや限界とは無縁です。遊び心や実験精神、直感に基づき、異なる要素を大胆に組み合わせる試みは、どこまでも可能性が広がります。例えば、ニューヨークの摩天楼がアールデコ風のモチーフになり、ヨーロッパの伝統建築の正面デザインが幾何学模様の美しいバッグに変身するかもしれません。パリのシンボルであるエッフェル塔は魅惑的な靴のヒールとなり、大きなインパクトを与えます。

　天才は、理屈に従わないと同時に、几帳面でもあります。パブロ・ピカソの名言によれば「プロのようにルールを学び、アーティストのようにルールを破ればいい」のです。

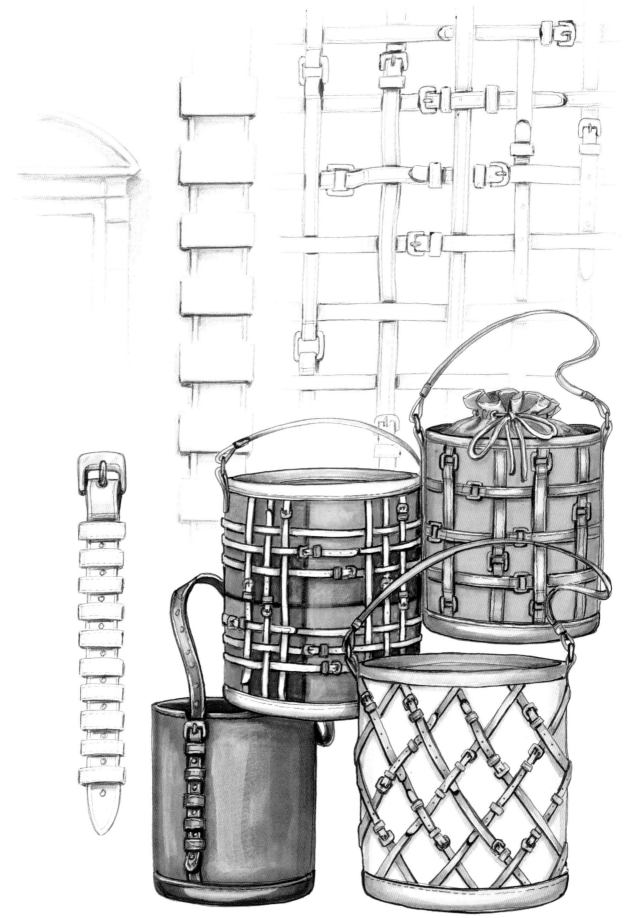

■ ニューヨーク

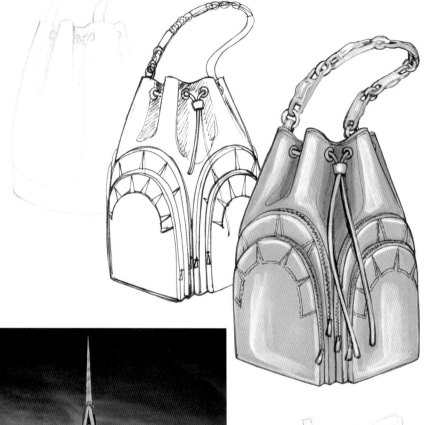

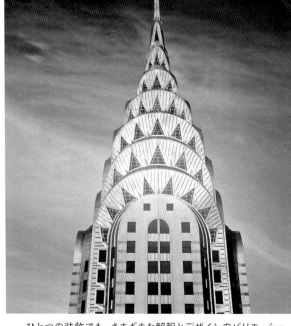

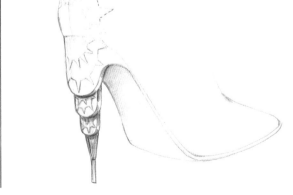

　ひとつの装飾でも、さまざまな解釈とデザインのバリエーションが生まれます。建築が面白いデザインにつながることは珍しくありません。ここでは、ニューヨークの超高層建築クライスラービルをもとに、デザインした例を見てみましょう。

　アールデコの構造の特徴である半円形の幾何学模様が、その

ままバケットバッグのデザインになります。

　右ページでは、ピンクのスリッポンシューズのプラットフォームソール（54ページ参照）のデザインになり、バッグのポケットのデザインにも生かされています。

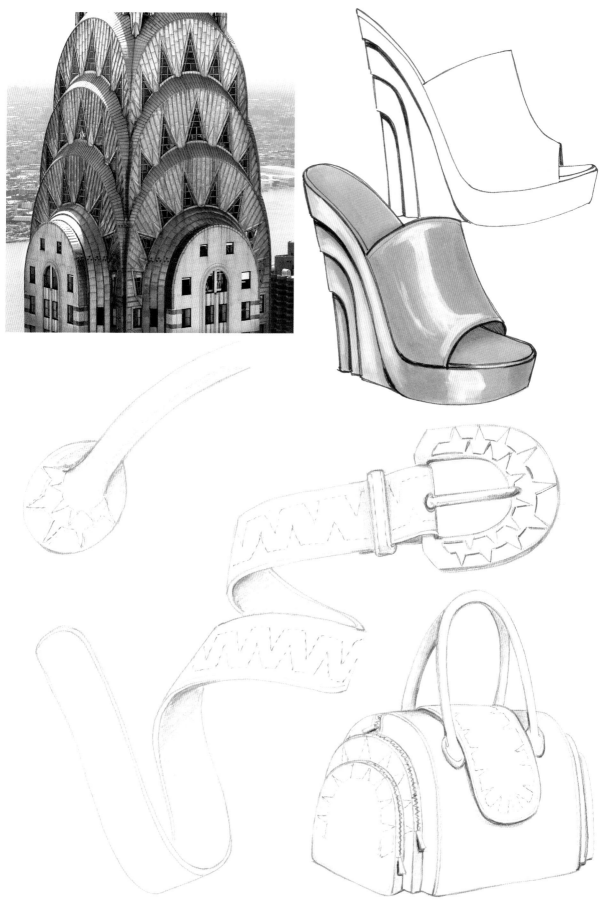

229

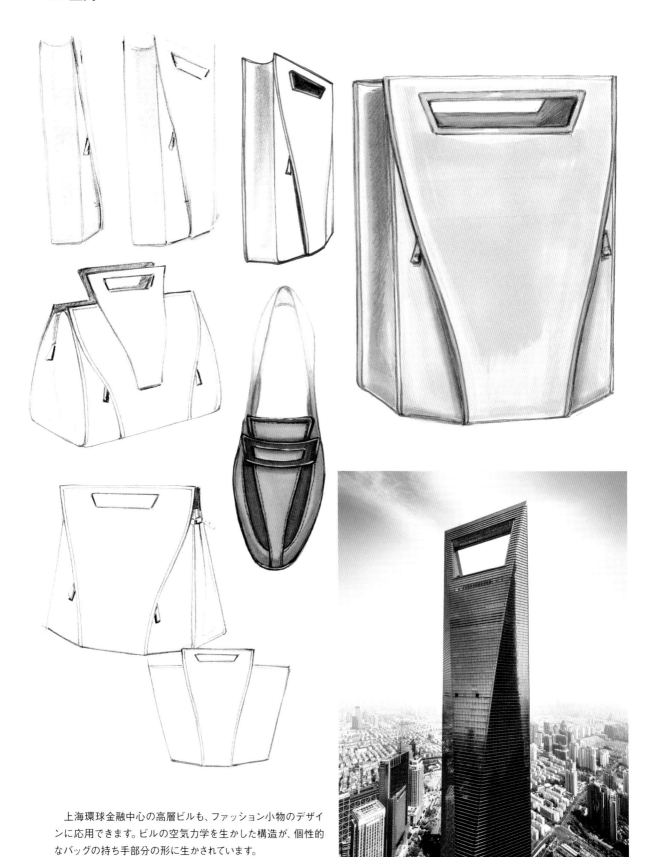

■ 上海

　上海環球金融中心の高層ビルも、ファッション小物のデザインに応用できます。ビルの空気力学を生かした構造が、個性的なバッグの持ち手部分の形に生かされています。

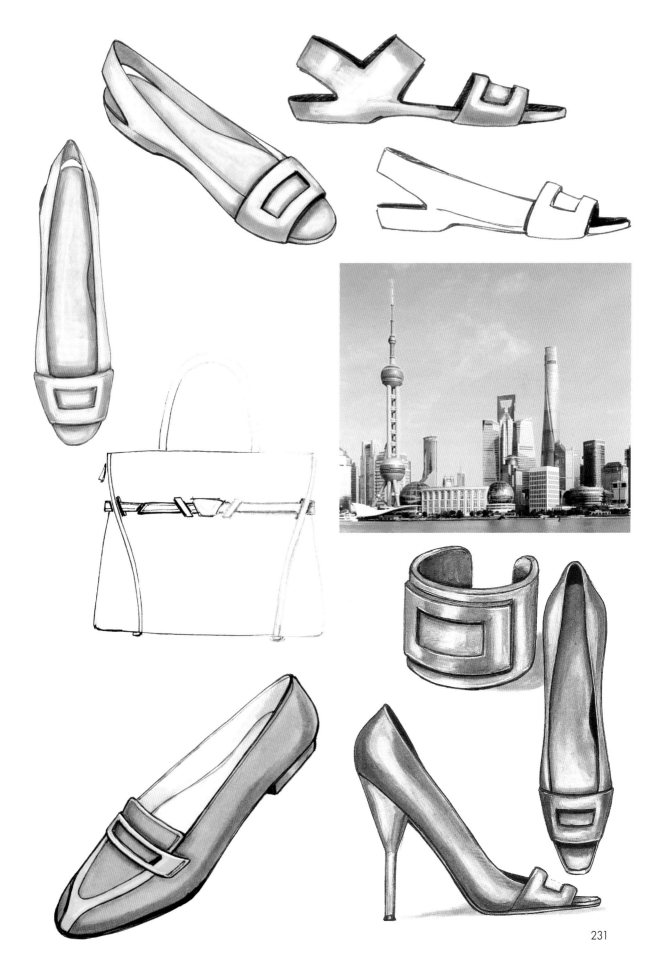

231

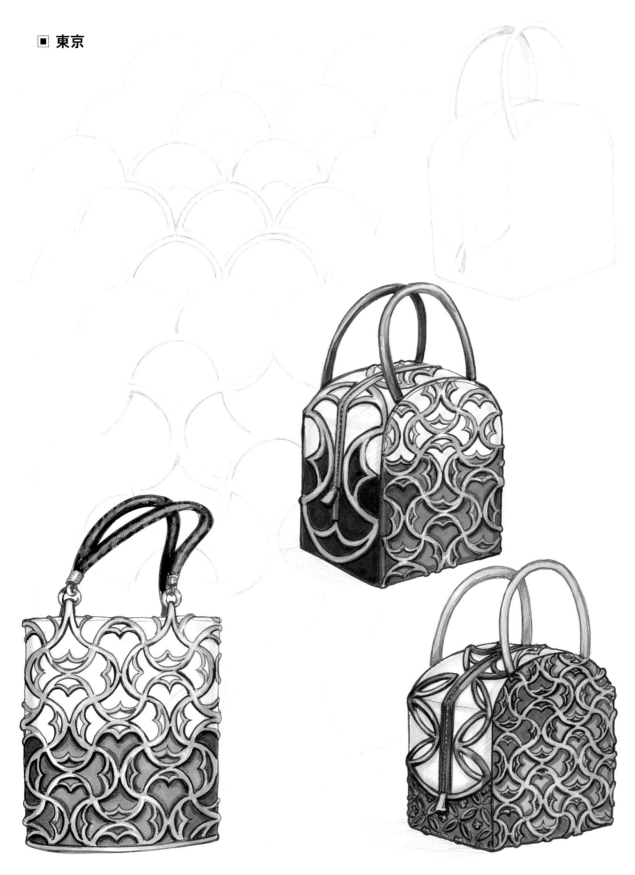

　日本伝統の幾何学的な模様をもとに、バッグやスリッポンをデザインしました。カラフルなモチーフや透明な素材を用いています。また、同じデザインで透かし模様のブレスレットも作ってみました。

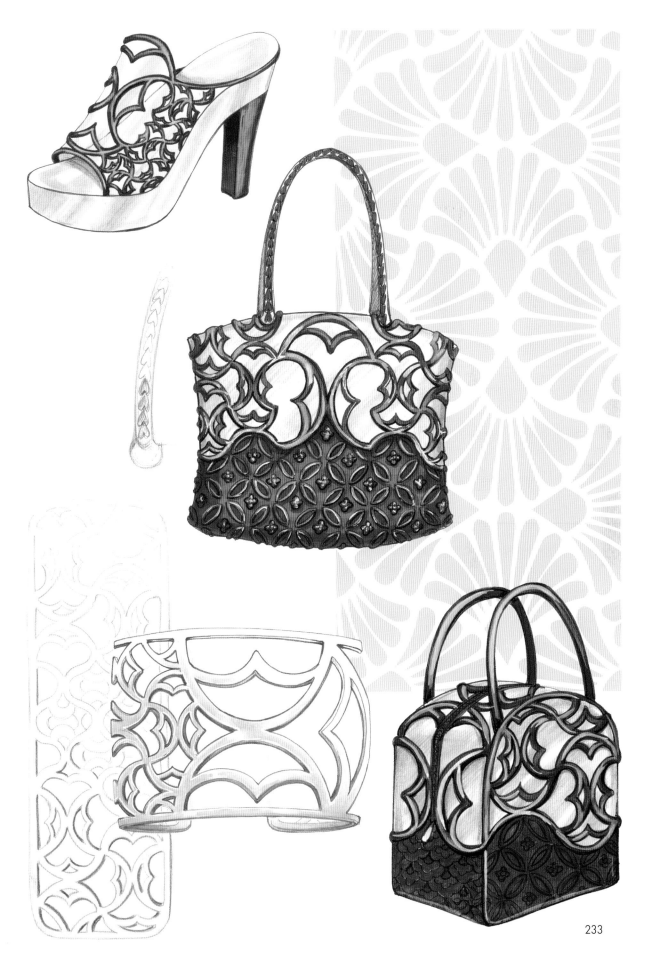

■ テヘラン

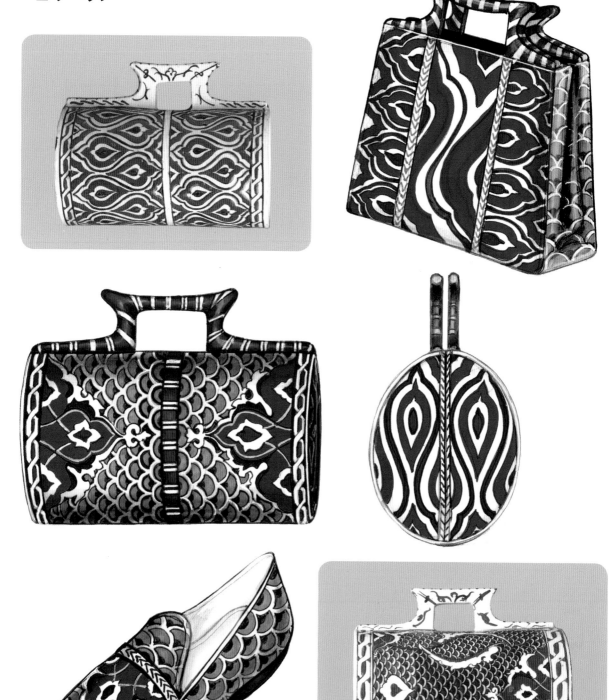

　ここではマグカップに装飾を施し、90度回転させてバッグの
デザインに変身させました。装飾のモチーフだけをバッグにプリ
ントしたり、マグカップの持ち手だけをバッグの持ち手部分のテ

ンプレートとして用いたりといったことも可能です。どんなもの
でもファッション小物のデザインに発展させることができるので
す。ぜひ、チャレンジしてみてください。

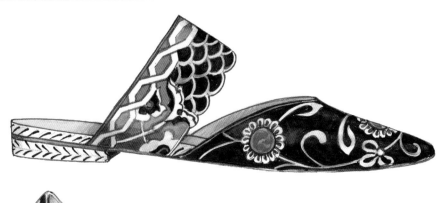
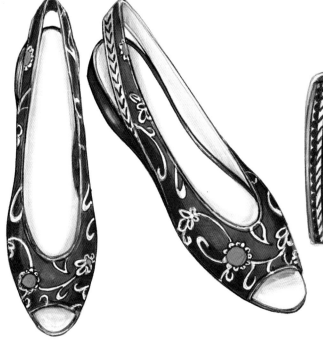
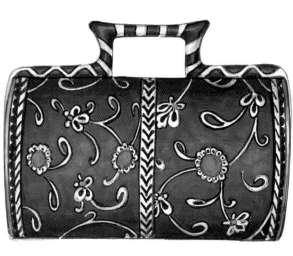

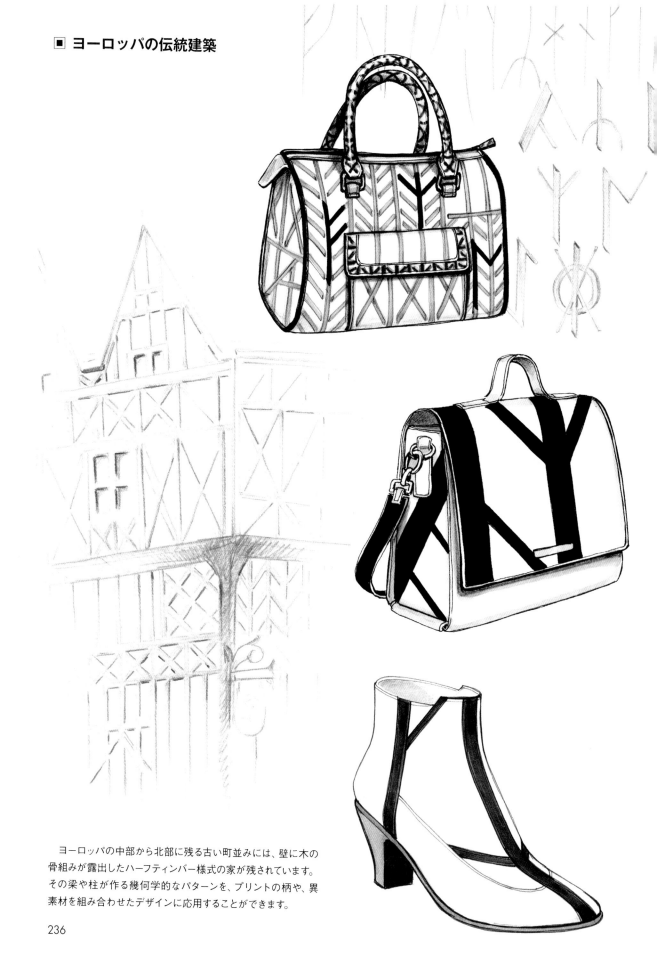

◼ ヨーロッパの伝統建築

　ヨーロッパの中部から北部に残る古い町並みには、壁に木の骨組みが露出したハーフティンバー様式の家が残されています。その梁や柱が作る幾何学的なパターンを、プリントの柄や、異素材を組み合わせたデザインに応用することができます。

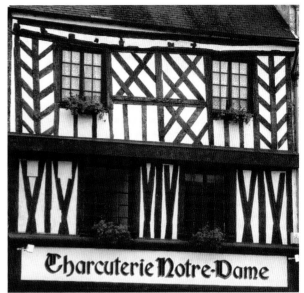

Charcuterie Notre-Dame

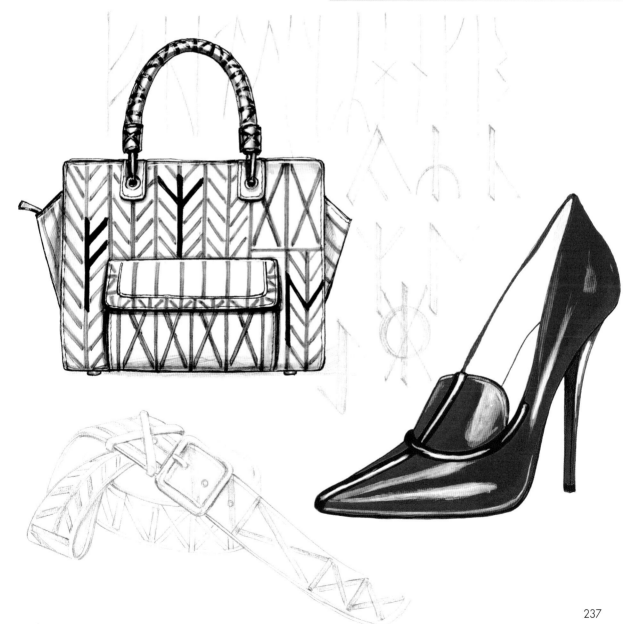

■ パリ

　パリの道路標示板の印象的なデザインは、箱形のハンドバッグやベルトのバックルに応用できます。ローファーとケリーバッグ風のバッグには、この標示板の輪郭をアイデア源としたストラップとスタッズ（飾り鋲）をあしらいました。

　ここに紹介するのはクリエイティブなアイデアを描いただけの

 もので、最終的な形やモチーフを見つけるための最初のステップにすぎません。スケッチが最終的な製品の実現に至るかどうかは別として、まずは自由な発想をすることが大切です。商品化を考えるのは、その次のステップです。

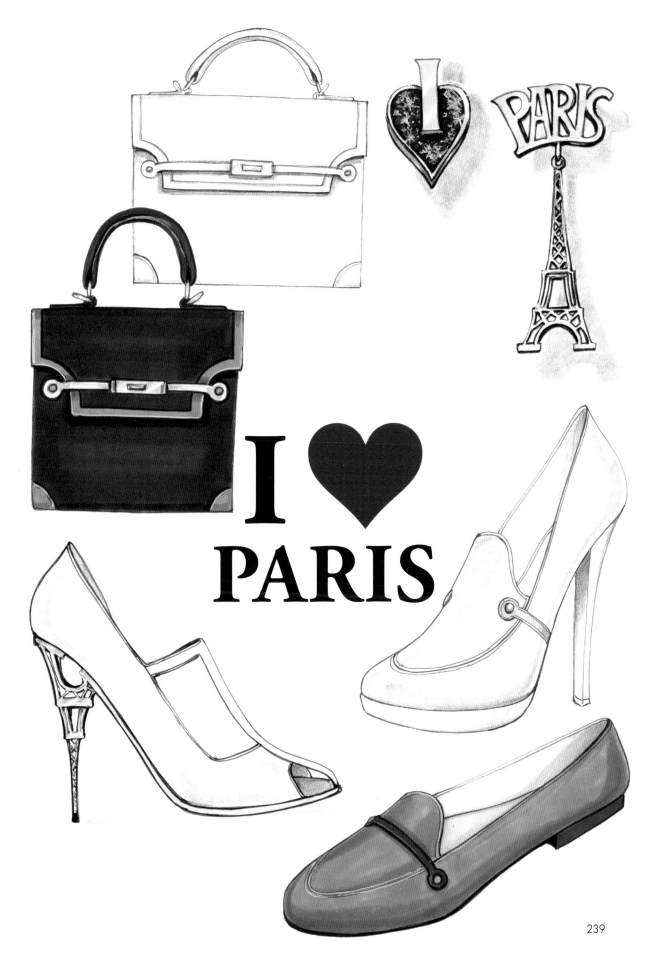

I ♥ PARIS

■ ミラノ

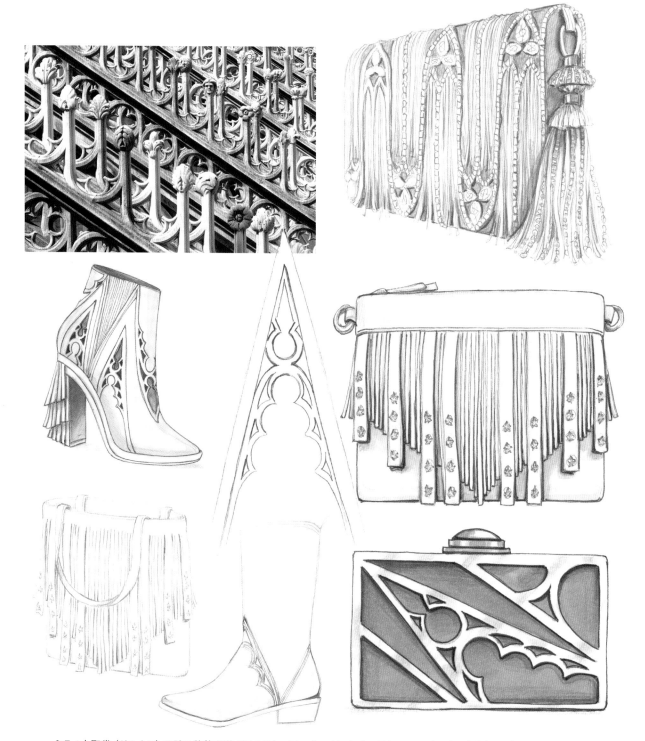

　ミラノ大聖堂（ドゥオモ）の壁の装飾を逆さにすると、シンプルなバッグやヒールによく似合うフリンジのようです。

　ほかにも、教会で見られる、中央から放射状にデザインされたバラ窓（円形の窓）のような調和のとれた幾何学模様は、刺繍やはめ込み細工のデザインの出発点になります。また、ゴシック建築特有のフリーズ（壁の装飾帯）をもとに、ベルトやバッグのストラップの模様をデザインしたり、帽子全体にプリントした

り、あるいはクラッチバッグの金属製の透かし細工に応用することもできます。

　こうしたパターンに基づく装飾的なストラップを、手袋や帽子、バッグや靴にあしらうこともできるでしょう。曲線的なフォルムがバッグや帽子などを華やかにし、ハンドバッグの持ち手や本体の形にもアクセントを加えてくれます。

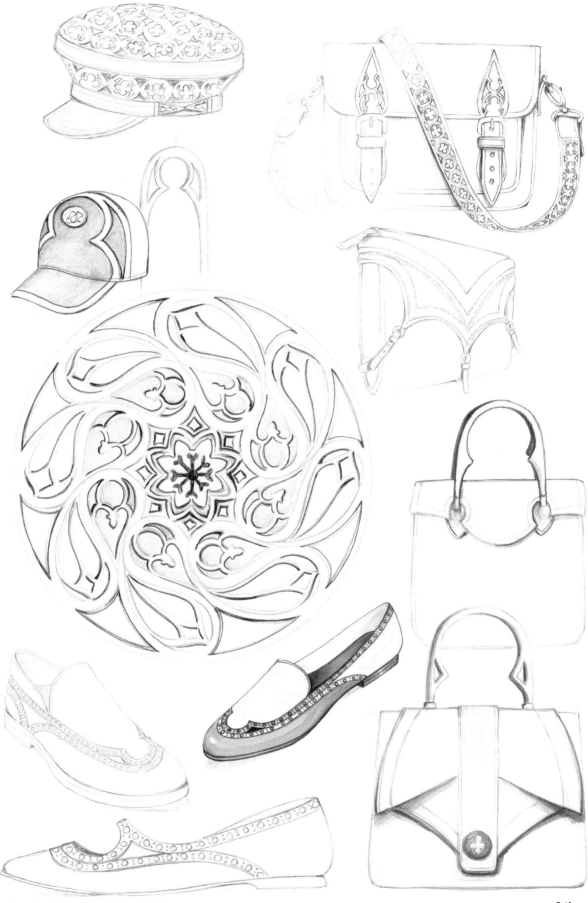

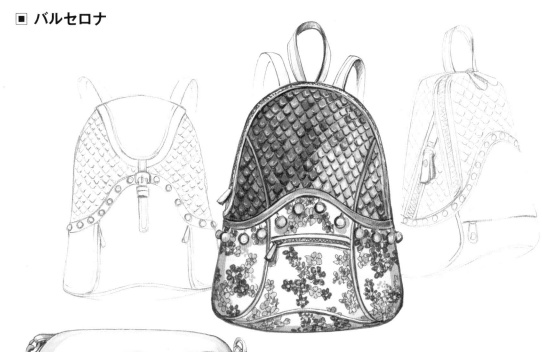

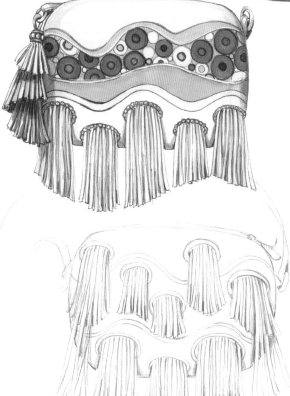

カサ・バトリョ

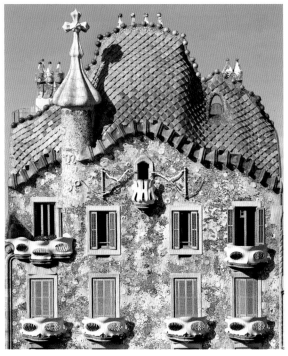

バルセロナの魅力といえば、ガウディの建築を連想しない人はいないでしょう。ガウディの作品は、どんなにささやかなディテールにも、すばらしいコレクションにつながる発想の息吹を与えてくれる力があります。

曲線的な形の純粋な美しさから、豊かで奔放な効果まで、インスピレーションが尽きることはありません。

たとえばカサ・バトリョを見れば、カラフルな瓦の屋根から鮮やかなヘビ革や花柄のバックパックが連想できますし、柔らかな曲線のバルコニーからは帽子や靴の輪郭が思い浮かびます。

カサ・ミラの曲線的な屋根は、オーストリッチを使った透かし細工に応用でき、煙突の形はリブ編みの模様で装飾されたバケットバッグにつなげられるでしょう。

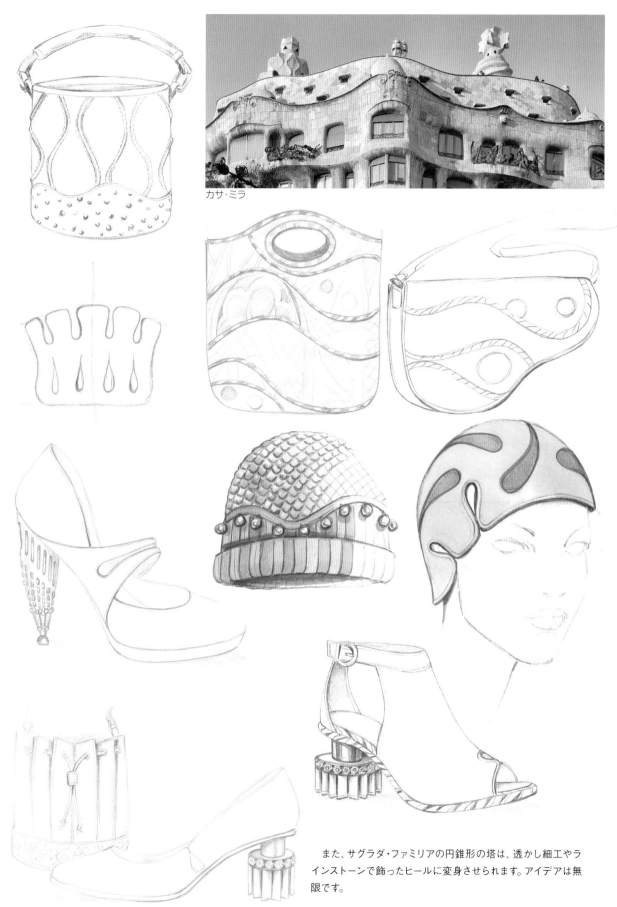

カサ・ミラ

また、サグラダ・ファミリアの円錐形の塔は、透かし細工やラインストーンで飾ったヒールに変身させられます。アイデアは無限です。

作品の形とデザイン
デザインを転換させる

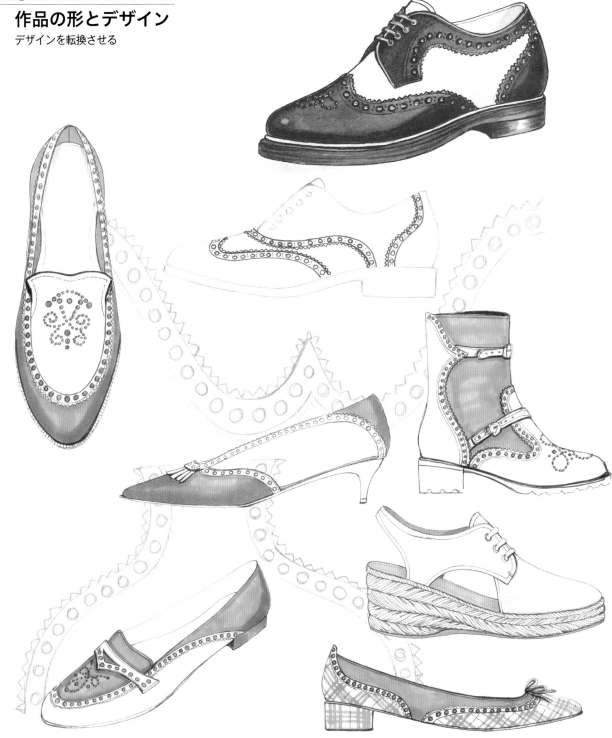

　創造的なプロセスは、いわば転換でもあります。何もないところから何かを生み出すことはできません。創造性とは、すでに存在する要素を本来の文脈から引き離し、独自の方法で新しい組み合わせを作り出す能力といえます。

　ここでは、オックスフォードシューズを、サンダル、ブーツ、スニーカーなど、全く異なるスタイルに変身させる方法を見てみましょう。オックスフォードシューズを特徴づけるディテールに着目し、応用します。オックスフォードシューズの特徴は、ツバメの尾のような切れ込み、穴飾り、それにジグザグのカットです。これらの装飾の要素を、小さな穴をスタッズ（飾り鋲）で置き換えたり、ジグザグの縁の代わりにルーシュ（飾り紐）を加えたりすることで転換させることができます。こうしたエクササイズを通して、創造性を鍛えることができます。

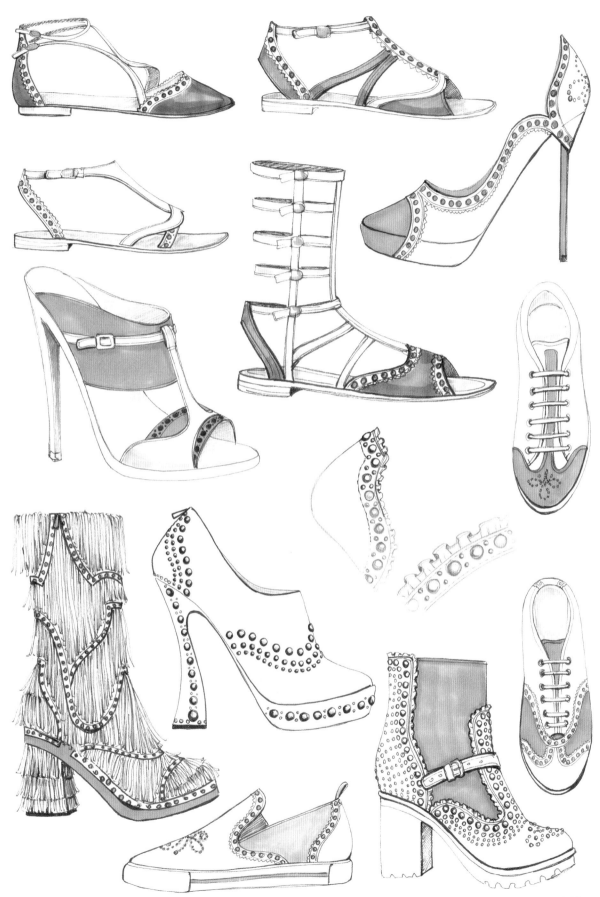

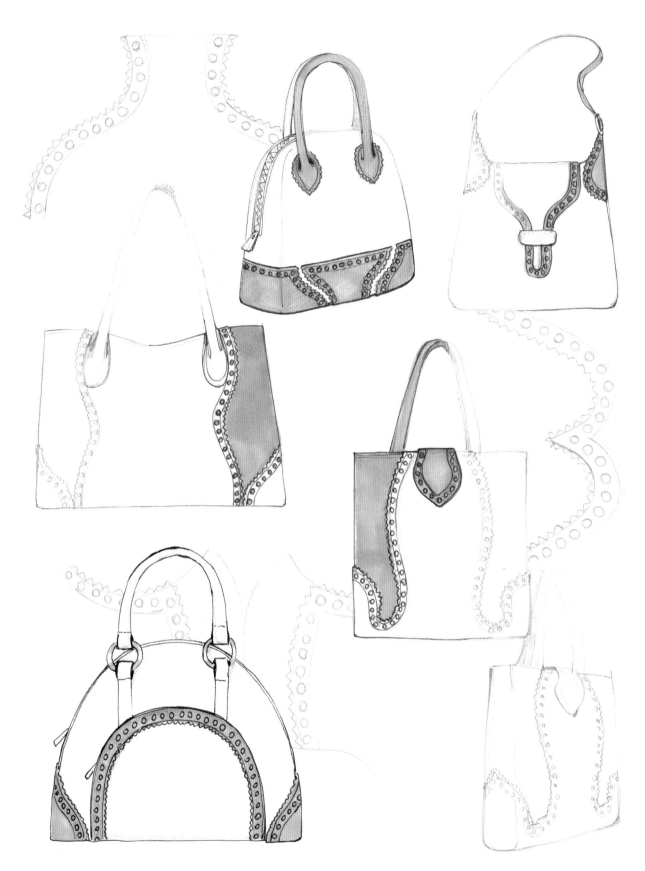

　同じ原則に従って、オックスフォードシューズを別の小物に変
身させることもできます。ここではバッグをデザインしてみましょ
う。形と装飾的要素を生かしつつ、それらを自由な組み合わせで
配置しなおします。

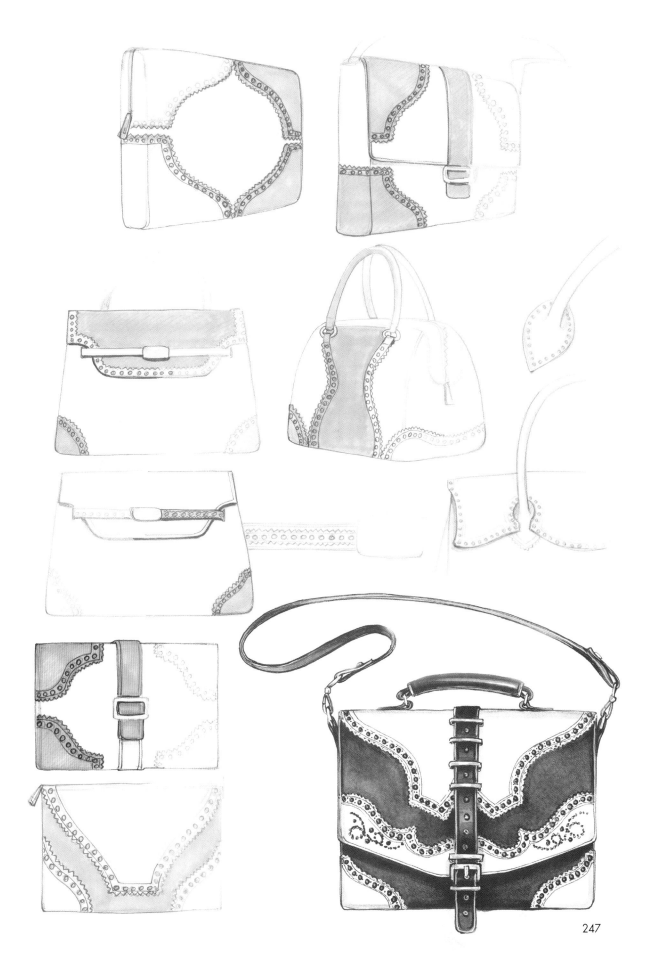

247

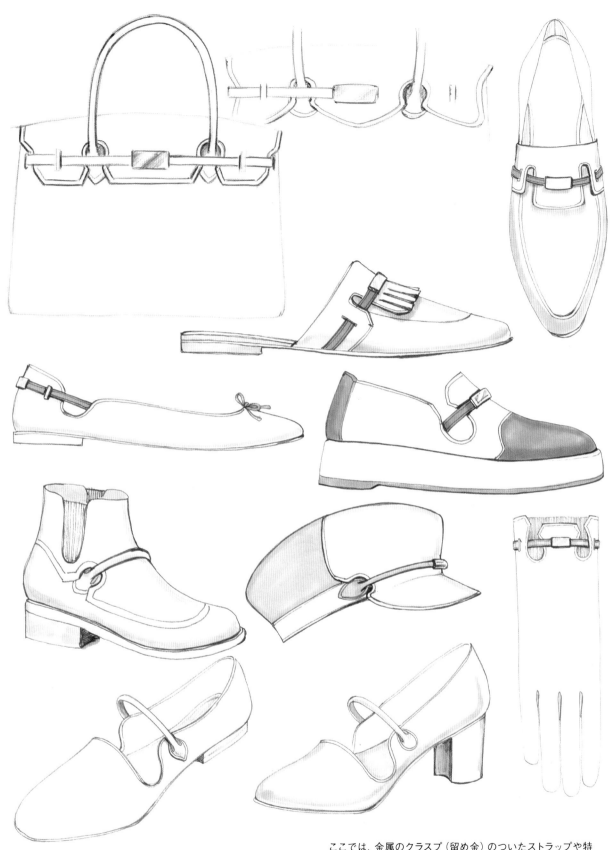

ここでは、金属のクラスプ（留め金）のついたストラップや特徴的なバーキン風の持ち手といったバッグのディテールを、手袋、靴、帽子などさまざまな小物に応用しています。

248

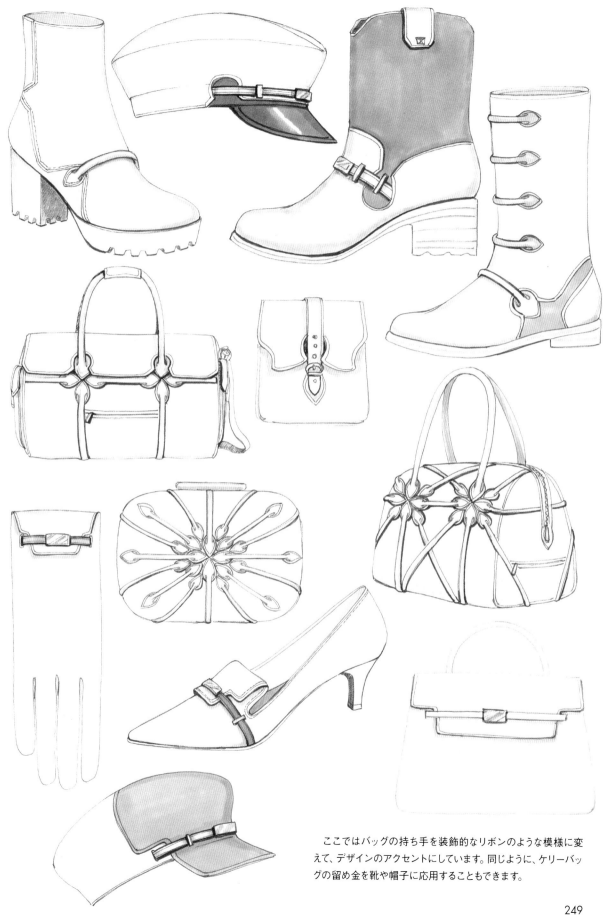

ここではバッグの持ち手を装飾的なリボンのような模様に変えて、デザインのアクセントにしています。同じように、ケリーバッグの留め金を靴や帽子に応用することもできます。

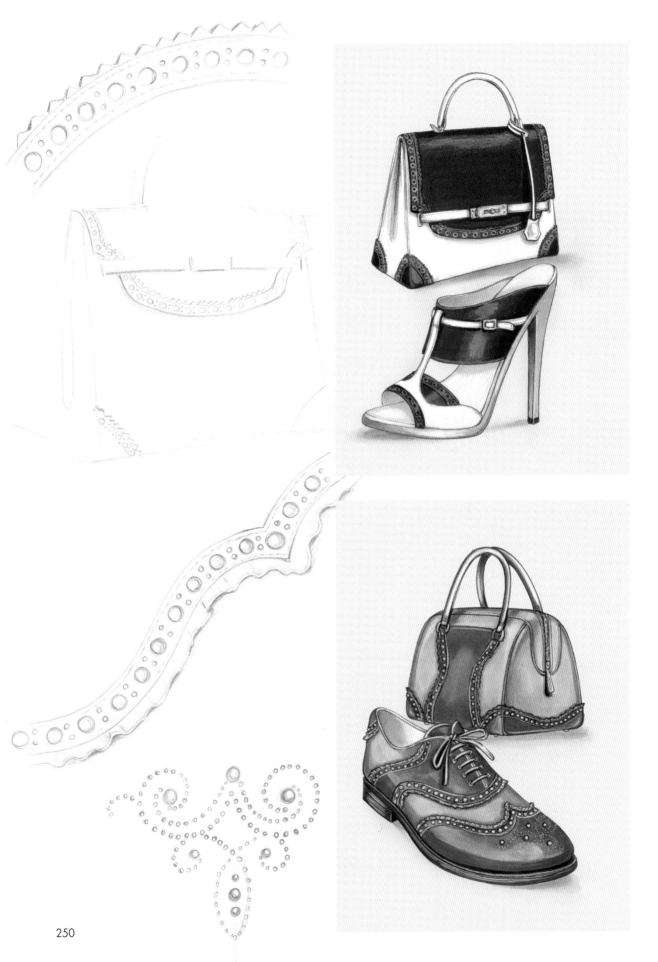

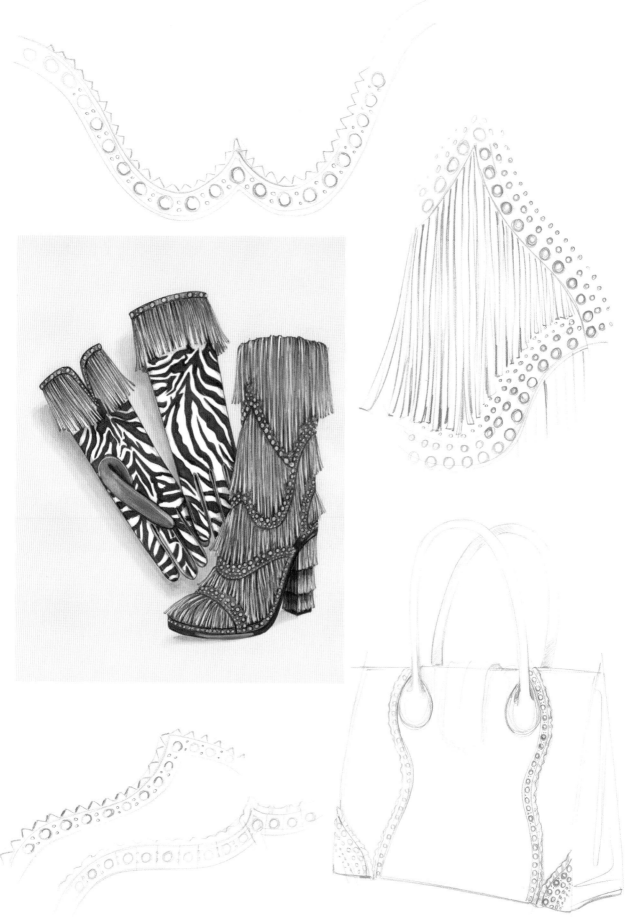

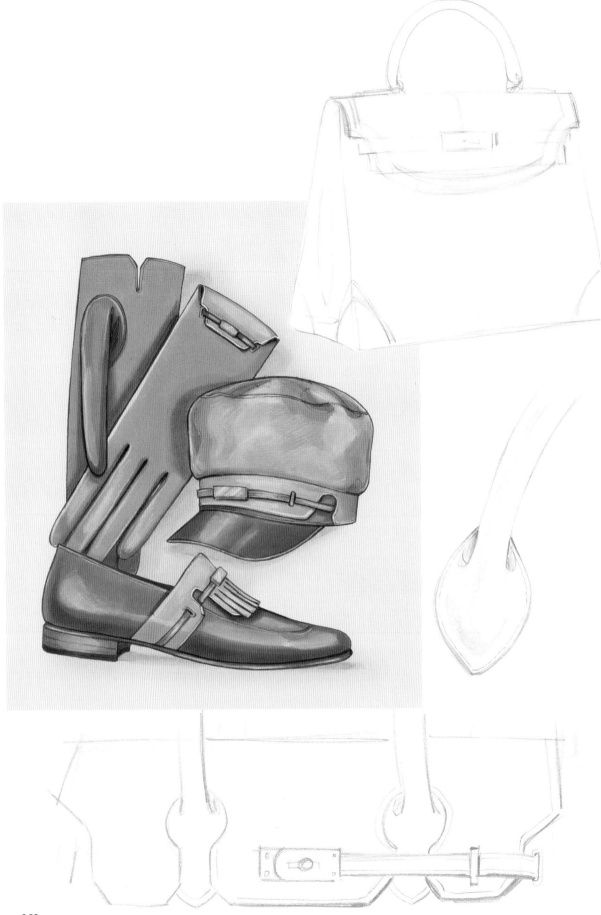

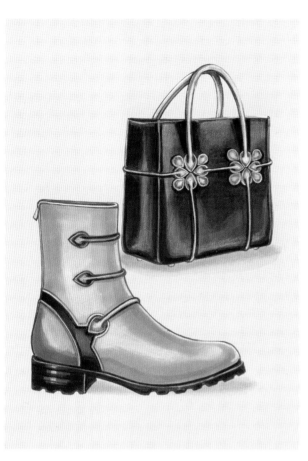

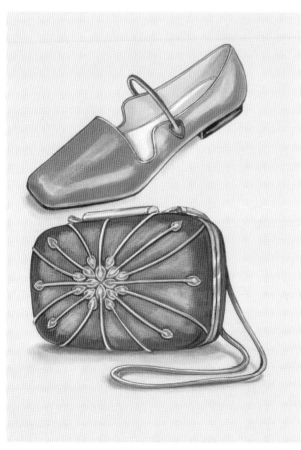

ファッションアクセサリーの近代史

　タイムマシンに乗った気分で、20世紀ファッション小物の世界を旅してみましょう。ファッションのトレンドは同時代の世界を反映するものです。

　20世紀は2つの世界大戦が起こり、好況期と復興の時代が繰り返されました。ファッションは過去の形やテイストをベースにしながら、素材の革新や体型の変化に合わせ、修正や調整が加えられました。競争の激しいグローバルファッションの市場が誕生し、常に新しいものを求める消費者のニーズに応える必要も出てきました。

　20世紀初頭は19世紀のスタイルを踏襲していましたが、第一次世界大戦後には新しい社会と文化の規範に基づき、産業や技術の進化を反映した大きな変化が次々と起こりました。19世紀のファッションが貴族文化に従っていたとすれば、20世紀のファッションや人々の振る舞いなどの流行を牽引したのは映画でした。

　ファッション小物の世界を探求するこの本の旅も、終わりに近づいてきました。ここで、過去100年間のファッション史の決定的な出来事をおさらいしたいと思います。現代のようなファッション小物が生まれた背景と、進化の原動力を探ってみましょう。時代を超える永遠のファッション小物を生み出した個性的な女性たちの影響も、忘れてはなりません。

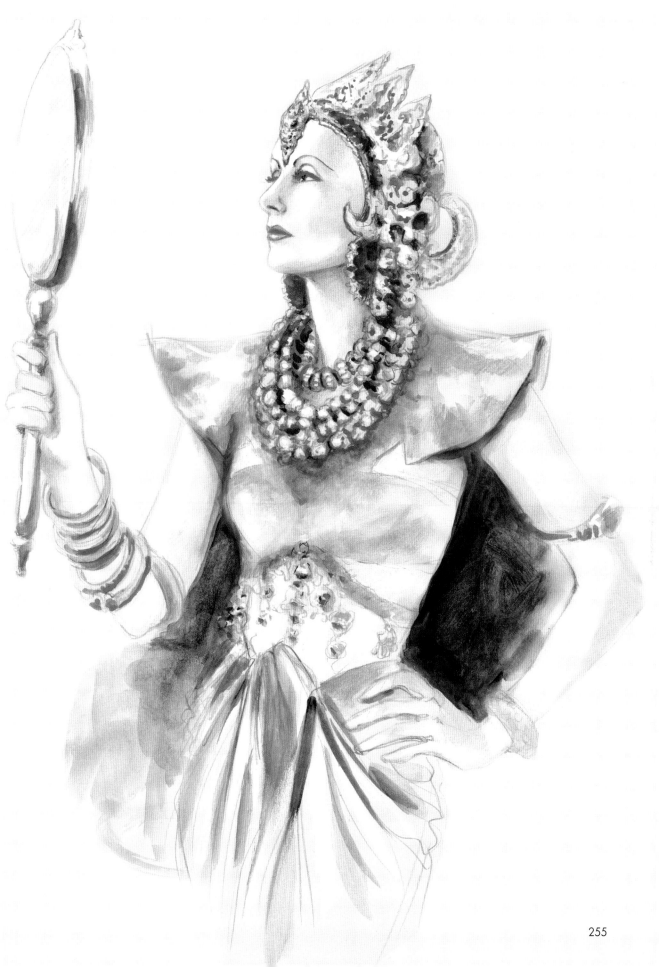

◼ 1910年代

　ベルエポック（美しい時代）とも呼ばれる時代です。サラ・ベルナールとエレオノーラ・ドゥーゼが、ヨーロッパの演劇界に君臨していました。歴史上、最も魅力的な時代のひとつであり、当時のファッションには大胆で官能的な曲線が豊富に見られ、新世紀にふさわしいエレガンスと美意識が生まれました。

　19世紀には大きな羽飾りの帽子が人気でしたが、帽子はリボンやレース、シルクフラワーで飾られるようになりました。また、革や刺繍した布を素材にしてサイドボタンをつけたアンクルブーツが、大きく広がるスカートを履く上流社会の女性たちの足元を彩りました。ジュエリーはエナメル素材で、トンボや花、石など自然からインスピレーションを得たデザインが人気を博しました。

　さまざまな素材を使ったバッグは、幾何学的な中東のデザインにもヒントを得て、刺繍や金属の装飾で飾られています。パリのポール・ポワレのアトリエでは、トルコ宮廷のオダリスクの衣装にインスピレーションを得たハーレムパンツやホブルスカート（ペンシルスカートの前身となった細身のスカート）、豪華なサテン地に羽毛や貴重なダイヤモンドのブローチをあしらったアラブ風のターバンなどが制作されました。

◼ 1920年代

　この時代を象徴するファッション小物は、フランス出身のデザイナー、カロリーヌ・ルブーが発表したクローシェ帽です。釣り鐘のような形でつばが狭く、多くはフェルトでできていて、昼間の装いに適しています。また、チェーン付きのハンドバッグも1920年代に登場しました。メタリックなメッシュやビーズを刺繍した布を素材に、フリンジや金属のモチーフがついているデザインが人気でした。

　手袋は、二の腕までの長さ、あるいは非常に短いものが、サテン、レザー、チュール（メッシュ生地）などで作られました。パールのロングネックレスは、ドレスやブラウスの上に着けるジュエリーとして流行しました。また、1927年のイングランドを舞台にした映画『ダウントン・アビー』（2019年）の貴族女性、メアリー・タルボットのように、背中が大きく開いたドレスに合わせて、後ろ側に長く垂らすこともありました。

　トゥが丸いチャンキーヒール（太いヒール）のTバーシューズ（T字型のストラップのシューズ）や、レースやスパンコールで飾ったヘッドバンドも人気でした。優雅な女性らしさを演出するティアラは、夜のおしゃれに欠かせない小物でした。

　耳元で揺れる幾何学的なデザインのダイヤモンドのイヤリングは、当時「フラッパー」と呼ばれた解放された若い女性に愛用されました。デザイナーのココ・シャネルはこの時代、「家を出る前に鏡を見て、身に着けているものを何かひとつ取り外しなさい」という名言を残しました。

◼ 1930年代

　1930年代のファッション小物のデザインは今では定番となり、世界中の人々を魅了しています。当時のスタイルは決して流行遅れにならないという事実をデザイナーはよく理解しており、保存されたデータを利用して、スタイリッシュな時代ならではのアイテムを復活させています。

　ナイロン素材のタイツが作られるようになり、当時の女性はメアリー・ジェーン（ストラップつきの靴。50ページ参照）やデコルテ・シューズ（丸みを帯びた靴。38ページ参照）、ブローグ・シューズ（つま先に近い部分に小さな穴を開けて装飾にした靴）、ピープトゥ・サンダル（つま先が開いた靴）に合わせて足元のおしゃれを楽しみました。

　ジャケットやコートには毛皮のえり巻き、ウエストにはレザーベルトを合わせるようになりました。当時流行したアールデコは、幾何学的なラインに古代エジプト美術の要素も取り入れ、美的感覚に優れたデザインとスタイルで、今日でもモダンな魅力を失っていません。

　ドイツ出身の女優のマレーネ・ディートリッヒは両性具有的な美しさで、超然としていて、冷徹で、神々しさを持つこの時代の女性像を象徴する存在となりました。ディートリッヒは競合する映画配給会社に所属していた同時代の女優、グレタ・ガルボと人気を二分し、対照的な女性像を発展させました。

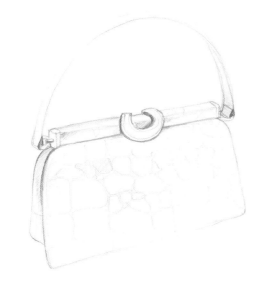

◼ 1940年代

　20年間に及んだファシズムの時代には、強さと完璧な肉体に基づく新しい女性像が生まれました。第二次世界大戦下の女性たちは、フリルなどの装飾を捨て去り、快適で機能的なスタイルを採用しました。洋服や小物は修繕しながら使われ、ヒールは低くなり、華やかさよりも快適さと丈夫さが優先されました。

　ナイロンは軍服の素材としても使われるようになり、アメリカでは女性が脚の後ろ側に黒い線を引いてストッキングを履いているように見せるのも流行しました。フェミニンなスタイルが復活し、ファッションにおいて革新が生まれるようになったのは戦後のことでした。

　1947年にデザイナーのクリスチャン・ディオールが、その後の10年間を通して象徴的なスタイルとなる「ニュールック」を発表しました。メガネの形も変わり、軽快で洗練されたキャッツアイ（レンズ枠が吊り上がったもの）が登場します。ピンナップガールは、靴に短いソックスを合わせ、スナップボタンのついたかっちりとした正方形のバッグを持つのがお決まりでした。

　アメリカ出身の女優、リタ・ヘイワースは、映画『ギルダ』（1946年）でサテンの長手袋を身に着け、退廃的で奔放で苦悩に満ちたファム・ファタールの役柄を見事に演じ、豊満な肉体によって美のアイコン（注目を集める存在）となりました。

■ 1950年代

完璧な洗練さを見せたもとケネディ大統領夫人ジャッキー・ケネディと、セクシーな女優マリリン・モンローが対照的な「スタイルアイコン」（注目を集める存在）として登場し、エレガントなファッションと恋愛遍歴を見せた時代でした。

ジャッキー・ケネディは貴族的でシック、マリリン・モンローは女性的な魅力にあふれていました。水玉模様のバッグや靴が軽やかでチャーミングな小物として流行し、初めて登場したビキニは当時の保守的な人たちに衝撃を与えました。

雑誌の表紙はマリリン・モンローや、女優のジェーン・ラッセルのような豊満な美女の写真で埋め尽くされましたが、一般女性は履き心地のよいバレリーナシューズを履き、カラフルなネッカチーフを首に巻き、ベルトで細いウエストを強調し、カジュアルな装いを楽しむようになりました。

ラインストーンが揺れるイヤリングや金属の大きなフープのイヤリング、ウェッジシューズ（56ページ参照）、ストロー（麦わら）素材のバッグ、オーバーサイズのメガネも人気を博しました。

カリフォルニアの高校を舞台にした映画『グリース』で、校内のグループ「ピンク・レディース」のメンバーは衿ぐりの深いトップとストレッチ素材のパンツにつやのある黒の革ジャケットを着て、不良少年たちを誘惑します。ピンヒールやスプール・ヒール、フレアスカート、キャッツアイのメガネといったロカビリー・ファッションの小物は、今も色あせることがありません。

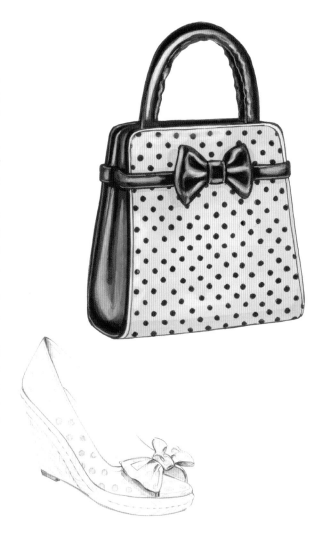

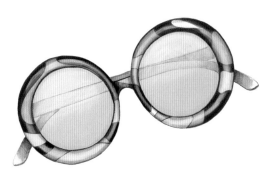

■ 1960年代

1960年代は起毛したスエードや光沢のある素材の小さなハンドバッグが大流行しました。チェーン、留め金、バックルなどの要素が装飾として使われるようになり、以前にはなかったデザインが生まれました。その究極の例が、デザイナーのパコ・ラバンヌが生み出した伝説的なバッグ「1969」で、全体がフレキシブルな金属の鎖を編み合わせてできています。

また、カラフルなプラスチックがさまざまな小物に使われ、デザイナーのエミリオ・プッチは多色づかいのパターンでピアスやオーバーサイズのメガネを彩りました。

1960年代はフェミニンなスタイルが再発見され、自由に表現された時代でもありました。さまざまな高さのピンヒール、ローヒールのデコルテ・シューズ（38ページ参照）などのエレガントで洗練された靴と、カラフルなラインストーンで飾ったプラスチックのヘッドバンドが人気を集めました。

デザイナーのマリー・クヮントは、ありとあらゆるタブーを破って、ニーハイブーツとミニスカートで女性の装いに革命を起こします。モデルのツイッギーは、フラットなモカシンシューズとミニドレスを愛用しました。女優のオードリー・ヘップバーンも当時を代表するスタイルアイコンで、映画『ティファニーで朝食を』で大きな黒のサングラスをかけた姿は、ファッション史に永遠に刻まれています。

■ 1970年代

ベトナム戦争の影響もあり、ヒッピーや女性解放の運動が生まれた時代です。色とりどりのワイルドな花柄や大きなデイジーのモチーフが典型的で、平和を愛し、自然を象徴するファッションで装った当時の若者はフラワーチルドレンと呼ばれました。

ストライプや花柄、サイケデリックな柄が、服だけでなくサンダルやベルト、丸いメガネ、ストロー（麦わら）素材の大型のバッグなどの小物を彩りました。

アメリカのテレビは当時のヨーロッパに見られた女性らしさへの憧れをかき立て、セクシー女優ファラ・フォーセットが出演した連続ドラマ『チャーリーズ・エンジェル』が大ヒットしました。ドラマで描かれた、セクシーで美しく、勇気のある女性たちの姿は、新時代の女性が手に入れた強さを表わしていました。

この時代の強い女性たちがフェミニンな服や小物を完全に捨て去ることはなかった一方で、デザイナーのイヴ・サンローランはマスキュリン・ルック（男性的なスタイル）を打ち出して成功を収めました。

つま先からかかとまで厚底になったプラットフォームのサンダル（56ページ参照）や、キャンバス地やデニム地のバッグは使いやすい実用的な小物で、過去の女性たちが従っていたファッションのルールからはかけ離れています。アビエイターサングラスのほか、フランス出身の女優ブリジット・バルドーがフランス南部のリゾート地サントロペでの休暇中に愛用したような、つばの広い帽子も流行しました。

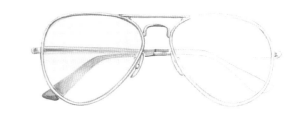

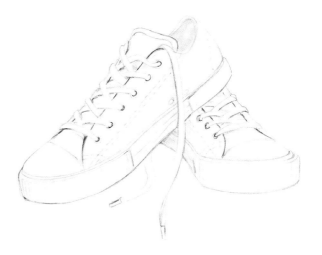

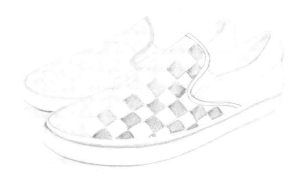

■ 1980年代

ファッション小物が最も重要な転機を迎え、ありとあらゆる色や形を用いた実験的なデザインが次々と誕生した時代です。マドンナがスタイルアイコンとして登場し、つま先が尖った靴、巨大なイヤリング、派手なメガネをはじめとする奇抜で派手な装いを見せました。マドンナの歌にあるように「マテリアル・ガール」は過剰なファッションを好むのです。

レースの手袋やスタッズ（飾り鋲）付きのブレスレット、長いチェーンストラップ付きの小さなバッグ、5センチのピンヒールのアンクルブーツ、革ひもを編んだネックレス、ヘッドバンド、そしてロックやパンクといった音楽に影響を受けたダークなサングラスが流行しました。

イタリアでは「パニナロ」と呼ばれる若者ファッションの革命が起きました。オレンジ色のヌバック（起毛皮革）を素材とするカウボーイブーツやワークブーツに、モンクレール社製のカラフルなダウンジャケットを合わせるのが典型的でした。

また、この時期には、野心的な若きエリートであるヤッピーたちが消費主義を追求し、成功した富裕な経営者が愛用する最高品質の服や小物を好むようになります。

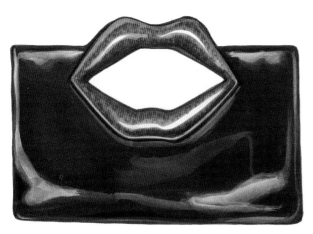

■ 1990年代

現代のファッション界で最も偉大な才能を持つデザイナーが台頭した時代で、特にイタリアのファッションは、ジャンニ・ヴェルサーチやジョルジオ・アルマーニら数多くのデザイナーたちによって世界的な成功を収めました。

さまざまなスタイルが流行し、クリエイションの現場では、ブランドやデザイナーの間で激しい競争が繰り広げられました。

ポップミュージックの分野では新時代にふさわしい女性像を表現したスパイス・ガールズが登場し、プラットフォーム（56ページ参照）のスニーカーが流行しました。

ジャンニ・ヴェルサーチはセクシーなスタイルを良質なデザインに高めました。

豪華な刺繍やバロック柄のシルクで彩られた非常に高いヒールのサンダルが流行しました。尖ったスタッズ（飾り鋲）をあしらって辛口な印象になった小さなクラッチバッグや、デコルテ・シューズも当時流行の小物です。

サングラスは宇宙服を思わせるようなデザインで、積極的に新しいものを取り入れる気性に富んだ、自信のある女性像を象徴していました。

この年代の「アイコン」であるスーパーモデルのナオミ・キャンベルやクラウディア・シファーが身に着けたドレスや小物は、カルト的な人気を博しました。

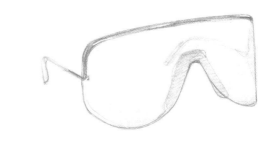

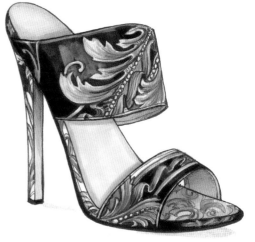

■ 2000年代

新ミレニアムへの扉を開いた2000年代、20世紀ファッションを形作ると同時に重荷になっていた遺産は過去のものになりました。インパクトがあると同時に柔らかさを感じさせるデザインが好まれるようになり、1990年代を特徴づけていた贅沢さへの希求は薄れ、精密で未来を志向するようなデザインが注目されます。

ソーシャルネットワークの誕生により、ファッション界の新たな主役はインフルエンサーとなりました。イタリア人のキアラ・フェラーニに代表されるような身近で若く美しい女性が、世界中の同年代の人々からフォローされ、称賛される世の中になったのです。「すべてが可能で、すべてが手の届くところにある」と誰もが信じた時代でした。

一方、有名ブランドは、偽造品の流通で大きな被害を受けたと報道されました。ブランドは自社のこれまでの作品を参考にしながら、新時代にふさわしい製品を発表しています。過去の象徴的なデザインが新時代にふさわしいファッション小物に生まれ変わり、グウィネス・パルトロウ、ジュリア・ロバーツ、レディー・ガガら女優やミュージシャンたちに愛用されました。

260

著者紹介

マヌエーラ・ブラムバッティ Manuela Brambatti

　マヌエーラは2年間のファッションデザイン課程を修了したのち、1977年にジョルジオ・コレッジャーリのスタイルオフィスでファッション界に入りました。クリツィアやジャン・マルコ・ベンチューリらさまざまなデザイナーとコラボレーションを行い、『イル・ジョルナーレ・テッシーレ（Il Giornale Tessile）』や『エル・フランス』などの雑誌ではイラストレーターとしての経験を積みました。キャリアのうえで最も決定的な出来事となったのが、1981年にジャンニ・ヴェルサーチとの出会いでした。ヴェルサーチの専属となり、レディースのプレタポルテ・コレクションのほか、舞台衣装、アクセサリー、オートクチュール、ホームコレクションに関わり、デザイン画やイラストを手掛けました。

　現在は、フリーランスで、イラストレーター、アーティストとしても活躍しながら、ファッションとデザインの両業界でクリエイティブな才能を発揮しています。

　2011年には、ミラノでジャンニ・ヴェルサーチに捧げる個展を手掛け、「ジャンニと一緒に見た夢、彼の思い出へのオマージュ」を表現しました。このときの作品の一部は、トニー・ディ・コルシア著『Gianni Versace - the Biography（ジャンニ・ヴェルサーチの伝記）』（Lindau Edizioni, 2012）に掲載されています。また、2011年には「ファッションの劇場（Il Teatro alla Moda）」展に参加しました。同展覧会は、ブレーシャのマッツケッリ美術館とミラノの衣装ファッション美術館を巡回しました。2015年にはコモで、ヴェルサーチのスタッフチームの元同僚であるウォルター・ラディスラオとブルーノ・ジアネシとともに、デザインの進展をたどって一連の作品を展示しました。

　マヌエーラのイラスト作品を掲載した書籍には下記のようなものがあります。『Vanitas（ヴァニタス）』シリーズ（Abbeville Press　アッベヴィル・プレス社）、『Versace Teatro（ヴェルサーチ・劇場）』第1巻、第2巻（Franco Maria Ricci　フランコ・マリア・リッチ社）、『Versace eleganza di vita（ヴェルサーチ・人生のエッセンス）』（Rusconi　ルスコーニ社）、『Gianni Versace - L'abito per pensare（ジャンニ・ヴェルサーチ　考えるための服）』（Arnoldo Mondadori Editore　アーノルド・モンダドーリ・エディトーレ社）、『South Beach Stories - Gianni and Donatella Versace（南岸の物語　ジャンニ・ヴェルサーチとドナテッラ・ヴェルサーチ）』（Leonardo Arte　レオナルド・アルテ社）。　2015年からイコン・エディトーレ（Ikon Editrice）とのコラボレーションを開始し、2017年に実践的なマニュアルである『Fashion Design Professionale（プロフェッショナルのファッションデザイン）』（英語版は『Fashion Illustration & Design（ファッションイラストレーションとデザイン）』、2017年にホアキ（Hoaki）社より出版）、2018年にデザイナーのコジモ・ヴィンチとの共著『ジュエリーのデザインと描き方』（ホビージャパン、2021年）を発表しています。

ファビオ・メンコーニ　Fabio Menconi

　イタリア・ペルージャ生まれのファビオ・メンコーニは、1990年にアンコーナのジェニー・バビロス・グループでキャリアを開始しました。ドナテッラ・ジロンベッリに見出されてジェニーのデザインチームに入り、創造的なビジョンを磨きました。若くしてブランドのセカンドラインであるジェニー・ドゥエのデザインや、ドルチェ＆ガッバーナのコンプリス・コレクションを手掛けました。

　その後はさらに第一線で活躍するようになり、ジロンベッリのアシスタントとして、ジャンニ・ヴェルサーチに協力してメゾンのすべてのコレクションに関わりました。偉大なイタリア人デザイナーが世界的な成功を収めた最盛期に、ファビオは複数の有名デザイナーのもとでの仕事を通して研鑽を積みます。セレモニードレス、イブニングドレス、カクテルドレスのほか、芸術的なデザインの小物（バッグ、靴、メガネ、スカーフ）を制作しています。

　1997年にはイタリアを離れ、国際的なハイファッションの世界に挑みます。エスカーダのクチュールラインのマネージャー兼スタイリストとなり、トッド・オールダムや、2人組で活動するマーク・バッジェリーとジェームズ・ミシュカとのコラボレーションを行いました。オートクチュールに加え、アカデミー賞やテレビイベント、VIPのウエディングドレスなど有名人の装いも手掛けています。ファビオのドレスは世界中のレッドカーペットで見られるようになり、ジョルジオ・アルマーニに注目され、アルマーニのイブニング・コレクションやオートクチュール・コレクションに加え、ハリウッドスター担当にも指名されるようになりました。

　その後、ドイツのブランド、レナランゲで仕事をした後、フリーランスとしてイタリア内外のブランドとコラボレーションし、最近は自身のブランドも立ち上げました。ファビオは長年のキャリアを通して、セレブリティを含む多くの女性たちに根強いファンを生み出しています。

原題：Disegnare Accessori
著者：Manuela Brambatti and Fabio Menconi
英語版原題：
Fashion Illustration and Design: Accessories
Shoes, Bags, Hats, Belts, Gloves, and Glasses
原書編集：Martina Panarello

【日本語版スタッフ】
翻訳：清水玲奈（れいな）
翻訳協力：株式会社トランネット
　　　　　https://www.trannet.co.jp/
カバーデザイン：萩原　睦（志岐デザイン事務所）
編集：森　基子（ホビージャパン）

ファッション小物のデザインと描き方
靴、バッグ、帽子、ベルト、手袋、メガネのデザインを学ぶ

2022年11月20日　初版発行

著　者　マヌエーラ・ブラムバッティ
　　　　ファビオ・メンコーニ
訳　者　清水玲奈
発行人　松下大介
発行所　株式会社ホビージャパン
　　　　〒151-0053　東京都渋谷区代々木2-15-8
　　　　電話　03-5354-7403（編集）
　　　　電話　03-5304-9112（営業）